The Artist's Illustrated

ENCYCLOPEDIA

techniques,
materials
and terms

PHIL METZGER

David & Charles

About the Author

 What do you do when you're forty years old with zero art experience and zero art training and your wife gives you a set of paints for Christmas? If you're Phil Metzger, you begin dabbling, paint some awful pictures that your relatives like, screw up your courage and leave your comfy IBM job to become an artist. You learn a little, teach some classes, learn some more and then begin exhibiting and selling your work at art shows around the country.

As he began learning about painting, Phil also started writing. His first book was a manual for computer programming managers. It was a big success and that led him to more writing. Now he has a couple of management books and six art books to his credit, along with a couple of self-published paperback art books and articles in art magazines. He's written several works of fiction, none of them yet published.

Today, Phil splits his time between teaching watercolor painting in Rockville, Maryland, and writing books. He loves doing both, but regrets there is never enough time for teaching, writing and the rest of life.

A DAVID & CHARLES BOOK

First published in the UK in 2001
First published in the USA in 2001 b y North Light Books, Cincinnati, Ohio

Copyright © Phil Metzger 2001

Phil Metzger has asserted his right to be indentified as author of this work in accordance with the Copyright, Designs and Patents Act, 1988.

A catologue record for this book is available from the British Library.

ISBN 0 7153 1242 1

Printed in China
for David & Charles
Brunel House Newton Abbot Devon

publisher's note
Some materials and products listed may not be widely available. If in doubt, consult your local art supply store for the nearest equivalent. 'Mat' is the US term for 'mount'.

metric conversion chart

to convert	to	multiply by
Inches	Centimeters	2.54
Centimeters	Inches	0.4
Feet	Centimeters	30.5
Centimeters	Feet	0.03
Yards	Meters	0.9
Meters	Yards	1.1
Sq. Inches	Sq. Centimeters	6.45
Sq. Centimeters	Sq. Inches	0.16
Sq. Feet	Sq. Meters	0.09
Sq. Meters	Sq. Feet	10.8
Sq. Yards	Sq. Meters	0.8
Sq. Meters	Sq. Yards	1.2
Pounds	Kilograms	0.45
Kilograms	Pounds	2.2
Ounces	Grams	28.4
Grams	Ounces	0.04

Edited by Nancy Pfister Lytle and Pamela Wissman
Production edited by Nancy Pfister Lytle
Designed by Wendy Dunning
Cover designed by Brian Roeth
Interior layout by Donna Cozatchy
Production coordinated by Kristen Heller

The Artist's Illustrated ENCYCLOPEDIA

techniques, materials and terms

Dedication

To Shirley Porter

Acknowledgments

Aside from my own experience, I drew on the expertise of many people in compiling the information in this book, and I wish to thank them all most sincerely. In addition, I made use of many art books, reference books, magazines and other writings in an attempt to make the encyclopedia entries as accurate as possible. Following are people whose help I gratefully acknowledge.

Manuscript Readers

Six brave people read the entire manuscript before I submitted it to the publisher. They caught all kinds of goofs and added lots of information, and for their help I am most thankful.

* **Shirley Porter**, artist and writer, my partner

* **Daniel K. Tennant**, artist and writer

* **Ross Merrill**, artist, Chief of Conservation at Washington's National Gallery of Art

* **Greg Albert**, artist, writer, and editorial director at North Light Books

* **Nancy Lytle**, my editor at North Light Books

* **Tom Howard**, copy editor

The North Light Staff

In addition to Nancy and Greg, many others contributed to the making of this book. Thanks to Rachel Wolf, who got if off the ground, and thanks to Pam Wissman, Wendy Dunning, Brian Roeth and Kristen Heller.

Individual Contributors

Over seventy artists graciously allowed me to use their work as illustrations. They are all listed at the rear of the book, along with their addresses and page numbers showing where their work appears. All artwork in the book not specifically attributed elsewhere is the work of the author.

TREE AND MEADOW | acrylic on canvas | 24" × 30" (61cm × 76cm). Collection of Scott Metzger, Frederick, MD.

Individuals and Companies

* Members of my art classes who suggested a number of entries.

* **Michael Ahearn** of Savoire Faire for product information.

* **Edwin Ahlstrom**, Professor of Art and head of the painting department at Montgomery College, MD, for help with certain definitions and for contributing art.

* **David Aldera** and **David Millman** of New York Central Art Supply for their help in tracking down pencil information.

* **Conrad Machine Company** for illustrations of printing presses.

* **Susan Conway**, owner of the Susan Conway Gallery in Washington, D.C., for help with the Pat Oliphant artwork and for introductions to artists James Hilleary, Pat Oliphant, Ross Merrill, Donald Holden and David Scott.

* **Trecie Coombs**, wife of artist William Coombs, for information about art shows and the National Association of Independent Artists.

* **Richard Frumess**, R&F Handmade Paints, Kingston, NY, for his help in writing about encaustic painting.

* **Mark Golden** of Golden Artist Colors, who gave me information about MSA paints and supplied several product photographs.

* **Deborah Gustafson** of ACMI for information about ACMI and ASTM seals.

* **Michael Hare**, Beach Brothers Printing, Rockville, MD, for information and photographs about offset printing and embossing.

* **Marah Heidebrecht**, who contributed art, suggested a ton of entries I had not considered and introduced me to the book, *Artist Beware*.

* **Margaret Hicks** for information about The Miniature Painters, Sculptors, & Gravers Society of Washington, D.C.

* **Vicki Jones**, store manager, Plaza Artist Materials, Rockville, MD, for excellent information on art materials and help in getting in touch with manufacturers.

JUST OVER THAT HILL | Shirley Porter | acrylic gouache on illustration board | 30" × 40" (76cm × 102cm)

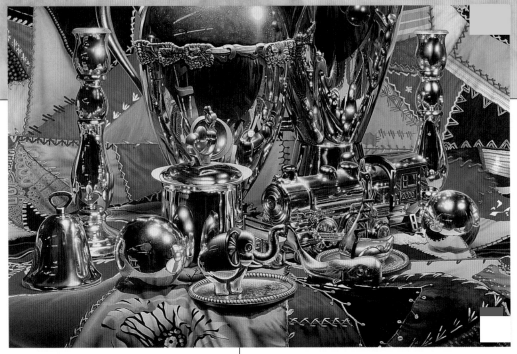

STILL LIFE ON A CRAZY QUILT | Daniel K. Tennant | gouache on illustration board | 39" × 59"(99cm × 150cm). Courtesy of Bernarducci·Meisel·Gallery, New York City.

✳ **Fred Kaplan** for his advice on photographing products and artwork.

✳ **Francis Knab** and **Jessica Offutt** of Graphic Visions Associates for help with slides and transparencies.

✳ **Margaret Kranking**, artist and teacher, who contributed art and pointed me toward a number of other contributors.

✳ **Joy Turner Luke**, artist, lecturer and leading activist in researching and setting standards for art materials; chairman of the ASTM Subcommittee on Artists' Paints and Related Materials, 1977–1990.

✳ **Shirley Miller** of Loew-Cornell for brush illustrations.

✳ **Tom Moran**, physics professor and college buddy, for his help with camera obscura.

✳ **Gert** and **Sheila Olsen** for contributing art and for help in locating other artists.

✳ **Kay Poole,** an artist who intoduced me to some new art materials.

✳ **Andrea Pramuk** of Ampersand Art Supply for information about Claybord.

✳ **Steven Roth** and **Richard Grenoble** of Chartpak for product information.

✳ **Mark Schachner**, AJ Fine Arts Ltd and Mill Basin Gallery and Restaurant, Brooklyn, NY, for contributing art by Erté.

✳ **Cornelia Seckel** and **Raymond J. Steiner** for help in locating illustrations and for contributing to several encyclopedia entries. Steiner and Seckel publish *Art Times*, a monthly commentary and resource for the fine and performing arts. CSS Publications, Inc., P.O. Box 730, Mt. Marion, NY 12456-0730.

✳ **Millie Shott**, artist and Curator of Art at Strathmore Hall Art Center, Bethesda, MD, for contributing art and for help in locating artists.

✳ **Mike Sonnenberg** of the Asphalt Institute for clearing up some information about art materials.

✳ **George Stegmeier** at Grumbacher, always a source of detailed knowledge about art materials.

✳ **Peter Stoliaroff**, printmaker and teacher, for reading and correcting sections about printmaking.

✳ **Mary Swift** of MacPherson's, distributors for M.A.B.E.F. easels, for supplying illustrations of easels.

✳ **Dan Tennant**, who not only contributed artwork and read the entire manuscript, but offered a steady stream of helpful advice and encouragement as well. He also pointed me toward several artists whose work appears here.

✳ **Ruthe Thompson**, assistant professor at Southwest State University, Minnesota, and art writer, for putting me in touch with several artists.

✳ **Bob** and **Karen Underhill**, Brookfield, CT, for help in locating enamel art.

✳ **Wendell Upchurch** of Winsor & Newton for paint information and paint sample charts.

✳ **Bruce Wall** of Binney & Smith, who dug out some answers I couldn't find elsewhere.

✳ **Robert Waller, Jr.** of Writing Instrument Manufacturers Association for PMA seals.

✳ **Bernadette Ward**, Royal Sovereign Company, for information about Wolff's carbon pencil.

✳ **James Weissenborn**, CEO of General Pencil Company, Redwood, CA, for contributions relating to pencils, charcoal, brush soaps and erasers.

LANDS END | Ross Merrill | oil on canvas | 30" × 40" (76cm × 102cm)

Introduction

About This Book

If you prefer a world where everything is black and white with no gray, you may sometimes be frustrated by definitions of things in the art world. Many terms are defined one way by one "expert" and another way by someone else who is equally qualified. Sometimes this happens because over long time periods language changes; sometimes it's because a popular book includes an error that never gets corrected and consequently becomes part of the lore; and often it's because someone with some sort of axe to grind—a manufacturer, perhaps?—throws out a new definition. In this encyclopedia I have tried to go with definitions that make sense in contemporary usage, indicating here and there older, no-longer-used definitions. I have tried to alert the reader to definitions that are suspect. In defining "Not" paper, for example, I conclude that there are so many competing definitions that the word is quite useless—so why use it? In all cases I have gone to more than a single source for my information. While this does not necessarily put the stamp of absolute authority on a definition, it guarantees, I think, that what you read here will be current and practical.

About Content

The intent of this book is to define terms, materials and techniques. It is not a typical how-to book. In many entries I have mentioned other books, my own included, where you might find more information about the subject. For example, if you want to know more about getting started in any of the major painting and drawing mediums, see *The North Light Artist's Guide to Materials & Techniques*; for more on perspective, see *Perspective Without Pain* and *Perspective Secrets*; for use of the technical pen, see *The Technical Pen*; for design, see *The Art of Color and Design*; for airbrushing, see *Realistic Painting*; for collage, see *Realistic Collage*; for painting birds, see *Drawing and Painting Birds*; for egg tempera painting, see *New Techniques in Egg Tempera* and so on. These and other excellent books are listed in the Acknowledgments.

About the Entries

Some words have multiple definitions, some relating to art and some not. In the interest of space conservation, I've included only the definitions that are relevant to artists. Thus, *liner* is defined in terms having to do with picture framing; oceangoing vessels are not mentioned. As for pronunciation, I've included my own simple version of a phonetic approach for a few words whose pronunciation may not be commonly known; syllables to be emphasized are in italics and alternative pronunciations are separated by a semicolon. Parts of speech are not indicated, but are clear from context. A great many words can be used as either a noun or a verb—*engraving*, for example—I decided not to take up precious space by including both senses, as long as the meaning is clear. A few brand names are included because of their common usage in the art business—Masonite, for example. Because context and capitalization clearly show these words as brand names, ® and ™ symbols are not used.

abaca fiber /ah buh *kah*; *ah* buh kah/
A tough fiber from the abaca plant, a relative of the banana plant; sometimes called banana fiber. It's also called by such names as Manilla hemp, but is not related to true hemp. It's used by some artists as an ingredient in handmade paper, especially paper used for sculpture or collage.

abbozzo /ah *bot* zo/
A sketch, rough model or rough copy of a work of art.

abstract
Not necessarily related to real forms or objects.

abstract art
Art containing little or no depiction of real objects or real scenes. Abstract art relies on shapes, textures, color, tone and other qualities for its impact, rather than on a *depiction* of things. In modern usage,

In 1890, artist Maurice Denis described the movement toward abstraction this way: "It should be remembered that a picture—before being a warhorse, a nude or an anecdote of some sort—is essentially a flat surface covered with colors assembled in a certain order."

abstract art is often used as synonymous with nonobjective or nonrepresentational art, but that's not quite accurate. The terms nonobjective and nonrepresentational always mean "totally unrelated to real objects," while abstract is a broader term that can mean *either* "vaguely based on real objects" or "totally unrelated to real objects." The illustrations show different levels of abstraction. *See illustrations on pages 10-12.*

Abstract Expressionism
A philosophy of painting in the United States in the late 1940s and the 1950s emphasizing the expression of emotion rather than depicting objects. Most Abstract Expressionist painters used large canvases, dramatic coloring and either loose brushwork or no brushwork at all. Paint might be flung, dripped or drizzled over a picture surface. Abstract Expressionists were more concerned with the act of painting and the expression of intense emotion than with the rendering of realism. One of the most famous and influential Abstract Expressionists was Jackson Pollock (American painter, 1912–1956).

accident
1 | An unplanned and uncontrolled effect, usually in a fluid medium such as watercolor. For example, two wet colors may run

Abstract art
In this abstraction, the "subject" is landscape, but the picture is really about colors, values and textures *suggested* by a landscape.

THE SCARLET PATH | John W. Moran | watercolor | 22″ × 29″ (60cm × 74cm)

together unaided by any brushing and produce unusual colors and textures you could not easily duplicate by intentionally brushing the paints together. The term is generally reserved for results that are attractive, so the event is often called a *happy* accident. *See illustration under backrun.*
2|The effects produced by action painters who often apply paint in unorthodox ways, such as flinging or dribbling. Some action painters, however, insist there is nothing "accidental" about what they do, because every action taken is a result of some psychological intent. *See action painting.*

acetate
A thin, tough, flexible transparent film used by artists in several ways: **1**: To separate pictures in a stack; **2**: to cover pictures for protection—for example, a temporary cover for a watercolor painting until it is framed properly under glass; or **3**: to lay over a painting or drawing that needs correcting—corrections may be explored with grease pencil on the acetate without harming the underlying picture. *See also Mylar drafting film; grease pencil.*

acetone
A highly volatile, flammable solvent used in many paint and varnish removers, including nail polish remover, and as a solvent by printmakers. Acetone is sometimes used in cleaning paintings and prints, but it's a strong solvent and should only be used by those who thoroughly understand its properties and how it may affect an artwork.

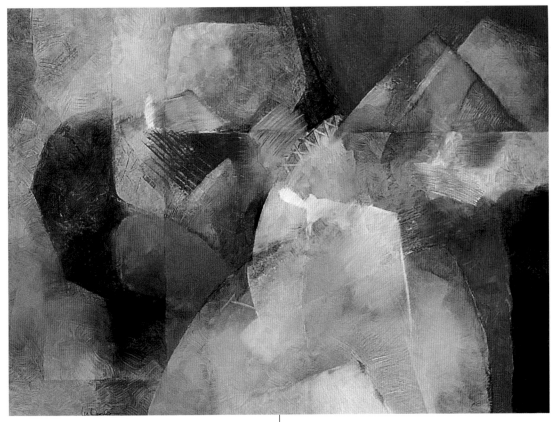

achromatic

1 | Made up of black, gray and white.
2 | Made up of hues other than black, gray and white, but of lowered intensity. For example, an intense red may be called a chromatic color, while that same red weakened by the addition of white or black is called achromatic.

acid

See pH.

acid free

Containing no material with a pH of less than 7. Although a pH of 7 is ideal, for practical purposes art materials such as papers are often considered acid free even if their pH is slightly below 7. *See pH; alkalinity; permanence.*

ACMI

See Art & Creative Materials Institute.

Abstract art
In this picture there is no subject at all, only a surface of color, texture and tone. Artist Coombs says about his work: "My images are created purely from my imagination with a high regard for the directional element of the design. Since my images are a direct result of my creative spirit, they are influenced by my life—they are an extension of who I am. They are purely nonrepresentational and many times I elect not to title them because of the influence a title may impose upon the viewer."

UNTITLED | William Eason Coombs | oil on museum board | 22″ × 30″ (60cm × 76cm). Collection of Harry Rand, Atlanta, GA.

acrylic

A generic term for a broad range of products based on chemical molecules that are particularly tough and stable called polymers. Examples of products are acrylic sheets (e.g., Plexiglas and Lucite), acrylic fibers used in clothing and carpets (e.g., Orlon), acrylic paints and adhesives. Acrylics are derived from petroleum. The first experiments with acrylics were made

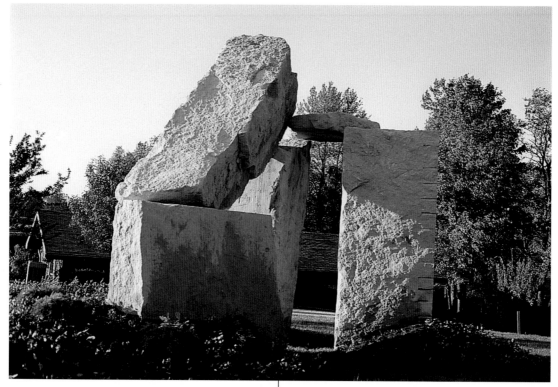

Abstract art
This is one of four structures by Mark Wallis that are part of an arranged environment in front of the Oliver Winery. This section measures roughly 20′ (6m) from corner to corner and is about 18′ (5m) high. The huge stone pieces were trucked from the quarry to the assembly site and put into place using a 50-ton hydraulic crane. Once assembled, Wallis sandblasted the stone surfaces to get the finish he wanted. He completed the project by landscaping the 100′ × 200′ (305m × 610m) area in which his stone sculptures were placed.

OLIVER WINE LIMESTONE ENVIRONMENT | Mark Wallis | 18′ × 20′ (5m × 6m). Commissioned by Oliver Wine Company, Bloomington, IN.

in 1880 by Swiss chemist Georg W.A. Kahlbaum and in 1901 by German chemist Otto Röhm. The earliest applications of their work were in making safety glass. *See polymer; acrylic paint; acrylic medium; Plexiglas; Lucite. See sidebar on page 13.*

acrylic emulsion medium
See acrylic medium.

acrylic gesso
A white material with the consistency of heavy cream used as a ground for acrylic and other paints. Acrylic gesso is not the same as white acrylic paint—although similar in makeup, dried acrylic gesso is more porous and has more "tooth" than acrylic paint. *See gesso, acrylic; gesso, true; ground.*

acrylic gouache
See gouache, acrylic.

acrylic ink
Ink made specifically for use in technical pens. Its pigments are finely ground to avoid clogging the pens. *See technical pen.*

acrylic medium or acrylic emulsion medium
A liquid or gel substance used to change the consistency and degree of glossiness of acrylic paint. Acrylic mediums have the same chemical base as acrylic paints, so

Acrylic mediums
Acrylic mediums are available in great variety.

The Acrylic Name

The products that painters have become accustomed to referring to as acrylic paints and mediums should more accurately be called acrylic *emulsion* paints and mediums to distinguish them from other acrylic products that are not emulsions—an example is MSA paint. However, manufacturers rarely include the word emulsion prominently on their labels, and artists have become accustomed to using the word acrylic without adding the word emulsion. For that reason, in this book we use the term acrylic in its popular sense to mean acrylic emulsion.

they are compatible and may be mixed generously with the paints without fear of weakening the paint film. Some acrylic mediums are misused as a varnish to protect a finished painting—this is not sound practice because a medium becomes a permanent part of the painting and is not removable. A varnish should be removable. *See acrylic varnish. See chart on page 17.*

acrylic paint

Paint made from three basic ingredients— pigment, water and a synthetic resin that acts as the binder—along with other ingredients, such as plasticizers, that improve the paint's performance. Acrylic paint in tubes has a buttery consistency; in jars or cans it is more fluid. In addition to basic acrylic paints there are many kinds of specialty acrylics, including the following:

Iridescent colors simulate the look of metals such as gold, silver and bronze.

Interference, or *refractive*, colors change when viewed at different angles, like certain birds' feathers or a slick of oil. Typically, at one viewing angle you see the paint's labeled color, such as red, and from another you see its complement, green.

In Case You Need to Paint a Blimp

Liquitex brand artist's-quality acrylic paint has been used to paint the Goodyear Blimp, Spirit of Akron, which says something about the ability of acrylics to withstand the ravages of weather and ultraviolet light! Goodyear used 45 gallons of Prussian Blue, 3 gallons of Cadmium Yellow and plenty of gloss and gel mediums. All told, the paint added about 180 pounds to the weight of the blimp.

Acrylic paint
Acrylic paint is sold in a variety of tube sizes. Those shown here range from $1/2$ fluid ounce to 7 fluid ounces.

Acrylic paint
Acrylic paint in jars and cans is more fluid than tube paint.

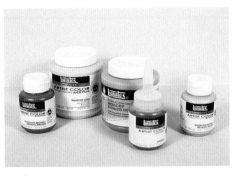

Acrylic paint
Because of the versatility of acrylic paint, it's used as the base for many specialty paints. Those shown here simulate the look of bronze, gold, silver, stainless steel and emerald.

Acrylic paint
A typical setup for painting in acrylics.

Airbrush colors are watery thin. Their pigments are finely ground to minimize the danger of clogging the nozzle of an airbrush.

Acrylic ink is similar to airbrush color and is intended for use in drawing pens.

See airbrush; binder.

acrylic varnish

A fluid used to coat and protect an acrylic painting against dirt and physical damage; may be brushed on or sprayed on. Most acrylic varnishes are removable (but see the note under the table on page 17) with-out damaging the underlying painting and they are not porous, so they shield the painting well against dirt. Modern acrylic varnishes, a few of which offer ultraviolet (UV) protection, are suitable for varnishing not only acrylic paintings, but oils and other paints as well. They are superior to more traditional varnishes for oil paintings, such as damar, mastic and copal varnishes, which discolor with age and must be periodically removed and replaced. Acrylic varnishes are available in gloss, satin and matte varieties—to determine which finish best suits your needs, try each on a throw-

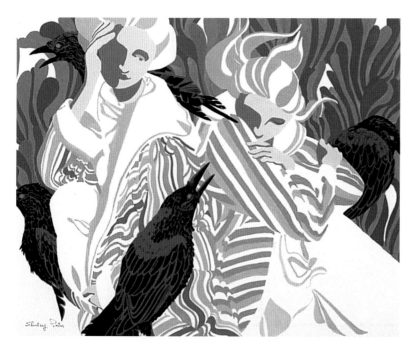

Acrylic paint

Because of its rapid drying time, acrylic paint is especially effective in hard-edged paintings like this one. To attain soft-edged acrylic paintings, you may use one or all of several techniques: **1:** Mix liberal amounts of fluid mediums with the paint; **2:** use retarding mediums; **3:** work rapidly to blend adjoining edges; or **4:** paint using small hatching strokes that overlap (*see crosshatching*).

SECRETS | Shirley Porter | acrylic on museum board | 30″ × 40″ (76cm × 102cm)

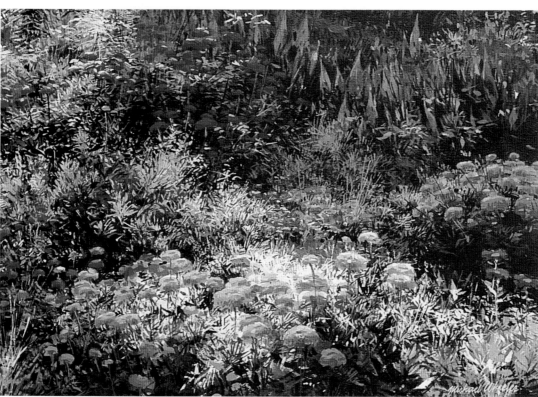

Acrylic paint

AUGUST GARDEN, ORANGE MARIGOLDS | Michael Wheeler | acrylic on canvas | 14″ × 18″ (36cm × 46cm). Collection of James Thomas.

Acrylic Mediums

Medium	Consistency	Transparency	Uses and Limitations
Water	thin	transparent	For thinning paint and for cleaning up. Used for thinning, it somewhat weakens the paint film, especially if used in proportions that make the paint thin and watery. Better to use one of the prepared mediums.
Gloss Medium	syrupy	transparent	Mix with paint in any proportion either to make paint more easily brushable or to make it thin enough to use as a glaze; gives paint a shinier appearance.
Matte Medium	syrupy	transparent in thin layers; cloudy in thicker layers	Mix with paint in any proportion to make paint more easily brushable and to give paint a duller, less shiny look.
Gel Medium	creamy	transparent	Mix with paint in any proportion to stiffen the paint and increase the transparency and brilliance of the color. Also a strong adhesive in collage.
Matte Gel Medium	creamy	translucent	Mix with paint in any proportion to stiffen the paint. Reduces transparency and brilliance of the color. A strong adhesive in collage.

away painting. It's not easy to remove varnish, so you can save a lot of grief by getting it right the first time.

It's important to understand the differences between acrylic varnishes and acrylic mediums. Acrylic mediums are sometimes used as varnishes, but mediums have two drawbacks: **1**: They are generally not removable and **2**: they are usually porous, allowing dirt to settle in the pores, thus making cleaning difficult. To avoid these problems, choose acrylic *varnish* rather than acrylic medium. Some examples of acrylic mediums and varnishes and their uses follow—many other manufacturers offer equally good products with equally confusing names. Learn to read labels and literature carefully. *See varnish; ultraviolet light. See chart on page 17.*

acrylic varnish remover
A fluid used to remove acrylic varnish from a painting without damaging the underlying painting. Read the varnish label to find out which specific varnish remover should be used to remove a particular varnish—what works for one brand of varnish will not necessarily work for another. *See examples in the chart under acrylic varnish, page 17. See varnish.*

acrylic watercolor
Acrylic paint thinned to a watery consistency and used in the same manner as tra-

Acrylic Mediums and Varnishes

Name of Product	Should be used as	Porous?	Removable?***
Liquitex Acrylic Gloss Medium and Varnish	medium *despite its name, this product should not be considered a true varnish because it is not removable*	yes	no
Liquitex Acrylic Matte Medium	medium only	yes	no
Liquitex Acrylic Matte Varnish	varnish only	yes	no
Liquitex Soluvar	varnish only	no	yes *mineral spirits or turpentine*
Winsor & Newton Acrylic Gloss Medium	medium only	yes	no
Winsor & Newton Acrylic Matte Medium	medium only	yes	no
Winsor & Newton Acrylic Gloss Varnish	varnish only	no	yes *Winsor & Newton Acrylic Varnish Remover*
Winsor & Newton Acrylic Matte Varnish	varnish only	no	yes *Winsor & Newton Acrylic Varnish Remover*

*** There is considerable dispute about removable varnishes. Although advertised as "removable," museum conservators have found that some of these varnishes, such as Soluvar, may "crosslink"—that is, form a bond with the painting—and may therefore be anything but removable. Even the manufacturers warn that varnishes advertised as removable may not be if the painting was not sufficiently "cured" or dried before the varnish was applied. The perfect varnish is not yet at hand. *See the sidebar under varnish.*

ditional watercolor. The chief difference between traditional watercolor and thinned acrylic is that acrylic paint is waterproof when dry. This means an acrylic "watercolor" is less prone to water damage; it also means that acrylic "watercolor" is more difficult to lift, or remove, than conventional watercolor.

action painting
Painting in which the physical activity of the artist is apparent. In paintings by Jackson Pollock or Willem de Kooning the viewer can easily imagine the artist slashing away with a large brush or splattering, throwing or dripping paint as he moves about the canvas. In some cases a large canvas lies on the floor and the painter

moves around its edges or even walks over the canvas while energetically applying paint. Sometimes used as a synonym for Abstract Expressionism. *See accident.*

additive color mixing

The combining of beams of light to produce new colors. The primary colors in additive mixing are red, blue and green. Beams of light of those three colors in equal intensities produce white; red and green produce yellow; red and blue produce magenta; and blue and green produce cyan. This is the type of color mixing that occurs on a television screen. By varying the intensities of the beams of primary colors, all colors may be produced. Painters should not confuse this with *subtractive* color mixing, which is what happens when *pigments*, rather than light beams, are mixed. In subtractive color mixing the primary colors are red, blue and yellow. *See subtractive color mixing; color wheel.*

adhesive

Any substance used to bond one surface to another. Natural adhesives, both organic and inorganic, have been used for centuries, and some of them have important roles in artists' materials. Many natural adhesives have been supplanted by synthetic ones. *See individual entries: acrylic mediums and gels; glue; animal glue; gelatin; casein; fixative; gum; mucilage; paste; Portland cement.*

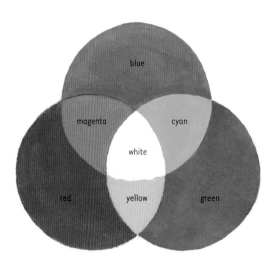

Additive color mixing
Here is what happens when three light beams—red, blue and green—overlap. Where all three overlap, the result is white.

aerial perspective

The effects of impurities in the atmosphere on how we see an object; also the use of drawing and painting techniques to mimic those effects. When you see a distant object, you're seeing it through a veil of air containing impurities such as soot, dust and water droplets. Those impurities affect the way you see the object in two ways: **1:** They block some of the light coming from the object, making the object appear more vague than it would otherwise be, and **2:** they filter out some of the longer wavelengths of light, such as the reds, and allow the shorter wavelengths, such as blue light, to reach your eye. The result of these two actions is that we generally see distant objects as less distinct and cooler (bluer) than they would appear if distance were eliminated. The farther away an object is and the more impure the air, the vaguer and cooler the object will appear. Also called *atmospheric* perspective. *See illustration on page 19.*

Aestheticism

A European art movement in the latter half of the nineteenth century that stressed the idea of "art for art's sake." Aestheticism had its roots in even earlier times, as philosophers argued the place of art in mankind's existence. There were those (moralists) who argued that art's function was to serve or assist in life, while aestheticists took the view that art and the beauty of art are of primary, overriding importance and are divorced from morality. There is a

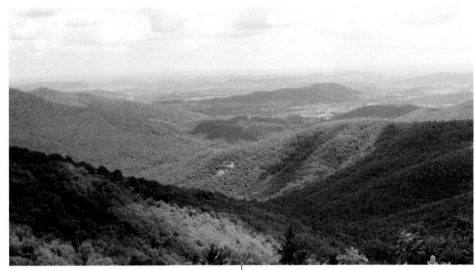

Aerial perspective
The farther away the hills are, the bluer and paler they appear. The darker areas in this scene are cloud shadows.

story that the son-in-law of Italian dictator Benito Mussolini once described the beauty of a bomb exploding among a crowd of unarmed people—an example of carrying Aestheticism to an extreme! Among the key players in the Aestheticist movement were writer and critic Oscar Wilde, illustrator Aubrey Beardsley and painter James McNeill Whistler.

afterimage

A visual sensation that persists for some time after the external stimulation that originally caused it ceases to exist. Sometimes this term is also applied to the halo of complementary color one sees around a color. *See successive contrast, law of; simultaneous contrast, law of.*

air eraser

A tool that uses a stream of abrasive particles to remove paint, ink, dirt, rust and other surface materials—a miniature sand blaster. It also has such diverse uses as shaping dental castings, "etching" glass and erasing defects on lithographic plates. An air eraser looks similar to an airbrush, but instead of directing a stream of air and paint at a surface it produces a mix of air and fine abrasive—the abrasive "erases" the target area by wearing it away. There are two

basic types of air eraser: **1:** One that has an attached cup for holding the finely powdered abrasive and **2:** one that is attached by a hose to a much larger container of abrasive, typically a quart. In either case, the user aims the air eraser's nozzle at the surface to be erased and uses a trigger mechanism to regulate the force and duration of the stream of abrasive particles. A common abrasive is aluminum oxide, similar to materials used by some stone sculptors in polishing their finished works. Erasers use the same kinds of air compressors used in

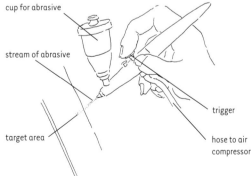

cup for abrasive
stream of abrasive
target area
trigger
hose to air compressor

Air eraser
An air eraser works like a small sandblaster to wear away a surface such as paint or corrosion.

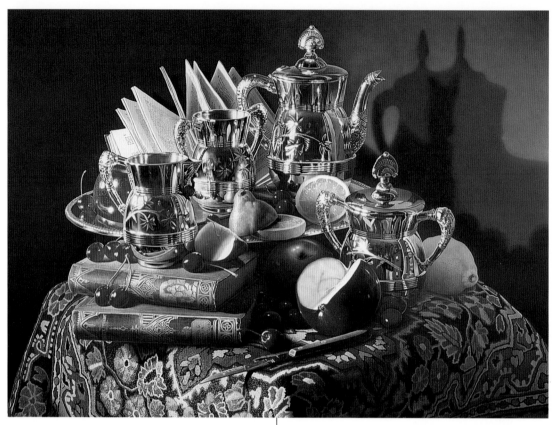

airbrushing, but the range of pressures needed varies from one eraser to the next. When using an air eraser, wear a respiratory mask to avoid inhaling the abrasive particles and the loosened target particles.

airbrush

A painting tool invented in 1893 by Charles Burdick. It uses compressed air to force paint through a small nozzle, resulting in a fine spray of paint droplets. The paint spray may be directed by the artist over a broad area of the painting or, by masking off portions of the work, over a restricted area. Airbrushes may be adjusted to vary the fineness and force of the spray. Usually water-based paints, especially watercolor and gouache, are used—they are less likely than other paints to clog the nozzles and they allow cleaning of nozzles with plain water. Thin versions of other paints, such as oils, may be used, substitut-

Airbrush

In this painting you can practically read the print on the pages of the open book! The accompanying illustrations show just three of the many steps required to build up one element of the picture, the silver creamer. As he worked on each individual area of the creamer, Tennant used cut masks to protect surrounding areas from being sprayed with paint. His basic approach to painting silver, as shown here, is to do a dark underpainting, then middle tones, lighter tones and, finally, highlights. Gouache is well suited to this painting procedure because light tones can be painted over darker tones with excellent coverage.

STILL LIFE WITH HEIRLOOMS | Daniel K. Tennant | gouache on museum board | 40″ × 50″ (102cm × 127cm). Private collection.

ing various solvents for water. In such cases, artists must take extreme precautions to avoid inhaling toxic sprays.

Airbrushes are of two basic types: **1**: A *single-action* airbrush has a trigger that releases a stream of air and paint. Increased pressure on the trigger releases more of both air and paint. **2**: A *double-*

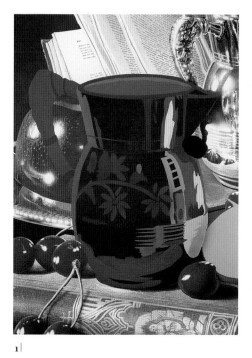

1|

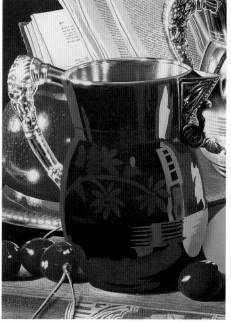

2|

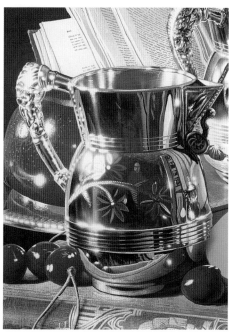

3|

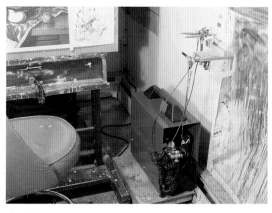

Daniel Tennant's work space

The blue box at the right is a compressor made by Badger; above it are airbrushes resting in their holders. At the extreme right is an old window shade used for testing colors, and at the left is Tennant's taboret, where he mixes paints. Above the taboret is a screen on which he projects slides of the image he is painting. The projector is on a counter about four feet (1.2m) behind the screen. Unlike most watercolorists, Tennant works at a vertical easel.

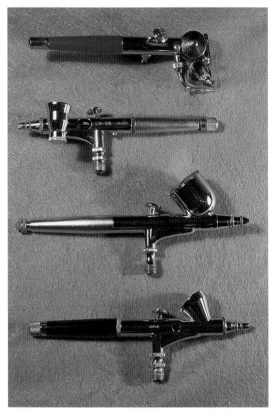

Airbrush

Four airbrushes used by Daniel Tennant. The top brush (red handle) is a model called the Paasche AB Turbo that makes use of a needle vibrating at high speed to supply the finest spray; next is a side-cup double-action model that allows for quick color changes; the third is a gravity-fed cup model that holds a lot of paint; and the last is a gravity-fed type that delivers a fine spray. Photo from *Realistic Painting* by Daniel K. Tennant, Walter Foster Publishing.

action airbrush has a trigger that works in two ways—when pressed down it releases only air, but when pressed down and pulled back it releases both air and paint. This type of brush allows fine control over both aspects of the paint spray—that is, the air and the paint.

In addition to the choices of single- or double-action, airbrushes may be either external mix or internal mix. *External mix* means that the paint and air come together outside the body of the airbrush—that is, there are effectively two nozzles close together, one for air and one for paint.

Internal mix means the air and paint are mixed inside the body of the airbrush and the mix exits through a single nozzle. External mix airbrushes give a coarser spray than internal mix.

Another variable is the type of paint reservoir that feeds an airbrush. All reservoirs are attached to the airbrush, but some work by suction and others work by gravity. *Gravity* reservoirs are attached to the top of the airbrush and gravity pulls paint from the reservoir down into the airbrush mechanism. *Suction* reservoirs are attached either to the side (left or right side, your choice) or underneath the airbrush. The rush of air in the airbrush sucks paint from the reservoir through a small tube. The top-mounted gravity reservoir allows you to position the airbrush as close to the painting as you wish; the side- or bottom-mounted suction reservoirs sometimes can get in the way as you maneuver the airbrush close to the painting. A big advantage to the suction reservoirs is that they are detachable—many are screw-type jars—so you can quickly switch paint colors by attaching different jars of paint. When using the top-mounted gravity reservoir, it's necessary to clean it before filling it with a new paint color. *See compressor.*

alabaster

1 A relatively soft, fine-grained form of the mineral gypsum (calcium sulfate). Alabaster, normally snowy-white and translucent, is used for carving statues and other ornaments. It is easily scratched and must be protected from injury. **2** In ancient usage, a calcium carbonate rock, a type of marble.

à la poupée /ah lah pooh *pay*/

A method of color printmaking involving a single plate rather than a separate plate for each color. In à la poupée, different colored inks are applied to appropriate por-

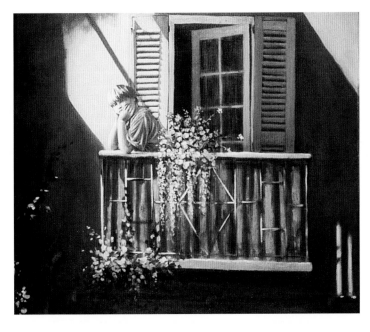

Alkyd paint

Compare Poulin's looser style with Gordon's tighter approach—in alkyd, as in many mediums, all styles are possible. Poulin found this scene in a market in the French village of Apt. He was taken by the aromas and colors of the area and the flowered balcony was just right in the afternoon light. When a boy appeared and nonchalantly leaned on the rail, the scene was perfect.

BALCONY, APT VILLAGE, PROVENCE | Bernard Poulin | alkyd on canvas | 24″ × 30″ (61cm × 76cm). Collection of the artist.

tions of the plate and a single run is made through the printing press. The tool used to dab colors onto the plate is a small ball of cloth tied off at one end and resembling a doll's head—the French word for doll is poupée. *See aquatint; three-color drop.*

alcohol

A solvent that dissolves many dried paint and varnish films. Common ethyl alcohol (ethanol) is derived from grain, while methyl alcohol (also called methanol or wood alcohol), formerly derived from wood, is now made synthetically. Both are volatile and poisonous.

alcohol, denatured

Ethyl alcohol containing additives that make it unfit for consumption. It's the kind of alcohol normally available as a solvent.

alkaline

The opposite of acid in chemistry. Acidic materials are most often responsible for problems such as yellowing and disintegration of artists' materials, but strong alkaline materials can be harmful as well. Art manufacturers try to make high-quality materials pH neutral—neither acidic nor alkaline. *See pH; acid free.*

alkyd paint

A paint similar to oil paint but with a significantly faster drying time. The binder in alkyd paint is an oil-modified alkyd resin. Unlike natural resins, which are derived from plants, alkyd resin is synthetic. It's made by combining alcohols and acids, from which came the name *alcid*, later changed to *alkyd*. Adding oil, such as linseed oil, to this synthetic resin produces the binder in alkyd paints. Long recognized as a superior paint for industrial use, alkyd later became refined for use as an artist's paint. Alkyd has several advantages over oil paint: It has a faster drying time, it forms a tougher film and all alkyd colors dry at the same rate. A thin glaze may dry in as little as an hour; a thicker film may dry in a couple of hours, or certainly overnight. Alkyds and oil paints may be freely intermixed; adding oil paint to alkyd, however, results in slower drying than with alkyd alone. Both use the same mediums and solvents—turpentine, miner-

Alkyd paint

Edward Gordon, well known for beautiful interior scenes such as this, finds alkyd the perfect paint for capturing fine nuances of light and shadow. He usually works on hardboard coated with many layers of acrylic gesso sanded to a smooth, eggshell-like finish. He builds up thin layers of alkyd so that early layers show through later ones and provide the glow that is a hallmark of his paintings.

UPSTAIRS | Edward Gordon | alkyd on hardboard panel | 16″ × 14½″ (41cm × 37cm)

Slow-Over-Fast

When alkyd paint is added to oil paint, the drying time of the combination is less than that of oil paint alone. To prevent later cracking of the paint film, faster-drying layers—that is, layers containing higher proportions of alkyd—should be painted first.

al spirits, Liquin and so on. *See oil paints, comparing.*

alla prima painting

Italian for "at once." Direct painting, usually with no preliminary underpainting, finished in a single painting session.

allegory ·

In literature, a story in which characters or events are not meant to be taken literally, but rather to symbolize other characters or events. An example is George Orwell's *Animal Farm*, in which animals and their behavior are intended to mimic humans and their behavior. In art, a picture containing figures or scenes that symbolize other figures or scenes. Example: the work of Hieronymus Bosch, who often included devils and grotesque creatures in his paintings to represent human attributes.

alloy

A substance composed of two or more metals or of one or more metals and a non-metal, combined usually in molten form. Often the addition of another element radically changes the nature of the base element. For example, a relatively small proportion of chromium added to iron produces one variety of "stainless steel," an alloy that resists corrosion and is in some ways ideal for outdoor sculptures; other steels are made by adding a variety of

ingredients to iron, including carbon, nickel, silicon and so on. Other common alloys in art are brass (copper+zinc) and bronze (copper+tin).

Bronze, in use since at least 3000 B.C., is prized in art not only because of its pleasant appearance and the patina it develops over time, but also for its behavior in a mold. When molten bronze is poured into a mold, it slightly expands as it hardens, thus filling the mold and faithfully recording the details within the mold; as it cools, it contracts slightly, making removal of the mold easier. A form of bronze with a high tin content is used for bells because of the quality of the sound when rung. An extremely hard, durable alloy, bronze is used industrially for such items as bearings. Brass also has a long history; it's more malleable than bronze and can be fashioned into a variety of decorative and utilitarian objects. Some varieties of both bronze and brass contain small amounts of elements other than the basic ones.

Alloys called fusible alloys are useful for their property of melting at relatively low temperatures—they are used in electrical fuses, fire sprinkler controls and in common solder, a mixture of lead and tin.

American Society for Testing and Materials

An organization that develops standards for testing and labeling many materials, including paints. Information may be obtained from ASTM, 100 Barr Harbor Drive, West Conshohocken, PA 19428-2959. *See permanence.*

analogous colors

Colors closely related along the color wheel. In the color schemes described by Stephen Quiller in his book, *Color Choices*, analogous colors are any three adjacent primary, secondary and tertiary colors. For example, red, violet and red-violet are anal-

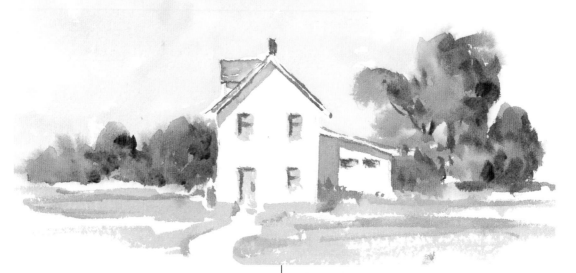

ogous colors. Using such closely related colors helps to assure color unity in a painting. *See color wheel.*

anamorphism

Drawing or painting an object in a distorted manner so that it looks normal (undistorted) only when viewed under unusual conditions, such as at a severe angle or in a curved mirror. Example: A well-known painting by Hans Holbein, *The French Ambassadors*, is realistically rendered in all respects, but at the bottom of the picture is a strange, elongated object. If you tilt the picture at a sharp angle so that the object appears foreshortened, you see that it is a skull.

ancient

In art, the time from the earliest civilizations until the fall of the Roman Empire in 476 AD.

angle of incidence

The angle at which light rays strike a surface. *See reflection.*

angle of reflection

The angle at which light rays rebound from a surface. *See reflection.*

angular perspective

Two point perspective. *See discussion under linear perspective.*

animal-free products

Materials that are not derived from animals. Many art materials, such as rabbitskin glue, gelatin, chamois, casein and natural brushes, are made from animal parts or animal products. For those who do not wish to use such materials there are substitutes available, perhaps the most prominent being synthetic brushes, available in all shapes and sizes from many manufacturers.

animal glue or protein glue

Adhesive made from the collagen found in the skin, hide and bones of animals. Depending on the particular ingredients and processing used, the product may be either clear (and edible) gelatin or darker (and inedible) glue—it's the latter that's generally called animal glue. An example is rabbitskin glue, used for sizing raw canvas. *See sizing; canvas, priming.*

animation
See Cubism.

antique
Under U.S. law, an article of artistic or historical significance more than one hundred years old.

A/P
"Artist's Proof," a designation written usually near the margin of a print to indicate that the print is a test copy. *See also print.*

appliqué /ap luh *kay*/
Broadly, something applied decoratively to another surface. A decoration cut from one material and fastened to a piece of the same or another material; a design made by stitching together, embroidering or pasting shapes onto a surface, such as quilts, skirts or tablecloths; a shaped piece of wood or metal attached as a decoration to furniture.

aquarelle
French term for transparent (as opposed to opaque) watercolor. Also a brand name for watercolor paper. *See watercolor.*

aquatint
A printing technique that creates tonal areas instead of, or in addition to, line. A metal plate is coated with a granular material such as rosin, and the rosin is fused to the plate by heat. Areas of the plate that are not to be etched at all are coated with a masking material, or stop-out, such as stop-out varnish. After cooling, the plate is given an acid bath and the acid bites the metal in the tiny spaces between grains of rosin; areas protected by stop-out are not bitten at all. Depending on the coarseness or fineness of the granules, how densely they are distributed over the plate and the strength and duration of the acid bath, any light, dark or graded tone may be achieved. This technique is often used in

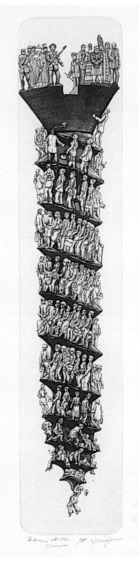

Aquatint

Here is an example of aquatint in black and white, one of Peter Stoliaroff's wry commentaries on mankind's economic-political-social order—or disorder. The title is a tongue-in-cheek bow to Henry James.

RETURN OF THE SCREW | Peter Stoliaroff | etching with aquatint | 23⁷/₈″ × 4⁷/₈″ (61cm × 12cm). Collection of The Cultural Foundation Museum, Moscow, Russia.

Different Strokes

Beyond the basic procedures printmakers use, there are variations galore! For example, in making the three-color aquatint shown here, Shirley Tabler used a process called *three-color drop*, meaning that she used a single plate and inked it three separate times for three runs through the press; each time, after inking the entire plate, she selectively wiped ink away from portions of the plate not intended to print in that color. A second method, called *à la poupée*, in-volves applying different colors to appropriate portions of a single plate and making a print with a single run through the press. Still another way of proceeding is to use three separate plates—one for yellow ink, one for red and one for blue—and running each piece of print paper through the press three times. In processes involving more than a single run through the press, care must be taken to ensure proper registration so that unwanted color overlaps don't occur.

Shirley Tabler begins by inking the plate with yellow and then care-fully wiping ink from those areas she does not want printed in yel-low. This is how the print looks after this first step.

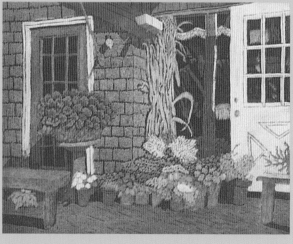

After the yellow ink has dried, she inks the plate with red, wipes areas that are not to be printed in red, and runs the paper through the press again. Here is the print with yellow and red combined.

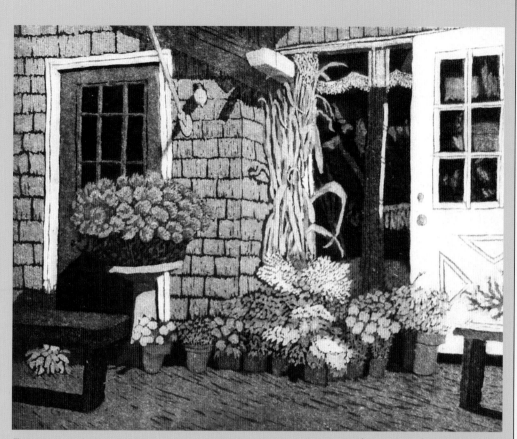

The print is run a third time, this time using blue ink. Most color printmakers proceed from lightest colors to darkest because the more assertive dark colors help to resolve any minor registration errors. Registration means the alignment of the paper with the plate each time the paper is run through the press. If not perfectly aligned, colors will be slightly out of place and areas of color will show some over-lap where no overlap was intended.

SECRET GARDEN MARKET | Shirley Tabler | etching with aquatint | 8″ × 10″ (20cm × 25cm). Courtesy of Washington Printmakers Gallery.

combination with either engraving or line etching so that the resulting print shows both line and tone. Modern printmakers sometimes use sprayed-on resists instead of granular rosin. The term *aquatint* is used because the subtle tones created are similar in appearance to washes created by fluid watercolors. Aquatint has been used by many illustrators and fine artists, including Francisco de Goya, Edgar Degas and Pablo Picasso. The development of aquatint provided an early way of publishing copies of paintings, since the process allowed a careful printmaker to approximate the many tones found in most paintings. *See print; etching; tone; bite; sugar lift. See sidebar on pages 28-29.*

arabesque

Used either as an adjective or a noun, arabesque means Arabian or in the Arabian manner and, in art, refers to designs made up of curved, flowing lines and patterns of flowers, leaves, scrolls and branches. This sort of design actually had its origins in Greek and Roman art, long before it became associated with Arab art. In Western usage, human figures and animal forms are included in arabesque designs—in Arabic usage, such designs were forbidden for religious reasons.

archaic

The early artistic period of any civilization. Specifically, the term is often used to mean the artistic history of Greece between roughly 650 and 480 BC.

architrave /ar keh trave/

The lowest band of an entablature in Classical architecture. *See illustration under Classical architecture.*

archival

Of lasting quality; permanent. The term is used frequently in connection with any of the materials making up a picture or the materials used to display the picture. For example, a watercolor painting may be executed on paper considered of archival quality because it's acid free and 100% rag; the matting and backing are considered archival if they are likewise acid free.

armature

1 | A supporting framework, often of metal wire, around which a sculpture is molded in clay or other plastic material. 2 | The iron frame of a window to which units of lead and stained glass are attached.

Art & Creative Materials Institute

A nonprofit organization of manufacturers that tests art and craft materials for safety. Free information about ACMI, including a list of products evaluated, may be obtained by writing to ACMI, Inc., 1280 Main Street, P.O. Box 479, Hanson, MA 02341. *See health label.*

art criticism

The evaluation and analysis of works of art. It may be that the "first" art critic was Florentine painter Cennino Cennini. His 1437 writing, *Il Libro dell' Arte,* was a handbook on artists' techniques and materials, but in it he also explored artists' attitudes—thus opening the door to considering more than just the nuts and bolts of making a work of art. He went beyond paints and grounds and supports to examine another ingredient—imagination.

During the nineteenth and especially the twentieth centuries, art criticism became increasingly prominent. Some art critics became so powerful that, rather than evaluating what had been created, they were influential in *leading* both artists and the public. Among art critics, as among artists, there are thoughtful, insightful, imaginative people who generally look for the positive, and there are oth-

ers who dwell on the negative—everyone has read reviews that seem to have no goal but to skewer the artist while making the critic look clever.

Art critic Raymond J. Steiner of *Art Times* says: "The art writers are always going to be a step behind. To my mind, art writers can only witness styles, methods, innovations, schools, techniques, materials, trends—they cannot (and should not) predict them or try to direct them." About the role of an educated, experienced critic, he says: "Look, let's face it: A critique is an opinion. And whether or not our multicultural, pluralistic, no-holds-barred, politically correct, open society likes it, all opinions are not alike or of equal worth ... theoretically, at least, a critic has done some homework in the field and brings a certain amount of expertise in making judgments." Writer David Hume identifies the critic as a person of good sense who is practiced, open to a wide range of art, able to compare and, thus, able to discern the beauties of design and reasoning.

Art Deco

An art movement of the 1920s and 1930s, revived during the 1970s and 1990s, that emphasized sleek, linear decorative designs that reflected modern technology. Where Art Nouveau had celebrated the curving, sensuous line, Art Deco went further to include sharp angles and patterns. Art Deco was applied to areas as diverse as furniture, architecture, jewelry, roadside diners and jukeboxes. The name came from a 1925 Paris Exposition that emphasized "*Arts Décoratifs*," or the decorative arts. *See illustrations on pages 31-32.*

Art Hazards Information Center

Up until 1996 this was a clearinghouse for information about hazardous materials. It no longer exists, but information gathered by this organization and updated informa-

Art Deco

Erté, whose real name was Romain de Tirtoff, was a Russian who became a sought-after designer and illustrator in both Europe and America. His fashion designs for *Harper's Bazaar* and his work on costumes and stage sets for French and American productions of musical reviews, theater and opera were the epitome of what we now call Art Deco. His adopted name, Erté, came from the French pronunciation of his initials, R.T. He died in France in 1990.

COSTUME DESIGN BY ERTÉ FOR GANNA WALSKA IN TOSCA, CHICAGO OPERA COMPANY | 1920 | gouache | 11½" × 8" (29cm × 20cm). Photo courtesy of Mark Schachner, AJ Fine Arts Ltd., Brooklyn, NY, and Sevenarts, Ltd. Copyright by Sevenarts, Ltd.

tion may be found at the Center for Safety in the Arts on the Internet at http://artswire.org:70/1/csa.

artifact

An article made by humans, especially one made for specific purposes, such as a tool.

artificial light

Light from sources other than the sun, moon and stars. Artists, and painters in

Art Deco

Costume design by Erté for Folies-Bergère, Paris | 1927 | gouache | 22″ × 14″ (56cm × 37cm). Photo courtesy of Mark Schachner, AJ Fine Arts Ltd., Brooklyn, NY, and Sevenarts, Ltd. Copyright by Sevenarts, Ltd.

particular, need to consider the light under which they are working and the light under which the finished work is likely to be viewed. It's sometimes a shock to see a painting, for instance, painted outdoors but shown in a room with incandescent light—what looked proper outdoors may look garish indoors. The same problem arises if you paint under, say, incandescent light but hang the work under fluorescent light. Obviously, the way to minimize such situations is to try, as nearly as possible, to paint and show under similar light. Many artists buy special lights that imitate natural light, but that's not a perfect solution either, unless the finished work is to be shown under natural light. *See north light.*

Art Information Center

A source for information on the art gallery scene in New York City. For a modest fee an artist may get an analysis of the outlook for

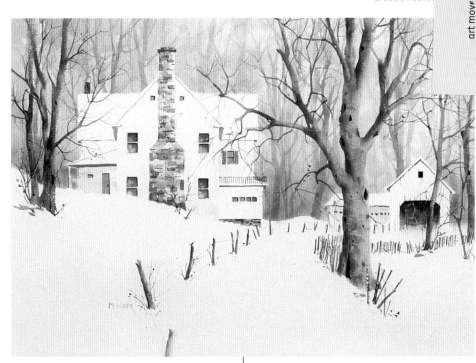

showing his or her work in New York City.
Dan Concholar, 55 Mercer Street, Third
Floor, New York, NY 10013, (212) 966-3443.

artistic license
Ignoring reality for the sake of the work of
art or deliberately "breaking the rules"
because you like the results. *See Edward
Gordon's* Solstice *under Photorealism for an
example of artistic license.*

artist-quality
Art materials, especially paints, that are of
the highest quality, as opposed to student-
grade products that cut corners to keep
costs low—for example, student-grade
paints, volume for volume, may contain less
pigment than artist-quality paints. Artist-
quality is a fuzzy term because there are
no standards defining its use. Sometimes
the only clue you have is that a manufac-
turer offers two similar products with a
big price difference. An advertising claim
that reveals lesser quality is one that
describes a product as intended "for the
artist on a budget."

Artistic license
Although this is a "realistic" scene with a light source
evident, there are no cast shadows. I chose to eliminate
them because I like the stark look of untouched whites
and minimal detail. Even though I took such liberties, the
scene seems convincing enough.

WINTER | watercolor on Arches 140-lb (300gsm) cold
press | 22″ × 30″ (60cm × 76cm)

artist's proof
A test copy of a print, sometimes sold
marked "A/P." *See discussion under print.*

art movement
A tendency or trend in art, usually involv-
ing many artists. Often, but not always, the
artists involved in a movement are familiar
with each other's work and are aiming at
common goals; sometimes, however,
artists work in a common direction but
not in any thought-out, organized way.
Often the terms art *movement*, art *style* and
art *school* are used interchangeably despite
subtle differences in meaning. In any case,
it would be a mistake to treat the members
of any of these groups as peas in a pod—no

Art Movements

Movement, Style or School	Approximate Time Period	Summary
Abstract Expressionism	late 1940s and 1950s	A philosophy of painting emphasizing the expression of emotion rather than depicting objects. Most Abstract Expressionist painters used large canvases, dramatic coloring and either loose brushwork or no brushwork at all.
Aestheticism	late nineteenth century	A European art movement that stressed the idea of "art for art's sake." Aestheticism had its roots in even earlier times, as philosophers argued the place of art in mankind's existence. There were those (moralists) who argued that art's function was to serve or assist in life, while aetheticists took the view that art and the beauty of art are of primary, overriding importance and are divorced from morality.
Art Deco	1920s–1930s	Emphasized sleek, linear decorative designs that reflected modern technology.
Art Nouveau	late 1800s–early 1900s	A style that emphasized flowing, sinuous lines—vines, mermaids, snakes, peacocks and women with flowing hair, for example.
Arts and Crafts Movement	1861–1900	Protested and tried to reverse the low level of craftsmanship and style in the decorative arts resulting from the mass production techniques of the Industrial Revolution.
Ashcan School	began 1908	Group of American painters and illustrators who painted common urban scenes with unfashionable subjects, including working-class people, streets, alleys and bars.
Automatism	1920s–1940s	An attempt to exert little conscious control over the painting process, letting the subconscious take over and guide the artist's hand.
Barbizon School	after mid-1800s	Group of painters who worked near the village of Barbizon in northern France and concentrated on humble landscapes. Strongly influenced the Impressionists.
Baroque Style	1600–1750	A vigorous art style in Europe characterized by strong value contrasts, complex forms and bold ornamentation suggesting drama and action.
Bauhaus School	began 1919	A school of art and design founded in 1919 in Germany with the aim of producing new architecture that combined artistic design, craftsmanship and newly emerging machine technology.

Movement, Style or School	Approximate Time Period	Summary
Biedermeier Style	early to mid-1800s	In painting, interior design and furniture design, a style characterized by middle class tastes in Germany and other parts of Europe. The name was derived from "Papa Biedermeier," a popular figure in satirical German poetry; it implies common, comfortable bourgeois (as opposed to highbrow) comforts and tastes.
Blaue Reiter, Der (The Blue Rider)	1911–1913	Second group of German Expressionists.
Bohemian School	fourteenth century	The art of Bohemia promoted by Emperor Charles IV (who became King of Bohemia in 1346). Charles ruled from Prague and invited artists from Italy, France and Germany to visit and work there. Under their influence, notable work was done in book illumination and, especially, in painted altarpieces.
Brücke, Die (The Bridge)	1905–1913	First group of German Expressionists.
Byzantine Style	330–1453	Art and architecture of the Byzantine Empire, successor to the Roman Empire. Byzantine works dealt almost entirely with religious subjects and were conservative, with little room for individual expression. Prominent in Byzantine architecture were domed churches decorated with magnificent mosaics.
Classicism	ancient Greece and Rome	Art distinguished by clarity, order, balance, unity, symmetry and dignity.
Conceptual Art	1960s	Art that may exist only as an idea and not necessarily as a physical reality.
Constructivism	early 1900s	A Russian art movement advocating the use of clean design and modern industrial materials, such as metal, plastic and wire, in abstract sculpture.
Cubism	early 1900s	A style of painting emphasizing the flat, two-dimensional picture surface and generally rejecting painting techniques that imitate nature, such as perspective, foreshortening, modeling and chiaroscuro. Cubist paintings depict radically fragmented objects, showing several sides of the objects simultaneously.
Dada	began 1915	An artistic, literary and political movement revolting against traditional bourgeois values and against the war (World War I).

a
b
C
D
E
F
G
H
I
J
K
L
m
n
o
P
Q
r
s
T
u
V
W
X
Y
Z

Movement, Style or School	Approximate Time Period	Summary
Early Christian Art	beginning of Christianity to about sixth century	Art produced during the early Christian era in the Western part of the Roman Empire (art in the East is usually considered under Byzantine Art). Until the conversion of Emperor Constantine to Christianity in 313, Christian art was mostly hidden (for example, in the catacombs) and largely symbolic. After 313, Christian art came into the open and gradually became more explicit, with pictures of Christ, for example, in place of earlier symbols, such as a fish or a lamb; at the same time there appeared Christian architecture in the form of shrines and churches.
Empire style	1795-1830s	A style in architecture, interior design and dress during the time of Napoleon and lasting until about the 1830s. In an attempt to revive the flavor of imperial Rome, Napoleon encouraged the use of classical columns and other signs of Greek and Roman architecture, as well as furniture that boasted rich and ornate woods and fabrics, and women's dresses and coiffures that mimicked classical times.
Expressionism	began early 1900s	Broadly, a move toward freeing the artist from subject matter and concentrating on the impact of the subject on the artist—in this sense, Expressionism began well before the 1900s and can include any art that's expressive beyond straight representation. More narrowly, any group specifically concentrating on emotional impact rather than literal representation.
Fauvism	1898–1908	Expressionist paintings done in bold, bright colors and distorted forms, so wild and agitated that a critic called the painters "Les Fauves" (wild beasts).
Futurism	1909-1914	An art movement that rejected traditional painting and sculpture and attempted instead to emphasize modern developments, especially machines and motion.
Gothic Style	1100s–1400s	A style of architecture, sculpture and painting that began in the twelfth century, became predominant in Europe and prevailed until the Renaissance. The name was invented by writers during the Renaissance who saw the style as vulgar and attributed it to the Gothic tribes that had destroyed the Roman Empire and its classical values during the fifth century.

Movement, Style or School	Approximate Time Period	Summary
Hellenistic Period	fourth to first century BC	The period of Greek cultural dominance following the rule of Alexander the Great. During this time Greek art became less confined and was greatly affected by the influx of ideas from the territories conquered by Alexander, including all the Near East and Egypt. Art, and sculpture in particular, became characterized by realism and a great deal of emotion.
Hudson River School	1825–1875	A group of painters who, over a period of about fifty years, painted realistic, romanticized pictures, primarily in New York's Hudson Valley.
Impressionism	mid-1860s to mid-1880s	A painting style intended to make a loose "snapshot," or impression, of a scene rather than a finely delineated, hard-edged picture. Impressionists worked mostly outdoors and tried to capture the light at a particular time of day. They used strokes of high-key color; blacks and grays were generally not used, even in shadow areas.
Kinetic Art	early and mid-1900s	Sculpture, such as Alexander Calder's mobiles, involving moving parts.
Luminism	third quarter of 1800s	An American painting style emphasizing the subtleties of light in landscapes and seascapes. Where Impressionist paintings might depict flat, splashy impressions of, say, an object or a sky, Luminist paintings faithfully portrayed the color and value changes that clearly delineate the object and show depth in the sky.
Mannerism	about 1520–1600	An art style that concentrated on depicting the human form in intricate poses and settings in which features were often exaggerated, or in unnaturally athletic poses within settings that were not necessarily realistic.
Minimalism	1960s	A painting style that attempted to throw off any need for social comment, self-expression and allusions to history, politics and religion—in fact, imagery of any kind—in favor of paintings that stood on their own as objects of interest and beauty.
Nabis	1890s	A group of painters led by founder Paul Sérusier, dedicated to the painting and color ideas of Paul Gauguin. The group, which included Maurice Denis, Pierre Bonnard and Édouard Vuillard, treated Gauguin's ideas as profound, almost mystical revelations and accordingly chose their name Nabis, from the Hebrew *navi*, meaning prophet.

Movement, Style or School	Approximate Time Period	Summary
Neoclassicism	1750–1830	A period of revival of the art of ancient Rome and Greece and of the Renaissance, perhaps as a reaction to the sometimes gaudy and ostentatious art of the Baroque.
Neo-Impressionism	late 1800s	Art movement that attempted to analyze and systematize the use of color. French painter Georges Seurat, the leader of this movement, painted with small, carefully placed dots of color in contrast with the Impressionists' freer, more spontaneous dabs of color.
Neoplasticism	early 1900s	A Dutch movement in painting and sculpture, begun by Piet Mondrian, aimed at painting pure form and color, totally free from realism and free from the artist's temperament.
Op Art	late 1950s–1960s	Art that relies on optical tricks or illusions to evoke visual responses; also called *optical art* or *retinal art*. Op artists—mostly painters, but also some sculptors—used bold colors and geometric designs in ways that made their pictures seem to move or vibrate. Some painted intense complementary colors side by side; others painted stripes, checkerboards, lines or concentric circles.
Oriental Art		The painting of Asian countries, especially China and Japan. Traditional Oriental art emphasizes line and the vitality of each brushstroke and tends to give low priority to elements that Western painters hold dear, such as perspective and shading. A characteristic of Oriental art is its continuing emphasis on lifelong learning and practice, a tendency not always present in Western art.
Ottonian Art	950-1050	European art during the period named for three successive German rulers of the Holy Roman Empire, all named Otto, who reigned shortly after the time of Charlemagne. After Charlemagne's death, there was a peiod of political and social turmoil. The Ottonians restored order and continued and energized the artistic activity begun under Charlemagne. There was a great deal of activity in ivory carving and in large wood sculpture, such as crucifixes and reliquaries (shrines or containers in which sacred relics were kept), and in the building of churches and monasteries.

Movement, Style or School	Approximate Time Period	Summary
Pointillism	late 1800s	The technique of placing dots of pure color side by side on the canvas rather than mixing colors on the palette, so that at a distance the colors visually merge and produce the desired effect. As a simple example, dots of blue and yellow, when viewed at a distance, give an overall green effect.
Pop Art	1950s—1960s	Art using commonplace objects, such as soup cans, comic strips and hamburgers, as subjects. They portrayed all aspects of popular culture, especially the images people were seeing increasingly in television advertising.
Post-Impressionism	mid-1880s to early 1900s	A period during which several Impressionist painters, unsatisfied with the Impressionistic aim of capturing fleeting light and color, endeavored to find more substance in painting, especially in the roles of color, form and solidity.
Pre-Raphaelites	1848—1854	A group of painters in England who organized to introduce into painting what they felt was a purer, more direct depiction of nature than what they saw being painted at the time. Their aim was to emulate the work of Italian artists of the Renaissance before the time of Raphael.
Proto-Renaissance	late 1100s—early 1200s	The period that set the stage for the Renaissance.
Realism	mid-1800s	A movement toward painting the common, the ordinary and even the ugly rather than stiff, formal pictures of the upper layers of society.
Regency Style	1811-1830	In England, a style of furniture and decoration during the period 1811-1830, the reign of George Augustus. From 1811 until 1820 he had been "acting sovereign," or *regent,* because his father, King George III, had been judged insane. In 1820, when George III died, George Augustus became King George IV. The Regency style was inspired by ancient Greek and Roman fashions, but also drew on Chinese and Egyptian themes. It tended toward rich decoration, including wood veneers and brass marquetry.
Regionalism		Any trend in American art whose theme is American life. The term is used especially in dealing with the Depression era.
Renaissance	1400—1600	A period during which in Europe, and especially in Italy, literature and the arts experienced a rebirth of the values and achievements of ancient Greece and Rome, lost or neglected during the long Middle Ages.

b c d e f G H I J K L m n o P Q r s t u v w x Y z

Movement, Style or School	Approximate Time Period	Summary
Rococo	1700–1760	A style in interior design, painting, architecture and sculpture featuring elegant, elaborate ornamentation making much use of curved, asymmetrical forms.
Romanesque	1000–1150	An art style in Western Europe that centered on churches and monasteries, with heavy vaulted ceilings and massive columns and walls necessary to support the weight of the ceilings.
Romanticism	late 1700s to mid-1800s	A general movement in literary, philosophical and art circles emphasizing the emotional, the spontaneous and the imaginative as opposed to classical, more rational traditions.
Social Realism	various times, including 1920s–1940s in America	A catchall label for artists whose work reflects the society about them. Some consider the Ashcan artists Social Realists; similar groups in England and in Russia have been labeled the same way.
Suprematism	1913–1919	An art style that eliminated all natural forms in favor of flat geometric patterns, seeking to represent feelings rather than objects.
Surrealism	between World War I and World War II	In literature and in art, a move to join the real and the unreal, the conscious and the unconscious. Surrealistic paintings often have a dreamlike quality, showing objects in incongruous settings.
Symbolism	1880s–1890s	A movement in painting aimed at more use of fantasy and imagination and less of straightforward depiction of objects. Symbolists looked for metaphors, or symbols, to suggest a subject, often making use of mystical or occult themes.
Synthetism	1880s	A style of painting emphasizing two-dimensional flat patterns, often with areas of pure color separated by strong outlines.
The Eight	began 1908	The eight original artists of the Ashcan School.
The Ten	1898–1918	A group of ten American painters who exhibited together in New York City and Boston for twenty years in order to try to get public attention for their work.
Tenebrism	introduced around 1600	The use of mainly dark tonality to give dramatic emphasis to a scene; often the background for the scene is very dark and shadowy and the foreground subject is lit as though suddenly illuminated by a spotlight.
Vorticism	1912-1915	An English art movement that has been called the English version of Cubism. It was founded by Percy Wyndham Lewis, a writer and an experimenter in abstract art forms. Vorticists painted themes involving modern machinery and industry.

matter what their broad aims and philosophies, artists are still individuals and can generally be counted on to take their own paths toward a common destination. Preceding is a chart summarizing and indicating the time periods for some of the major movements, styles and schools. The time periods are rough, since it's rare that a movement, style or school can be traced to a single event. In addition, some of them have resurfaced some time after their initial appearances—for example, Art Deco was in vogue during the 1920s and 1930s, but is considered by some art historians to have had a resurgence during the 1970s and again in the 1990s. *See individual entries for more information.* Note that in this book all movements, styles and schools are capitalized for consistency; in other books you may find some capitalized, some not, for no apparent reason.

Art Nouveau

An art movement ("new art") of the late 1800s and early 1900s that emphasized flowing, sinuous lines—vines, mermaids, snakes, peacocks and women with flowing hair, for example. The movement had a great influence on the work of artists such as Aubrey Beardsley, an outstanding English illustrator of the 1890s. One of the better known practitioners of Art Nouveau was Alphonse Mucha (1860–1939), who first gained prominence for his posters, theatrical sets and costumes for actress Sarah Bernhardt in Paris. *See illustrations on pages 42-43.*

Arts and Crafts Movement

A movement that began in1861 in England to protest and reverse the low level of craftsmanship and style in the decorative arts resulting from the mass production techniques of the Industrial Revolution. The movement began when poet and designer William Morris organized a group of manufacturers and interior decorators with the aim of reviving the spirit and practice of medieval craftsmanship. The group produced handcrafted jewelry, metalwork, furniture, textiles and other items that have had a great influence on succeeding generations.

arts and crafts show

A public exhibition and salesplace for all kinds of arts and crafts. Such shows gained popularity about the middle of the twentieth century and since then have become a major venue for selling arts and crafts. Shows take place along city streets, in parks and fairgrounds, in rural settings and in convention centers. Items offered for sale directly to the public include paintings, drawings, collages, sculptures, photography, ceramics, knitwear, tapestry, glassware, jewelry, dolls and furniture—the list is practically endless.

There are two basic types of shows, those organized by business promoters and those sponsored by civic groups. In either case, the artist or craftsperson applies for admittance to the show by submitting samples of his or her work, usually on 35mm slides. Once accepted, the artist/

Artists Unite!

Over the decades artists and craftspeople have complained about the difficulties of applying for and attending arts and crafts shows. For example, rules vary greatly among promoters and often large fees are charged simply for applying for admission to a show. In the 1990s the National Association of Independent Artists was formed to try to air grievances and bring some order to the business. The organization may be reached at the following Web site: www.naia-artist.org.

Art Nouveau

Untitled design from Documents Décoratifs | a style book of designs by Alphonse Mucha , first published in 1901; this design courtesy of Dover Publications, Inc., from *The Art Nouveau Style Book of Alphonse Mucha*, 1980.

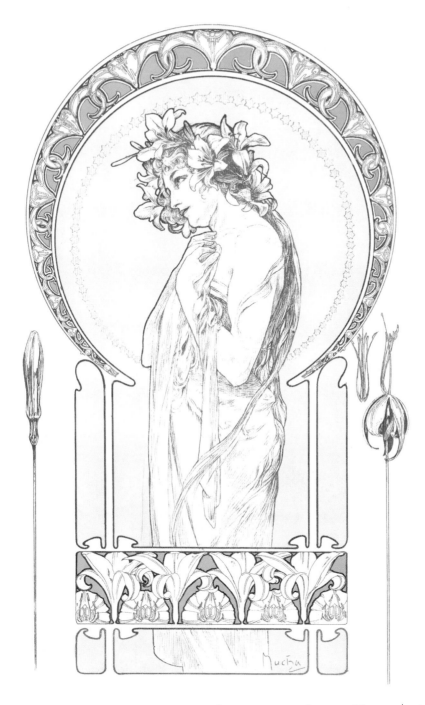

Art Nouveau

Untitled design from Documents Décoratifs | a style book of designs by Alphonse Mucha, first published in 1901; this design courtesy of Dover Publications, Inc., from *The Art Nouveau Style Book of Alphonse Mucha*, 1980.

a
b
c
d
e
f
g
h
i
j
k
l
m
n
o
p
q
r
s
t
u
v
w
x
y
z

Arts and crafts show
Early strollers at a typical show set up along a city street in Florida.

craftsperson sets up a booth in a location designated by the show organizers and sells his or her wares to the attending public. For some, such shows are an occasional event, but for thousands of people the shows are their way of making a living. Exhibitors must be prepared for inclement weather—most have tents to protect their displays—and also must be prepared to meet and deal with customers. This business is very rewarding for some, moderately successful for many and a losing venture for others. For an excellent discussion of arts and crafts shows, see a series of articles by artist Lewis Lehrman in *International Artist* magazine, beginning with the June/July 1998 issue. For extensive listings of show schedules and equipment suppliers, see *Sunshine Artist* magazine, 2600 Temple Drive, Winter Park, FL 32789, (800) 597-2573, or *ArtFair SourceBook* and *CraftFair SourceBook*, 2003 NE 11th Avenue, Portland, OR 97212-4027, (800) 358-2045.

art school

1 | A place where art is taught. 2 | A group of people following a common doctrine or teacher. *See examples under art movement.*

Arts and crafts show
Each exhibitor supplies his or her own tent, display racks, display bins, chairs, umbrellas and all the items necessary to conduct business, such as credit card processing equipment.

arts, the

A term traditionally embracing two broad categories: liberal arts and fine arts. The usual definition of liberal arts is study in language, philosophy, history and literature intended to develop general intellectual skills as opposed to professional or vocational skills. Fine arts are concerned with the aesthetic, that is, creation of the beautiful. The fine arts include painting, printmaking, sculpture, architecture, music and dance. Many writers include literature under fine art—as is often the case in artistic matters, definitions are not cut-and-dried. In the case of literature, its *study* might fall under liberal arts, while its *creation* might fall under fine arts.

Art Students League, The

An art school formed in 1875 in New York City when a group of artists and students, led by Professor Lemuel Wilmarth, broke away from the prestigious National Academy of Design, then the foremost art school in America. The split was in reaction to disappointment with certain of the National Academy's actions and policies, including its strict adherence to academic rules and its resistance to change. The Art Students League of New York went on to become a leading force in American art, its membership including over fifteen hundred American artists and teachers of such diverse backgrounds as Will Barnet, John Carlson, Alexander Calder, Thomas Eakins, Childe Hassam, George Inness, John Pike and Howard Pyle. The school now operates at 215 West 57th Street in New York City. For a fascinating look at the school and its history, *see The Art Students League of New York: A History by Raymond J. Steiner.*

art style

A distinctive manner of expression. *See examples under art movement.*

Ashcan School

A group of American painters and illustrators in the early 1900s who painted common urban scenes using unfashionable subjects, including working-class people, streets, alleys and bars. The eight original members of this group, often called The Eight, met and organized in 1908 to exhibit their paintings, which were at odds with the popular, more genteel themes of the day. The Eight were Robert Henri, Arthur B. Davies, Maurice Prendergast, Ernest Lawson, William Glackens, John Sloan, George Luks and Everett Shinn.

asphaltum

A dark, viscous substance found both in natural deposits and as a component of petroleum. It's the main component, along with gravel, of a common paving material—but in that usage, it's traditionally called asphalt. Asphaltum was once, but no longer, used as an ingredient in oil colors. In ancient times it was used as a sealant and preservative—it's mentioned as an embalming material in Edgar Allan Poe's 1850 story "Some Words With a Mummy." Today it's an ingredient in many etching grounds. *See etching.*

assemblage /ah *sem* blij; ah sem *blazh*/

A composition of objects fastened to a surface. Any materials may be used: common objects are wires, papers, metals, plastics, wood, shells, cloth and glass. The distinction between an assemblage and a collage is fuzzy: Usually assemblage refers to a composition of mostly nonpaper materials or materials having appreciable thickness, while collage generally implies the use of flat papers. *See illustrations on pages 46-47.*

ASTM

See American Society for Testing and Materials.

Assemblage

In this piece, Broe used paper, wire, wood, copper, glass, plastic screen mesh and acrylic and enamel paint. The pieces are fastened with hot glue.

SCHEHERAZADE | Joy Broe | assemblage | 30″ × 20″ (76cm × 51cm)

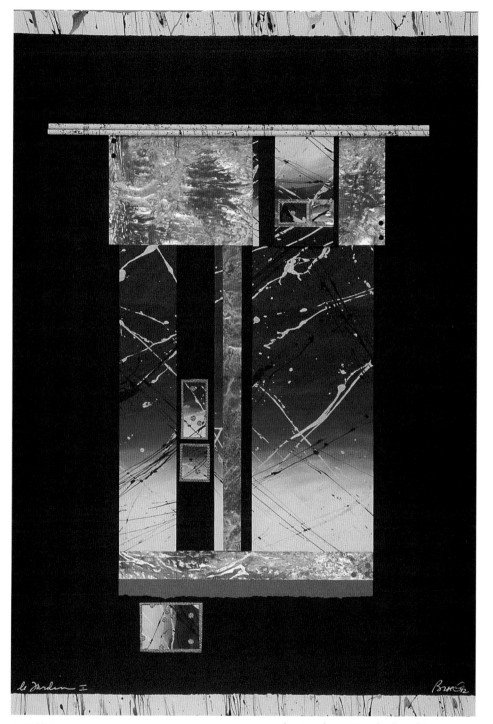

Assemblage

ORACLE | Joy Broe | assemblage | 30″ × 20″ (76cm × 51cm)

asymmetry

A design in which one half (e.g., of a picture) is not a mirror image of the other half; lack of symmetry. Many works of art are designed asymmetrically to provide the excitement of tension. Symmetrical designs, as a rule, tend to be quieter and more serene than asymmetrical designs.

atelier /at el *yay*/

French term for an artist's or designer's studio or workshop; also refers to some private art schools. *See studio.*

atmospheric perspective

The effects of impurities in the atmosphere on how we see an object, or the use of drawing and painting techniques to mimic those effects. Also called *aerial perspective* or *color perspective*. *See aerial perspective.*

atomizer

Any device used to produce a fine spray. Before the advent of pressurized cans, mouth-operated sprayers were used. In situations where a uniform spray is not paramount, a well-cleaned household spray bottle (e.g., a Windex bottle) works well. You can also buy a can of compressed air that attaches to a jar into which you pour the liquid to be sprayed. Many products, such as fixatives and varnishes, come in pressurized cans. When using any sprayer, avoid breathing in the spray if it contains anything other than water.

atrium

In Roman architecture, a rectangular space, open to the sky, surrounded by suites of rooms.

autographic print

A print whose creation closely reflects the artist's touch. A print such as a lithograph is said to be more autographic than, for example, a silkscreen print because the lithographic process responds to delicate variations in pressure and line as the artist draws on the stone or plate, while the silkscreen artist, once having designed and decided on the color screens needed, produces the actual print using more mechanical procedures.

Automatism

A painting technique in vogue during the 1920s to the 1940s in which the artist tried to exert little conscious control over the painting process. The idea was to let the subconscious take over and guide the artist's hand. Automatist paintings by Surrealists Salvador Dali, André Masson and Jean (or Hans) Arp often had a dreamlike quality.

avant-garde

French term meaning vanguard or in the forefront. Avant-garde art is nontraditional or new and experimental. The term is often used pejoratively to describe the latest "in" art, the latest overhyped art, a new art gimmick or outrageous art intended to stir controversy.

background

1| The far distance in a landscape painting. 2| The space immediately behind the subject in a portrait or still life. 3| The space around a subject in a picture and in the same plane as the subject.

backlighting

Lighting situated behind the subject. Backlit objects appear relatively dark and look quite flat.

Light source is behind the tree

faint halo around edges

tree looks dark, flat, not much detail

Light source is at the side

shadow on side of tree away from light

sunlit

Backlighting

When an object is backlit there is little light on the side facing you, so the object appears dark and flat with little detail visible. Lit from the side, however, more detail can be seen.

excess water around edge

water dropped into wet paint

edges where two pigments
run together

Backrun
Here two fluid paints merge. The more fluid paint moves into the
thicker paint, pushing pigment ahead of it. Where the fluid paint
ceases to move, the piled-up pigment forms a ragged edge, or
backrun. These edges are sometimes called blossoms, blooms or
backwashes. There are similar results when plain water merges with
wet paint. The roundish splotches here were caused by drops of
water falling into the painted surface. The long splotches along the
edges of the paper were caused by excess water on the painting
board crawling into the paint—to avoid these blemishes, wipe away
excess water around the edges of the paper.

backrun

The merging of two areas of fluid paint,
especially in watercolor, resulting in
unusual textures or colors. Also, the merg-
ing of an area of wet paint with an area of
plain water. Sometimes a backrun is
acceptable and even desirable; other times
it's an unwanted blemish. Backruns are
most prominent when the two areas con-
cerned are of unequal wetness—plain
water, for example, introduced into an
area of watercolor paint that has begun to
dry but that remains just damp. The more
fluid water flows aggressively into the less
fluid paint, pushing pigment along with
it. Backruns are sometimes called blos-
soms, blooms or backwash.

backwash

Backrun, blossom or bloom. *See backrun.*

badger hair

Relatively inexpensive animal hair, some-
times from the badger, used in artists'
brushes. *See brush construction.*

ballpoint pen

A writing and drawing instrument that
has a tiny metal or plastic ball that inks
itself by contact with an ink reservoir with-
in the pen's body. The first practical ball-
point pen was patented in 1895 by a

Hungarian named Lazlo Biro—for a time, his pens were called "biros." Although useful for sketching and in transferring a drawing, many ballpoint pens contain inks that quickly fade and thus are not suitable for permanent work. *See transfer.*

bamboo pen
See pen, bamboo.

Barbizon School
A group of painters who worked near the village of Barbizon in northern France, a little south of Paris, after the mid-1800s. The Barbizon painters concentrated on humble, natural scenes, mostly quiet landscapes such as those painted by their leader, Theodore Rousseau. A well-known example of Barbizon art ist Jean-François Millet's 1857 painting *The Gleaners*, depicting workers in a field. The Barbizon painters strongly influenced the Impressionists.

baren
A round, smooth pad, either flat or slightly convex, used to press a paper against an inked wood or linoleum block to lift an impression from the block.

stiff plastic disk

bamboo wrapping

plastic disk

tiny bumps on underside

Baren

Typical barens: a plastic version and a traditional Japanese type.

The Japanese baren is covered with thin bamboo; the plastic one is made with many tiny bumps over its surface. The bamboo texture and the plastic bumps help to distribute pressure evenly as the baren is gently but firmly pressed against the paper being printed.

bark paper
Paper made from the thin bark of various plants. Two popular types are Mexican bark paper and banana bark paper, both of which are available acid free and in a variety of colors, from off-white to dark brown. These papers are sometimes used as painting surfaces but are more commonly used in collages and bookbinding. *See illustration on page 52.*

Baroque /bah *roke*/
A vigorous art style in Europe between about 1600 and 1750. In architecture and sculpture, as well as in painting, the era produced work that was intense and emotional, often on a grand scale. Baroque art is characterized by strong value contrasts, complex forms and bold ornamentation suggesting drama and action. Masters of this art form included Peter Paul Rubens and Giovanni Lorenzo Bernini.

barrel vault
See vault.

basilica [from Greek *basilikos*, meaning imperial]
1| An ancient Roman building used as a meeting place and court of justice. Basilicas were generally oblong with a wide aisle (the nave) flanked by two narrower aisles separated from the nave by rows of columns. At the end of the hall there was often a rounded portion called the apse, where a head official would be seated. 2| Early Christian churches built on the general plan of the Roman meeting places. Many changes evolved in the designs, including, during the time of Emperor Constantine, the addition of the transept, an aisle at right angles to the nave just before the apse, giving the basic floor plan the shape of a cross. 3| A Roman Catholic church with special privileges because of its historical back-

Bark paper
The tree, fence posts and barn are made from Mexican bark papers.

A WINTER TREE | Michael David Brown | collage | 13½″ × 18″
(34cm × 46cm)

ground or its association with a major saint. 4| Usually capitalized, Basilica was a ninth century code of law for the Byzantine Empire.

basket weave
A weave in which the warp and weft are usually threads of similar size and in which the weft crosses the warp alternately, forming a regular pattern. *See weaving.*

bas-relief /bah ruh *leef*/
Bas means "low" and relief means "raised," so bas-relief is sculpture in which carved forms protrude only slightly from a surrounding background; compare this to high relief, sculpture in which more than half of a form stands out from the background. *See illustration under relief.*

basse-taille /bah *sty*/
An enameling technique in which powdered enamels are deposited into cells cut into a metal base, as in champlevé. But in the basse-taille process, the floors of the cells are carved in relief before enamel is added, providing for unusual visual effects. *See champlevé; enamel.*

batik /bah *teek*/
A method of decorating fabric practiced for centuries in Southeast Asia. A piece of cloth, typically cotton or silk, is coated with melted wax in areas that are not to

Batik
The image was drawn on the fabric support in pencil and then a succession of dyes was used in this order: yellow, light blue, darker blue, red and, finally, black. The finished batik was glued to a backing and framed under glass.

BLUE HERONS | Janice Cline | batik on cotton fabric | 22″ × 28″ (56cm × 71cm)

receive color. The cloth is then dipped in a dye that colors the unwaxed areas. Next, wax is painted on other areas, and the cloth is dipped again using another dye color. The process is repeated as often as necessary, and finally at the end all the wax is removed from the fabric by heating, melting and blotting it. There are lots of variations to the procedure—some wax may be removed between dippings, for example, so that those areas are exposed to more than one dye color.

Bauhaus /*bow* house; ow as in owl/
A school of art and design founded in 1919 in Germany by architect Walter Gropius. Its aim was to produce new architecture that combined artistic design, craftsmanship and newly emerging machine technology. A major result of Bauhaus teaching was the introduction of designers into every facet of building and manufacturing, so that now few products are made without the input of design experts. The school was opposed by traditionalists and

Birds-eye view

Here is a bird's-eye view of a city in which three-point perspective is evident. If you project the sides of the skyscrapers downward you'll find that they meet at a vanishing point deep in the earth.

CHICAGO AERIAL | Don Townsend | scratchboard on canvas | 40″ × 66″ (102cm × 168cm)

was closed in 1933 by the Nazis. Many of its members moved to the United States, where Chicago became the new center of Bauhaus teaching.

beech charcoal
Charcoal made from beech tree twigs. *See charcoal.*

beeswax
A yellowish substance secreted by bees to form honeycombs. White beeswax—ordinary beeswax with impurities removed—is used in a number of ways by artists, including **1**: as an ingredient in some matte varnishes, **2**: as a painting medium *(see encaustic painting)* and **3**: as an ingredient in the ground that coats an etching plate *(see ground; etching).*

Biedermeier Style
In painting, interior design and furniture design, a style characterized by middle class tastes in Germany and other parts of Europe during the early to mid-1800s. The name was derived from "Papa Biedermeier,"

a popular figure in satirical German poetry; it implies common, comfortable bourgeois (as opposed to highbrow) comforts and tastes.

binder
A paint ingredient that holds (binds) pigment particles to each other and to a ground. Typical binders include linseed oil (oil paint), gum arabic (watercolor paint), acrylic resin (acrylic paint), gum tragacanth (pastels) and egg yolk (egg tempera). Also called *vehicle. See individual paint entries.*

bird's-eye view
A view of a scene as seen from above in which the horizon, or eye level, is very high. *See linear perspective; three-point perspective.*

bistre or bister

A transparent, yellowish brown to dark brown pigment, used principally as an ink. Once popular for its warm tone and its transparency, bistre is made by boiling a mixture of water and soot from burned wood.

bite

To "eat away" a surface by exposing it to an acidic or caustic substance. Examples: **1**: the exposure of lines on an etching plate to acid; **2**: exposure of a linoleum block to caustic soda. *See etching; linoleum cut.*

blanc fixe /blahnk fix/

An inert white powder (barium sulfate) used to give gouache its body; it's also used in the manufacture of some lake colors and is the white pigment in some modern fresco palettes. Also called *constant white*. *See lake; gouache.*

blanket

A soft, resilient material, such as felt, used in printmaking. When running a plate, such as etched metal, through a press, a blanket is usually placed between the printing paper and the roller to help distribute the roller's pressure evenly to the paper. Also called a *mat*. *See printing press.*

Blaue Reiter, Der (The Blue Rider)

A group of German Expressionists in the early 1900s. *See Expressionism.*

bleeding

1| The tendency of some pigments in an early layer of paint to show through later layers. This was once a problem, particularly in oil paints, but is of little importance in modern paint formulations.　2| The crawling of a fluid paint or ink along a porous surface.　3| Penetration of a sheet of paper by ink or paint so that the color becomes visible on the flip side of the paper. This is often a problem with the inks used in markers.

bleed-proof paper

Paper treated so that inks or paints applied to one side do not penetrate and show through on the other side.

blender

1| Any soft brush used for blending adjacent areas of paint. *See blending; brush, painting.*　2| Kitchen appliance used by paper artists to make pulp.　3| An instrument manufactured by Chartpak, similar to a marker pen but containing a clear solvent instead of color. It's used to mix marker colors on a surface and to lift marker colors from a surface.

blending

Manipulating paint so that adjacent colors intermix gently, with no sharp edges between them. Often this is done by lightly stroking the paints using a broad, soft brush such as a fan brush or badger blender. In the case of dry mediums, such as colored pencil, pastel and charcoal, blending may be done by rubbing adjacent areas with a tortillion, a stump or a finger. The airbrush is also an excellent tool for blending fast-drying mediums such as gouache.

blind contour drawing

Drawing an object's shape without looking at the drawing until you finish, an exercise that helps promote eye-hand coordination.

bloom

1| A whitish haze that sometimes forms on the surface of a colored pencil picture. *See wax bloom.*　2| A dull, whitish area that sometimes forms on or within a varnish layer, usually caused by moisture either on the surface or within the varnish mixture. 3| A blotch (sometimes desirable) in a

watercolor painting that occurs when water or fluid paint is introduced into a damp area of paint. *See accident; backrun.*

blossom
Bloom, backrun or backwash. *See backrun.*

blot drawing
A drawing technique that uses random or accidental marks or stains (blots) as its starting place, letting the nature of the blot lead the artist to develop a picture—akin to the psychological testing technique of using inkblots to elicit responses from a patient. The idea has been explored by many artists, but was studied carefully by watercolorist Alexander Cozens in England in the 1780s and described in his book, *A New Method for Assisting the Invention in Drawing Original Compositions of Landscape.* The technique has been used by Automatists and Surrealists such as Max Ernst. *See Automatism; Surrealism.*

blotting paper
Absorbent paper used to suck up ink or other fluids from a surface. It's used especially by pen-and-ink artists working with dip pens that occasionally drop an unwanted blob of ink onto the picture surface. It's also used by printmakers to remove excess moisture from the surface of a sheet of soaked printing paper.

blown oil
Linseed or other painting oil that has been thickened by blowing air through the oil, usually at elevated temperatures, to oxidize it. Blown oil is inferior to stand oil and is not recommended for permanent painting. *See stand oil.*

Blue Wool Scale or British Blue Wool Standard
A set of eight wool cloths colored with eight different blue dyes having a range of rates of fading that vary from very fast to very slow. The set of cloths is used by some manufacturers as one way of testing the lightfastness of their paints—they compare the fading of the paint to the fading of the cloth under the same conditions. The results from using these cloths (or the set of eight colored papers that have recently replaced them) are not very reliable. Testing methods that follow ASTM recommendations (spelled out in ASTM standard D 4303) are much more reliable. *See ASTM; permanence.*

body color
Color attained by the use of opaque paint—as opposed to transparent color, which depends not only on the paint color but on the color of the underlying layer as well.

Bohemian School
The art of Bohemia (a region of the Czech Republic) during the fourteenth century promoted by Emperor Charles IV (who became King of Bohemia in1346). Charles ruled from Prague and invited artists from Italy, France and Germany to visit and settle there. Under their influence, notable work was done in book illumination and, especially, in painted altarpieces. One of the better known altarpieces was done by an artist known as the Master of Wittingau.

bole
A dull red earth color used to make a smooth, nonabrasive ground for gold leaf.

Borco board
Brand name for a rubbery sheet of material used as a cutting surface, especially by collage artists who often cut papers. This sheet makes a better cutting surface than cardboard because it has a firm, dense tex-

ture and when cut into it's "self-healing"—the cut closes up. You can fasten it to your work surface and make a great many cuts on it before having to replace it.

box easel

An easel that folds so that all its parts are contained in a compact rectangular box. *See French easel; pochade box.*

bracing

Reinforcing the back of a painting panel to prevent warping; also called cradling. *See more under cradling.*

brayer

A roller made of hard rubber used to apply ink to a printing surface such as a woodcut block; often used for other tasks, such as flattening a bumpy surface or pressing a piece of collage in place.

bridge

A device that helps to keep the artist's hands from touching, and perhaps smearing, the painting or drawing in progress. A simple mahlstick is one type of bridge. Another is the homemade bridge. *See mahlstick. See illustrations on page 58.*

bright

A flat paintbrush with relatively short filaments. *See brush, painting. See illustration on page 58.*

bristle

A coarse, stiff hair from the back of a hog, used in making bristle brushes. *See brush construction; hog bristle.*

bristol paper or bristol board

[bristol sometimes capitalized]
Strong paper formed by pasting together, under pressure, two or more sheets, or plies, of thinner paper. In the early days of European papermaking, mills sent their

Box easel

A typical box easel. The whole assembly folds neatly for storage and carrying. Photo courtesy of M.A.B.E.F. easels, distributed by MacPherson's, 1351 Ocean Avenue, Emeryville, CA 94608.

Brayer

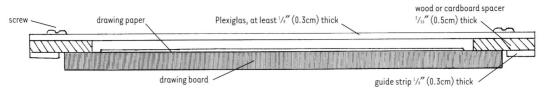

screw — drawing paper — Plexiglas, at least ⅛″ (0.3cm) thick — wood or cardboard spacer ³⁄₁₆″ (0.5cm) thick

drawing board — guide strip ⅛″ (0.3cm) thick

Bridge

You can easily make a satisfactory bridge using simple materials. Decide on the width of the drawing board with which you want to use the bridge and choose the bridge's dimensions accordingly. The Plexiglas hand rest is separated from the drawing by the thickness of the spacer you choose to use.

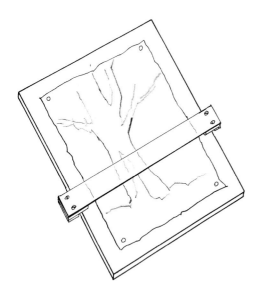

Bridge

A bridge that spans the drawing allows the artist the freedom to have his hand close to the drawing without touching it.

Bright

fine papers to Bristol, England, for pasting. The term is sometimes also used to describe strong single-ply drawing paper.

British Blue Wool Standard
See Blue Wool Scale.

broken color
An area that appears rough or textured because of numerous sudden changes of hue or value. You can get such effects in a variety of ways, including: **1**: lightly dragging a brush over a rough surface; **2**: patting or dabbing at a surface with the flat side of a brush, as in the illustration; or **3**: dabbing at a surface with a sponge or wadded tissue. *See illustration on page 59.*

Brücke, Die (The Bridge)
A group of artists forming the first wave of German Expressionism in the early 1900s. *See Expressionism.*

brush cleaning
See brush maintenance.

brush construction
Most painters' brushes consist of a brush head, a ferrule and a handle. (Exceptions are bamboo brushes and hake brushes in which the brush head is fitted directly into the hollow of the handle without a ferrule.) The brush head is the business end, and it consists of a bundle of *filaments* in a

Broken color
First blue paint was lightly dragged over a yellow ground using the flat side of a brush; now white paint is being dragged over the blue in the same manner. Usually such manipulations are done only when the underlying paint has dried, but sometimes paints are applied over still-wet areas.

particular shape, such as round, flat or filbert. The ferrule is a sleeve that grips the brush head and serves to attach the head to the handle. The best ferrules are made of nonrusting metal, and they are seamless to prevent fluids from getting inside and loosening the cement that helps hold the filaments in place. Handles are usually hardwood, stained or laquered for durability and grip; some less-expensive handles are made of plastic.

The filaments that make up the brush head are of three general types: soft animal hair, stiff hog bristles and synthetic. Animals used range from expensive kolinsky sable (a member of the weasel family) to inexpensive squirrel. The more expensive varieties are chosen for their strength, durability and "spring," or ability to snap back to their original shape after each stroke. Hog bristles are used for brushes that require considerable strength and relative stiffness for handling thicker paints,

especially oils. Synthetic filaments are made from modern materials such as nylon and polyester. Synthetics have been improved tremendously since their first use decades ago and are, for many artists, the brushes of choice. They are considerably less expensive than most animal-hair brushes.

Any type of brush—animal hair, bristle or synthetic—may be used with any medium. For painting in acrylics, however, synthetics are recommended because acrylic paint tends to be harsh and destructive of animal hairs and bristles; also, bristle brushes absorb moisture and become soft if used with acrylics.

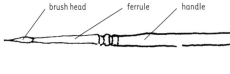

brush head — ferrule — handle

Brush handles are made either long or short, depending on the intended use of the brush. Typically, an oil or acrylic painter works at an easel at a distance from the painting surface, so long-handled brushes are appropriate; watercolorists often work on a horizontal or slightly slanted table surface and hold their brushes similar to writing instruments, so watercolor brushes are made with shorter handles. Any brush may be used, of course, for any medium, as long as it suits the artist. Among the common filaments used in brushes are the following, listed in rough order of cost, from highest to lowest.

kolinsky sable—Tail hairs of a member of a family of mammals called *Mustelidae*, found in northern Asia; generally considered the best of natural hairs for brushmaking; the most expensive of brushes.

red sable—Hairs of other members of the *Mustelidae* family; high quality, but not as fine or as springy as their kolinsky cousins; less expensive than kolinsky.

sabeline—Not truly sable, but the better grades of ox hair, usually dyed to look like sable.

ox hair—Strong hairs with good spring, from several varieties of cattle.

bristle—Coarse hair from hogs.

camel hair—Hair from a number of animals, such as squirrel, goat, pony or horse—not camels; great variation in composition and cost.

squirrel—Truly squirrel hair; relatively inexpensive; holds a lot of liquid and is used for "mop" brushes in watercolor.

Brush construction
A typical artist's brush. The filaments making up the brush head are arranged (by hand in better brushes) before being inserted into the ferrule. They are held in place by the crimping of the ferrule and usually also by cement inside the ferrule. When animal hairs or bristles are used, the exposed ends are left natural—they are not cut to shape. The ends inside the ferrule may be cut to fit. There may be as much or more filament length inside the ferrule as out. Brush handles vary in shape depending on the manufacturer—most have gradually tapering handles and some have a noticeable bulge near the ferrule to make the handle "fatter" for a better grip.

synthetics—Manmade materials such as nylon and polyester; used in all media, especially acrylics.

other—Hair from a variety of other animals is used, sometimes in combination with synthetic hairs and sometimes with other animal hairs. Among the hairs used are those from badgers, goats, skunks and fitches.

brush head
The bundle of filaments (animal hairs, bristles or synthetic fibers) at the end of a paintbrush.

brush heel
The curved portion of a brush head near the ferrule when the brush is pressed against a surface.

brush maintenance
There are two reasons to take good care of your brushes: They're expensive and they perform better when kept clean and properly shaped. Here are some basic rules for brush care.

Brush maintenance
Proper ways to store
brushes.

Brush maintenance
A good way to ruin a brush.

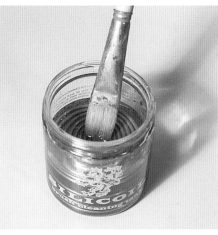

Brush maintenance
Keep the solvent level well above the ribbed coil. Gently
rub the brush against the coil to loosen paint. You can
reuse the solvent in this brush-cleaning jar as long as there
is enough room for sediment to collect at the bottom.

1: Keep brushes in their proper shapes by storing them either upright in a container, brush heads *up* or by laying them flat: *Never* rest a brush on its head. **2**: If moths or mice become a problem, keep your brushes in a container with mothballs or flakes. It's possible for pests to ruin an expensive brush. **3**: Don't let paint dry in a brush. Acrylic paint is the most difficult to clean out once it hardens, but oils, too, are tough to remove completely once dried. Even easily dissolved paints such as watercolors will begin, little by little, to clog the brush up high near the ferrule and make the entire brush head gradually less pliant. Once you let paint harden in a brush, the scrubbing necessary to remove the paint is hard on the brush head. **4**: Cleaning depends on the type of paint you're using. For water-based paints, swish the brush in

cold or lukewarm (never hot) tap water, changing to clean water and swishing again until no more color escapes from the brush. Then, to get at the paint hiding up high in the filaments near the ferrule, rub the brush in some brush soap and press it gently against the palm of your hand under running water to squeeze out any reluctant paint. Finish up with more clean water to remove the soap. Shape the bristles with your fingers and put the brush aside.

For oil and alkyd paints, follow the same procedure, but use turpentine, mineral spirits or citrus solvent in place of water. Then finish up with brush soap and water and, finally, clean water. To avoid wasting a lot of solvent buy a product such as Silicoil or the Bob Ross Cleaning Screen. Place one of these gadgets in the bottom of a wide-mouthed jar or can and fill the container halfway with solvent. Clean a brush by gently rubbing it against the coil or screen. As paint loosens it mixes with the solvent, but later settles to the bottom of the container, leaving clean solvent above. You can reuse the solvent as long as there is enough room for sediment to collect at the bottom. When the buildup of sediment reaches the screen, empty the jar and refresh it with new solvent. You can make your own arrangement using a piece of window screen, an inverted tea strainer or an inverted can with holes punched in its bottom. Such homemade screens work, but they may wear out your brushes faster than the smoother-finished commercial products. *See illustration on page 61.*

brush, painting

Any tool consisting of either natural or synthetic filaments attached to a handle and used for applying paint. Brushes are made in a great variety of shapes and some are called by different names, depending on the manufacturer. Some common brushes are shown here; others are shown under their individual headings. *See illustrations on pages 63-64.*

brush pen

A marker pen with a flexible, fibrous point that allows the pen to be used similarly to

Brush pen

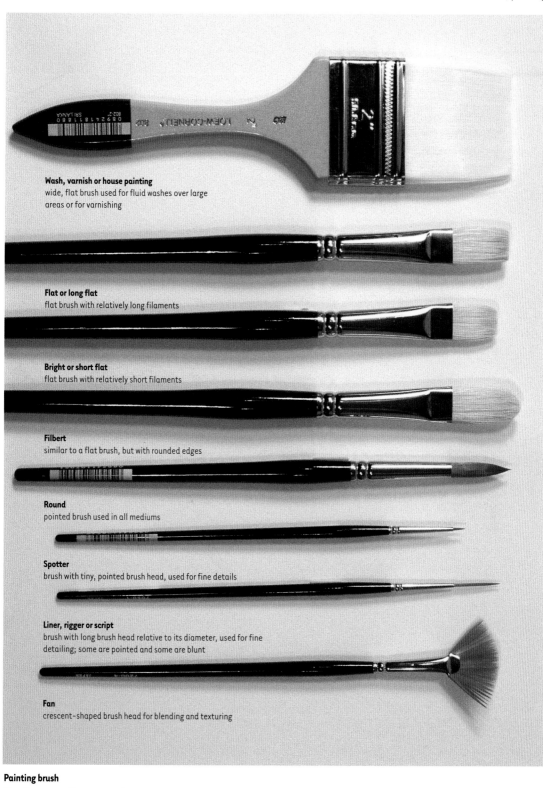

Wash, varnish or house painting
wide, flat brush used for fluid washes over large
areas or for varnishing

Flat or long flat
flat brush with relatively long filaments

Bright or short flat
flat brush with relatively short filaments

Filbert
similar to a flat brush, but with rounded edges

Round
pointed brush used in all mediums

Spotter
brush with tiny, pointed brush head, used for fine details

Liner, rigger or script
brush with long brush head relative to its diameter, used for fine
detailing; some are pointed and some are blunt

Fan
crescent-shaped brush head for blending and texturing

Painting brush

Manufacturers offer a tremendous variety of specialty brushes, but
here is a set of popular basic brushes. Brushes courtesy of Loew-
Cornell, 563 Chestnut Avenue, Teaneck, NJ 07666-2490.

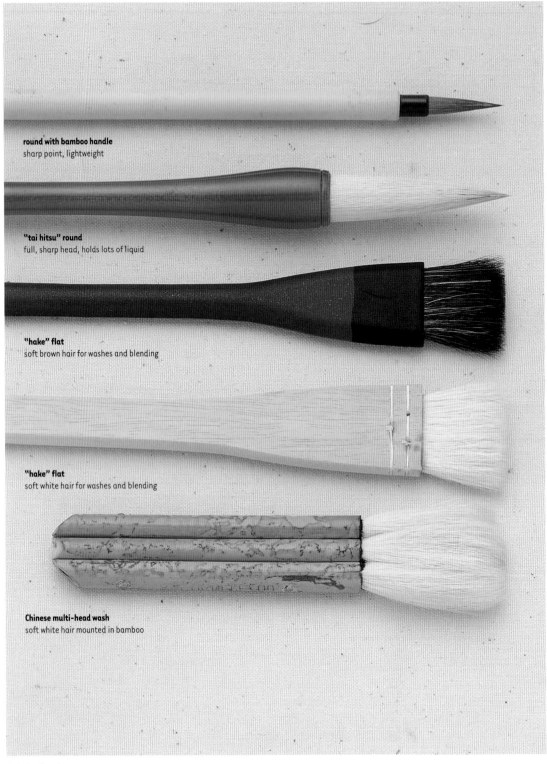

round with bamboo handle
sharp point, lightweight

"tai hitsu" round
full, sharp head, holds lots of liquid

"hake" flat
soft brown hair for washes and blending

"hake" flat
soft white hair for washes and blending

Chinese multi-head wash
soft white hair mounted in bamboo

Painting brush
Here are brushes used in traditional Oriental watercolor and
sumi-e painting. Photo courtesy of Loew-Cornell, 563 Chestnut
Avenue, Teaneck, NJ 07666-2490.

Soaps to Use

It's safe to use ordinary hand soap in place of brush soap, but be sure to use a brand, such as Ivory, that contains no lotions. Lotion-type soaps may clog the tiny scales found on most animal hairs, reducing the ability of the hairs to hold paint.

Brush soap

Some brush soaps are made for use with all types of paints; others are intended for specific paints, such as hard-to-clean acrylics. The gel shown here is also suitable for washing paint from the skin; toxic solvents such as turpentine should not be used on the skin because they may enter the body through the skin's pores. Photo of Brush Cleaner and Preserver courtesy of General Pencil Company, P.O. Box 5311, Redwood City, CA.

a round paintbrush, making either fine or broad lines. The brand shown, Sakura's Pigma Brush, comes in several colors. The words "archival ink" are stamped on the pen along with the statement "Micro pigment ink for waterproof and fade-proof lines."

brush reshaping

Restoring a brush to as near its original shape as possible. A brush head can become distorted and practically useless if it's left sitting on its head or if paint is allowed to dry in it. Often a brush can be reclaimed by thoroughly cleaning it (*see brush maintenance*), finishing up with a wash in brush soap and then clean water. After cleaning, always reshape the damp filaments with your fingers.

brush sizes

Although there is no universal standard for expressing artists' brush sizes, in the United States sizes are usually expressed in one of three ways: **1**: The size of a flat brush is stated in inches and fractions of an inch measured across the width of the ferrule; **2**: The size of a flat brush may be designated by a number—no. 12 equals one inch (2cm) across, no. 6 equals one-half inch (1cm) across and so on; or **3**: The size of a round brush is the diameter in millimeters of the brush head where it emerges from the ferrule—a no. 5 brush

measures one-quarter inch (5mm) in diameter.

Painters often get hung up on finding just the right-size brush, especially if they want to get a brush they've seen an instructor or another artist use. They look for a no. 10 round and find it's not quite the same size as the no. 10 round they saw in use—two different manufacturers, two different brushes. The specific numerical size of a brush is not important—choose brushes that give you a decent variety of sizes and forget about the numbers. Buy sizes that are comfortable for *you* to use.

brush soap

Soap made especially for cleaning paint from brushes. *See brush maintenance.*

brush storage

See brush maintenance.

brush washer

A jar or can containing a ribbed coil or a screen immersed in a solvent. When a brush is gently scrubbed against the coil or

Burin

Burin
Here's the business end of a burin.

screen, loosened paint sifts to the bottom of the container. *See illustration under brush maintenance.*

buckling
The warping of a piece of paper because of uneven wetness. Buckling is avoided by first stretching the paper and then taping, tacking, stapling or clamping it to a board. *See cockling; stretching paper.*

buffer
A substance added to another material to keep that material's pH in a desired range. In papermaking, buffers are often added either to the pulp or to the finished paper to make it either pH-neutral or slightly alkaline. *See pH.*

bumper
A small pad of nonabrasive material, such as rubber or felt, attached to the back corners of picture frames to keep the frames from touching, and possibly marring, the wall.

buon fresco /bwan *fress* koh/
Painting done on fresh, damp plaster—usually called simply *fresco*. Painting done on already-dried plaster is called *secco fresco,* or more commonly, secco. The Italian *buon*

(meaning "true" or "good") designates this as the preferred method of fresco painting. *See fresco; secco.*

burin /byoor in; *burr* in/
An engraver's tool with a steel shaft and a sharp, oblique point at one end and a handle at the other; a type of graver. A burin cuts into a metal plate by being pushed forward rather than being drawn toward the artist. *See graver; engraving.*

burnisher
1| Any of several tools having hard, smooth, rounded ends used for polishing or smoothing a surface by rubbing.
2| In the case of colored pencil drawings, a pencil with light-colored pigment such as white, clear or yellow used to burnish a darker area—the result is a satiny, pearly finish in that area. *See illustrations on page 67.*

burr
The slightly irregular raised edges formed when a metal plate is gouged by a tool, as in engraving or drypoint. The effect is similar to that of a plow digging a furrow in a garden and piling up soil along the furrow's edges. If unwanted, burrs are removed with a scraper. In drypoint the

Burnisher

Burnishing with a colored pencil. Rubbing the light-colored pencil over darker areas softens the look of the color and gives it a pearly sheen.

Burnisher

Typical burnishers.

etching engraving drypoint

Burr

Engraving and etching leave grooves in a plate with little or no ridge alongside the groove; drypoint leaves a definite ridge of burrs. The burrs may be left so that they affect the look of the prints, or they may be reduced or eliminated using scraping tools.

burrs are usually preserved because they give drypoint prints their characteristic slightly textured appearance. *See drypoint; engraving.*

Byzantine Art and Architecture

Art and architecture of the Byzantine Empire, the eastern half of the old Roman Empire. The capital of the Byzantine Empire was Byzantium, renamed Constantinople (now Istanbul, capital of Turkey). The Empire lasted from 330 to 1453 AD Byzantine works dealt almost entirely with religious subjects and were conservative, with no room for individual expression. Figures in frescoes and mosaics were stylized, done with line and flat shapes rather than form, and features were rendered in a static manner as though done by formula. Art was done anonymously—there is little that can be attributed to any individual. Prominent in Byzantine architecture were domed churches decorated with magnificent mosaics, which heavily influenced the art of most of Europe for over a thousand years.

cake watercolor
A hard, individually wrapped chunk of watercolor paint meant to be inserted into pans, small depressions in a palette or watercolor box. *See watercolor paint.*

calligraphy [Greek: "beautiful writing"]
1| Artistic, stylized or elegant writing in any language. Carved Egyptian hieroglyphs and Sumerian cuneiform symbols may be considered early forms of calligraphy, along with the brushed symbols of Chinese and Japanese writers and artists. In the Western world, writing such as that shown here typifies modern calligraphy.
2| Ornamental lines and strokes in painting and drawing.

Calligraphy
Here Michael Podesta is using a broad-tipped pen for the red lettering. He uses a variety of pens, some with specially-shaped tips, some narrow and some very wide. Certain pens have split nibs that draw two or more lines at once.

I will lift up mine eyes unto the hills, from whence cometh my help. My help cometh from the Lord which made heaven and earth. Psalm 121

Calligraphy

This piece is typical of Michael Podesta's work. He uses inks for the lettering and watercolor for the pictorial areas.

PSALM 121 | Michael Podesta | calligraphy on paper | image 9½" × 7" (24cm × 18cm)

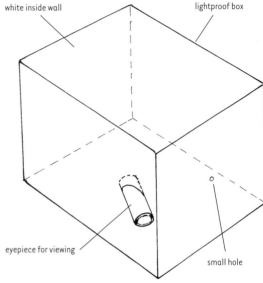

white inside wall

lightproof box

eyepiece for viewing

small hole

Cameo

Besarion Darjania, sculptor and teacher, lives in Tbilisi, Republic of Georgia. He is a member of the Union of Georgian Artists. He carves his exquisite cameos from shell, coral, minerals and mammoth tusk.

WOMAN WITH CROWN | Besarion Darjania | carved mammoth tusk | 1.76″ × 1.36″ (44mm × 34mm) | Collection of Carol Zilliacus. Photo courtesy of Norman Watkins.

Camera obscura

Here's a simple camera obscura you can make from a cardboard box. The eyepiece is a tube, such as a piece of garden hose, glued or taped in place so that no light can seep into the box from around the eyepiece. You must place your eye firmly against the eyepiece so that no light gets in around the edges. Place an object in front of the aperture and you'll see a reverse upside-down image on the inner wall of the box. To be successful, the object must be brightly lit and the aperture must be small—try a pinhole size and gradually enlarge it till you get a satisfactory image.

cameo

A small relief carving, usually on a gemstone or a shell. The area around the design is cut away so that the design stands out. *See relief.*

camera lucida

From the Latin meaning "light chamber," an 1807 invention using a glass prism to help draw an object accurately. The prism was situated some distance above a sheet of paper. By placing his eye at just the right position near the top edge of the prism, the observer could see projected onto the paper the image of an object set up in front of the prism. He could then trace the object's image onto the paper. Because it was tricky to get the proper alignment

between the object, the eye and the prism, the device was not very practical.

camera obscura

From the Latin meaning "dark chamber," this is a box that is dark inside and has a tiny hole in one side. An inverted image of the scene outside the hole appears on the opposite wall inside the box. Sometimes such a box was made large enough to contain an artist, who could then trace the projected scene on paper. Described long ago by Aristotle, and later discussed in the writings of Leonardo da Vinci, portable versions were used by artists during the sixteenth and seventeenth centuries, usually with a convex lens in place of the pinhole. Later it was discovered—primarily through

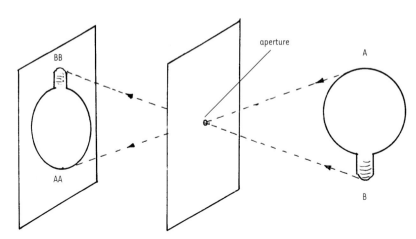

the work of a French scientist, Niépce, and an artist, Daguerre—that the image on the wall could be captured by light-sensitive chemicals, and so the camera was born. *See also camera lucida.*

canvas

A woven fabric used as a support mainly for oil and acrylic paintings. For centuries linen and cotton (and some hemp) were the main fibers used. Although more expensive than cotton, linen is considered the better of the two because of its strength and appealing surface texture. During the latter half of the twentieth century, synthetic fibers such as nylon, polyester, acrylic and fiberglass have been used. Although their durability has not been tested over centuries, their record so far is good. The synthetics are not as subject to sagging (due to moisture absorption) as are the natural fibers, and synthetics do not rot.

Most canvas can be bought either raw (no coating) or primed (coated with a ground such as acrylic gesso or white lead oil paint). Canvas may be either single or double primed, meaning either one coat

Camera obscura

Light emanates from point *A* at the top of the bulb in all directions. The narrow beam of light that finds its way through the pinhole aperture strikes the screen at *AA* as shown; similarly, light from the bottom, point *B*, strikes the screen at *BB*. The result is an inverted image. The image is also switched left-right in the same manner. Moving the screen closer to or farther from the aperture changes the relative size of the image; moving the object (the lightbulb) also changes the relative size of the image. The smaller the aperture, the sharper the image.

Canvas

Canvas may be bought in rolls, prestretched on stretcher strips or mounted on a stiff backing of cardboard or hardboard.

or two of the priming material—the choice is one of personal preference. Single priming results in a more flexible canvas with more obvious canvas texture. Canvas prepared to accept inkjet colors (*see giclée*) is also available.

Canvas textures range from a fine, dense weave with no knots or irregularities (commonly called portrait canvas) to a medium weave to a coarse, loose weave. Some canvases are so loosely woven that there is a problem with tiny holes (called pinholes) that are not filled in with priming. *See pinhole. See illustration on page 71.*

canvas board

Canvas glued to a rigid backing, such as hardboard, wood or cardboard. The cardboard versions are unsuitable for serious painting because most of the cardboards in use are not acid free, so they don't have a long life, and cardboards are also likely to warp. The wood or hardboard versions, if properly prepared and of sufficient thickness, are less likely to warp.

canvas, cotton

See canvas.

canvas, hessian

Burlap made from either jute or hemp and sometimes used by artists as a painting support even though this material is less archival than linen or cotton.

canvas, linen

See canvas.

canvas panel

Another name for canvas board—canvas mounted on a stiff backing such as hardboard or cardboard.

canvas, priming

Coating a canvas with a ground in preparation for painting. For acrylic painting, a

Risky Business

Applying oil or alkyd paint over an acrylic gesso ground carries a small risk of separation of the layers. Painting in oil or alkyd over an acrylic paint layer, however, is much riskier because acrylic paint is slicker and has less tooth than acrylic gesso. Furthermore, acrylic paint may not be safely applied over an oil layer.

ground of acrylic gesso is suitable; for oil or alkyd painting, many artists use an acrylic gesso ground, but an oil or alkyd ground is safer because there is some chance of separation between an acrylic gesso ground and an oil or alkyd paint layer.

Acrylic gesso may be applied directly to raw canvas. An oil or alkyd ground may not be applied directly to canvas because the acidity of those grounds will damage the canvas fibers. Before applying an oil or alkyd ground, canvas should be sized (*see sizing*) to isolate the canvas fibers from the oil or alkyd. *See ground. See sidebar.*

Canvas, sizing

See sizing.

canvas storage

Canvas, whether painted or raw, should be stored in a well-ventilated area free of excessive moisture to prevent the growth of mold. Raw canvas may be safely rolled up; primed or painted canvases, too, are routinely rolled up, but no matter how loosely rolled there is danger of cracking the primed or painted surface. Conservators recommend rolling with the painted surface outward to put the least strain on the paint film; rolling with the painted surface inward would subject the film to crinkling because of compression. The best way to store painted canvas is

flat—not rolled. If the canvas is mounted on stretchers, it can be stored on end, separated from other canvases by spacers to allow air to circulate freely. If it's necessary to store canvases in a horizontal stack, separate them with silicone paper (such as that used by bakers) or glassine to prevent their sticking together and limit the number of canvases in a stack.

canvas, stretching

Canvas for painting is sometimes glued to a stiffer material such as wood or Masonite (a brand of hardboard) to give rigidity while retaining the appealing texture of the canvas. Usually, however, canvas is stretched taut over a frame of wood strips. The illustrations show the basic steps in stretching a canvas. *See stretcher bars; key. See illustrations on pages 74-75.*

canvas stretching pliers

A tool with wide, textured jaws for gripping canvas and applying tension while fastening the canvas to stretcher bars.

Canvas stretching pliers

canvas, synthetic

Canvas woven from synthetic fibers such as polyester. During the relatively short time they have been used (several decades), synthetics have been shown to have certain advantages over linen and cotton in that they do not rot and do not shrink or swell with changes in humidity. Some artists avoid using synthetic canvases because they dislike their slicker look and feel. However, once a canvas has been primed, the slickness of its fibers is no longer a consideration because the fibers are covered by the priming. *See canvas.*

canvas texture

See canvas.

canvas transfer

The reproducing of a picture onto canvas. One method of doing this is by using the giclée technique. *See giclée.*

canvas weight

Canvas is not sold literally by weight; this term is a loose indicator of the thickness of the threads used in its manufacture, along with the density of the weave.

capital

The decorative top of a column. *See illustration under Classical architecture.*

carbon black

Any of a number of forms of pure, or nearly pure, carbon that are finely powdered and intensely black, and that have excellent hiding power. Most carbon blacks are soots derived from the partial combustion of hydrocarbons (materials made up of carbon and hydrogen). Carbon black is used in many inks, such as India ink, and in some paints; it's a principal ingredient in tires, making up as much as one-quarter of the weight of a standard automobile tire. The fineness and the hue (ranging from dense black to a bluish black) depend on the specific fuels and processes used to produce the soot. One form of carbon black is lampblack, made by burning oil in such a way as to give off a dense cloud of soot.

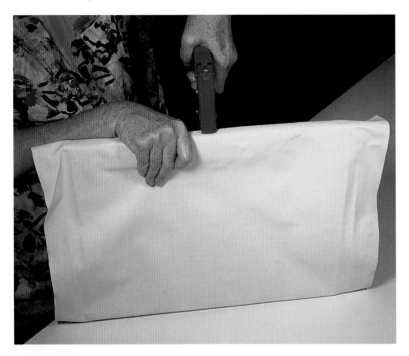

1 | Staple or tack the first side, starting in the center. Ordinary steel staples or tacks may be used; some prefer nonrusting brass or copper tacks.

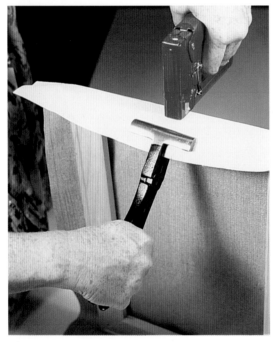

2 | Hold the canvas taut and staple the opposite side.

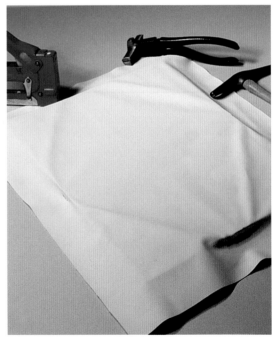

3 | Repeat for the other two sides. Now you have a taut diamond shape in the middle of the canvas with the four corners still loose.

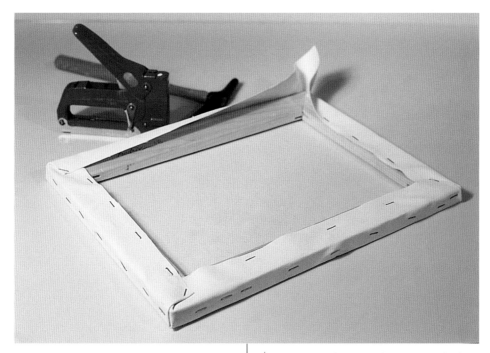

carbon pencil

A wood-clad rod of charcoal, carbon black and a slightly oily binder. Compared with a charcoal pencil, a carbon pencil is less gritty or crumbly and moves more smoothly over the paper. The ingredients are for Wolff's carbon pencil made by Royal Sovereign in England—other carbon pencils may use somewhat different ingredients. *See illustration on page 76.*

Carborundum

Trade name for silicon carbide, a tough abrasive used in saw blades and sharpening tools. Artists sometimes add powdered Carborundum to acrylic gesso or true gesso to give added tooth to painting grounds. *See ground.*

cardboard

A general name for a wide variety of paper products made from cellulose fiber (usually wood pulp) in varying thicknesses. There are two general types of cardboard: cheap, common cardboard and archival cardboard. The common cardboards are

4. Add staples gradually from the center of each side outward toward the corners. Don't finish one side at a time; add a few staples to each side in turn until you reach the corners. Fold the canvas neatly at the corners and staple the folds. Finally, staple the excess material to the backs of the stretcher strips. The canvas should be taut and wrinkle-free. If you see wrinkles developing as you staple, remove some staples, pull the canvas taut and re-staple. Don't rely on pounding triangular pegs, or keys, into the corners to remove wrinkles—their use should be reserved for removing sags that may develop later. If you drive pegs too far into the stretcher strips, you may expand the overall size of the stretched canvas so much that it will no longer fit its intended frame.

usually brown or gray in color and are acidic; they are not suitable for use in any permanent work of art. They should not be used to back a watercolor or pastel or other work on paper. Examples of that type are ordinary corrugated cardboard, used mostly for making boxes, and chipboard. Archival cardboards are those treated to eliminate acidity; they include many types of mat board and some special corrugated cardboards made with artistic needs in mind. (Other acid-free mat

Carbon pencil

Ed Ahlstrom used simple materials to build up this strik-
ing design. He began with a lay-in of powdered charcoal
spread over the paper. He manipulated the charcoal with
an electric eraser, using the eraser to lift light areas and
suggest texture. All the fine finish work was done with
several grades of Wolff's carbon pencils, which allow a
wide range of values from light, pearly grays to velvety
blacks.

NEW, NEO, NOUVEAU | Ed Ahlstrom | powdered charcoal
and Wolff's carbon pencil on Lenox 100% rag paper | 40"
× 26" (102cm × 66cm). Collection of the artist.

Caricature

PHIL AND SHIRLEY | George Kochell | pastel over marker | 11″ × 17″ (28cm × 43cm)

boards are 100% rag–they contain no wood cellulose and are not usually spoken of as *cardboard*.) All types of cardboard absorb moisture and are likely to warp. *See mat board; canvas board.*

caricature
A picture that exaggerates by distorting or emphasizing certain features of the subject, usually a person. Often the intent is to ridicule or satirize the subject, especially in political caricature, but just as often the intent is to capture the subject's likeness in a light and comical manner. From the Italian word *caricature*, probably coined by one of three Italian brothers named Carracci in the 1500s.

Carolingian Art
Art of the time of Charlemagne (768-814), who united most of Christian Europe into a single entity, the Holy Roman Empire.

The name Carolingian derives from the Latin for Charlemagne: Carolus Magnus (Charles the Great). Charlemagne admired the classic art and architecture of Rome and set about trying to import and revive Roman traditions. He had books, whole libraries, and scholars imported to his reigning city of Aachen in what is now Northwest Germany. The Carolingian period saw the revival of Early Christian basilicas, the building of bronze foundries, and the establishment of scriptoriums, places where manuscripts were copied and illustrated.

carrageenan /kahr ah *geen* un/
A type of seaweed used in many food products and as a size for paper that is to be marbled. *See marbled paper.*

cartoon

1| A full-size preparatory drawing for a large painting or mosaic, for tapestry weaving or for an easel painting. The drawing is done in some detail on paper, and the paper is hung over the space (usually a wall but sometimes a floor or ceiling) where the painting, mosaic or other artwork is to be executed. The drawing is traced using the transfer method or by "pouncing." *See fresco; mural; mosaic; transfer; pounce wheel.*
2| A drawing intended as satire, caricature, humor or story entertainment.

cartridge paper

A strong paper used **1**: for making shotgun cartridges, **2**: as a cheap drawing paper and **3**: sometimes for printing in offset lithography.

Cartoon

For the Sunday, February 20, 2000, Arts section of *The Washington Post* newspaper, Pat Oliphant wrote an essay on the work of Honoré Daumier, then on exhibit at the Phillips Collection in Washington. The essay, as incisive and witty as Oliphant's drawings, compares the dangers of offending the mighty in Daumier's day with the pressures of today's political correctness. To accompany the essay he drew this cartoon, giving us the rare treat of a master of today's political satire paying homage to a master from another age. The Daumier picture, circa 1852-58, is called *The Uprising*.

HOMAGE TO DAUMIER | Pat Oliphant | pen and India ink and wash | 10¾"x 13¾" (27cm × 35cm). Courtesy of Susan Conway Gallery, 1214 30th Street NW, Washington, DC 20007.

carving

The creation of sculpture by cutting away hard material such as stone or wood. Compare to *modeling*, building up a sculpture using soft or plastic materials.

casein glue /kay seen; kay *seen*/
An adhesive made from casein, a protein obtained from milk.

casein paint /kay seen; kay *seen*/
Casein paint is an opaque, water-soluble medium similar in many ways to gouache—but rather than a gum binder, it uses casein, a derivative of milk curd. Used as a powerful adhesive for centuries, casein was adopted as a binder in artists' tube paints in the 1930s. Although other water-based paints, such as acrylic and gouache, have become more popular, casein paint is still used by many illustrators and fine artists.

Casein paint is thinned and cleaned up with water. It may be painted in thin wash-

Casein paint
Many artists use casein for painting tight, representational book and magazine illustrations. Some, like Debbie Wels, use the medium for easel paintings in a looser, more painterly style.

THIRD AVENUE | D. Wels | casein on canvas | 34″ × 40″ (86cm × 102cm)

es or in heavier, more impasto fashion—but not too thick, as a thick film may crack. You can cover dark paint with light and vice versa. The paint dries fast to an even matte finish. Once dry, the paint surface may be burnished with a soft cotton cloth to get a satiny glow. Casein paintings may be done on any surface used for gouache, such as watercolor paper or illustration board, or on most non-oily surfaces. To avoid cracking, a rigid support is best, but some artists, including Debbie Wels, whose work is shown here, prefer canvas with an acrylic gesso ground. Canvas is acceptable provided you don't build up too thick a paint layer and provided the canvas

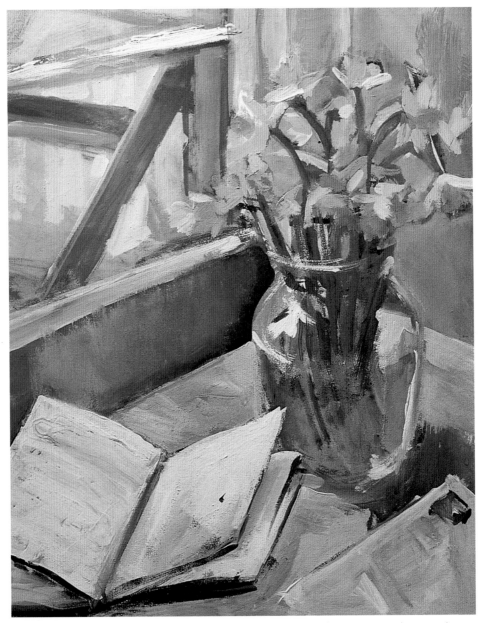

Casein paint

DAFFODILS | D. Wels | casein on canvas | 20″ × 16″ (51cm × 41cm)

Casein paint
Casein paints are not widely available. A current manufacturer is Shiva.

is tightly stretched. You may use the same brushes, palette and other tools as for gouache. Like gouache, but unlike acrylic, casein paint may be easily sanded or scraped to make corrections. It may also be varnished with damar or acrylic picture varnish to enhance the depth of color and protect the surface, but many artists choose to frame casein pictures under glass, without varnish.

cast bronze

Bronze is an alloy of copper, tin and sometimes small amounts of other elements—varying the proportions of the ingredients results in differences in hardness, malleability and color. Because of its agreeable color, durability and workability, bronze has long been used by artists for casting sculptures. Although the making of a bronze sculpture requires much skill and knowledge on the part of the sculptor (or the foundry expert who actually carries out the casting process), the general process is simple: A mold (a negative impression of the work to be cast) is built, and molten bronze is poured into the mold. Once cooled, the mold is removed and the casting is refined and

finished by the sculptor. *See lost-wax process; sand-casting.*

casting

An object formed by filling a mold with fluid or semi-fluid material. Some paper sculpture is made by pouring pulp into a mold; some metal sculptures and many metal ornaments are made by pouring molten metal into a mold.

cast paper

Paper sculpture made by pouring fluid paper pulp into a mold. *See casting; sculpture, paper.*

cast shadow

An area that is darkened because some object is blocking light from getting to that area. For example, an apple on a table casts a shadow on the table because the apple prevents light from getting to that part of the table. The darkening that occurs on the apple itself on the side away

highlight modeling, or shading

cast shadow

Cast shadow
The shadow on the table top is called a cast shadow; the shadow around the dark side of the apple is called modeling, or shading. Notice that the edges of the cast shadow are not sharp—this is due partly to diffraction and partly to the fact that there was some light in the room other than the primary source. The highlight on the apple is essentially a reflection of the light source.

Cast shadow

The shadow cast by the dark flashlight is fairly solid, but notice that the edges of the shadow get fuzzier the farther the shadow is from the object casting it. The shadow is also lighter out toward the end. Both effects are caused mainly by reflected light in the surroundings bouncing off walls, the ceiling and other surfaces. Some of that light falls into the shadow area. More of this reflected light falls into the part of the shadow far out from the object because it is not blocked by the object. Some of the fuzziness is also caused by the diffraction of the light as it passes the edges of the flashlight. *See diffraction.*

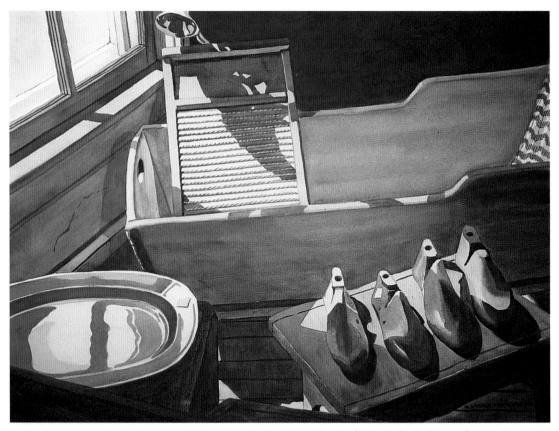

Cast shadow

The contrasts between the lighted and shadowed areas, as well as between warm and cool colors, give this simple scene a great deal of spark.

SECOND CHANCES | Margaret Graham Kranking | watercolor on Arches cold-press paper | 22" × 30" (56cm × 76cm)

a
B
c
D
e
F
G
H
I
J
K
L
m
n
o
P
Q
r
s
T
u
V
W
X
Y
Z

Center of interest
Here are several objects—a bottle, a glass, an apple, a bowl and a chunk of cheese. Lined up in a row or randomly scattered, there is no focus, or center of interest. By rearranging the objects (here are just two of many possible arrangements), we direct attention toward the center of the grouping, the wine bottle.

from the light source is a special case of shadow called shading or modeling. *See shadow; modeling. See illustrations on page 81-82.*

cast stone
Any of various mixtures of cement, sand, ground natural stone and other ingredients used to simulate natural stone. *See casting.*

cellocut /sell o cut/
A method of making prints using a sheet of plastic. Liquid plastic is poured over a rigid support of hardboard or cardboard and allowed to solidify. The artist works the plastic with various tools, scraping, gouging and texturing it to form an image. Sometimes the plate is used in an intaglio process—that is, ink is forced into its

grooves and depressions and the rest of the surface is wiped clean. Or the plate may be used for relief printing, in which ink is confined to the raised surfaces. *See print.*

Center for Safety in the Arts
See Art Hazards Information Center.

center of interest
The area of a picture the artist wants the viewer to concentrate on; the most important visual element in the picture. In the case of abstract or nonobjective pictures, there may be no center of interest, but rather a concentration on color, texture or other elements spread over the picture. Most representational pictures do have a center of interest and sometimes more than one—a main center of interest and

a

b

Center of interest

The main actor is the house; everything else is supporting cast. The
straight road (a) leads the eye to the house, but too directly. The
winding road (b) does the same job, but not so obviously.

Charcoal
Strokes made by (top to bottom) hard and soft charcoal
pencils, a compressed charcoal stick and hard and soft
vine charcoal.

subordinate ones. Artists often build the
other elements in their pictures to subtly
lead the viewer's eye toward the center of
interest. Also called focal point. *For paint-
ings with no center of interest, see Larsen's work
under nonrepresentational art and Coombs'
work under abstract art.*

chalk

The natural form of chalk is soft limestone
(calcium carbonate) ranging from white to
buff to gray in color. Pure white chalk for
artists' use and schoolroom use is artifi-
cially prepared in a finer form called pre-
cipitated chalk. It's used as an ingredient
in some artists' paints, including gouache,
casein and pastels, not as a pigment but to
provide body and opacity. In its purest,
whitest form (called whiting), it's also used
to substitute for gypsum in a variant of
true gesso. *See gesso, true.*

chamois /shammy/

A soft leather made from the hide of the
chamois, a small goatlike animal, or from
sheep. Chamois cloths are often used by
artists to wipe clean an area of pastel or
charcoal.

champlevé /shahmp luh *vay*/

Decoration in which enamel is deposited
into cells cut into a background metal. *See
discussion under enamel.*

charcoal

Charcoal is a form of carbon, made by
heating wood in the absence or near-
absence of air so that the material cannot
burn. Artist's charcoal is made from such
materials as willow twigs, beech twigs and
vines (vine charcoal). Depending on the type
of wood used, the temperature and how
long the heat is applied, the resulting char-
coal has varying degrees of softness/black-
ness—for example, willow charcoal is
usually blacker than vine charcoal. Some
charcoal is used in its "natural" form, just
as it comes from the oven—a coarse, brittle
material. Another form is compressed
charcoal—the charcoal, sometimes with
other materials added, is formed into
sticks under pressure. Compressed char-
coal is darker, denser and less subject to
breakage than uncompressed charcoal.
Charcoal can be bought in three basic
forms: chunks, sticks and pencils clad in
wood or paper. Chunks are usually uncom-
pressed; sticks may be either compressed

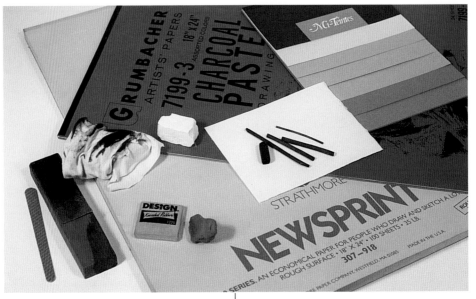

or uncompressed. Charcoal pencils contain compressed charcoal. Wood-clad pencils can be sharpened (carefully) in a regular pencil sharpener; other forms are usually sharpened with a knife or sandpaper. Charcoal is a permanent material, not subject to fading. When buying charcoal, keep in mind that degrees of hardness/softness vary a great deal among manufacturers—for example, General's "hard" charcoal pencil is harder (and therefore makes a lighter stroke) than Grumbacher's "hard." In fact, depending on the type and sources of the wood used, a given manufacturer's charcoal may vary considerably from one batch to the next. *See illustrations on pages 85-90.*

charcoal, compressed
Charcoal that has been made more dense, less crumbly, under pressure. *See charcoal.*

charcoal paper
Paper with varying degrees of tooth for making charcoal drawings. Rougher papers are better able to hold charcoal than smoother ones. Papers made for pastel work are similar to charcoal papers and are perfectly satisfactory for charcoal use.

Charcoal

When working in charcoal, your needs are few. All you really need is a piece of charcoal and a sheet of paper. There are, of course, other items that are helpful, including a soft cleaning cloth, a sandpaper block or emery board for sharpening, an assortment of papers, a variety of forms of charcoal (vine, sticks and pencils), white chalk for highlights, a drawing board for support, erasers (especially kneaded rubber), a tortillion or stump and a can of spray fixative (not shown).

Moreover, pastel papers are available in more colors, thicknesses and varieties of surface texture than are charcoal papers. *See pastel paper.*

charcoal pencil
A rod of compressed charcoal, usually encased in wood or paper. *See charcoal.*

charcoal stick
Any slender piece of charcoal for drawing, including vine charcoal and compressed charcoal. *See charcoal.*

charcoal, white
Not charcoal at all, but a white material, usually in pencil form, made of pastel-like ingredients and intended to be compatible with charcoal. White charcoal, such as

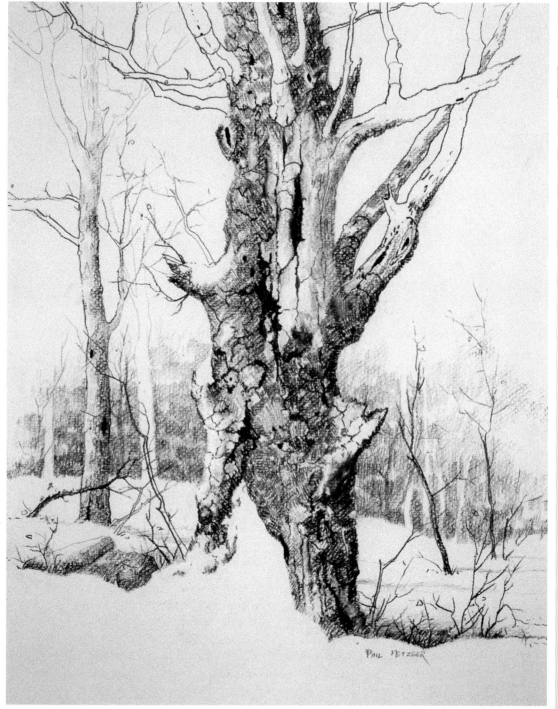

Charcoal pencil

To suggest texture, I used hatched and crosshatched marks and three grades of General Pencil charcoal pencils: soft, medium and hard. To minimize smudging I used a bridge (*see bridge*).

1 | One way to work up a scene like this is to use "staging"—working from background to middle ground to foreground. Using hard vine charcoal, I laid in the first stage, the most distant woods, lightly and roughly. I used masking to retain a clean line between the foreground and background.

2 | With medium vine charcoal, I drew middle-ground trees, using more definition than in the background.

3| Again using medium charcoal, I laid in the snow-capped rocks.

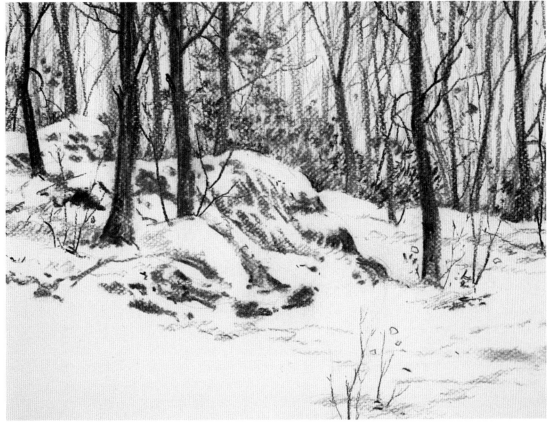

Charcoal

I drew the foreground trees using a combination of medium charcoal and very black, soft willow charcoal.

SNOWY WOODS | charcoal on white charcoal paper | 9″ × 12″ (23cm × 30cm)

a
B
C
D
e
F
G
H
I
J
K
L
m
n
o
P
Q
r
s
T
U
V
W
X
Y
z

Charcoal

This portrait was done in a single three-hour sitting. Judith Ahlstrom used vine charcoal for most of the work but sharpened details with charcoal pencils.

Robert | Judith Koesy Ahlstrom | charcoal on Canson Mi-Teintes paper | 20" × 16" (51cm × 41cm)

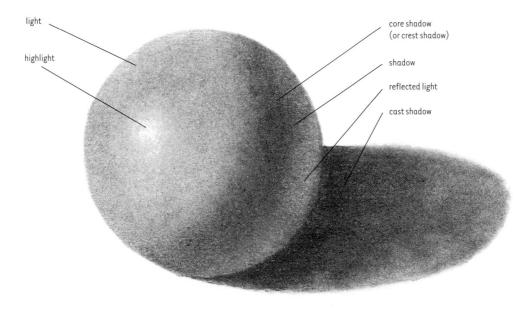

light

highlight

core shadow
(or crest shadow)

shadow

reflected light

cast shadow

that made by General Pencil, may be stroked over charcoal marks for a light gray, satiny effect, but it's virtually impossible to lay "white charcoal" over charcoal and get a bright white highlight. For that, pastel or chalk are more effective.

chasing

Ornamentation of a metal surface by hammering with a variety of tools on the front surface, as opposed to repoussé, which involves hammering from the rear.

chiaroscuro /kee ahr uh *skyur* oh/

[Italian chiaro "light" and oscuro "dark"] The use of a range of values—that is, light and shaded areas in a picture—to give the illusion of form, or solidity. This technique took hold during the Renaissance, when many painters, including Leonardo da Vinci, used chiaroscuro to create the illusion of space and depth in their compositions. With the proper balance of light and shadow, including some sharply contrasting areas, it's possible to create a believable relief effect. Chiaroscuro contrasts with the flat forms favored in much Oriental

Chiaroscuro

When light strikes a rounded object, a complex arrangement of lighted and shaded areas results. Reduced to essentials, as in this sphere lit by a single light source, there are usually three distinct areas: **1:** highlight, the brightest area, the reflection of the light source; **2:** light, the next brightest area, receiving light directly from the light source; **3:** shadow, the entire side of the object away from the light source. Within the shadow area there is a further breakdown; the part of the shadow adjacent to the light area can usually be seen as a dark strip called by various artists the core shadow, the crest shadow, or the shadow accent. Beyond this core shadow is a lighter area of reflected light, caused by light from surrounding objects invading the shadow area. Finally, there is a cast shadow, which is usually darkest near the object and lighter where it's most distant from the object.

Another term often used is halftone. Like many other terms, halftone has taken on several meanings. Sometimes it's used to mean light, in the sense discussed above. Halftone is best reserved to mean any shade between the lightest and darkest parts of an image.

and Egyptian art. *See chiaroscuro woodcut; grisaille; sfumato.*

chiaroscuro woodcut

A sixteenth-century woodcut technique used to simulate gradations of light and dark. The technique involves using more

Children's art

Some typical art by six children aged five to nine: Alison Metzger, Daniel Kraus, Brittany Fazendin, Derrick Fazendin, Samantha Kraus and Dana Metzger.

than a single block. Areas to be printed darkest are cut into one block, the next lightest areas are cut into a second block and so on. The print is made by successive impressions, first inking the dark areas with dark ink, then the next lighter areas with lighter ink and so on until a succession of shades is laid down. To create convincing gradations in tone it's necessary to pay attention to registration—that is, making sure that the printing paper is fixed in the same relative position as it is printed in turn by each block. *See registration; woodcut.*

children's art

Art made by children with or without instruction. In their early years, especially in schools but also in homes, many children are exposed at least to the basics of colors and drawing. What seems clear is that the most expressive art produced by children is that not bound by too many adult "rules." Probably the worst thing a teacher can do to a child whose artistic future is wide open is to force artistic discipline upon that child ("No, Mary, that's not how a tree looks—do it like this.") Many

mature artists try consciously to forget the rules and create like children—a difficult undertaking at best.

china marker

A rod of crayonlike material clad in paper, used to write on slick surfaces; also called grease pencil. *See grease pencil.*

chiné /she *nay*/

A mottled fabric pattern produced by printing, dyeing or painting some of the threads before weaving them into cloth.

chine collé /sheen koh *lay*/

A print that includes colored and/or textured papers in addition to the basic print paper. There are many variations to this printmaking process, but the basics are these: An inked printing plate (e.g., etched or engraved) is placed face-up on the bed of the press. Colored or textured papers (often thin oriental papers torn to suit the artist) are coated with adhesive on one side and then laid over the plate, glue side up. Regular printing paper, usually heavier and stiffer than the colored/textured papers, is placed over the gluey papers and

the combination is run through the press. Depending on the shapes and placements of the torn papers, some of the printing paper may show through. The result is a print with inked lines on a varied surface of colored or textured papers.

Chinese White

A relatively opaque watercolor paint that has zinc white (zinc oxide) as its pigment. Chinese White is often used to restore white highlights in a painting where the white of the paper has been lost. Although this is a fairly common practice, it's avoided by purists who insist that a watercolor painting should be done using only transparent colors. When only relatively small areas are involved using opaque touches works quite well, but when large areas of an otherwise transparent watercolor are done opaquely the results can be disconcerting, because the opaque passages may seem out of place.

chipboard

A stiff, dense, usually gray cardboard made in varying thicknesses from wood pulp. Most brands are acidic and are not suitable

Citrus solvent

for use as painting supports or framing materials for artwork.

chisel brush

A loose term meaning any brush with a clean, sharp edge.

chisel, stone

Any tool used to cut or chip away stone. *See illustration under sculpture, stone.*

chisel, wood

A sharp tool used to cut away excess wood or to incise a wood block, as in preparing a woodcut. *See woodcut; wood engraving.*

chroma

Also called chromaticity, this term is sometimes confusingly used to mean saturation, but more often it refers to the combined effect of both saturation and hue. It's a term mostly found in detailed academic treatments of color and is of little importance to the practicing artist.

ciment fondu

A very hard, fast-setting cement used by sculptors to make lightweight but durable castings, including large-scale outdoor works.

cinquefoil |sink foil; *sangk* foil|

1| Members of the rose family having five-lobed leaves and five-petaled flowers.
2| A design based on five lobes, or petals, or arcs. The word comes from the Latin *quinquefolium* (five + leaf). One of the designs often used in Gothic windows.

cire perdue |seer puhr *dew*|

Lost-wax process. *See lost-wax process; sand casting.*

citrus solvent

A solvent, thinner and brush cleaner for oil and alkyd paints made from citrus fruits. It

Cityscape
This busy scene shows New York City with its bright array of skyscrapers, signs and traffic. Painting such a scene realistically demands a lot of time and patience and a keen eye for detail and color.

THANK GOD IT'S FRIDAY! | Margaret Graham Kranking | watercolor on Arches 260-lb. cold press | 25¹⁄₄″ × 40″ (65cm × 102cm)

has a reasonably agreeable odor. Like turpentine and mineral spirits, it is toxic.

cityscape

A drawing or painting depicting an urban scene. Cityscapes may focus on many different elements, such as buildings, traffic, bridges, alleys, people and parks—it's quite an open-ended category.

clamp, paper

A metal fastener used to secure a piece of drawing or painting paper to a board. After stretching watercolor paper by soaking, clamps are an effective means for holding the stretched paper in its expanded state as the paper dries and attempts to shrink back to its normal size. *See stretching paper.*

Classical architecture

The architecture of ancient Greece and Rome. Prominent in such architecture is a set of styles, or orders, involving columns of various designs resting on foundations called pedestals and supporting an entablature. The entablature consists of three sections, or bands, called the architrave, frieze and cornice (*see dia-*

Paper clamp
Among the many kinds of clamps available, the type shown here works best. They have reasonably strong jaws and they open wide enough to accept a paper and drawing board as much as ³⁄₄″ (2cm) thick. The clamps shown are 3″ (8cm) wide.

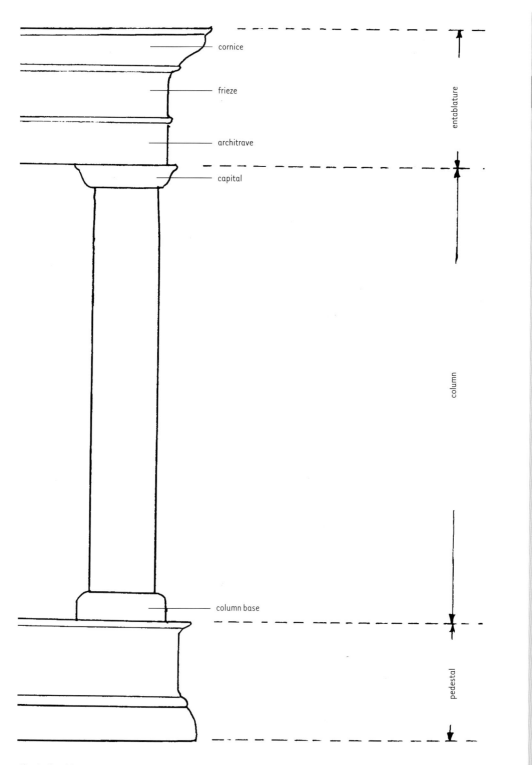

cornice

frieze

architrave

entablature

capital

column

column base

pedestal

a
B
C
D
e
F
G
H
I
J
K
L
m
n
o
P
Q
r
s
T
U
V
W
X
Y
Z

Classical architecture

This simplified drawing shows the main elements of
Classical Greek and Roman architecture. Much modern
design is similar, but often modern entablatures are dec-
orative rather than supporting.

Doric

Ionic

Corinthian

Classical architecture
The three main capitals topping columns in Classical Greek and Roman architecture.

gram). At the top of a column is the capital. There are three basic designs for classical capitals—Doric (the simplest), Ionic and Corinthian—and two less common designs, Composite and Tuscan. The basic architectural styles originated in Greece and were adopted, with some changes, by the Romans. *See illustrations on pages 95-96.*

Classicism
1| The art of ancient Greece and Rome.
2| The qualities embodied by the art of Greece and Rome—clarity, order, balance, unity, symmetry and dignity.
3| Painting, drawing and sculpture emphasizing clean, precise draftsmanship.

claw chisel
A toothed chisel used by sculptors to chip away relatively small bits of stone after major forms have been cut using other types of chisels. *See sculpture, stone.*

clay
Earth that is plastic and somewhat gummy when moist but becomes permanently hard when heated. The many varieties of clays consist chiefly of aluminum and silicate minerals formed by the weathering of rocks such as granite. Some common varieties of clay are: china clay, or kaolin, used in ceramics; pipe clay, similar to kaolin, but with a larger percentage of silica; potter's clay, less pure than pipe clay; sculptor's clay, sometimes mixed with fine sand; and brick clay, a mixture of clay and coarse sand. When clay dries out it disintegrates, so a clay sculpture must be fired to solidify it.

Claybord
A brand of rigid hardboard support coated with a fine kaolin clay and suitable for work in many drawing and painting mediums. The boards are available in several

Claybord

Claybord is suitable for a variety of mediums, including pencil, ink, watercolor, acrylic gouache, oil and scratchboard. Courtesy of Ampersand Art Supply, Austin, TX.

surfaces, including white (both textured and smooth) and black. The black surface, India ink over white clay, is suitable for scratchboard art. The manufacturer, Ampersand, also makes clay-coated Pastelbord, which has a gray surface. *See scratchboard; pastel.*

clay-coated support

A paper or other support coated with a thin layer of fine clay. The clay surface may be painted or drawn on directly, or it may be scraped through to reveal the usually white surface underneath. *See Claybord.*

cleavage

Separation, or delamination, between two layers in a painting, usually two paint layers. Conservators commonly "set cleavage"—that is, repair such defects—using a glue such as rabbitskin glue and moderate heat and pressure from a small electrically heated spatula.

cliché-verre /klee *shay* vair/

A printing technique popular in the late 1800s, inspired by the invention of photography. The artist coated a piece of glass with an opaque material, such as paint, and used sharp tools to make a drawing by cutting through the coating (similar to the process for preparing an etching). The drawing was placed on a sheet of photosensitive film and exposed to light. When developed, the film showed a drawing in black where the lines had been cut on the plate, while the rest of the developed film (the part shielded from light exposure by the opaque coating on the plate) remained white. French painter Camille Corot was one of those who experimented with this printing technique. From the French *clicher*, to stereotype or imitate, and *verre*, glass.

cloisonné /kloy zah *nay*/

Decoration consisting of small cells (cloisons) of enamel separated by wires soldered to a metal background. The design is formed by soldering the wires in place; the cells between the wires are filled with enamel and then fired. *See discussion under enamel.*

cloisonnism

In painting, the use of areas of pure color outlined in black, mimicking the cloisonné enameling process in which areas of colored enamel are enclosed by metal outlines.

A major practitioner of this form of painting was Georges-Henri Rouault (1871-1958). He was a painter, printmaker and ceramicist, but he also worked in stained glass. It was his work in stained glass that apparently led to his use of cloisonnism in painting. *See illustration on page 98.*

cockling

Rippling or warping of a surface, especially a watercolor paper that is unevenly wet.

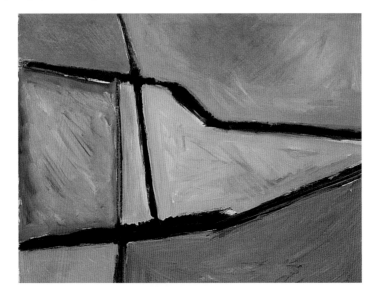

Cloisonnism
One of a series of paint-ings using cloisonnism done by artist David Scott during a long and suc-cessful career. Scott is an admirer of the paintings of Rouault.

EARTH AND SKY | David Scott | acrylic on paper | 30″ × 36½″ (76cm × 93cm). Courtesy of Susan Conway Gallery, Washington, D.C.

Cockling
The wet (colored) areas expand, forming hills, leaving the dry areas as valleys.

Cold-press paper
Here are three papers, Arches hot press, Arches cold press and Fabriano rough, coated with the same paint. The paper's surface has a great influence on the look of the paint strokes.

The portions of the paper that are wet expand while the dry areas do not, result-ing in a "hills and valleys" effect. This is usually avoided by first stretching the paper and clamping, taping or tacking it to a rigid board. *See stretching paper.*

cold-press paper
Paper having a moderately textured sur-face. The term is used mostly in describing watercolor paper and illustration board, which traditionally are manufactured in three degrees of surface texture: hot press (smooth), cold press (moderately textured) and rough (prominently textured). *See papermaking.*

cold-pressed linseed oil
Linseed oil extracted from flax seeds without heat and under less pressure than is used in producing hot-pressed oil. It's more expensive to make cold-pressed

oil, but those paints that use it are considered superior to paints made with hot-pressed oil.

collage

An artistic composition made by gluing various materials to a background, or support (from the French *coller*, "to glue"). Most collages are made from papers glued to a paper support, but often other materials are used, including cloth, wire, shells, leaves and paint—anything the artist wishes. Although any glue may be used, acrylic mediums are the most reliable because they are permanent, nonyellowing and waterproof. Another method used by some artists when dealing with flat papers (not bulky, three-dimensional items) is a dry-mount press. For much more about collage, *see Realistic Collage* by Michael Brown and Phil Metzger. *See dry mounting; assemblage.*

collagist

One who makes collages.

Collage

Millie Shott began with a painted watercolor background support. She cut strips from watercolor paintings and glued them in place in three layers and in three directions—horizontal, vertical and oblique—in imitation of a weaving pattern. The strips are threaded under and over one another in an irregular fashion. They are held in place with acrylic medium, just enough to fasten them without flattening them severely, so that the surface of the composition has a springy, slightly three-dimensional appearance.

INTERWOVEN COMPOSITION | Millie Shott | watercolor strips | 15″ × 22″ (38cm × 56cm)

collagraph

A print that is usually both inked and textured. Techniques differ widely among artists, but a general approach is this: A three-dimensional surface is built up using a variety of materials, and ink is applied over the surface of the built-up plate. Some areas are wiped free of ink, while recessed areas retain ink. Colored inks may be used in selected areas, or the print may later be hand-colored. The plate is run through an etching press under great pressure, forcing

Collage

Brown began by painting the sky on watercolor paper and then worked his way forward, gluing pieces of paper for the horizon, then the water, next the basic buildings, the pilings and, finally, the foreground textured areas. The materials are all paper, some bought and some handpainted. All pieces are fastened with matte acrylic medium.

SPRUCEHEAD RETREAT | Michael David Brown | collage | 10″ × 15″ (25cm × 38cm)

Collage

Another collage by Brown in a strikingly different mood.

CRESCENT BEACH | Michael David Brown | collage | 13½″ × 20″ (34cm × 51cm)

paper into the inked depressions and resulting in both inking and some embossing. *See etching. See illustrations on pages 101-102.*

collotype

A reproduction created using a photomechanical process when excellent fidelity is required. A plate is coated with light-sensitive gelatin and a photographic negative is placed on top of it. Light passing through the negative causes the gelatin to harden in proportion to the amount of light getting through. The hardened areas, after certain treatments, accept ink, again in proportion to the amount of light that got through to each area. From the plate a limited number of reproductions (usually a few thousand) may be printed. This process is also called photocollography.

colophony

An archaic name for rosin. *See rosin.*

Collagraph

This is a commentary on the renewal and rebuilding of an urban courtyard. Grace Bentley-Scheck used a number of materials in this collagraph, including Masonite, several layers of smooth, thin paper, silk organza, acrylic gloss medium, acrylic gesso and modeling paste. Coloring was a fairly involved process. The plate was inked with umber and then wiped so that ink remained in the recesses (intaglio inking); the low brick wall was also intaglio-inked with a color called brick dust. Then four colors were rolled on the top surfaces (relief inking)—those colors were pink-orange, brick orange, pink and plywood buff. After printing, five additional colors were applied by hand. All kinds of prints show some differences, however slight, from one copy to the next; these collagraphs show a bit more variation, in part because of the hand-coloring involved. For more on this artist's collagraphs, see *American Artist* magazine, August 1999.

REVERBERATIONS IN AN URBAN COURTYARD | Grace Bentley-Scheck | collagraph | 22″ × 30″ (60cm × 76cm). Edition of 100.

Collagraph

REFLECTIONS ON PROVIDENCE | Grace Bentley-Scheck | collagraph | 22″ × 30″ (56cm × 76cm)

color

In general usage, *color* is used synonymously with hue to describe an object's appearance as red, green, blue, yellow, pink and so on. But color is really a more inclusive term than that, and it includes the properties called hue, saturation, value and temperature.

Hue is the particular identification of a color such as red, green, yellowish-green, orange, etc. The number of hues for artists' paints is large, numbering in the hundreds—but the potential number of hues is limitless. Any new paint mixture that has even a tiny difference from other paint mixtures can be given a new hue name.

Saturation is a hard-to-measure term. It means the degree of purity, or brilliance, of a particular hue. For example, if you squirt some brilliant Cadmium Red from a tube and then mix a little of anything else with it—say, white or green—you will have reduced the red's saturation. It will appear weaker (less intensely red) with the white added and duller (again, less intensely red) with the green added—both mixtures will be less saturated than the paint straight from the tube.

Value means the lightness or darkness of a particular passage in a drawing or painting. A way to think of value is this: If you photograph the passage using black-and-white film, how will that passage look when the film is developed—white, light gray, darker gray or black? *See value.*

Temperature refers to the relative warmness or coolness of a particular paint. Hues in the red-orange-yellow-brown range are called warm colors; those in the blue-green range are called cool. Yet there are

Color: hue

A sampling of hues: blue, green, yellow, red and orange.

less saturated	saturated	less saturated	less saturated	saturated	less saturated

Color: saturation

Here are two saturated colors, Cadmium Red and Cobalt Blue, flanked by less saturated versions of the same two colors. The lighter shades were made by mixing a little white with the paint; the darker, by mixing black with the paint.

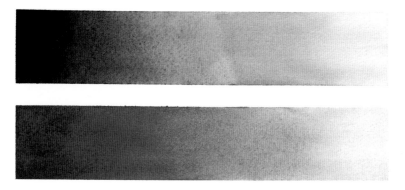

Color: value

Each color has a range of values from dark to light.

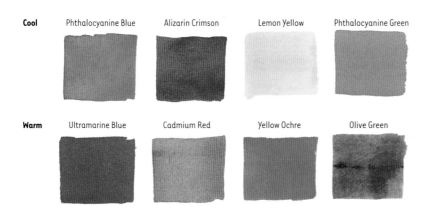

Cool Phthalocyanine Blue Alizarin Crimson Lemon Yellow Phthalocyanine Green

Warm Ultramarine Blue Cadmium Red Yellow Ochre Olive Green

Color: warm and cool

a B c D e F G H I J K L m n o P Q r s T u V W X Y Z

Colored pencil: pencils and sticks

Both colored pencils and color sticks may be used for any kind of stroke, but sticks are more often used for broad areas or dark, dense areas.

Colored pencil: strokes

Strokes on smooth paper made by (top to bottom) a color stick, a soft pencil and a hard pencil.

degrees of warmness or coolness. Yellow Ochre, for example, is a warmer yellow than, say, Lemon Yellow—the Lemon Yellow has a sort of cold feel about it. Similarly, Phthalocyanine Green "feels" cold compared to Olive Green.

colorant

Any material used to give color to another material. We tend to use the word pigment to mean colorant, but a pigment is only one kind of colorant; another kind is a dye. Pigments and dyes are both colorants. *See pigment; dye.*

color copier

A machine (the familiar office copier) that reproduces a multicolored image. Copies of artwork made on color copiers are called photocopies or color copier reproductions. *See reproduction; print.*

colored pencil

A thin core of colored material usually clad in wood. Once a drawing material for children's use, colored pencils have become a serious artist's tool. The core of a colored pencil contains colorant, a gum binder, a chalk or clay filler and wax. The wax helps the color to adhere to a drawing surface and provides a smooth texture— the more wax, the smoother the glide of the pencil across a drawing surface.

There are two types of colored pencils, those with a thick, relatively soft core and those with a thinner, harder core. The thicker leads are generally used for broader strokes and the thinner ones for fine detail. Most colored pencils are advertised as waterproof and smudge-proof, but there are some, usually called watercolor pencils, whose strokes are water soluble. In addition, there are chunks of material (without the wood covering) called color sticks that are made of the same materi-

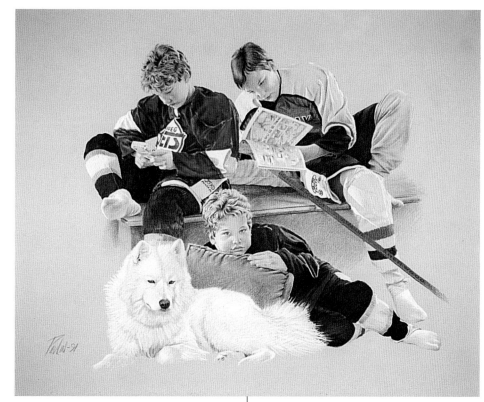

Colored pencil
Poulin has long been acknowledged as a master of colored pencil art. In this striking design he catches the individuality of all the characters but uses their common interest in hockey to unite them.

FAMILY PORTRAIT-1 | Bernard Poulin | colored pencil on acid-free mat board | 24″ × 30″ (61cm × 76cm). Collection of Mr. and Mrs. R. Lotocki, Winnipeg, Canada.

als as the core of colored pencils but with a higher proportion of pigment. These are used mainly for laying down broad strokes or for dense dark areas, but they may also be sharpened and used in the same manner as the pencils. Often, especially when using dark colors, a waxy substance (possibly a fatty acid) rises to the surface of a colored pencil picture, resulting in a pale, whitish haze commonly called wax bloom. It can be removed by gently rubbing the surface with a soft cotton cloth or a tissue, and its return can be prevented, once the picture is finished, by lightly spraying the surface with fixative.

Colored pencil artists use a wide variety of supports, including all drawing papers, pastel papers and drafting film. Colored pencil strokes adhere well to most surfaces, including slick ones. Many kinds of erasers are used, kneaded rubber being

one of the more popular ones because it's least likely to damage the drawing surface.

Like any pencil, colored pencils may be used to draw sharp lines or, laid flat against the paper, broad passages. You can also use a dot, or pointillist, technique. Many artists use combinations of strokes, but perhaps most common are hatched and crosshatched strokes. Color may reasonably and safely be built up in many layers; however, there have been occasions where built-up color has flaked off. It's difficult to cover a dark area with

Colored pencil

This picture was done on Mylar 5 mils thick, matte both sides, using Prismacolor pencils. Guthrie, another master of colored pencil, set up the still life in the morning sunlight and photographed it to capture the quickly changing shadows. He likes working on Mylar because it allows for crisp edges and it gives him no trouble with the wax bloom that often occurs on paper. One drawback is that the film doesn't hold as many layers of color as papers would. He solves this problem by coloring the first layer or two on the reverse side; then he flips the transparent Mylar over and finishes with more layers on the fresh side. This flipping gives the added advantage of seeing the picture in reverse, which often helps to make design errors obvious. *See wax bloom; mirror.*

HAPPY HOUR | Robert Guthrie | colored pencil on Mylar | 14″ × 28″ (36cm × 71cm)

light colors, so the usual procedure is to work from light to dark. Among the techniques you can use for special effects are the following:

Burnishing—Forcefully rubbing over a colored area, especially a dark area, with a light-colored pencil to give the area a pearly, satiny effect.

Impressing—Making shallow grooves (impressions) in the drawing surface so that when a colored pencil is stroked flat across the area, the pigment will not get down into the grooves, and the grooves will show up as lighter lines.

Blending—Using a tortillion, a stump or your finger to rub across adjacent colors to blend them.

Sgraffito—Gouging or scraping a colored area to expose lower layers of color or the drawing surface itself.

Frottage—Making an impression on the paper by laying it over a textured object and rubbing with the flat of a pencil.

Manufacturers rate the lightfastness of their pencils using a variety of symbols, such as A, B, C, D and E or five stars down to one star. It's prudent to use only the pencils rated in the top two categories and forget the rest. Most colored pencils do not conform to ASTM lightfastness standards, so they are not necessarily a truly permanent medium. As for toxicity, look for a Pencil Makers Association (PMA) seal that declares the pencil in accordance with ASTM toxicity standards. If you can't find the PMA approval seal or a similar statement of nontoxicity on the package, buy another brand that does carry such approval notices. This information is not stamped on individual pencils, so you'll need to look further into the manufacturers' literature to find what you need. *See PMA; permanence.*

colorfield painting

A form of abstract painting prominent in the 1960s and still popular today, emphasizing color and de-emphasizing emotional expression, social commentary and recognizable imagery. Some color field paintings are hard-edged and geometric, but many include soft edges and hazy, atmospheric effects using staining and soaking techniques. *See Magna. See illustrations on pages 107-108.*

color index name
See label, paint.

color index number
See label, paint.

color intensity
Saturation. *See color.*

color lithography
See lithograph, offset.

color mixing
There are several techniques for color mix-

Colorfield painting

James Hilleary, still active today, was one of the highly successful Washington color painters of the 1960s and 1970s. He and a handful of his contemporaries developed the technique of staining canvas, first with a paint called Magna and later with water-based acrylics.

VARIATION II | James Hilleary | acrylic on cotton canvas | 79″ × 136″ (201cm × 345cm)

ing. **1:** Paints can be mixed directly on the palette with painting knives or brushes. **2:** Paints can be mixed on the support. **3:** A color can be painted over an existing color in a thin layer (a glaze) so that the two layers visually mix. **4:** Colors can be applied in small adjacent dabs or strokes so that from a distance they seem to interact and form new colors *(see Impressionism; Pointillism). See color wheel; additive color mixing; subtractive color mixing.*

color, opaque
See opaque color.

color permanence
See permanence.

Colorfield painting

Reflection Series VIII | James Hilleary | acrylic on cotton canvas | 46″ × 37″ (117 × 94cm)

color stick

An oblong piece of colored material, usually about ¼″ (.5cm) square and 3¼″ (8cm) long, made from the same ingredients as colored pencils but with a higher concentration of pigment. *See colored pencil.*

color systems

Any of several ways of identifying and cataloging colors. The color wheel is a limited system—a convenient way of representing colors in a rough but practical manner. However, other systems define colors in a much more rigorous way. Two of the more prominent systems were devised by Albert H. Munsell and Friedrich Wilhelm Ostwald. Both systems catalog colors in terms of three basic characteristics: hue, value and saturation. One of the flaws in existing color systems is that the effect of one color on another is not taken into account *(see simultaneous contrast, law of). See color wheel.*

color, transparent

See transparent color.

color triangle

A schematic way of representing colors by arranging them around an equilateral triangle, with the primary colors—red, yellow and blue—at the vertices. It's more common to use a color wheel than a triangle. A useful early version of a color triangle was developed by Charles A. Winter and is called the Dudeen Color Triangle. It may be found in a book by John Sloan (of the Ashcan School) called *Gist of Art: Principles and Practise Expounded in the Classroom and Studio.* It is also reproduced in Stephen Quiller's *Color Choices. See color wheel.*

color unity

The use of a dominant color or family of colors in a picture to produce a result that is visually satisfying; a discernible and satisfying overall color theme. *See design; unity.*

color wheel

A conventional way to show the relationships of paint colors to one another by arranging them in a circle, or wheel. Another way to show the same concepts is by arranging the colors around a triangle. In either case, three paint colors—red, blue and yellow—are placed equidistant around the circle or triangle. Those colors are called *primary* colors. Pairs of primary colors are mixed to produce a second set called *secondary* colors—orange, green and violet. Sometimes the scheme is carried further, and the mixing of a primary color with a secondary color adjacent to it on the wheel or triangle is called a *tertiary* color—the primary red mixed with the secondary orange, for example, produces the tertiary color red-orange.

For an excellent treatment of color, see Stephen Quiller's book, *Color Choices,* Watson-Guptill, 1989.

An important concept arising from these color arrangements is this: Any two colors opposite one another on the wheel are called complementary colors. Red and green are complements, as are orange and blue or yellow and violet. Complementary colors have some interesting attributes: **1**: By mixing any two complements you can produce a great variety of grays. Green and red, for instance, when mixed in the right proportions, produce some beautiful grays, as do yellow and violet or blue and orange. But note that the grays you get depend very much on which particular colors you choose. For instance, Phthalocyanine Green and Alizarin Crimson will give one range of grays, but Phthalocyanine Green and Cadmium Red will give far different results. Not all grays created by mixing

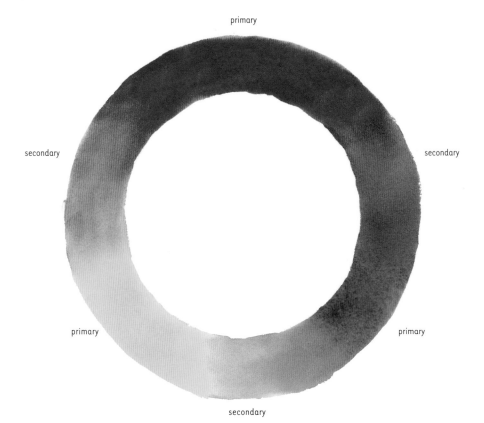

primary

secondary

secondary

primary

primary

secondary

complements are equally satisfying—some will be dead or muddy looking. **2:** To dull a color, add a bit of its complement. A bright red, for example, can be quieted by adding a little green to it (and vice versa). **3:** Complementary colors placed side by side tend to enhance one another. Placing blue next to orange, for example, makes both colors seem more lively. *See Pointillism; simultaneous contrast, law of ; successive contrast, law of; subtractive color mixing. See illustrations on pages 110-112.*

Colour Shaper

Brand name for a series of silicone-tipped tools, outwardly resembling brushes, that may be used with any type of paint, modeling clay or other plastic material. The tips come in a variety of sizes and shapes, including chisel, flat, pointed and split. They may be used to put paint

Color wheel

Here are the three primary colors—red (Alizarin Crimson), yellow (Aureolin) and blue (Phthalocyanine Blue). Between them are the secondary colors—orange, green and violet.

Colour Shaper

These silicone-tipped tools come in a variety of sizes and shapes. Courtesy of Royal Sovereign Ltd., London, England.

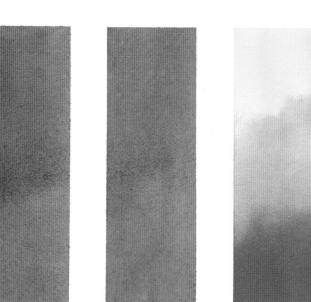

Color wheel: grays from complements

Any primary color mixed with its complement gives a range of grays. The colors used here are Alizarin Crimson + Phthalocyanine Green; Phthalocyanine Blue + orange mixed from Alizarin Crimson and Aureolin; and Aureolin + violet mixed from Cobalt Blue and Alizarin Crimson.

Color wheel: graying with complements

Suppose you paint a foreground barn red and want to place a similar barn farther in the distance. The red of the distant barn should be muted (*see aerial perspective*). This can be done simply by adding a bit of green (the complement of red) to the red that was used for the brighter barn.

Color wheel: adjacent complements

The two squares of yellow are the same, but surrounding one square with yellow's complement, violet, makes the yellow seem more intense. Of course, some of the effect you see is because any color will look stronger when surrounded by a darker color (*see value*). *See simultaneous contrast, law of.*

a
B
C
D
e
F
G
H
I
J
K
L
m
n
o
P
Q
r
s
T
U
V
W
X
Y
Z

Color wheel: complements in a painting
Here the complementary reds and greens combine to give a vibrant, perhaps surreal, effect.

CHIMNEYS 'N SUCH | Al Lachman | pastel on acrylic-gessoed museum board | 30″ × 36″ (76cm × 91cm)

onto a surface, move paint around, make marks in the paint and so on. Because their tips are made of silicone rubber, they wipe clean easily without solvents. They are useful to watercolorists for applying masking fluids. These gummy fluids are hard to clean from regular brushes but can be easily cleaned from Colour Shapers.

commission, art

An agreement between an artist and a patron to make and deliver a particular work of art. Commissions range from verbal "handshake" agreements to formal written contracts spelling out terms and conditions, including delivery time, size and nature of the art, materials, framing (of a picture), delivery (of a heavy sculpture), payment and so on. While many artists like to operate on a friendly, informal basis, with little or nothing in writing, others try to head off problems by putting

in writing a simple description of what's expected of both the artist and the patron. An especially important aspect of a commission agreement is a statement of acceptance—that is, a clear explanation of **1**: what is required of the artist in order for the patron to accept the finished work, and **2**: what is expected of the buyer.

compass

A device for drawing circles. By replacing the pencil in one leg of the compass with a blade, it can be used for cutting circles, which is sometimes helpful to a collagist.

complementary colors

Colors opposite one another on the color

Complementary colors
An example of the strong visual impact of the complementary colors red and green placed side-by-side.

QUIET MOMENTS | Marah Heidebrecht | watercolor | 11″ × 15″ (28cm × 38cm)

wheel (e.g., red and green, blue and orange, yellow and violet). Two complementary colors mixed in suitable proportions produce a range of grays; mixed full strength they produce dark gray or brown. *See color wheel; simultaneous contrast, law of.*

composition

Composition and design are often used interchangeably, but there is a slight difference in meanings. Composition means the total content of a work of art, while design means the arrangement of the elements of a work of art. Composition, then, is a more inclusive term than design. In common usage, composition might include everything about the artwork, while design suggests a layout or plan. *See design.*

composition leaf

Inexpensive substitutes for gold and silver leaf. "Gold" composition leaf is made of brass; "silver" composition leaf is made of shiny aluminum. Like genuine leaf, composition leaf is made in extremely thin sheets. It's used by framers in decorating frames and by artists in paintings and collages. Composition leaf should be coated (for example, with acrylic varnish) to protect against tarnishing. *See illustration on page 114.*

Composition leaf
Porter used a combination of acrylic paint and gold and silver composition leaf to build an abstract background. When satisfied with the abstract pattern of colors and shapes, she introduced the subject, bugs, using pieces of leaf and acrylic paint. The transparent lighter wings are thinned acrylic paint. Pictures using leaf offer different looks depending on lighting conditions—at different times of day and at different viewing angles they may markedly change their appearance.

BUGGED | Shirley Porter | acrylic paint and composition leaf on illustration board | 24″ × 30″ (61cm × 76cm)

compressed gas
Gases, such as carbon dioxide and nitrogen, stored in a tank and used instead of an air compressor by some airbrush users. Compressed-gas tanks must be refilled periodically. *See compressor; airbrush.*

compressor
A device, electrically driven, for supplying air under pressure for use in airbrush painting. There are two basic types: piston compressors and diaphragm compressors. *Piston* compressors force air under pressure into a metal storage tank rather than directly to an airbrush. The airbrush, in turn, is connected to the tank. The compressor does not run all the time you are using the airbrush—it only turns on when the pressure in the tank falls below a set level. Although historically noisy, modern versions are very quiet. *Diaphragm* compressors are connected directly to the airbrush and run continuously to keep supplying air under pressure. They are equipped with valves that automatically vent the air into the room when the airbrush is not being triggered. *See airbrush; compressed gas. See illustration on page 115.*

computer art
Art made using the computer as a tool. This is a fuzzy term that will no doubt

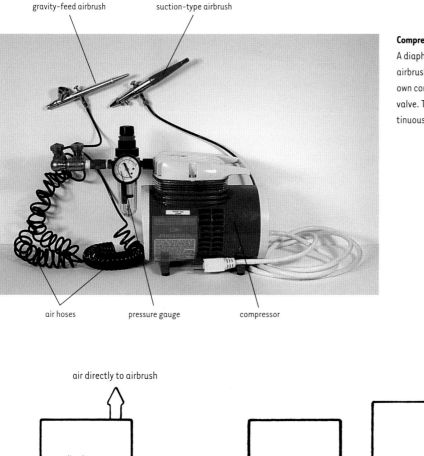

gravity-feed airbrush suction-type airbrush

air hoses pressure gauge compressor

Compressor

A diaphragm compressor with two airbrushes—each airbrush has its own connection and its own shutoff valve. The compressor provides continuous air directly to the airbrush.

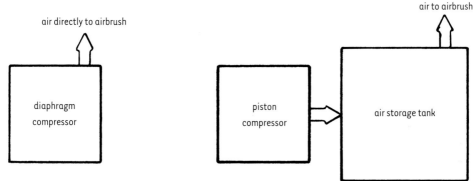

air directly to airbrush

diaphragm compressor

air to airbrush

piston compressor

air storage tank

Compressor
Diaphragm and piston compressors

come into much greater focus as cameras, scanners, computers and printers become more closely integrated. At present many artists are learning to enter images into a computer, manipulate them using software and print out images in full color using inkjet printers. If an artist manipulates an image on a computer screen, changes it in the same ways he might change a painting and then prints a paper or canvas copy of what he has created on the screen, is the printed image original art? This is more than a philosophical question, for its answer will have great impact on the art market. Art shows will need to widen their lists of acceptable media and patrons will need to decide the value of such art. There is bound to be much controversy over computer art, but it seems clear that eventually computer art will be accepted, just as the new medium called oil was accepted 500 years ago and the medium called acrylic was accepted 50

a
B
C
D
e
F
G
H
I
J
K
L
m
n
o
P
Q
r
s
T
u
V
W
X
Y
Z

A Conservator's View

"The longevity of a painting is dependent on the quality of three key elements: the materials selected by the artist, the construction of the painting and the environment to which the painting is exposed. The artist can control the first two of these elements by selecting durable materials and using sound painting technique, but the artist rarely controls the third element, the environment in which the painting is exhibited and stored. The best environment is one that is moderate, without extreme changes of temperature or relative humidity.

The painting materials must be of the highest quality if they are to be lasting. The support must be durable, whether it is a fabric, paper, a seasoned wooden panel or other material. Like the support, the ground materials must be of high quality, and most importantly, the paints must be compounded of lightfast, stable pigments ground into a durable binder. After aging, any varnish used should be free from yellowing and easily removed without damage to the paint.

The best of today's artists' materials are remarkably durable if properly used and the paintings appropriately housed. Most manufacturers provide lightfastness or durability ratings for their various grades of paints. Using these ratings, the artist can anticipate the longevity of the materials in the painting. The artist cannot expect second-grade or student-grade materials to provide the longevity that is characteristic of the highest-quality materials.

If the painting is to last, the artist must use sound painting techniques so the painting is free from construction faults that may lead to premature degradation. Unfortunately, many artists do not understand or follow sound techniques. Many paintings from the mid-1900s have prematurely aged due to a combination of these factors and, as a result, the subtlety of the image has been destroyed. The untimely deterioration of the support, delamination of the various layers or premature cracking can lead to a dramatic distortion of the appearance of a painting and compromise the artist's intent. With the passage of time, we reassess the past and the artist should ensure that his works offer a fair representation of his skills and creative intent."

—Ross Merrill, Chief of Conservation at the National Gallery of Art, Washington, D.C., reprinted with Mr. Merrill's permission.

years ago. The computer is a new medium. Manipulations of color on a screen will eventually be seen to be as valid as manipulating paints with a brush instead of the fingers.

There are at least three ways in which computer art can now be generated. You may 1: photograph a subject with a special camera, connect the camera to a computer and enter the image into the computer; 2: enter a photograph or other image into a computer using either diskettes or a scanner; or 3: start with no image at all and build one on the screen using special drawing and painting software. In all three cases the "artist" at the computer may alter the image in countless ways, including combining two or more images or even overlaying one image with another as in a double exposure—quite an exciting prospect. As impressive as current drawing and painting software is, it's bound to become much more dynamic, especially as keyboards and computer mice give way to

handheld tools that actually feel more like brushes, pencils, pastels and so on. It's easy to foresee a day when one may even mix electronic paint on a palette before applying the "paint" to an image on a computer screen. All that will be missing is the smell of turpentine, although that could also be managed!

The making of gicleé reproductions is a step toward computer art. *See gicleé; scanner.*

Conceptual Art

Art that may exist only as an idea and not necessarily as a physical reality. During the 1960s there was a movement to redefine art (there were many such movements during the twentieth century) in such a way as to downplay the need for actual art objects and emphasize instead the *concept* of a work of art. This was a philosophical inquiry into the very nature of art. American artist Sol Lewitt laid out specifications for drawings, including lengths and types and shapes of lines, and these specifications for doing the drawings were considered the art—the drawings themselves were almost beside the point. Other artists simply printed words on gallery walls vaguely describing some object and left the object itself wholly to the imagination.

conservation

The protection and, in some cases, restoration or repair of works of art. In an informal way, every artist practices conservation when he or she chooses materials and methods with an eye to permanence. In the more formal sense, conservation is the business of specially trained people in museums, galleries and private practice whose job is to protect artworks from damage from exhibition, storage or shipping environments or from mishandling. A hundred years ago an artist might be excused for using materials and practices that might lead to eventual damage to his or her art. But now there is so much information available that such excuses are feeble at best. Art magazines and books (such as this one) are full of helpful information. *See sidebar on page 116.*

constant white

Another name for blanc fixe (barium sulfate), an inert white powder that gives gouache its body. *See gouache.*

Constructivism

A Russian art movement of the early 1900s, founded by sculptor Vladimir Tatlin. The movement's name implies "construction" of abstract sculpture using practical industrial materials, such as metal, plastic and wire. Tatlin's works of 1913–1917 were the first examples of this art. Constructivism, which advocated abstraction along with utilitarianism, found acceptance in the newly born USSR, where utilitarianism in art was held to be paramount—art was to be understandable and socially useful. Constructivism's advocacy of the use of modern materials and clean design had a strong influence on sculpture, architecture and industrial design during the middle of the century, both within the USSR and in the Western world.

Conté crayon

A stick of chalklike color used for drawing. These crayons are denser, less chalky and

Conté crayon

Conté crayon

PHIL | Ned Mueller | Conté crayon (bistre color) on smooth newsprint | 13" × 16" (33cm × 41cm)

less brittle than most pastel sticks. The range of colors is Black, White, Bistre (Brown Umber), Gray, Sanguine Orange, Sanguine Brown and Sanguine Red.

contour drawing

Drawing the outline of a shape as opposed to the details within the shape. As a learning exercise, students often do rapid contour drawings of a subject in a single continuous line, never lifting the pencil, pen or brush from the surface.

contrapposto [Italian for "set against"]

Positioning, or twisting, of the human body so that hips, shoulders and head are turned in different directions. The idea began with ancient Greek sculptures that gradually discarded stiff poses in which the subject stood evenly on both legs, and introduced poses in which the subject's weight was on one leg, with the other leg in a naturally relaxed position. During the Renaissance, Italian sculptors, notably Verrocchio, Donatello and Michelangelo, revived and built on the idea, giving it the name contrapposto, suggesting movement and tension between parts of the body.

conventionalization

1| Following well-accepted norms in any field. 2| In art, the use of simplified symbols or forms to represent natural forms.

cool color

Color at the short-wavelength end of the spectrum (e.g., blue and green), so named because those are the colors associated with cold objects such as ice and water.

copal

A resin exuded from a variety of tropical trees. Copal has long been used as a constituent of certain oil varnishes, but it has been found to have serious defects—

cracking and darkening—and is to be avoided by artists concerned with the longevity of their work.

Coptic Art

The artwork of the Copts (Egyptian Christians) during roughly the third to the twelfth centuries. Although much of this art—especially carvings in wood and stone, and wall paintings—was religious in nature, a good deal of it was not. Human, animal and plant forms are fairly flat, with little detail and a limited number of motifs.

copying

Duplicating another work of art. Copying is a time-honored tool for learning; many a student has copied work by an admired master in an attempt to learn the master's techniques and even the tools and materials he or she used. Copying a teacher's demonstrations in an art class is an excellent way to get up to speed relatively quickly, and most teachers encourage the practice (although some do not). What's important is that copying be used for learning and not as a way of stealing someone else's ideas and profiting from them. You should never exhibit or sell as your own work a piece copied from someone else, and even when hanging a copy in your own home it's proper to sign the work with a clear statement such as "copied from Rembrandt."

 The ethics of copying extend beyond the mediums used; if you copy in paint someone else's *photograph*, credit must be given the photographer. If you plan to use your copy in any way other than your own private study or viewing, get permission in writing from the photographer and wherever you show the work give clear credit to the photographer.

 The inevitable question arises: If you change something in the picture so that

it's different from the original, is it any longer a copy? If you move a rock or a tree, is that sufficient to make the work your own? Probably not, but this is a subjective judgment and in extreme cases it might only be answered by a judge and jury in a court of law! *See copyright.*

copy machine

An ordinary office duplicating machine that delivers copies of an original image either in color or in black and white. There are at least three ways in which copy machines are useful to the artist.

1: Some artists sell reproductions of their work made on a copy machine. As a buyer of such reproductions, or as an artist selling them, there are two important considerations: Is the paper used of high enough quality to ensure decent longevity? Are the inks used reasonably lightfast? It's possible to use papers with a high rag content that have a good life span, but inks are more problematic. While inks have improved greatly in recent years, none that I am aware of claim to be lightfast to the same degree as, for example, artists' paints. There is not a great incentive so far to use lightfast inks because copiers are traditionally intended for uses not requiring archival quality. In any case, it seems incumbent on the artist to make sure his or her customers know what they are getting.

2: A copy machine can be a time-saver in enlarging or reducing the size of a sketch before transferring it to a painting support.

3: Given a basic starting sketch, copies may be made for quickly and cheaply trying out alterations to the initial sketch.

copyright

The exclusive legal right to reproduce, publish or sell a literary, musical or artistic work. A copyright gives the writer, musician or artist protection against the unauthorized use or sale of his or her work. Early copyright laws, going back to a 1710 English statute, protected only nationals, but in 1886 an international agreement was reached that extended across state boundaries. Since 1978 the life of a copyright has been defined as the author's life plus fifty years; for copyrights awarded before that time, the term of coverage was twenty-eight years, renewable one time for another forty-seven years. To establish copyright ownership of a work of art, write the word copyright or the symbol © along with the year and your name somewhere on the artwork where it may reasonably be seen. For full information about copyrights, write: U.S. Copyright Office, Library of Congress, 101 Independence Avenue SE, Washington, D.C. 20540.

core shadow

On a rounded form such as a sphere, light and shade are sometimes described by these four terms: light (the area facing the light source); halftone (shaded area between the highlight and the darkest area); core shadow (the darkest area); and reflected light (area on the dark side of the sphere somewhat lightened by the invasion of reflected light). The core shadow is usually seen as a fuzzy band between the halftone and the area of reflected light. If not for reflected light, the core shadow would continue darkly all the way around the object. Also called crest shadow. *See illustration under chiaroscuro.*

Corinthian order

One of three dominant styles (orders) of Greek architecture. *See illustration under Classical architecture.*

cornice

The uppermost band of the entablature in Classical architecture. *See illustration under Classical architecture.*

cotton

Plant fibers used in making artists' canvas and papers for drawing, printing and painting. Papers made from cotton fibers are strong and durable compared to those made from wood pulp. Cotton in the form of balls or swabs is used in cleaning picture surfaces—long-fibered cotton is preferable to short-fibered cotton for such use because it is less likely to leave a fuzz of short fibers, called *linters*, on the picture surface. *See papermaking; canvas.*

counterchange

In a painting, the contrast of an area of dark against light alongside an area of light against dark—the sort of situation you would have on a chess board with a white piece on a black square alongside a black piece on a white square.

counteretching

The process of resensitizing a lithographic plate to once again accept lithographic crayon. In preparing a lithographic plate for printing, one of the steps following completion of the drawing on the plate is to apply a solution called the etch, which prevents the addition of any further drawing. If proofs are pulled and a decision is made to add to the drawing, the effect of the etch must be reversed. This is done using various chemicals, and the process is called *counteretching*. Note that this use of the word *etch* has nothing to do with the printing process called *etching*. *See etch; etching.*

counterproof

A print made by pressing a paper against a freshly pulled proof while the ink is still wet. The resulting image is the reverse of that on the pulled proof, so it is the same as the image on the printing plate and may be used directly to study the plate image.

cracking

The appearance of faults in paint films of appreciable thickness—oil, gouache, acrylic, alkyd or casein. Here is a checklist of some of the more common causes of cracking in various types of paintings: *See chart on page 122.*

cradling or bracing

Reinforcing the back of a painting support to prevent warping. The usual method is to glue wood strips to the rear of the support. Whether cradling is required depends on the size and thickness of the support material and the paint to be used—watery acrylic paint, for example, is more likely to cause warping than is oil paint. *See illustration on page 123.*

craft knife

See knife, craft.

craquelure** /krak *loor*/

A network of fine cracks in a painting, usually caused by shrinkage of the paint film.

crayon

Loosely used to mean any drawing material in stick form, but more commonly meaning one of three types of drawing materials: lithographic crayon, Conté crayon and children's crayon. Lithographic crayons, sold in both stick and pencil form in a range of hardnesses, have lampblack pigment and wax as their principal ingredients. They are intended for drawing on a lithographic plate (*see lithograph*). Conté crayons are traditionally made in a series of colors, including white, black and a range of red-browns. They are suitable for drawing on almost any dry surface (*see Conté crayon*). Children's crayons are primarily pigments and wax.

crest shadow

See core shadow; chiaroscuro.

Causes of Cracking

Type of Painting	Causes of Cracking
acrylic	flexing at cold temperatures
gouache, egg tempera, casein	too rapid buildup of thick paint painted on flexible support
oil, alkyd	lean (less oily) layers painted over fat (more oily) layers fast-drying layer painted over slow-drying layer shock, such as being dropped on a corner use of copal mediums overuse of driers
painting on canvas	canvas rolled up canvas too loosely stretched canvas poorly mounted to wood or hardboard temperature/moisture extremes in surroundings
painting on true gesso	gesso solution too high in glue content layers of gesso having different recipes gesso too thick insufficiently rigid support temperature/moisture extremes in surroundings
painting on wood	poorly cured wood temperature/moisture extremes in surroundings causing wood to flex and split thin wood not sufficiently supported

criblé or criblée /kree blay/

A printmaking technique in which round marks are made in a printing plate using punches and a hammer—this is called cribbling the plate. By placing punch marks closer together or farther apart, tones may be created. This technique may be used either in relief or intaglio printing—that is, ink may be confined to the surface of the plate or to the pits in the plate. Once quite popular, criblé is now more often used in combination with other techniques, especially in engraving and etching. *See print.*

cropping

Trimming a picture to remove unwanted outer areas, to remove damaged edges or to fit the picture to a mat or frame.

cross-barrel vault

See vault.

crosshatching

Linear strokes at angles to one another. *See illustration under hatching.*

crow quill pen

A variety of dip pen that is smaller and has sharper nibs (points) than ordinary dip pens. *See illustration under pen, dip.*

Cubism

A style of painting emphasizing the flat, two-dimensional picture surface and generally rejecting painting techniques that imitate nature, such as perspective, foreshortening, modeling and chiaroscuro.

thin hardboard or wood

smooth wood strips glued in place

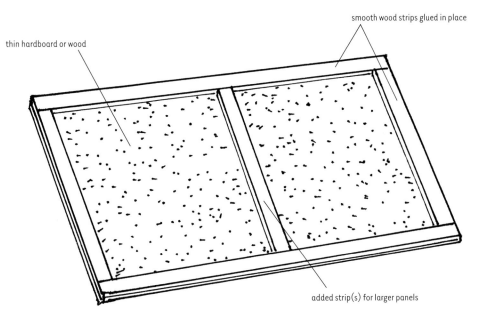

added strip(s) for larger panels

Cubist paintings depict radically fragment-ed objects, showing several sides of the objects simultaneously—in this sense, Cubism depicts what the mind knows, not just what the eye sees. Cubist paintings are also often considered "animated." By show-ing a figure such as Marcel Duchamp's *Nude Descending a Staircase* in a number of slightly different positions, the illusion of motion or the passage of time is created. That sort of technique, of course, became a staple of the cartoonist's trade in depicting motion by cartoon characters. The term Cubism is based on negative remarks by critic Louis Vauxcelles, who described an early work of Georges Braque, *House at L'Estaque*, as made up of cubes.

Cubism was created principally by Pablo Picasso and Braque in Paris between 1907 and 1914. Their early Cubist paintings were heavily influenced by the late work of Paul Cézanne, paintings in which Cézanne concentrated on two-dimensional forms and eliminated conventional perspective techniques. Picasso's famous 1907 painting *Les Demoiselles d'Avignon* set the stage for

Cradling
Lay the board face down on a smooth surface. Cut smooth wood strips to size, coat them with wood glue and place them on the rear of the board. Lay another sheet of board over the whole assembly and place weights on top of it. Let it dry overnight.

Cubism and perhaps all "modern" paint-ing. In this picture, five female nudes are presented in fractured angular shapes and the viewer sees parts of the figures as though viewing them from several differ-ent positions at once.

cuneiform /kyu *nee* ah form/
A form of writing using wedge-shaped characters, from Latin *cuneus*, meaning "wedge." Cuneiform writing was done by impressing into soft clay marks made by wedge-shaped instruments. Probably invented by the Sumerians in southern Mesopotamia, the use of cuneiform writing spread throughout much of the Middle East from about 3000 BC to around the first century AD Early cuneiform writings use pictographs (characters resembling real objects), but gradually the pictographs

were replaced by more stylized forms, eventually becoming wedge-shaped marks bearing no resemblance to objects.

cut-plate etching

An etching made using a plate shaped according to the etching's subject rather than the usual rectangular shape. The metal plate is cut using tools such as jewelers' saws and files. In these etchings the plate mark occurs along the cut edges of the plate, giving the pulled print a slightly embossed effect. The edges of the cut plate are usually beveled with a file to lessen their sharpness and prevent their cutting through the paper and the blankets. *See etching; plate mark; blanket.*

cylinder machine

A high-speed machine used to make paper. A cylinder mounted on a horizontal shaft rotates with its lower surface immersed in a pool of pulp. As the cylinder turns, its wire-mesh surface picks up a uniform coating of pulp. The excess water drains away as the cylinder rotates, and the drained layer of pulp is fed onto a moving belt to be further dried and processed. Fibers picked up by the rotating drum tend to intertwine randomly, thus simulating the character of the mat of fibers characteristic of handmade papers. Paper made by these machines is called mouldmade because it has the look and feel of papers made by hand in moulds. *See papermaking.*

Cut-plate etching

Stoliaroff used a jeweler's saw to cut the zinc plate in the shape of the bear and ball. To avoid having sharp edges that would cut too deeply into the paper and blankets, he beveled all edges with small files.

Russian Bear | Peter Stoliaroff | cut-plate etching | 7⅛" × 2¾" (18cm × 7cm). Collection of the Cultural Foundation Museum, Moscow, Russia.

D

Dada /*dah* dah/
An artistic, literary and political movement that began in Zürich in 1915 as a revolt against traditional bourgeois values and against the war. Dada artists, such as Franco-German Jean Arp and Frenchman Marcel Duchamp, created works that were intended to shock the viewer and show the artists' disgust with contemporary living. Although it's not certain how the name was chosen (it means hobby horse), it is thought to be the word in a German-French dictionary pointed to when a knife was inserted into the dictionary.

daguerreotype /dah *ger* oh type; dah *ger* ee oh type/
The first successful photograph, developed by Frenchmen Louis-Jacques Daguerre, a painter, and Joseph Niépce, a physicist, in the 1830s. This early type of photograph was made using a plate coated with silver iodide. The plate, inside a camera, was exposed to an image and then treated with chemicals to "fix" the image on the plate.

damar [also spelled dammar or dammer]
A resin obtained from coniferous trees in Asia. After it oozes from a tree it hardens into a brittle straw-colored solid. Dissolved in turpentine it dries to a clear, hard film and has been long used as a varnish for oil paintings.

damar varnish
See damar; varnish.

darkening of oil paint
Over time, certain conditions may cause an oil painting to darken: **1**: Linseed oil—the oil in the paint itself as well as oil added in the form of mediums—may darken (yellow) slightly with age. The amount of yellowing depends on the quality of the linseed oil used in the paint (cold-pressed oil, for example, is considered far better than hot-pressed) and on the amount of oil used (some artists add copious amounts of oil to their paints as they work). **2**: Varnishes containing copal resin tend to darken significantly. By using only the best grades of paint and avoiding the use of copal, artists can help ensure that their paintings will not experience significant darkening.

daylight-simulation bulbs
Electric lightbulbs, usually fluorescent, that produce light close in color to that of sunlight on a clear day at midday (sunlight in early morning or late afternoon is usually much warmer in hue than at midday).

dead color
Thin underpainting color that tends to be absorbed into a canvas, leaving a colored surface that is faint and matte rather than vibrant or glossy.

decal
An image made on a specially prepared paper for transfer to another surface. Usually the paper containing the decal image is moistened to allow the paper backing to be pulled away, leaving the image to adhere to the target surface.

decalcomania /dee kal koh *mane* ee ah/
1| Decal. 2| The technique of painting on paper using gouache or other opaque paint and then pressing the paper, with the paint still damp, against another surface such as paper or canvas, resulting in a textured impression on the second surface. The suction and the slight shifting of the surfaces as they are separated produce intriguing patterns of paint that are almost impossible to attain through ordinary brush work. Sometimes the patterned surface is accepted as is; often the artist uses the surface as a starting point for a picture, finishing in more conventional ways. The results of this process are similar to those obtained in making a monotype. Artist Max Ernst used this technique in his surrealist paintings. *See monotype.*

déchirage /day sure *ahzh*/
Torn paper used in collage.

deckle
A frame, usually made of wood, around the edges of a mould used in making handmade paper. Some paper pulp seeps under the edges of the deckle, resulting in the irregular edge on handmade papers called a deckled edge. *See papermaking.*

découpage /day koo *pahzh*/
[French: "cutting out"]
The art of pasting cutouts, usually paper, onto surfaces such as wood, glass or metal. The cutouts are often arranged to describe a scene or tell a story. The cutouts are pasted in place and then covered with several coats of clear varnish or lacquer. Découpage originated in France in the seventeenth century and was used for decorating bookcases, cabinets, screens, fans and many other articles.

design
The layout or arrangement of the parts of a work of art. The *elements* of design—that is, the building blocks—are shape, size, color, texture, line, direction and value. The *principles* of design govern the way these elements are put together to build an effective design. These principles are unity, conflict, dominance, repetition, alternation, balance, harmony and gradation. All these terms—the seven elements of design and the eight principles of design—are reasonably well accepted among artists and teachers, but it should be understood that these terms and their definitions are not universally accepted. Some people add to, or subtract from, the lists of elements and principles, and others use synonyms—tone instead of value, for instance. Still others would insist that all these terms are window-dressing and that a real artist does not do art in such an analytic way; what these critics may be missing is that "real" artists do indeed analyze their work, but they do so automatically, subconsciously, every time they create.

Each of the elements of design is fairly self-explanatory—we all know the meaning of the words shape, size, color, texture, line, direction and value. But the meanings of the principles are not so obvious. Here is a brief explanation.

Unity—When all the parts of a picture, sculpture or piece of architecture seem to work together in a psychologically satisfying way, we say the designer has achieved unity. A painting of a landscape showing

objects we normally associate with a natural landscape—sky, land, buildings, roads and so on—has unity; a painting of a landscape with a jukebox in the middle of a cornfield lacks unity. The jukebox is jarring, out of place, like a bit of rock-and-roll music inserted into a funeral dirge or, to use an Edgar Whitney example, a rabbit's tail on an elephant.

Conflict—Conflict occurs when seemingly opposing ideas are introduced—for example, both round and rectangular shapes in a picture, or both curved and straight lines in architecture. Conflict piques our interest, but if the conflict is not resolved we may be unsatisfied with the art. We resolve conflict by using dominance.

Dominance—When there are conflicting ideas, resolve the conflict by making one or the other dominant. If there are both round and rectangular shapes, emphasize either the round ones or the rectangular ones; if there are straight and curved lines, emphasize one or the other.

Repetition—As in music, the visual arts need recurring themes. If a certain texture appears in a painting, for example, it's usually satisfying to repeat it in more than one place. Repetition in sizes, shapes, line directions and so on all contribute to the unity of the picture. Color repetition may be especially important—rather than a pure blue sky over a yellow and green field, introduce a hint of yellow and green into the sky and a bit of the sky's blue into the field. Many painters underpaint in a single color so that the finished picture will have bits of that color showing through all over its surface, thus imparting some color unity.

Alternation—In an opera, a composer would quickly lose the audience if he or she gathered all the arias together in the first act. Suppose you're painting a still life with many rounded (dominant) objects and fewer rectangular ones. The objects might be arranged in such a way that there is a pleasing mix rather than having all the rounded items in one group and all the rectangular ones in another.

Balance—Like kids on a seesaw, a work of art is usually "happiest" when its conflicting elements are brought into visual balance. Except in very formal works, where severe symmetry is desired, it's best to achieve balance in asymmetrical ways. For example, a large mass at the left of a picture might be balanced by a much smaller, but strategically placed, object somewhere at the right (similar to the way a skinny kid on the long end of the seesaw can balance a heavier kid on the short end). Or a large area of moderate color might be balanced by a small, well-placed dot of intense color elsewhere in the picture.

Harmony—Harmony means the close association of either objects or design elements in a picture. A desk and a chair would be an example of object harmony; similar textures or shapes would be examples of harmony of design elements. A picture containing a square shape, a circle, an ellipse, a rectangle, a triangle and a lozenge might lack harmony.

Gradation—Gradation makes for smooth transitions. There are obviously many situations in which abrupt transitions are desired for the sake of drama—perhaps the starkness of a white birch tree against a dark woods background—but there are many more that might benefit from gentle gradation. For example, intermediate textures help smooth the way from an area of coarse texture to one of fine texture; gently curved lines help the transition from straight to severely curved; and gray tones may ease the way from bright areas to dark. *See composition.*

Detail and edge variation
The first two buildings are the same size and shape, but the fuzzy edges and lack of detail in one signal that it is farther away than the other. Making the fuzzy building smaller and lighter in value also enhances the illusion of distance.

design elements
The ingredients from which designs are built: shape, size, color, texture, line, direction and value. *See design.*

design principles
The guidelines for combining design elements to make an effective design: unity, conflict, dominance, repetition, alternation, balance, harmony and gradation. *See design.*

designers gouache
Winsor & Newton's name for its gouache, so named because decades ago the company made colors for English carpet designers. *See gouache.*

detail and edge variation
A technique for suggesting depth in a picture. Since faraway objects generally look less detailed and softer edged than nearby objects, painting them soft edged and less detailed in a picture plants the suggestion that they *are* far away.

diaper
A decorative repeat pattern of squares, octagons or other regular shapes, each shape containing objects such as leaves, blossoms or geometric designs. This form of decoration was common on the walls of Gothic architecture, either painted or carved; it's seen in many fabric, stained glass and pottery designs.

dichroism
The property of some substances to look different under different viewing conditions. For example, some paints such as Alizarin Crimson look different when used opaquely versus transparently. Also, some paints take on a different appearance depending on the angle at which they are viewed.

diffraction
The slight bending of light as it passes the edge of an object. The amount of bending depends on the wavelength of the light. Sunlight is made up of light of many different wavelengths, so as a ray of sunlight passes the edge of an object, the different component colors undergo slightly different bending, or deflection, resulting in a cast shadow whose edges are not perfectly sharp. *See illustration under cast shadow.*

digital art
Pictures made using a computer and associated equipment, including scanners, printers and digital cameras. *See computer art.*

digital camera
A camera that records a scene in a computer-acceptable format rather than on regular photographic film. Digital images are fed into a computer either by connecting the camera electrically to the computer or by recording images on magnetic disks, which are then inserted into the computer. *See computer art.*

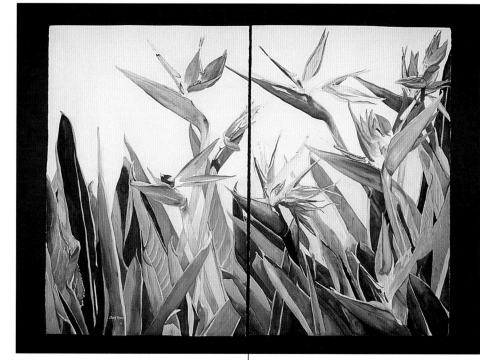

a B C **D** e F G H I J K L m n o P Q r s T u V W X Y Z

diluent

A liquid used to thin, or extend, another substance. Water added to watercolor paint is a diluent; oil of cloves added to oil paint (to retard drying) is a diluent. A diluent is different from a solvent in that it does not necessarily chemically dissolve the material it's mixed with. *See solvent.*

diorama

A scene usually viewed through an aperture or a window and consisting of a painted or photographed realistic background with figures, animals, or other objects placed between the viewer and the background. Museums (especially natural history museums) often use dioramas to depict wild animals in their natural-looking habitats. Dioramas may depict objects either life-size or smaller or larger than life.

dip pen

An ink pen that has removable nibs (points) and that picks up its ink supply by being repeatedly dipped into a container of ink. Each time the pen is dipped, a small amount of ink clings to the underside of the nib. The ink is fed fairly uniformly to the tip along a fine groove cut into the nib. *See illustration under pen, dip.*

diptych /*dip* tik/

Any work of art done in two parts meant to be shown side by side. Sometimes the two parts are hinged, as in freestanding panels used as screens or room dividers, or tablets meant to be folded closed when not

Diptych

Sometimes a diptych is made up of two pictures that are related, but are not necessarily intended to be joined to make a single scene. In this work, Manning painted the two halves as part of the same scene, but the two could be hung with space between them and still be effective. In fact, the pieces could each be treated as stand-alone paintings.

PARADISE THICKET | Marty Manning | watercolor on Arches 1114lb. cold press | 60″ × 80″ (152cm × 203cm). Collection of the artist.

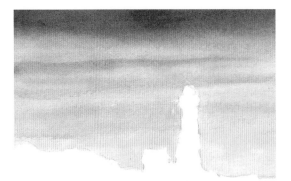

being viewed. Altarpieces were often made either in this form or as triptychs. Although most diptychs are paintings, some are carvings done on flat panels.

direction

The general path or orientation of a line in a drawing or painting. Most pictures have a dominant direction, either vertical, horizontal, or oblique. *See design.*

direct painting

Painting done usually in one session without underpainting and without glazes, and directly from the subject; alla prima painting.

distemper

A term used loosely to mean cheap water-based paint with a glue or casein binder, such as poster paint.

distilled water

Water that has had impurities removed from it by evaporation. The distillation process depends on the fact that as impure water is boiled and turned into vapor, the impurities stay behind while the pure water vapor rises. The vapor is cooled and forms into droplets that are collected in a clean container.

Divisionism

Another name for Pointillism.

dominance

In design theory, the resolution of conflicting ideas by making one idea more important than the others. For example, if a painting or drawing contains both rectangular and curved shapes, one or the other should be dominant. The same applies to color, direction and all the other design elements. When viewing a picture, it's usually (but not always) unsettling and unsatisfying to see compet-

Direction

In one sketch the sky direction is basically horizontal, suggesting a quiet, calm day. The center sky is predominantly vertical in direction, suggesting more weather action than in the first sketch. The third is oblique, or diagonal, and clearly indicates movement or action.

Dormer

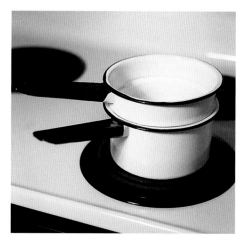

Double boiler

ing elements unless the competition is resolved. *See design.*

Doric order
One of three dominant styles (orders) of Greek architecture. *See illustration under Classical architecture.*

dormer
A structure projecting from a sloping roof and containing a vertical window; also, the window in such a structure.

dots
See lithograph, offset.

double-action airbrush
An airbrush with a trigger that works in two ways—when pressed down it releases only air, but when pressed down *and* pulled back it releases both air and paint. This type of brush allows fine control over both aspects of the paint spray—that is, the air and the paint. *See airbrush.*

double boiler
A combination of two pots made so that one nests partway into the other. The low-

er pot holds water and the upper holds some material to be heated indirectly—that is, without direct contact with the heat source. Materials such as rabbitskin glue or gesso mix are usually heated in this manner in order to heat them evenly without burning or scorching.

double shadows
Two (or more) shadows cast by the same object because light from two or more sources strikes the object. *See the illustration under shadow.*

drafting film
Acetate film, transparent or nearly transparent, used for laying over a drawing or painting and making corrections or exploring design possibilities. *See Mylar drafting film.*

drafting tape
A paper tape similar to, but less tacky than, masking tape. Drafting tape is preferred by most artists to masking tape for use on paper surfaces, such as watercolor or drawing paper, because drafting tape is less likely to damage the surface of the

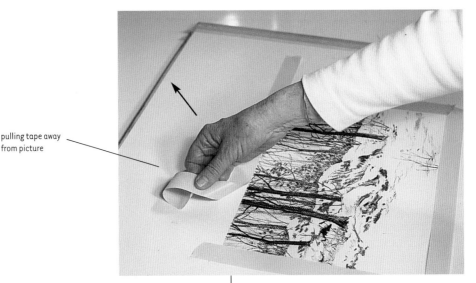

pulling tape away
from picture

paper when the tape is removed. Some *masking* tapes stick so firmly to paper that when they are removed they tear the delicate surface of the paper. Drafting tape is used to mask a portion of a picture to keep paint, charcoal or other materials from those areas. It's also used to mark off the edges of a picture so that when finished the tape may be removed, leaving a clean border around the picture.

dragging

Moving a paintbrush over a surface with the brush held fairly flat against the surface to produce a rough, textured, broken effect in the paint. *See illustration under broken color.*

drawing

A picture that emphasizes line and shape rather than mass and color. Any definition of drawing is bound to be imprecise—are pictures made using colored pencils drawings, or are they, because they're fully colored, considered paintings? It's an academic question and you can choose any answer you wish, but for the most part the dominance of line and shape defines a picture as a drawing.

Drafting tape

Drafting tape is available in several widths, including $\frac{1}{4}''$ (0.6cm), $\frac{1}{2}''$ (1cm), $\frac{3}{4}''$ (1.9cm) and $1''$ (2cm). It's thin enough that you can see pencil lines through it, so you can stick the tape down over a drawing and carefully cut through it with a sharp blade, leaving tape only over the areas you wish to protect. When removing tape from the edges of a picture, pull it slowly in a direction away from the image so that if a tear occurs it will not damage the image.

Drawings have at times been considered only a step along the way to a finished work of art, such as a painting or a sculpture, but now drawings have a solid place in art, important in their own right. A drawing may be of three general types: **1:** a sketch used to record information or to try out design ideas; **2:** a study used to show in some detail an object that may become part of a more inclusive work; or **3:** a finished drawing intended to stand on its own as a work of art.

drawing bridge

A device that helps an artist to avoid smudging a drawing. *See bridge.*

drawing through

Drawing the parts of an object you can't see as though you *can* see the hidden edges

eyelids wrapped
around the eyeball

unseen edge of eyeball

unseen edge of eyeball

Drawing through

Imagining you can see through an object and lightly
sketching the hidden lines, as in these pencil sketches,
can help you draw the object convincingly.

a
B
C
D
e
F
G
H
I
J
K
L
m
n
o
P
Q
r
s
T
U
V
W
X
Y
Z

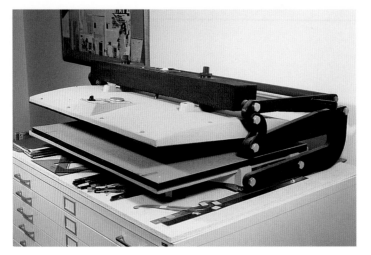

Dry mounting
A typical dry-mount press.

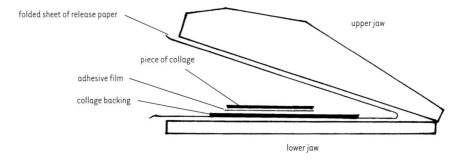

folded sheet of release paper

upper jaw

piece of collage

adhesive film

collage backing

lower jaw

Dry mounting
Using a heat-type dry-mount press to adhere a collage
paper to a backing, or support.

right through the object. This technique helps you understand the total form of the object and that, in turn, helps you to draw it more convincingly.

drier

A substance added to paint to speed up drying; a siccative. Driers are most often used in oil painting, because oil paints dry relatively slowly. Driers are added to some oil paints during manufacture. The painter may add more drier to speed up the process even further, but must do so with caution. Driers can harm an oil film by causing eventual cracking and darkening. Their use in thick oil applications is especially dangerous because they speed up the drying of the outer surface of the film

before the inner paint has had a chance to dry, leaving a fragile skin over the painting. Authorities such as Mayer recommend avoiding the use of driers; for those who do use them, cobalt drier seems safest.

dripped paint

Abstract Expressionist painters use various means for applying paint to canvas—one of them is to lay the canvas flat on the floor and allow paint to drip from sticks, brushes, cans, bottles or other containers as the artist moves about the canvas.

dry mounting

Any method of adhering materials such as prints, drawings and photographs to a backing without using fluid adhesives

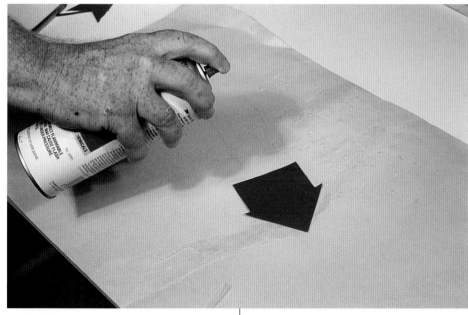

Dry mounting: tacking
Artists who use dry mounting usually tack collage pieces lightly in place first to make sure they're satisfied with the piece and its placement. Here collagist Michael Brown sprays the back of a piece with 3M Spray Mount. If you use just a light coat of spray, the piece may be easily removed and shifted.

such as glues or pastes. Dry mounting is commonly used by photographers to fasten photographs neatly and securely to a background; some collagists dry mount the papers that make up their collages. A sheet of dry-mounting adhesive, or tissue, is laid between two surfaces to be joined, and this three-layer sandwich is then exposed to both heat and pressure between the jaws of a press. The adhesive film melts and joins the surfaces securely. You can simulate dry mounting by coating one or both surfaces to be joined with spray cement (which is not really dry, of course) and then pressing the two surfaces firmly together.

Some framing shops mount art prints and reproductions using a vacuum press that automatically sprays adhesive on the surfaces to be joined, flattens and aligns the surfaces by sucking the air from between them, and then presses the two surfaces together.

dry-mounting adhesive
A thin transparent film that is dry and flexible (similar in feel to household freezer wrap) but that melts and forms a glue when heated. It comes in sheets and rolls and in varying degrees of permanence, including some of archival quality. Also called dry-mounting tissue and dry-mounting film. *See dry mounting.*

dry-mounting release paper
A stiff paper treated with a heat-resistant material such as silicone. It has a look and feel similar to household waxed paper, but unlike waxed paper it won't melt or become sticky when heated. Release paper is inserted between the jaws of a dry-mount press and the work being mounted to protect the jaws from becoming sticky from any melted adhesive around the edges of the work. *See dry mounting.*

dry-mounting tissue
Dry-mounting adhesive.

dry painting technique

In watercolor, painting on a relatively dry surface rather than wetting the paper first. *See wet-in-wet painting; watercolor; sand painting.*

dry rot

Decay of wood caused by fungi that destroy the wood's cellulose, leaving the wood weak and crumbly. Dry-rot fungi thrive in moist conditions, so paintings done on wood panels must be kept in well-ventilated, low-humidity environments.

dry watercolor technique

Painting in watercolor without wetting the entire surface of the paper. *See watercolor.*

drybrush

1| Painting in watercolor using stiff paint with very little water. Sometimes the objective is to get a rough, textured appearance, but artists such as Douglas Wiltraut, whose work is shown here, use drybrush in a controlled way to get very fine nuances of color and value change.

2| Painting in any medium using relatively stiff, not fluid, paint. Although most often associated with watercolor, the term is frequently applied to painting in oil, acrylic and other mediums.

Drybrush

Douglas Wiltraut uses an exacting technique similar in some ways to his use of egg tempera (see illustration under egg tempera). In this painting he first established pale areas of base color using more fluid techniques, but then built on that foundation using careful drybrush strokes.

MONK | Douglas Wiltraut | drybrush watercolor on Arches triple elephant rough | 37″ × 57″ (94cm × 145cm). Collection of the artist.

dryer

Any device used to blow heated air across the surface of a painting to speed up drying. Dryers are commonly used by water-

Dryer

An ordinary hair dryer may be used for drying water-based paints—oil and alkyd should not be artificially dried because it's likely that only a surface "skin" will dry, leaving the underlying paint soft. The dryer should be held far enough away from the painting that the air stream does not puddle the paint or push it aside, but once the paint is nearly dry, the dryer may be moved closer, as in this illustration.

color painters without ill effect, but they may cause harm if used to dry paints that are applied in appreciable thicknesses—for example, oils, impasto acrylics and gouache. Drying a thick paint may cause a skin to form over the surface of the paint while the paint under the skin remains soft, something like a pudding that's cooled too fast. The skin may later crack.

There are at least two types of dryers commonly used:

1: An ordinary hair dryer, which puts out a narrow, fairly intense stream of heated air, so it should be held high enough above the wet paint that the air stream does not disrupt, or "puddle," the paint. It can be moved over the surface of the painting by hand, or you can hang the dryer overhead and shift the painting beneath it. **2:** A modified exhaust fan. Here is one way to build such a dryer. Start with a kitchen or bathroom exhaust fan, one in which the fan is enclosed by a long metal sleeve. Add heating coils and a switch and suspend the rig from a boom that swings back out of the way when the heater is not in use. You can easily add a rheostat to give

you control over the fan's speed. Although the construction is simple—you'll need only a few tools and a couple of hours to do the job—be careful with the electrical hookup. If you're electrically challenged, get an electrician to help out! *See illustrations on pages 137-138.*

drying oil
An oil that forms a hard, tough, fairly elastic film when exposed to air. Oils such as linseed and poppyseed oil, used as binders in artists' oil paints, are drying oils.

drying time
The time it takes a paint film to dry or cure. Water-based paints dry by simple evaporation of the water in the paint; other paints

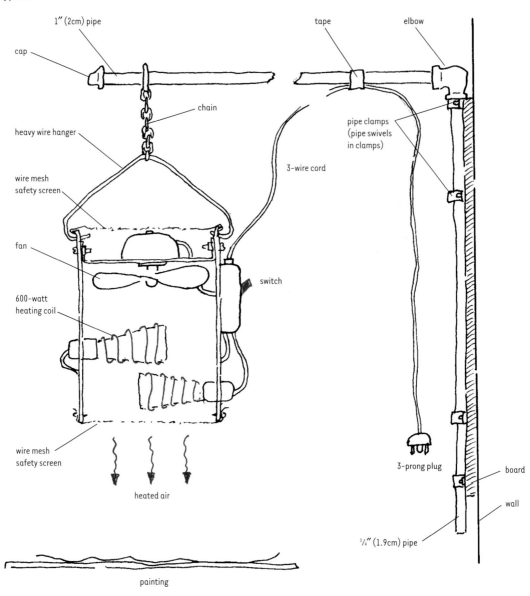

1" (2cm) pipe

cap

chain

heavy wire hanger

wire mesh
safety screen

fan

600-watt
heating coil

wire mesh
safety screen

heated air

painting

tape

elbow

pipe clamps
(pipe swivels
in clamps)

3-wire cord

switch

3-prong plug

board

wall

¾" (1.9cm) pipe

Dryer
Here's a handy dryer you can make yourself.

"dry" as various chemical reactions, such as oxidation, take place, causing the paint film to solidify.

drypoint
One of the most direct of the intaglio printing techniques. Lines are scratched directly into a metal plate (without the acid-resistant coating used in etching) using steel-pointed or diamond-pointed needles. The resulting lines are irregular, with tiny burrs along the edges of each line. The size and nature of the burrs depend on the pressure exerted and on the angle at which the needle is held to the plate. The lines are not usually made

Drypoint

very deep—in fact, the burrs along the edges are often more responsible for holding ink than are the lines themselves. The ragged lines in drypoint are in contrast to the sharper, cleaner lines of an engraving. Copper plates are commonly used for drypoint, but because copper is relatively soft the burrs are easily disturbed or worn off. For that reason drypoint artists run small print editions. Larger edition sizes can be attained by electrolytically coating the finished copper plate with a thin coating of steel before pulling prints. The steel coats the burrs and makes them able to withstand more wear. *See engraving; etching; print.*

dust box

A box used to deposit rosin evenly on the surface of an etching plate that is to be used in the aquatint technique. The plate is placed on a shelf above a layer of finely powdered rosin. The box is closed and the rosin is stirred by a fan or by shaking so that a uniform layer settles onto the printing plate. *See aquatint.*

dye

A substance that dissolves in liquids (unlike a pigment, which does not dissolve) and imparts its color by staining a material or by being absorbed by a material. Dyes by themselves are generally not sufficiently lightfast for use in artists' paints. However, they are used indirectly in a class of paints called *lakes. See lake; colorant.*

E

Early Christian Art

Art produced during the period from the beginning of Christianity to around the sixth century in the Western part of the Roman Empire (art in the East is usually considered under Byzantine Art). Until the conversion of Emperor Constantine to Christianity in 313, Christian art was mostly hidden (for example, in the catacombs) and largely symbolic. After 313, Christian art came into the open and gradually became more explicit, with pictures of Christ, for example, in place of earlier symbols, such as a fish or a lamb; at the same time there appeared Christian architecture in the form of shrines and churches.

earth color

A colored mineral literally taken from the earth, used as a pigment; paint having such a mineral as its pigment.

earth sculpture

See sculpture, earth

easel

Any structure made to hold a painting or drawing in a position suitable to the artist. Most easels hold a picture upright, more or less vertical, but some, such as French easels or box easels, are adjustable so they hold the work in any position from horizontal to vertical. Easels are available in a

Raw Sienna Raw Umber Burnt Sienna Burnt Umber

Earth color
A few examples of earth colors.

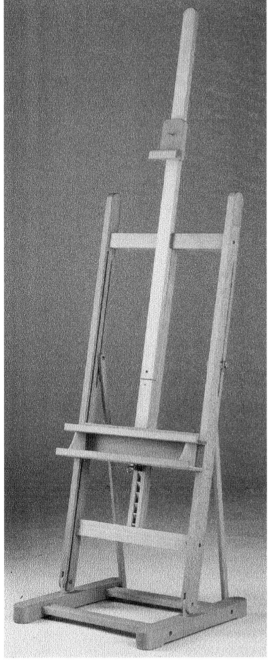

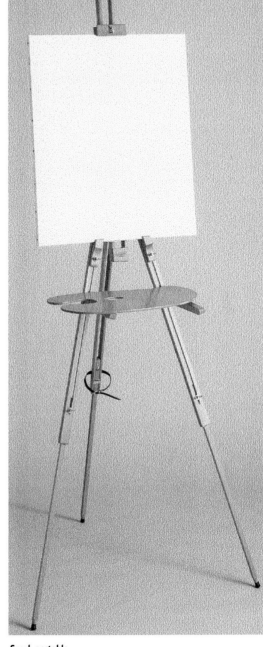

Easel: studio

An easel sturdy enough to handle most work; not intended as a portable easel. Studio easels come in heavier models, some with casters for rolling about and some with cranks to lower and raise the shelf on which the artwork sits.

Easel: portable

A reasonably steady easel for those on a limited budget or having limited space; this easel is lightweight and may be folded when not in use.

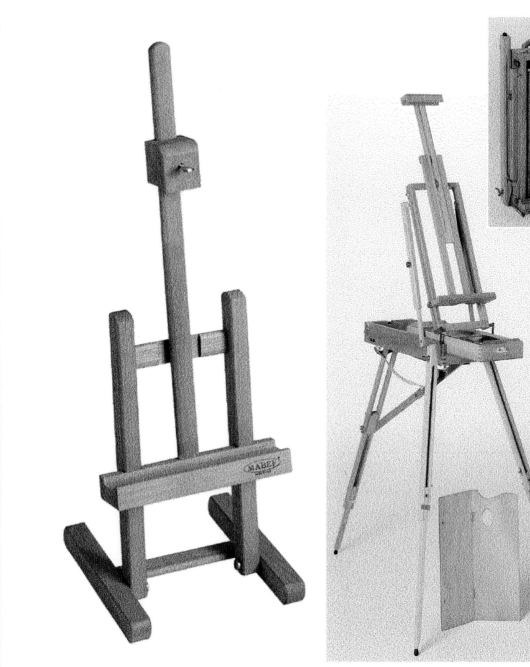

Easel: tabletop

This squat easel sits on a table or counter rather than on the floor.

Easel: backpacker's

Similar to a box easel, this one is even slimmer and lighter and has handles and straps suitable for backpacking.

great many forms. *See box easel.* All photos courtesy of M.A.B.E.F. easels, distributed by MacPherson's, 1351 Ocean Avenue, Emeryville, CA 94608. *See illustrations on pages 141-142.*

easel painting
Painting done on a panel, canvas, paper or other portable support, as opposed to a wall. Murals (paintings on walls) were the most common form of painting until the thirteenth century, when easel painting became popular.

ébauche /ay *bosh*; o as in own/
1| A sketch or outline; a roughing out. In the nineteenth century many oil painters roughed in a composition with an unde-tailed monochromatic underpainting as a guide to doing a full-color, detailed paint-ing. They called this an ébauche. Many painters still do such an underpainting, but the term ébauche is not frequently

Edge
An effective combination of soft and hard edges. There are enough hard edges (painted on dry paper) to define the subject crisply, but enough soft edges (painted on wet paper) to keep the painting from becoming too stiff and photographic.

CAMELIA | Shirley Porter | watercolor on cold-press paper | 7″ × 10″ (18cm × 25cm)

used. More common are the terms *under-painting* and *lay-in*. 2| A maquette or any rough version of a sculpture.

edge
The outer perimeter of a section of a draw-ing or painting. How edges are treated by the artist greatly affects the visual impact of the work. In striving for perspective (a three-dimensional look) artists often soft-en the edges of objects intended to be seen in the distance and sharpen the edges of those that are close. When a quiet effect is wanted, adjacent edges are often softened and blended; for bolder effects, edges may

be left sharp. The treatment of edges in a picture can often influence the artist's choice of materials—a soft sky is more easily obtained using oils rather than acrylics, for example, because oils may be easily blended to eliminate edges.

edition

The number of copies of a print or reproduction to be made. *See print; reproduction.*

efflorescence

A powdery residue, usually whitish, that forms as moisture evaporates from a surface and leaves behind dried particles originally trapped in the moisture. Efflorescence is a problem in mural painting on walls such as brick or stucco. As moisture seeps through such walls it carries with it minute particles of the wall material, and when the moisture reaches the outside

Egg tempera

According to critic Raymond J. Steiner, Robert Vickrey describes his paintings as "dreamscapes" painted "in his head." Vickrey's use of symbols, pale color and odd juxtapositions gives his pictures a haunting quality. He is one of the few contemporary masters of the egg tempera medium. Before his time egg tempera was looked upon as a tedious medium that must be done the old way, piling tiny stroke upon tiny stroke to gradually build a picture. Vickrey uses plenty of "tiny strokes," but he also slashes and spatters and lays on paint with broad brushes and painting knives as a foundation for his final, delicate finishes. Many people were introduced to his work through his covers for *Time* magazine; for that work, always under the pressure of deadlines, Vickrey often used convenient and easily portable tube watercolors, rather than dry pigments, to mix with his egg medium.

SARAH'S BALLOONS | Robert Vickrey | egg tempera on gessoed hardboard panel | 20″ × 24″ (51cm × 61cm). Private collection.

surface of the wall it evaporates, leaving the particles as an unsightly film.

egg-oil emulsion

A combination of egg (either whole or yolk) and various oils (such as stand oil) to produce a paint binder that has some of the characteristics of egg tempera and some of the feel of oil paints. Artists have experimented with many recipes, but there are none that are commercially available.

egg tempera

Paint that has egg as its binder. Egg tempera painting predates oil painting—tempera was in wide use during the 1300s and 1400s—but its popularity rapidly declined as oil painting advanced. In the mid-1900s egg tempera found new audiences, thanks to the work of Andrew Wyeth, Robert Vickrey and, a few others.

Egg tempera is a mix of pigment, water and ordinary hen's eggs. Some artists vary this formula by adding oils to the recipe.

Egg tempera

Douglas Wiltraut uses untempered hardboard as his support. He coats the back with six thin layers of true gesso (after first sizing with rabbitskin glue) and the front with five layers—the paint on the front later constitutes a sixth layer. By applying layers of gesso first to one side and then to the other in alternating fashion, he ends up with a gessoed hardboard that has no warp. In a departure from the practice of others, he does not premix his dry pigments with water. Instead, he has little piles of dry pigment on his glass palette and he mixes as he goes. As he paints, he builds up many layers of thin glazes—the effect is like laying sheets of colored acetate one over the other to get a cumulative color effect.

THE MIGRATOR | Douglas Wiltraut | egg tempera on gessoed hardboard panel | 28″ × 38″ (71cm × 96cm). Collection of Mr. And Mrs. Bruce Viechnicki.

The white of the egg, or even the whole egg, may be used, but most prefer the yolk, which provides a more elastic film. Egg tempera is painted in thin, translucent films. A stroke dries rapidly, so it's easy to build up layers of paint without disturbing paint already laid down. Traditionally, egg tempera is painted using many tiny

Options

You have some options in choosing your egg tempera paints. At least one manufacturer, Daler-Rowney, offers egg tempera paint in tubes. This paint contains some linseed oil and other ingredients in addition to egg yolk. The paint has a different feel from that of regular egg tempera, and the linseed oil poses a small danger of yellowing with age. Another choice is to substitute watercolor paint (or even gouache) for the traditional water-plus-pigment paste. You simply mix watercolor paint with your egg yolk medium. I've found this a convenient way to paint in egg tempera, and I know of no problems between the egg medium and the gum arabic in the watercolor.

hatched strokes, but modern painters such as Robert Vickrey use combinations of such controlled strokes along with much freer strokes laid down broadly with wide brushes or painting knives. Although any nongreasy, porous ground is suitable, the longtime favorite is true gesso. A gesso surface, sanded to a pearly smoothness, accepts the paint beautifully and provides the whiteness that helps give a tempera painting its unique glow. An alternative to true gesso is acrylic gesso, but the "feel" of the two is different, and adhesion between the paint and an acrylic gesso ground is probably less strong than with true gesso.

The support for an egg tempera painting should be rigid—flexing could cause cracking or flaking off of the paint layer. Hardboard, wood, and watercolor or illustration boards are all suitable as supports. In the case of watercolor or illustration boards, no ground coating is needed—you can paint directly on the boards.

To prepare egg yolk medium, crack an egg and gently toss the yolk from one half-shell to the other, letting the white drain away. Put the yolk on a paper towel and pat it dry. Lift the yolk in your fingers (carefully!), hold it over a small, clean jar (such as a baby-food jar) and break the yolk's sac. Let the contents run into the jar and discard the sac. Add enough water (distilled water is best) at room temperature to make a mixture the consistency of light cream. Store the medium in the refrigerator between painting sessions—it should keep for several days without spoiling.

To prepare pigments, mix powdered pigments with water to form pastes; store the pastes in small airtight jars with lids, or in metal or plastic tubes. At painting time, mix small puddles of paint on your palette by combining color paste and egg medium—a fifty-fifty mix is about right. Mix only small amounts because the paint dries rapidly—you can keep it moist on the palette by gently misting it with water from a sprayer. Apply the paint in any manner you wish—hatching, crosshatching, painting knife, sponge or wide brush—but keep the layers thin because thick layers might crack. Corrections are relatively easy to make, especially if you're painting on a smooth, hard ground, by carefully skimming off an area of paint using a sharp razor blade—the paint will peel away quite easily. Egg tempera dries quickly to a tough film, but complete curing may take as long as six months or so. The finished painting can be easily damaged by water or by scratching, so it's common to frame egg tempera under glass. At the least, the frame around a painting should be deep enough to give some protection against physical damage. *See emulsion; tempera; gesso, true.*

Eight, The
The original members of the Ashcan School: Robert Henri, Arthur B. Davies,

Maurice Prendergast, Ernest Lawson, William Glackens, John Sloan, George Luks and Everett Shinn. *See Ashcan School.*

electric eraser

A slender motor-driven eraser that looks like an electric drill. The eraser strips that fit into the end of the device come in several different varieties, depending on the type of surface that is to be erased. Because of the inherent power of such an eraser, it's wise to use it with an erasing shield, or template, that protects the areas surrounding the section to be erased. *See erasing shield.*

Elmer's Glue-All

A synthetic adhesive made from polyvinyl acetate (PVA), nontoxic and strong, popular among artists for a variety of uses, such as bonding layers of mat board and joining wood frames. It's also used by collage artists, although acrylic gel mediums may now be more popular.

embossing

Raising a surface in relief for ornamentation. Embossing is done by forcing material, usually paper, into a die, or mold.

Embossing

An example of embossing on white paper using a brass mold, or die. Guy Schum uses this sheep design as the logo for his advertising and graphic design business. It's a wistful reminder of a year he and his family spent farming in Ohio in an attempt to leave behind the rigors of high-tech living near Washington, D.C.

SHEEP | embossing by Guy Schum | Schum & Associates, McLean, VA | approximate size: 1⅝" × 3" (4cm × 8cm). Photo courtesy of Michael Hare, Beach Brothers Printing, Rockville, MD.

Although commonly done by machine, artists frequently do hand-embossing. A simple embossing may be done by forming a mold out of modeling paste, letting the mold harden and then pressing a sheet of damp paper into the recesses of the mold. When allowed to dry, the paper will bear the raised pattern of the mold.

Empire Style

A style in architecture, interior design and dress during the time of Napoleon (1795-1815) and lasting until about the 1830s. In an attempt to revive the flavor of imperial Rome, Napoleon encouraged the use of classical columns and other signs of Greek

Enamel cloisonné

Joanne Conant used the cloisonné enameling technique to make this beautiful broach. The work is basically enamel on a silver base, but there is also some gold under thin layers of enamel and a strip of 18K gold soldered to the silver border at the right. For all her work, Conant does preliminary drawings like the one shown to help her decide exactly where each soldered strip will be placed to form the cells for the enamel.

IRIS | Broach | Joanne Conant | cloisonné with gold and silver | approx. 3½" high × 1½" (9cm × 4cm) wide

and Roman architecture, as well as furniture that boasted rich and ornate woods and fabrics, and women's dresses and coiffures that mimicked classical times.

emulsion

A combination of tiny droplets of one liquid dispersed in another liquid. Homogenized milk, for example, is an emulsion of fat droplets in a watery liquid. Certain artists'

paints, such as egg tempera and casein, are emulsions. *See tempera.*

enamel

A relatively soft glass made by firing mixtures of silica, lead oxide and sodium carbonate (soda) or potassium carbonate (potash) at high temperatures. The combination of these ingredients melted together is called *flux* or *fondant;* various metal

oxides may be added to the molten flux to produce a range of beautiful colors. By varying the proportions of the basic ingredients and sometimes by adding other ingredients, the enamel may be made either transparent, translucent or opaque. After being fired and cooled, the enamel is either broken into chunks or crushed into granules for use by jewelers and other artists. The artist usually must further grind the chunks or granules and then wash the resultant powders with water and pick out any grains of impurities that might be present.

The enamel powders are moistened with water and applied to a base object, usually made of a metal such as gold or silver. The moistened powders are allowed to dry under moderate heat; once dry, the object is fired at high temperatures until the powders melt and fuse to the metal. After cooling, the hard enamels may be stoned (shaped and smoothed) with corundum or silica abrasives, which produce a matte finish. The piece may be returned to the kiln for a short time ("flash fired") to return to a gloss finish. There are several traditional ways of applying enamels to a base.

Cloisonné—Wires are either soldered to a metal base or joined to a layer of enamel by heat to form small cells (cloisons). Then the individual cells are filled with moistened enamel powders of appropriate colors. Some artists, like Joanne Conant, use the tips of fine brushes for picking up and depositing enamel into the cells; others use different tools, such as dental probes. Wires forming the cells are usually copper, silver or gold. The cloisonné technique is traced back at least as far as the fifth century BC in India and a little later in Greece; the Byzantines perfected the art in the sixth century AD.

Enamel cloisonné

Conant is adding water to spoonfuls of enamel colors in preparation for depositing the bits of enamel into individual cells.

Enamel cloisonné

Here you can clearly see each cell filled with enamel. This is a box with a removable cover.

SEA URCHIN | box | Joanne Conant | cloisonné with silver | approx. 2″ (5cm) high × 3″ (7cm) wide. Courtesy of Niece Kimpton Gallery, Tucson, AZ.

Champlevé—Enamel is deposited into cells *cut* into a background metal using engraving tools or acid. This form of enameling requires a thicker base than cloisonné, so a less expensive base, such as copper, is generally used. Enamel powder is dropped

Enamel plique-à-jour
A tricky, time-consuming enameling technique, plique-à-jour gives the effect of stained glass when light is shone through it. This piece has two hemispheres connected by three metal arms. The two parts twist to close up and form a sphere.

AURORA BOREALIS | Joanne Conant | plique-à-jour | approx. 3" (8cm) high × 4" (10cm) diameter

into the cut grooves in the same manner as in the cloisonné technique.

Plique-à-jour—Enamel is deposited into cells in the same way as in cloisonné, but with a significant difference—the metal strips forming the cells are not permanently attached to the base. After the enamel has been fired, stoned and polished, the enamel and strips are separated from the base. The result is like a miniature stained glass window.

Encrusted enameling—Moist enamel powder is painted onto a sculpted surface, often made of gold, and fired.

Basse-taille—As in champlevé, cells are cut into a metal base, but the "floors" of the cells are carved in relief using chasing tools to create lines, shapes and textures. Translucent enamels are added to the cells and, because of the irregularities of the carved surfaces under the enamel, the enamel takes on varying thicknesses, giving rise to visual effects different from enamel of uniform thickness. In addition, the metal under the enamel may be silver or gold and the brightness of these metals shows through the enamel, adding to the overall visual beauty.

Painted enameling—With no separating wires or ridges, moist enamels are painted onto a surface, usually copper, and each patch is allowed to dry before adding the adjacent patch. There are many variations to this type of enameling, depending on the artist's preferences.

enamel paint

Any of a large array of paints that dry to hard, glossy finishes. Enamel paints are made using a variety of binders and other ingredients and are generally intended for commercial and household use.

encaustic painting

Painting in which the primary medium is hot wax. Encaustic painting dates from ancient Greece and Egypt, according to the writings of the Roman historian Pliny, writing in the first century AD; it was essentially a lost art until the eighteenth century, when it was revived. Since then,

Encaustic painting

To provide a rigid support, John King fastened a panel of $^1/_4''$ (0.6cm) plywood to a rectangle of canvas stretcher strips. He prepared the wood surface by painting it with pure beeswax and then using a heat lamp to melt the wax so that it became absorbed into the wood. He applied encaustic paint directly to this surface. He did not buff the surface, preferring the more matte appearance of the unpolished encaustic. Usually King does not frame his encaustic pieces, but leaves them free-standing with the edges visible.

UNTITLED | John King | encaustic on wood | 36″ × 39″ (91cm × 99cm). Photo courtesy of Richard Frumess, R&F Handmade Paints, Kingston, NY.

encaustic painting has enjoyed periods of popularity. Up until the twentieth century the tools for this method of painting were cumbersome—the paint and the painting surface had to be heated in some manner and, until the advent of electric heaters, this was no simple matter.

Encaustic paint consists usually of finely ground pigments, hot white beeswax and resin. As with any painting medium, various artists have experimented with other ingredients, but a simple mix of pigment, wax and resin is the most common recipe. Painters in this medium use a palette heated by various means, usually electrical, and they apply the paint either by pouring or by using painting knives and stiff brushes, such as those made of hog bristles. Encaustic paint may be applied thinly or thickly to almost any surface. Some artists like the fact that it can be built up into low-relief surfaces. Once finished, the painting is heated carefully and uniformly until the surface develops an overall satiny sheen. This process is called burning in or fixing and it's where the method gets its name—encaustic comes from the Greek for "burning in." The heating process fuses the paint into a uniform layer and helps bond the paint to the support. Once solid and cooled, the painting may be buffed gently with a soft cloth to get a uniform sheen.

Encaustic paintings are as permanent as most mediums. They can be damaged, like most others, by scraping or flexing of the support, and extreme heat (above 170 degrees or so Fahrenheit) can melt the wax. A very hot day will not cause damage,

but may make the painting's surface slightly tacky.

encrusted enameling

An enameling technique in which moist enamel powder is painted onto a sculpted surface, often made of gold, and fired. *See enamel.*

engraving

An intaglio printing process in which a metal plate, usually copper or zinc, is cut into with sharp tools to form an image. The plate is inked and its surface is wiped clean so that ink remains only in the cut grooves. Damp printing paper is placed on the plate's surface and paper and plate are run through a press under sufficient pressure to force the paper down into the plate's fine grooves, where the paper picks up ink. The resulting image on the paper is the reverse of that cut into the plate. *See illustration under mezzotint. See printing press; print; burin; rocker; roulette.*

entablature

In Classical architecture, a horizontal band resting on a series of columns. The entablature consists of three layers—the lowest is called the *architrave*, the middle is the *frieze* and the upper is the *cornice*. In some Renaissance and modern architecture the entablature does not actually rest on pil-

lars, but still is a prominent feature at the top of a wall. *See illustration under Classical architecture.*

entasis /*en* tuh sis/

A slight intentional curving of a line in architecture in order to combat the optical illusion of sagging, or weakness, that occurs when perfectly straight lines are used. If we view a column, for example, that is perfectly vertical and uniform in thickness, the column appears to us to be slightly pinched in the middle. Classical architects found that the illusion is negated by tapering the column (so that it's a bit narrower at the top than at the bottom) and by making its vertical edges slightly curved (convex). Entasis was well known by Greek and Roman architects—the Parthenon in Athens is a prime example of its use—but it was used many centuries earlier by the builders of ziggurats in Mesopotamia. Each ziggurat wall had a slight outward horizontal bulge when viewed from one corner to the next.

eraser

A material used to lift or rub away pencil, ink, charcoal and other marks. Common pencil erasers usually are made of rubber, oil and a fine abrasive, such as pumice, along with other minor ingredients, but that recipe is modified greatly in manufac-

Eraser

A few of the many types of erasers available. Clockwise from top right: **1:** kneaded rubber erasers, useful whenever you want to minimize the danger of damaging the paper surface; **2:** an all-purpose eraser strip that you renew by feeding it through an adjustable collar—similar strips are made encased in paper that you peel away to reveal more eraser; **3:** Magic Rub, a soft-textured eraser that won't leave a stain on your paper; **4:** White Pearl, intended for removing ballpoint ink; **5:** a Sakura ink eraser; **6:** a white vinyl general-purpose eraser; **7:** Artgum, an eraser that crumbles as you use it; and **8:** Pink Pearl, a popular type used for erasing large areas. Not shown, ordinary pencil erasers that vary greatly in effectiveness—some of them leave a pink blemish on the paper.

strips of mat board

fastener

turing specialty products such as the kneaded eraser. *See electric eraser.*

erasing shield

A thin sheet of metal or plastic with holes of various shapes and sizes through which a restricted area of a drawing may be erased—the shield protects the areas you don't want to erase. A shield is particularly useful when using an *electric* eraser because without the shield's protection it would be easy for the high-speed eraser to stray and erase or damage adjacent areas.

estimating angles

Determining the proper slants of lines in a drawing. The simplest method is to hold a straightedge, such as a pencil or a ruler, at arm's length, close one eye and line up the straightedge with the edge of a building or other line whose slant you want to define. Then lower the straightedge to your drawing paper and copy the angle onto your paper. The problem with this method is that it's likely your wrist will turn a bit as

Estimating angles

Make this angle-measuring device by joining two pieces of mat board with a bolt or other fastener so that the two legs of the device can swivel—but make the hinge snug enough that the legs don't swivel too easily. Align one leg with a line such as the vertical side of a building, and adjust the second leg along a line whose slant you want to draw, such as the sloping roof. Now the angle between the two legs is an accurate representation of the angle in the subject.

Erasing shield

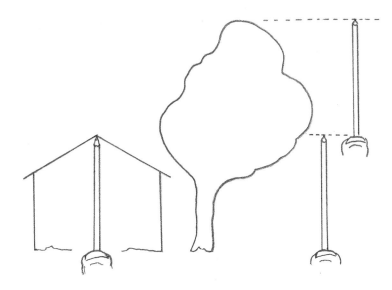

Estimating sizes
The height marked by your thumb for the shed fits about twice into the height of the tree.

you lower your straightedge to the paper, and the result may not be accurate. A better method is to make a simple angle-measuring device, as shown here. Line up one leg of the device with one edge of the subject you are drawing and then swivel the other leg to align with another edge. Lay the device on your paper and copy the angle you measured.

estimating sizes

Determining the relative sizes of real objects in order to represent them in the same proportions in a drawing. A simple technique involves the use of a straightedge, such as a pencil. Suppose, for example, you want to determine the relative height of a tree and a shed. Hold the straightedge at arm's length, close one eye, and then align the top of the straightedge with the top of the shed. Slide your thumb down the straightedge to mark where the bottom of the shed is. The distance from the top of the straightedge to your thumb represents the height of the shed. Now, keeping your thumb in place on the straightedge, move it to the tree and make a rough estimate of how the height of the

tree compares to that of the shed. In the example shown, the marked height of the shed is about half that of the tree. On your drawing, therefore, choose a height—say, three inches (7.5cm)—for the shed and then draw the tree twice as high, or six inches (15cm). You can make more accurate estimates by using a ruler, rather than a pencil, as your straightedge.

etch

An acidic solution added to a lithographic plate after the drawing is finished to desensitize the plate to any further marks. This has nothing to do with what we normally think of as etching—this faulty use of the word etch arose during the early days of lithography. *See counteretching.*

etching

An intaglio printing process in which a metal plate is coated with an acid-resisting ground, often containing beeswax. The design is scratched or pressed

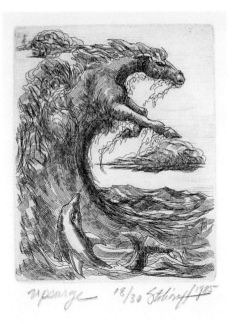

Etching

Stoliaroff's images are often rooted in history or mythology. In this print he combines his fascination for horses with the mythological idea that horses evolved from the sea.

UPSURGE | Peter Stoliaroff | line etching | 4⅞″ × 4″ (12cm × 10cm)

Etching needle

A typical etching needle. Often an artist wraps the shaft of the needle with tape or other soft material to make it more comfortable to hold. Most etchers also devise their own special needles—for example, Peter Stoliaroff fastens together a row of sewing machine needles in a comblike array for use in cutting sets of parallel lines rapidly. Photo courtesy of Peter Stoliaroff.

through the waxy layer to expose the metal underneath. The plate is then immersed in acid, which "bites" into the exposed metal, forming shallow grooves. After cleaning the ground from the plate, the plate is coated with ink and then wiped so that the only ink remaining is in the grooves. Printing paper is soaked in water and thoroughly blotted. The dampened, softened paper is run through a press against the inked plate and is forced downward into the grooves, where it picks up ink.

There are many variables at work in etching. The plates, commonly copper or zinc, sometimes aluminum or magnesium, each react differently to the action of the acid, usually nitric or hydrochloric acid. The strength of the acid and how long the plate is exposed to it greatly influence how deep a "bite" the acid causes. The pressure exerted by the printing press also affects the image, as do the choices of inks and papers.

Although an etching can be made straightforwardly by scratching the design through the ground, exposing the plate to a single acid bath and then printing, usually much more is involved. The artist may wish to expose one area to acid longer than other areas, so he may cover an area with some masking material, or stop-out, during part of the acid-exposure process. Often parts of the plate are specially treated to give a shaded or textured result (aquatint) rather than a simple line image. The artist may add cut or scratched lines after the acid-etching is complete, as in drypoint and engraving.

See aquatint; soft-ground etching; ground; print; drypoint; engraving.

etching needle
A steel point used to draw through a ground to expose the metal plate under the ground. *See etching.*

experimental art

Any art that uses new and untried methods, materials or techniques. Many artists experiment on a modest basis, but some, not content with the tried-and-true, attempt to open up entirely new avenues of expression. Sometimes experimental work ends up nowhere and is forgotten, but often such work leads to entirely new "schools" of art. The Impressionists were, in their day, experimenters; so were Pointillists, collagists, color field painters and kinetic sculptors—but today such work has solid acceptance. Much recent experimental art has concentrated on the use of new materials and new combinations of materials.

Expressionism

A trend in painting and graphic arts that de-emphasized literal renderings and instead tried to represent the emotional reaction of the artist toward the subject. As Matisse put it: "Composition is the art of arranging in a decorative manner the various elements at the painter's disposal for

Experimental art

This is one of a series of works Wall has done using this general procedure: He fastens a sheet of thin aluminum to a stiff support, such as plywood or hardboard, by bending the edges of the aluminum around the support. This gives him a flat surface with slightly rounded edges. He sands the surface and washes it thoroughly with an alcohol-water mixture. He primes the surface with either a commercial primer/sealer (Aqua Lock or 1-2-3 Bullseye Primer/Sealer) or a hard, clear acrylic base (Golden GAC 200). Next he coats the surface with three to five layers of acrylic gesso, wet-sanding between coats to an eggshell smoothness. He draws on this surface using mostly graphite in either powdered, stick or pencil form. He mounts shaped gessoed aluminum pieces to the surface using Crazy Glue or Super Glue and works on those pieces also with graphite. Finally, he sprays the whole assemblage with several coats of acrylic matte varnish to seal the graphite.

PARINIRVANA (DEATH OF BUDDHA) | Bruce Wall | graphite on gessoed aluminum | 11″ × 14″ × 1½″ (28cm × 36cm × 4cm). Collection of Walter Van Vort, CA.

the expression of his feelings." While Impressionists had tried to show the subject as they saw it, Expressionists tried to show their *reaction* to the subject. Edvard Munch, Vincent van Gogh and Paul Gauguin were among those who set the stage for twentieth-century Expressionism with their use of brilliant colors and evocative lines and shapes.

The term Expressionism is used in two ways: in a broad sense referring to any trend toward emotional expression in art, and in a narrower sense referring to specific groups or individuals striving for such expression in their own ways. Two of the most influential groups were Die Brücke (The Bridge) and Der Blaue Reiter (The Blue Rider) in Germany. Die Brücke artists included Ernst Ludwig Kirchner and Emil Nolde. Their work was characterized by violent, jagged lines, harsh colors and crowded, busy canvases representing anger and disgust with what they saw as the ugliness of modern life. The group's first exhibition in 1906 in Dresden marked the beginning of German Expressionism; they disbanded in 1913.

The Blue Rider group was formed in Munich, Germany, in 1911 and lasted until 1913, just before World War I began. The group was named for a painting by one of its founders, Wassily Kandinsky. Other members of the group were Paul Klee, Franz Marc and August Macke. These artists were the second wave of German Expressionists; although their aims were still to become liberated from subject matter and to use colors, shapes and lines in expressive, nonrepresentational ways, their approach was less angry and more lyrical than that of their predecessors, Die Brücke.

extender

1| A device that allows the use of pencils, pieces of charcoal or other drawing materials that have become too short to hold comfortably. An extender, in effect, lengthens the pencil or other tool. 2| In paints, a material added to the pure pigment and binder to alter the paint in a variety of ways, such as providing bulk or adding tooth. In some cases, the reason for an extender is to reduce tinting power—pigments such as the phthalocyanines, for example, have such great tinting power that they need "toning down" to make them more compatible with other paints on the palette. Alumina hydrate is commonly used to extend transparent pigments, and blanc fixe is often used as an extender for opaque pigments.

eyedropper

Any instrument with a squeezable bulb and a narrow tube that is used to add small amounts of substances to mixtures— for example, adding a drop or two of ox gall to watercolor paint to make the paint more spreadable.

eye level

A plane parallel to the ground and passing through the observer's eyes. In linear perspective, eye level is the reference that governs the slanting of receding horizontal lines in the picture—receding lines above eye level slant down, and receding lines below eye level slant up. *See discussion under linear perspective.*

fading

Loss of brilliance in a color caused by the influence of environmental factors (especially ultraviolet light) on colorants that are not completely stable. *See permanence.*

fan blender

A fan-shaped brush used for blending or feathering paint. In drybrushing it's also useful for painting such textured subjects as grass and wood. *See brush, painting.*

fat

Containing a high proportion of oil. Many artists choose to remove some of the excess oil from oil paint before they use it. They do this by squirting a mound of paint onto a sheet of paper, such as bond or newsprint, and letting the paint stand until the paper has drained some of the oil from the paint. The draining is easy to see because a ring of oil develops around the paint.

fat-over-lean rule, oil

You should not cover a layer of oil or alkyd paint with a less flexible layer. Always paint flexible "fat" layers over less flexible "lean" layers. To do the reverse would be like having a lean "skin" over a fat pud-

Fan blender

An Exception?

It's now common practice to paint oil or alkyd over a ground of acrylic gesso. This is an apparent violation of the fat-over-lean rule (because the acrylic layer is *more flexible* than the later layers of oil or alkyd paint). Conservators report that the practice has led to some adhesion failures. The safest route is still to use an oil or alkyd ground for an oil or alkyd painting.

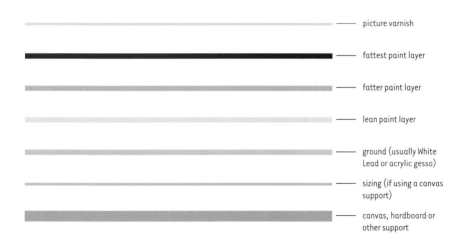

picture varnish

fattest paint layer

fatter paint layer

lean paint layer

ground (usually White Lead or acrylic gesso)

sizing (if using a canvas support)

canvas, hardboard or other support

Fat-over-lean rule
The layers in a typical oil painting.

ding. Any movement in the pudding underneath is likely to crack the skin.

Fat means containing a relatively high proportion of oil, such as linseed oil, and *lean* means relatively less oil. Oil or alkyd paints become fatter when you add to them such preparations as linseed oil, stand oil or various oil-containing mediums. Paint becomes leaner when you dilute it with turpentine or mineral spirits. If you paint without additives, using paint straight from the tube, you're reasonably safe. If you paint a turpentine-thinned layer over a layer of straight paint, you violate the rule—in that case, the chances of damage (cracking) are much diminished if the fat underlayer is well cured.

fat-over -lean rule, pastel

Soft pastel may be easily applied over hard pastel, but not vice versa. When stroking hard pastel over a passage of soft pastel, the hard pastel tends to gouge and push aside the soft.

However, hard can be applied over soft for specific, limited results—for example, to sharpen details.

Fauvism

A form of Expressionist painting in France from about 1898 to 1908, characterized by the use of bright, pure color and distorted forms. Henri Matisse was a leader of this group, which also included André Derain, Maurice de Vlaminck, Raoul Dufy and Georges Braque. The name came from critic Louis Vauxcelles, who, because of the violence he saw in these paintings, called the painters "Les Fauves" (wild beasts).

ferrule

A metal sleeve that joins a brush head to a handle. *See brush construction.*

fiber-tip pen

A pen with a soft, porous tip that transfers ink from a reservoir to a writing surface. Because of the nature of the tip and the type of ink used, these pens can be used for marking on slick surfaces such as plastic or glass.

figurative

Involving the human figure—as in figurative drawing and figurative sculpture.

Filbert

for example, the *design* of a structure may be considered fine art, but not the *building* of the structure. So-called commercial art is not called fine art because it has as its purpose some economic goal, such as selling a product (which begs the question: Don't most painters, sculptors and printmakers aim to sell their products?). Many refuse to include *illustration* under fine art, even though much illustration is certainly "fine" in the best general sense of the word. And, of course, many would argue that if the word *beautiful* is part of the definition of fine art, then any object not considered beautiful in the conventional sense would have to be rejected as fine art—a most subjective judgment, indeed.

filbert
A flat brush with distinctly rounded corners. *See brush, painting.*

filigree
1| Delicate ornamentation in jewelry using fine threads of metal, especially gold and silver, braided and entwined in decorative patterns. 2| An openwork (decoration perforated by openings) of delicate and intricate design.

film, dry-mounting
Dry-mounting adhesive. *See dry mounting.*

final varnish
A varnish used to protect a completed picture from dirt and damage. *See varnish.*

fine art
Any visual art concerned with the making of beautiful, nonutilitarian products. Usually painting, printmaking, sculpting and architecture are considered fine art, and the term often includes literature and the performing arts as well. Strict definitions are hard to come by—in architecture,

finger blending
Use of the fingers to smear paint, pastel, charcoal or other mediums to achieve a softer, less hard-edged, appearance. While such blending has its place, many artists avoid its use, or at least its overuse, because blending often results in a duller, less lively passage.

fixative
A liquid spray used to help bind particles of charcoal or pastel to a surface or to prevent smearing of graphite or colored pencil. Fixatives are available in pressurized spray cans, but some artists prefer to mix their own varieties and apply them with atomizers or spray bottles. Fixatives are made from a variety of ingredients, including both natural and synthetic resins, and glues such as casein. Those containing resins are essentially dilute varnishes.

Fixatives should be used sparingly, especially on pastels, since they alter the appearance (color and value) of the surface—the more fixative used, the more dramatic the change. Many pastel artists refuse to use any fixative, preferring to rely on proper framing to give their pictures

Health Note

Almost any sprayed substance, including fixative, poses a health risk. Inhaling fixatives can cause a variety of serious problems, as attested to by the warnings on the containers—this includes fixatives that are called by such names as "no-odor." The only safe way to spray fixative is outdoors while wearing some sort of respiratory protection—at least a face mask.

Flat

the protection they need. When fixative is used, it should be sprayed on lightly and evenly, just enough to keep particles of charcoal or pastel from becoming easily dislodged or to prevent accidental smearing of a graphite or colored pencil surface. The artwork should be placed against a support at an angle and sprayed lightly and evenly from side to side. Each spray "stroke" should begin and end well off the edges of the picture—that way, there is less chance of unwanted buildup each time you change direction. Drops of liquid often form around spray nozzles, so to avoid having drops fall onto the picture, don't hold the spray can or bottle directly over the work.

Workable fixative is more dilute, so the thin film it forms interferes less with further work on the picture. *See framing.*

flag
The naturally split tip of an individual hog bristle. When used in making a paintbrush, the split ends of the bristles hold more paint than bristles that have had their ends cut off. Each split bristle acts as a miniature paintbrush.

Flake White
Oil paint that has white lead (basic lead carbonate) as its pigment. Flake White is a toxic paint. *See health hazards.*

flat
A brush with a flat, rectangular head and relatively long filaments, compared with the *bright*, which is flat with shorter filaments. *See brush, painting; bright.*

flat painting
A painting, either representational or non-representational, that ignores perspective (the illusion of depth) and instead relies on surface qualities such as color, pattern, line and texture to make an impact.

flax
A plant of the family *Linaceae* whose tough fibers are used to make linen cloths, including fine artists' canvas. Linen canvas is stronger than cotton and is less subject to the negative effects of atmosphere and microorganisms. Seeds of the flax plant are used to make linseed oil, the binder most often found in oil paints.

fleur-de-lis/fleur-de-lys /fluhr deh *lee*/
A stylized representation of the iris (French, lily flower) used in much ornamentation and heraldry, especially in France. *See illustration on page 162.*

Fleur-de-lis

flint

A type of hard quartz mineral used in some abrasive products, such as sandpapers, and as an additive to some painting grounds to help provide tooth. Flint pebbles are also used in certain commercial grinding processes, such as grinding pigments for paints. Sharp pieces of flint were used by Stone Age man for making weapons and tools.

flocculation

The tendency of grains of pigment in certain paints, such as Ultramarine Blue, to attract one another and gather in small clusters rather than disperse evenly in the binder. Compare this to *granulation*, which is the tendency of pigment particles to settle into depressions in paper or other supports. Both result in a mottled, or grainy, effect, often used by artists to suggest textures.

floral

Any picture having flowers as its subject.

flow enhancer

A general name for products added to water-based paints to **1**: decrease viscosity, especially for use in airbrushing and **2**: reduce surface tension, increasing the paint's ability to spread and stain paper or fabric. Examples are Golden Acrylic Flow Releaser and Liquitex Flow Aid.

flowed paint

1| Fluid paint, such as oil or acrylic, that has been applied by pouring it over the support. 2| Fluid paint, such as watercolor, that has been applied in any manner and then made to run, or flow, over the painting's surface by tilting the painting. *See p'o-mo.*

flung paint

Paint that is thrown at the canvas or other support from some distance rather than applied with a brush or other tool. Some artists dip their hands in the paint (a dangerous action if the paint is toxic) and fling it with a snap of the wrist; others flick paint with a brush or shake paint through a sieve. The usual reasons for flinging paint are **1**: to produce random colors and textures and **2**: to express emotion. *See Expressionism; Abstract Expressionism; Automatism.*

fluorescent light

See light, fluorescent.

fluorescent paint

Paint that absorbs light at one wavelength and emits it at another, similar to the action of a fluorescent light tube. The result is color that "glows" strongly. Fluorescent paints, made by combining polymer materials with dyes, are not rated as lightfast and are not suitable for permanent painting.

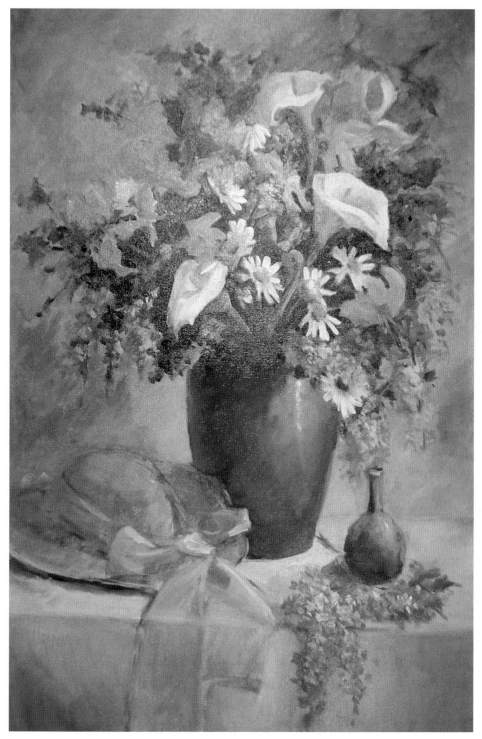

Floral

This painting in traditional watercolor takes its name from a shopping mall called Borgata, where the artist found these irises at a Japanese vendor's stall. She named the painting for the mall and for the Japanese poetry form called haiku.

BORGATA HAIKU | Marty Manning | watercolor on Saunders Waterford paper 200-lb. (425gsm) cold press | 22″ × 30″ (56cm × 76cm)

a
B
C
D
e
F
G
H
I
J
K
L
m
n
o
P
Q
r
s
T
u
V
W
X
Y
Z

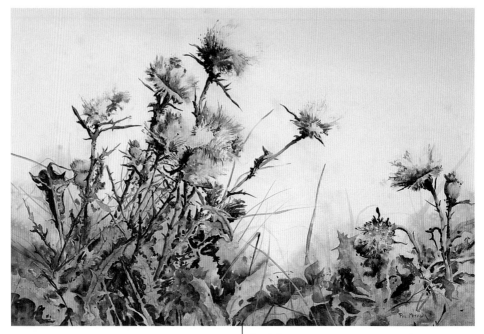

Focal plane
In many pictures, the focal plane is in the middle distance; in this case, the focal plane is very close to the observer, with only a vague suggestion of anything in the distance.

THISTLES | watercolor on illustration board | 22″ × 30″ (56cm × 76cm)

flux

The basic mixture of ingredients in enamel before coloring is added; also called fondant. *See discussion under enamel.*

foamboard or foam board

A stiff, lightweight material consisting of foam sandwiched between two sheets of paper. The foam is a plastic material that entraps countless tiny bubbles of gas. Foamboard for artists' use comes in a number of thicknesses, typically ⅛″ (0.3cm) and ³/₁₆″ (0.5cm). Some are acid free and are the preferred product for most artistic uses. This product is listed under a variety of similar-sounding names, including the brand name Fome-Cor.

focal plane

A plane perpendicular to the line of sight and representing the distance at which the eye (or a camera) is focused. When you observe any scene, your eyes focus on objects either near to you or far from you or somewhere in between—the eye cannot focus on more than one distance at the same time. If you focus on distant objects, things near you will be blurred; if you focus on objects near you, distant objects will be blurred. Painters trying for realistic renditions of scenes usually place their focal plane at a particular distance, such as the middle ground, and slightly blur objects that are not near the focal plane. One of the first artists who paid attention to focal planes was Jan Vermeer. In his 1667 oil, *The Art of Painting*, an artist is pictured sitting at his easel in the middle ground of the painting; very close to the viewer, in the painting's foreground, is some drapery painted in a slightly fuzzy, out-of-focus fashion.

focal point

A center of interest in a picture. *See center of interest.*

foil
1| A thin sheet of any metal, used in packaging and sometimes in art—for example, in assemblages and collages. In art, even thinner sheets than foil are usually preferred—these are called leaf (gold leaf, silver leaf, etc.). *See leaf; composition leaf.* 2| A leaf-shaped design, especially in the windows of Gothic architecture. Basic designs include *trefoil* (three lobed), *quatrefoil* (four-lobed) and *cinquefoil* (five-lobed).

folk art
A wide range of artifacts, including paintings, drawings, carvings, needlework, basketry, etc., made by people who learn their skills by absorbing the knowledge of those around them. Folk art comes usually, but not always, from rural settings rather than as a result of formal academic training. The term is a broad one, taking on new meanings and including new products as societies evolve. In a general way, folk art, primitive art and naïve art are synonymous.

foreground
The part of a drawing or painting that appears closest to the viewer.

foreshortening
Making receding lines shorter than they really are in order to present an illusion of depth. We see a line parallel to the picture plane at its maximum length; if we turn that same line at an angle to the picture plane, it appears shorter. Any line or surface (e.g., an arm, a tree branch or a wall) turned at an angle to the picture plane appears shorter than it actually is.

form
Usually the word *form* connotes the *three-dimensional* characteristics of an object—that is, height, width and depth; the word *shape* is used when objects are described in

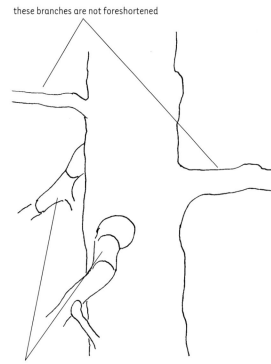

these branches are not foreshortened

these branches are foreshortened

Foreshortening
A branch either advancing or receding is foreshortened; branches extending sideways (parallel to the picture plane) are not foreshortened.

two dimensions, height and width. It's fairly common, however, to use the words *form* and *shape* interchangeably.

formalism
Broadly, an adherence to forms and rules. In art, the representation of objects using geometrical "rules" and standards, as opposed to attempting to show actual natural appearances. Formalism emphasizes rules and structure over content.

found object
An object not intended as a work of art, but deemed suitable for inclusion in a work of art. Found objects may be either natural (such as stones, feathers, or twigs)

Fountain pen

or artifacts (objects made by humans). Found objects are often incorporated by artists into assemblages and collages.

fountain pen

A writing pen with a built-in ink reservoir that delivers ink continuously to the nib, or writing tip. Although there had been other attempts at designing a workable fountain pen, the first practical one was produced in 1884 by an American inventor named L.E. Waterman. Fountain pens are perfectly suitable for artistic work, provided care is taken to fill them with permanent inks.

Fourdrinier machine /for druh *neer*/ [usually capitalized]

A high-speed papermaking machine named for two brothers who directed its development in 1807. Their machine was based on an earlier one patented by Nicholas-Louis Robert in France in 1798. Paper made on this machine is the least expensive of the three types of paper: handmade (made one sheet at a time by hand); mouldmade (made on a cylinder machine that simulates the handmade process); and machine-made (made on a Fourdrinier machine). Machine-made paper is less strong than the others, and its surface texture is more mechanical and generally less appealing to the artist. *See papermaking.*

foxing

A yellowish or brownish stain that appears on papers, caused by molds that grow under damp conditions and also by the rusting of microscopic bits of iron in the paper. Conservators use a variety of treatments to eliminate these stains.

frame, metal

A picture frame made usually of aluminum and given a variety of metallic or painted finishes. *See framing.*

frame spacer

In framing, a strip of material, such as plastic, that separates a picture from the glass. Also called *insert. See illustration under framing.*

frame, wood

A picture frame made primarily of wood, sometimes painted, stained or otherwise decorated and sometimes with a liner, typically of wood covered with linen.

framer's points

Flat, pointed pieces of metal used to secure a picture in a wooden frame. They are driven in mechanically with a tool called a point driver that operates similarly to a staple gun.

framer's tape

Tape with a strong adhesive and a plastic, cloth or paper backing used to attach works on paper to mat boards or backings. While such tapes are reasonably long-lasting, only a few (e.g., Lineco brand archival gummed paper tape) are advertised as archival. Conservators prefer the use of hinges made from acid-free rice papers and pH-neutral wheat paste or other pH-neutral adhesives.

framing

Enclosing a work of art, especially two-dimensional art, to protect it and enhance

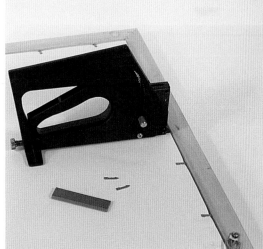

Frame: metal

Here is a typical metal frame with a mat and picture in place. Alongside the assembled frame is the back of another showing the kind of hardware usually used for assembly. All that's needed to put together such a frame is a screwdriver.

Framer's points

Here is a point driver tool in position to "shoot" a point into the wood frame. Lying alongside the driver are individual points and a cartridge of points—the cartridge is loaded into the tool in the same way you load staples into a stapler.

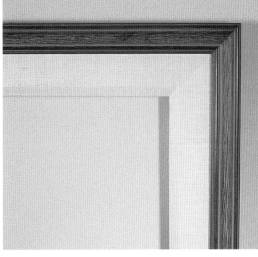

Framer's tape

A typical way of attaching a print, a watercolor or a drawing to the rear of a mat. Another way is to attach the artwork to the backing rather than to the mat. In either case, archival-quality tape should be used.

Frame: wood

A typical stained wood frame with a linen-covered inner liner.

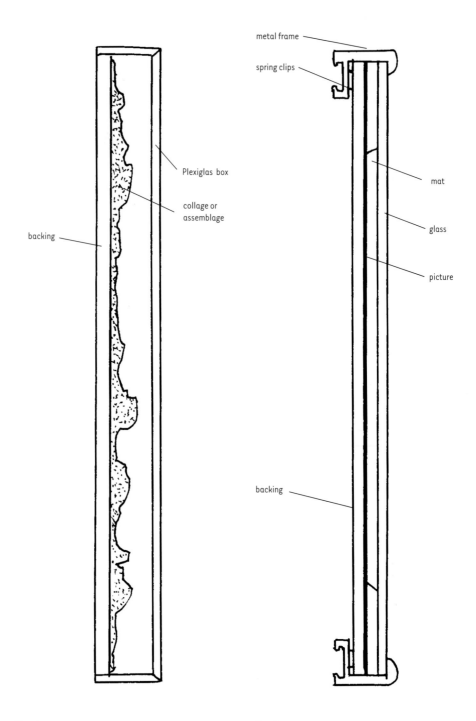

Plexiglas box

collage or
assemblage

backing

metal frame

spring clips

mat

glass

picture

backing

Framing

A collage, assemblage or paper sculpture can be protect-
ed under a plastic box. This arrangement solves the prob-
lem of dusting the art.

Framing

One type of frame for watercolors or other art on paper. A
wood frame may be substituted for the metal one shown
here.

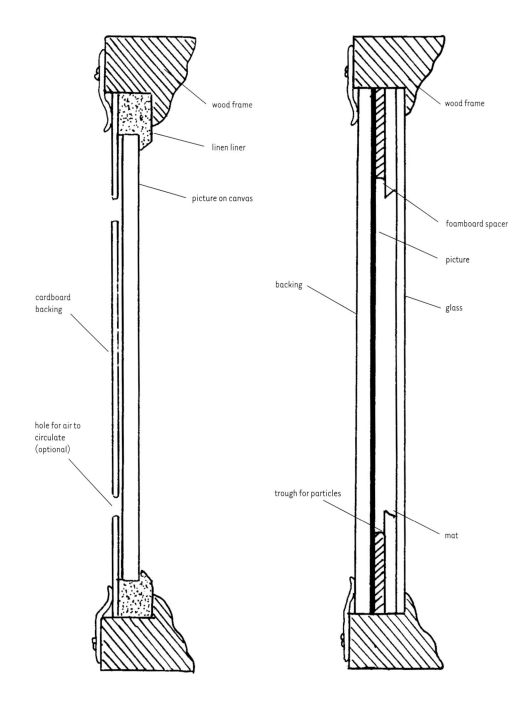

wood frame

linen liner

picture on canvas

cardboard
backing

hole for air to
circulate
(optional)

wood frame

foamboard spacer

picture

backing

glass

trough for particles

mat

Framing

A common method for framing work on canvas.

Framing

One way to frame a pastel or charcoal picture. Loosened
particles of color fall into the trough, out of sight.

Framing a scene

By adjusting a pair of simple right-angle pieces of card-board, you can select the part of a scene you want to concentrate on.

its appearance. Modern frames are made of many materials, including wood, aluminum and plastics. Although the choice of frame is subjective, there are some commonsense considerations. **1**: Space must be left between the edges of the art and the frame to allow for expansion of the art due to heat and humidity. A picture on illustration board, for example, can easily expand enough under humid conditions to force the sides of the frame to separate at the mitered corners. **2**: The part of the frame holding the art (called the rabbet) must be deep enough to accept not only the art but also other materials sandwiched with it, such as glass, mats and backing. **3**: The art should be protected from the destructive effects of acids by using acid-free mat boards and backings. Backings such as ordinary brown corrugated cardboard, which is decidedly acidic, should never be used. **4**: Sometimes a frame can be a transparent box made of glass or Plexiglas so the art may be viewed from the sides (and even the rear) as well as from the front. Some collages and assemblages fall into this category. **5**: When framing art on

stretched canvas, it's good practice to protect the rear of the canvas with some stiff material to prevent puncturing or other damage. **6**: When framing a pastel or charcoal, Plexiglas should not be used because its electrostatic properties tend to attract particles of pastel or charcoal to its inside surface. Also, it's helpful to mat in such a way that there is a hidden trough into which loosened pastel or charcoal particles may fall. *See illustrations on pages 168-169.*

framing a scene

Using any device to help isolate ("frame") a scene for drawing or painting. If you're looking out over a broad piece of countryside trying to decide which part of it to paint, it's helpful to be able to focus on one area at a time and block all the rest from your view. To do this, make a rough rectangle with your fingers and look through this rectangle at the various possibilities. Another method is to use two

fresh plaster (intonaco) ready for painting

drawing on dry plastered wall

L-shaped pieces of cardboard that you hold together to form rectangular holes in differing proportions. A 35mm slide mount also makes a handy viewfinder.

French chalk

A form of talc (magnesium silicate) that may be finely powdered (as in talcum powder) and has a soft feel. It's used by lithographers in preparing stones for printing.

French easel

A box easel that originated in France. *See illustration under box easel.*

fresco

A painting done on moist lime plaster using pigments mixed with water. Frescoes are usually murals, although there is no reason they cannot be painted on separate, movable, prepared plaster slabs of any size. Because of pollution, moisture and temperature extremes outdoors, frescoes are nearly always painted indoors. The following are the basic steps in painting a fresco.

Fresco
Here is a wall prepared for painting a fresco. The drawing has been transferred from the cartoon on paper to the next-to-last layer of plaster. The day's final layer of wet plaster is at the upper left, ready for that part of the drawing to be restored. Then that section is painted while the plaster is still wet.

1: A full-size drawing, or cartoon, is prepared (*see cartoon*). 2: The surface to be painted is coated with several layers of plaster consisting of lime (calcium oxide), sand and water. 3: When the next-to-last layer of plaster is set, the drawing is transferred from the cartoon to the plaster. One method of transfer is to perforate the lines in the cartoon with many small holes (*see pounce wheel*) and then to dust dry pigment through the holes as the cartoon hangs against the plaster surface. Sometimes, instead of perforating, the outline is traced over with a point to make faint grooves in the plaster. 4: A final layer (called intonaco) of lime plaster, white and finely textured, is applied, but only over a section small enough that it can be painted in one work-

peeled-back paper backing tacky film

drafting tape liquid friskets

ing session, before the plaster dries. **5**: A section of the cartoon is used for a second time to reestablish the drawing now covered by the fresh intonaco. The remaining portions of the drawing on the areas not yet given a final plaster coat remain to guide the artist. (An alternative approach is to apply the intonaco in such a thin layer that the drawing on the previous layer shows through.) **6**: The wet section of fresh plaster (fresco means "fresh" in Italian) is painted with pigments mixed in water. The paint penetrates the plaster and becomes strongly bonded with it as the plaster dries. Fresco paint does not lie on the surface in a film as other paints do. Not all pigments are suitable for fresco painting, because some would react chemically with the alkaline lime in the plaster. **7**: The next painting session (probably the next day), a new section, adjacent to sections already completed, is covered with fresh plaster (intonaco) and painted.

This type of fresco is also called *buon fresco* (Italian for "true" fresco) to distinguish it from the form of painting called *secco fresco. See secco.*

Frisket

Two popular liquid friskets, drafting tape and acetate film. The film, used often by airbrush artists, has a paper backing which, when peeled away, exposes the film's tacky surface. Liquid friskets are normally applied using a brush, but the brushes must be immediately cleaned with soap and water to avoid having them ruined by the frisket. Never use a good brush for this purpose—cheap children's brushes will work fine, and you can throw them away when finished. A good alternative is to use, instead of a brush, a silicone-tipped product that cleans easily (*see Colour Shaper*).

frieze

The middle band, often elaborately carved, of the entablature in Classical architecture. *See illustration under Classical architecture.*

frisket

A material used to protect part of a picture temporarily to prevent paint or ink from getting into that area; a mask; a resist. There are two basic kinds of frisket: **1**: a liquid that is "painted" over the area to be protected and **2**: any solid material such as paper, tape or plastic that can be cut to fit the shape of the area to be covered. In all

cases, the frisket must be easily removable without damaging the underlying art. *See masking tape; drafting tape.*

fritch scrubber

A brush with short synthetic filaments used by watercolorists to scrub, or lift, paint from a picture. They are available in several sizes and are an effective lifting tool.

froissage

Crumpled or crushed material, such as tissue, used in a collage.

frottage

An image made by placing a sheet of paper over a textured object (such as a name carved in a gravestone) and rubbing with the flat of a pencil, a color stick or other pigmented tool. A rubbing.

fugitive color

A color that fades relatively quickly, making it unsuitable for permanent painting.

Some fugitive colors are used by illustrators and others who are not concerned with permanence because their objective is short term. *See permanence; labels, paint.*

Futurism

An early twentieth-century art movement that rejected traditional painting and sculpture and attempted instead to emphasize modern developments, especially machines and motion. Many Futurist paintings depicted objects, such as cars or people, in a way similar to multiple camera exposures so that the objects seemed in motion. The term *Futurism* was coined by Italian poet Felippo Tommaso Marinetti. In 1909 he published a manifesto denigrating the "worn and irrelevant" art of the past and extolling the virtues of the new, the modern, the untried. Several painters joined with Marinetti in 1910 to issue Futurist manifestos. Although the movement ended in 1914, it had an impact on Russian Constructivists and on artists Duchamp, Léger, Delauney and others.

gargoyle
1| A carved spout in the form of a human or animal, usually grotesque, attached along the edge of a roof to direct water out and away from the building. Gargoyles were common on Gothic structures in the Middle Ages. 2| A grotesque carved figure.

Gatorboard
A rigid sheet of foam material with paper facing on both sides, used by some artists as a drawing or painting board, as a backing for framing works on paper or as a bulletin board. Gatorboard comes in three colors, white, black and tan and in several thicknesses. It's considerably denser, and therefore heavier, than foamboard and also less susceptible to denting or cracking than foamboard. It is not pH-neutral, so it's unsuitable as a painting support unless coated with gesso or other material.

gel medium
A smooth, thick preparation that may be added to paint to make the paint stiffer and, depending on the type of gel used, possibly increase or decrease the paint's glossiness. Different gel mediums are available for acrylic and oil or alkyd paints. *See acrylic medium.*

gelatin
Protein obtained from animal bones, hides and other tissues. Gelatin is widely used in food and pharmaceutical products and in the manufacture of photographic film. In art, gelatin is used as **1**: an ingredient in some inks; **2**: a size for many watercolor papers; **3**: a size for hardboard panels before coating with true gesso; **4**: a size for canvas; **5**: a photographic stencil in silk-screening; **6**: a photosensitive plate in collotype; and **7**: a binder in children's tempera paints. *See size; silkscreen print; gesso, true; collotype.*

genre
A particular kind of art, music or literary work. In literature, mystery novels are one genre and historical novels are another. In painting, florals, landscapes and wildlife paintings are genres.

genre painting
This is a specific and peculiar usage of the word genre. It means the realistic painting of ordinary people in ordinary life without religious, historical or idealized treatment, usually in fairly intimate settings. The work of such artists as Pieter de Hooch, Jan Vermeer and Jean-Baptiste-Siméon Chardin is considered genre painting. *See genre.*

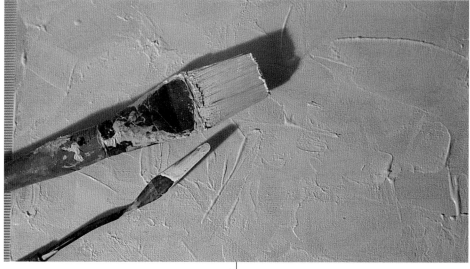

a
B
C
D
e
F
G
H
I
J
K
L
m
n
o
P
Q
r
s
T
u
V
W
X
Y
Z

gesso, acrylic

A product with the same base ingredients as acrylic paint, but that is more textured, more porous and more absorbent than acrylic paint—qualities that make it suitable for its intended use as a ground. It may be used as a ground for nearly all painting mediums, including acrylic, oil, alkyd, gouache, casein and pastel—however, conservators report some failures when using oil or alkyd over acrylic gesso grounds, so an oil or alkyd ground is safer to use with those paints. When used as a ground on raw canvas, acrylic gesso may be applied directly to the canvas—it is not acidic and will not rot the fibers. It may also be applied to hardboard, wood and other supports, provided those surfaces are first cleaned of oils and grease and are sanded to provide tooth; it's also good practice to size hardboard or wood to prevent their colors from staining the gesso (a condition known as support-induced discoloration). Acrylic gesso may be applied in any number of layers until the desired degree of coverage is achieved. It may be sanded smooth or left textured; sanding it smooth will somewhat reduce its paint-holding ability. When dry, acrylic gesso is

Gesso: acrylic
Acrylic gesso may be applied with a knife, brush, spatula or any handy tool. It may be left rough, as here, to provide a textured ground, or it may be put on smoothly and, when dry, further smoothed by sanding. Acrylic gesso may be applied as a ground to any nonoily, nonslick support, including canvas, paper, wood and hardboard.

Gesso: acrylic
Acrylic gesso is available in small jars and cans and in large (gallon) containers. Although usually white, it's available in several colors as well. Since it is not acidic, it may be applied directly to the support (unlike an oil ground, which is acidic and must be separated from most supports).

tough and sanding is not easy, so unless you want a textured ground, it's a good idea to brush on the gesso smoothly in the first place to minimize sanding; many artists use a fine-textured paint roller to apply gesso smoothly. *See ground.*

gesso, true

A mixture of a white pigment (gypsum) and a binder (glue or casein). The word gesso is from the Italian word for gypsum. Gesso (which in this book we call *true gesso* to distinguish it from the now-popular, but altogether different, *acrylic gesso*) has been used for centuries as a ground for many mediums. Similar grounds, using chalk or whiting instead of gypsum, were used in northern European countries such as Germany and The Netherlands. The primary use of gesso during pre-Renaissance and Renaissance times was as a ground for egg tempera painting. It is also suitable for most other mediums, including oil. When sanded to an ivorylike finish, true gesso provides a beautiful, receptive surface. Unlike acrylic gesso, true gesso is brittle, so it's not suitable for use on flexible materials such as canvas or unbacked paper. The

True gesso
To prepare a hardboard support with a true gesso ground:
1: Sand the hardboard to remove oil and grease and to break the hardboard's slick surface. **2:** Clean the sanding dust with a damp cloth or paper towel. **3:** Coat both sides of the panel with size (see sidebar for preparing size). **4:** When dry, coat one side of the hardboard with gesso, using a broad, soft brush; when dry to the touch (a few minutes), coat the other side to equalize stress and prevent warping. Repeat with enough coats (usually three or more) to cover completely. **5:** When thoroughly dry, sand the gesso to the finish you want.

usual supports for true gesso are wood and hardboard.

Many artists prepare true gesso according to favorite recipes, some dating back to the fifteenth-century writings of Cennino Cennini. These days there are excellent prepared mixes, such as Rowney Gesso Powder, Grumbacher Dry Gesso Mixture and Fredrix Gesso Ground Dry Mix. The usual ingredients in such products are finely crushed marble to supply body and tooth, titanium white pigment and animal glue. They should be prepared for use according to label directions, which vary from one brand to another. *See ground; pinholes.*

Sizing

Wood or hardboard panels should be sized before receiving gesso to close pores and prevent too-deep absorption of the gesso into the panel. The usual sizes are rabbitskin glue and gelatin. If using rabbitskin glue, follow the package instructions for its preparation. If using gelatin, there are two choices: **1:** ordinary unflavored cooking gelatin, available in grocery stores, and **2:** commercial leaf, or sheet, gelatin at chemical, laboratory and drug supply warehouses. If using cooking gelatin, dissolve it in water as directed on the package; if using commercial gelatin, dissolve it in water, about one part by volume of gelatin to sixteen parts cold water. In either case, once the gelatin has dissolved and has produced a thickish mass, heat it in the top of a double boiler until it becomes a clear liquid. Stir constantly and don't boil it.

Scrub a thin layer of the warm gelatin or glue onto both sides of the panel with a stiff brush. Don't lay on a thick, visible layer. Let the gelatin or glue dry thoroughly before applying gesso.

gesture drawing
Any drawing technique intended to capture an action, movement or attitude of a person or an animal. Usually such drawing is quick, sketchy and spontaneous.

giclée |zhee *clay*|
A method of reproducing art using an inkjet printer. Giclée reproductions, first produced in the 1990s, are gaining wider acceptance as the materials used (especially the inks) have been improved. To make a giclée reproduction, a picture is first stored in a computer in digital form using either a scanner or a special camera connected to the computer. Using appropriate software, the image may be modified while being viewed on the computer screen; modifications include color adjustments, value adjustments and removal of flaws such as dust specks on the original picture. Once the image is satisfactory to the artist, it's printed using an inkjet printer, which deposits millions of tiny (roughly the size of blood corpuscles) droplets of ink per second on a sheet of paper or canvas fastened to a rapidly rotating drum. The French word *giclée* (to spurt or squirt) was adopted to describe the process. Depending on the size and complexity of the image, each reproduction may take minutes or as much as an hour to print.

Reproductions may be made on fine grades of watercolor paper, printing paper or canvas, thus improving longevity. However, early inks used were not permanent enough to satisfy dealers and buyers interested in permanence, so manufacture and testing of new, more stable inks got under way, and this search is ongoing. An artist interested in having giclée reproductions made must make it his business to understand the materials that will be used by the printing company he chooses.

The giclée process offers another exciting use: Using computer software, an artist may significantly alter the image stored in the computer. Or, to carry this a step further, you may generate an entire image in the computer using software to "paint" on the computer screen. You may generate an image from scratch or put together montages made from pieces of other images stored in the computer.

Early giclée reproductions were called *Iris reproductions* (or Iris prints, a misuse of the word print), named for Iris Graphics, a supplier of inkjet printers. Today the terms giclée and Iris are often used interchangeably, even when equipment other than Iris

brand is used. To be accurate, a reproduction made using Iris equipment should be called an Iris giclée and a giclée reproduction made on ABC equipment should be called an ABC giclée. *See Iris; reproduction.*

glare

1| Excessive shine, due to reflected light, that interferes with viewing an object or artwork. A variety of glasses are available that help eliminate glare. *See glass, framer's.*
2| Excessive glossiness of a paint surface, especially in oils and acrylics. Gloss may be reduced by mixing matte mediums with the paint or by varnishing with matte varnishes.

glass

A hard, usually transparent, material formed by melting and then cooling sand (silicon dioxide) and other ingredients, notably limestone (calcium carbonate) and sodium carbonate. There are hundreds of variations to the glassmaking process, depending on the use to which the glass is to be put. Glasses with high sparkle and brilliance used for fine tableware ("lead crystal") and costume jewelry ("paste") are made by adding lead compounds to the mix. Glass that is colored by the addition of a variety of metallic oxides during the glassmaking process is called stained glass. Such glasses were used in windows of the twelfth and thirteenth centuries, particularly those of the great European cathedrals, and are used today for all manner of articles, including decorative panels, tableware and jewelry. *See glass, framer's; paste.*

glass, framer's

Glass used to protect pictures. The main dangers to pictures of all kinds are **1**: fading, discoloration and embrittling by ultraviolet light; **2**: physical damage; and **3**: environmental damage from dust, pollution and moisture. By framing under glass, many of these threats can be minimized, depending on the type of glass selected. Today there is a good variety of glasses from which to choose for those willing to pay the price. Listed below are the kinds of glass available in roughly ascending order of cost. Keep in mind that these are generic descriptions. When you shop for glass, research and ask questions of your particular supplier to be sure what you're getting—one supplier's "museum glass" might be another's "conservation glass." Prices for the most expensive (and most effective) glasses can range beyond $100 per square foot.

Ordinary window glass—Heavy and often flawed by tiny bubbles, uneven thickness and color distortion. Not suitable for picture framing.

Clear picture glass—The least expensive and most commonly used glass in framing. It's thinner (and therefore lighter weight) than window glass and is reasonably free of blemishes. Slightly distorts some colors.

UV-blocking glass—Filters out as much as 97 percent of ultraviolet light, the source of so much picture damage. Also called conservation glass.

Nonglare glass—Has a matte surface that scatters reflected light to minimize glare. This glass has two problems. First, it alters the appearance of the artwork, slightly dulling it and making it appear out of focus. Second, the farther away from the artwork it is, the greater the dulling effect, so double- or triple-matting is not practical.

Anti-reflective glass—Has a coated surface that reduces glare significantly without the dulling effect of nonglare glass.

Museum glass—Combines the best qualities

of other glasses by being anti-reflective, UV-blocking and reasonably free of color distortion.

glaze

A thin, transparent layer of darker paint laid over a lighter layer. Sometimes the objective of a glaze is to methodically build up color over an underpainting done in shades of gray (*see grisaille*); in other cases a glaze is intended to slightly alter the color already laid down; and in still other instances a glaze of one color is laid over another color so that their combined effect is a third color—for example, a blue glaze over yellow to produce green. In all cases, the effect of a glaze is akin to that of laying a sheet of colored transparent plastic over a surface. Although historically associated with oil painting, the term is now used in acrylic, watercolor and other mediums as well.

glaze medium

Any painting medium used to thin paint sufficiently to use the paint as a glaze. In

Glazing

This is one of many watercolors Holden exhibited in 1999 at the Susan Conway Gallery in Washington, D.C. A glowing review of that show in *The Washington Post* by Ferdinand Protzman said of *Wooded Island* that "the picture's mesmerizing power derives from the lovely gradations of color and light that seem to grow organically from each fiber of the thick watercolor paper." Holden achieves his light effects using many layers of glazes, often alternating a warm glaze with a cool one; here he alternates pinkish glazes with bluish ones.

WOODED ISLAND | Donald Holden | watercolor on Arches 300-lb. (640gsm) rough | 7¹⁄₄″ × 10¹⁄₄″ (18cm × 20cm). Photo courtesy of Susan Conway Gallery, Washington, D.C.

oil and alkyd painting there are many prepared mediums, such as Liquin, Res-n-Gel and Grumbacher Alkyd Painting Medium; in acrylic work, acrylic gloss mediums and gels may be used; in watercolor, water is the medium.

glazing

1 | Painting a thin layer of paint over an existing layer. The usual objective in glazing is to build up subtle color nuance as

Glazing

All of this painting is done transparently. In particular, the water area is a succession of glazes of Phthalocyanine Blue and Green, each layer painted only after the preceding layer was bone dry. When glazing in watercolor, it's necessary to lay down each glaze rapidly to avoid loosening and disturbing the paint underneath.

QUARRY | transparent watercolor on Arches cold-press paper | 22″ × 30″ (56cm × 76cm). Collection of Lee Geismar, Gaithersburg, MD.

each paint layer shows through subsequent layers. Although glazing is most often associated with oil painting, it applies readily to other mediums as well, including acrylic, watercolor and even pastel. In the case of pastel, glazing means lightly stroking one pastel over an existing layer. But for fluid mediums, glazing always means painting a thinned layer of paint over an existing layer that has been allowed to dry. In one type of glazing, colored layers are painted over a monochrome base layer so that a final color effect is gradually built up (*see grisaille*).

2| A layer of transparent material, usually glass or Plexiglas, placed over a picture to protect it from physical damage. Some glazing materials are made to protect also against fading by blocking out ultraviolet light (*see permanence; ultraviolet light; glass, framer's*). *See illustrations on pages 179-182.*

gloss finish
A shiny surface.

glue
In modern usage, any of a large variety of adhesives. In stricter usage, however, glue is an animal protein substance that forms a strong adhesive when combined with water and sometimes other ingredients. Examples of such glues are rabbitskin glue,

1 | A thin coat of acrylic Cadmium Yellow Light lays the foundation.

2 | A glaze of Raw Sienna is next, heavier on the darker side.

3 | Next, a glaze of Phthalocyanine Blue, resulting in a greenish effect.

4 | Finally, a glaze of purple (Alizarin Crimson + Phthalocyanine Blue), along with a few spots of Raw Sienna.

a
B
C
D
e
F
G
H
I
J
K
L
m
n
o
P
Q
r
s
T
u
V
W
X
Y
Z

Glazing

Marah Heidebrecht captured the glow of these lanterns perfectly by using several glazes of transparent watercolor, gradually building toward the color intensity you see here. This painting is based on a photograph by professional photographer Richard W. Brown, Barnet, VT. The painting is reproduced here with Mr. Brown's permission.

GARDEN EVENING | Marah Heidebrecht | watercolor on cold-press watercolor paper | 11″ × 15″ (28cm × 38cm)

calfskin glue, gelatin and casein. *See individual entries.*

glycerin

A clear, thickish liquid in the alcohol family that once was a by-product of soap-making, but is now made synthetically. It's an ingredient in a great many commercial paints and enamels, foods, pharmaceutical and medical supplies, nitroglycerin explosives and so on. In art, glycerin is an ingredient in some watercolor and gouache paints, used as a plasticizer—that is, to improve moistness and brushability and to prevent caking.

glyptic

The art of carving or engraving gems or hard stones.

gm/m² or gsm

Grams per square meter, a way of designating different thicknesses of papers. *See discussion under pound.*

goat hair

Hair used in some inexpensive brushes. *See brush construction.*

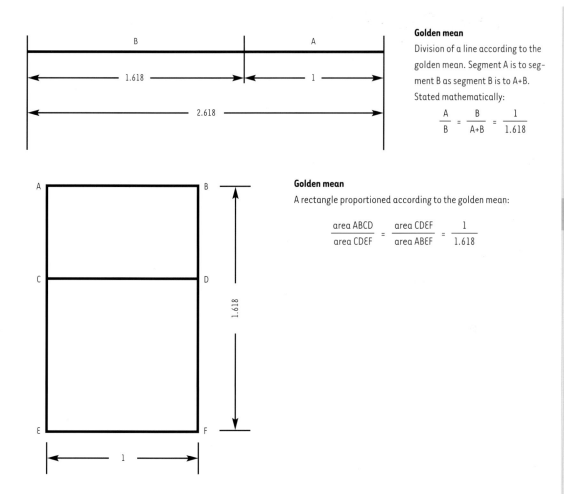

Golden mean

Division of a line according to the golden mean. Segment A is to segment B as segment B is to A+B. Stated mathematically:

$$\frac{A}{B} = \frac{B}{A+B} = \frac{1}{1.618}$$

Golden mean

A rectangle proportioned according to the golden mean:

$$\frac{area\ ABCD}{area\ CDEF} = \frac{area\ CDEF}{area\ ABEF} = \frac{1}{1.618}$$

gold leaf

An extremely thin sheet of gold, used to decorate frames, furniture, illuminated manuscripts and sometimes paintings and collages. *See leaf*

golden mean [often capitalized]

A certain specific division of lines or spaces that theoretically gives an artwork the most pleasing appearance; also called *golden section*. The best division of a line, according to this theory, is such that the ratio of the shorter part to the longer part equals the ratio of the longer part to the whole line. The ratio mathematically is approximately 1:1.618. Historians have pointed to many works of art, from Classical times to the present, in which this ratio has been used, and researchers have conducted visual tests that often conclude that picture divisions based on the golden mean are indeed most satisfactory to most people. The golden mean was known to the ancient Greeks and Egyptians; in 1509 mathematician Lucas Pacioli wrote of it as the "divine proportion." The term *golden mean* seems to have come later. If the theory of the golden mean has validity, it's reasonable to assume that good designers use it quite naturally—not necessarily consciously—because they find golden mean proportions pleasing.

Proportions suggested by the golden mean may appear in the overall design of a picture or piece of architecture and in

Gothic Style
Flying buttresses, Notre Dame Cathedral, Paris.

many subsections of the design as well. A well-known example is *The Golden Altarpiece* in the Basilica of San Marco in Venice, in which the golden mean is repeated several times. For more discussion of the golden mean, *see* Graves, *The Art of Color and Design.*

golden section
See golden mean.

Gothic Style
A style of architecture, sculpture and painting that began in the twelfth century, became predominant in Europe and prevailed until the Renaissance. The name was given by writers during the Renaissance who saw the style as vulgar and attributed it to the Gothic tribes that had destroyed the Roman Empire and its classical values during the fifth century—

one definition of Gothic is "uncouth, barbarous." The Gothic style, most strongly associated with architecture, was introduced in France and is most prominent in the great cathedrals. Romanesque architecture, which preceded Gothic, featured thick, heavy stone walls required to hold up the massive combined weight of walls and ceilings. Gothic architecture introduced a new form of building in which walls and ceilings could be made much thinner because weight was now supported by stone piers (called flying buttresses) leaning against the outer walls at intervals. The walls between buttresses no longer had to be thick and solid; they could be made thinner and could accommodate large windows, which were filled

Gouache

PALM SUNDAY | Ned Mueller | gouache on Crescent cold-press illustration board | 10″ × 13″ (25cm × 33cm)

with stained glass in artful designs. The lighter architecture also allowed for higher, more decorative ceilings. Sculpture during the Gothic period evolved from stiff, formal, unadorned figurative work to increasingly more natural and detailed poses and individualized faces and figures. Much of the sculpture was done in connection with the building of cathedrals, occupying niches both inside and outside the cathedral walls.

In Gothic painting, the human form of classical Greek and Roman times was dominant, but a new, naturalistic treatment of faces and hands, as well as attitudes, or postures, was added. These tendencies were apparent in manuscript illumination, fresco painting and panel painting (paintings executed in egg tempera on wood supports). In fresco and panel paint-ing, Giotto di Bondone, who lived from either 1266 or 1276—the dates are in doubt—until 1337, broke new ground that forever changed painting. He painted figures in more naturalistic settings and gave them more human qualities than previous Church-mandated rules had allowed. People in his paintings suddenly appeared as flesh-and-blood creatures with varied expressions.

gouache /gwash/
Opaque watercolor. Like watercolor, gouache contains a gum binder and ingredients such as sugars and glycerin to improve the paint's handling characteris-

tics. Unlike watercolor, gouache paints contain an added ingredient such as precipitated chalk or blanc fixe to make the paint opaque. *See water-based paints compared; blanc fixe; precipitated chalk. See illustrations on pages 185-186.*

gouache, acrylic
A gouache-like paint that uses an acrylic binder rather than a gum binder. Acrylic gouache dries to a flat finish, similar to regular gouache (and unlike the glossier finish of regular acrylic paint). For a short time—a minute or so—acrylic gouache may be reworked and manipulated the same as regular gouache, but then it dries and becomes almost insoluble. You can paint over acrylic gouache without disturbing earlier layers.

Gouache

In this gouache painting Daniel Tennant used both traditional brushwork and airbrushing. He especially likes the way airbrushed gouache enables him to get just the right feel in such areas as shadows and the shine on smooth objects. In outdoor scenes, airbrushed gouache convincingly portrays such elements as fog and haze. *See airbrush.*

A Rare Find | Daniel K. Tennant | gouache on museum board | 30″ × 40″ (76cm × 102cm). Collection of Moriah Publishing, Inc., Beachwood, Ohio.

graded wash
In watercolor, a fluid application of paint that gradually increases or decreases in strength (color or value or both). Usually a graded wash covers a fairly large area, such as a sky. Using a large brush, strokes of paint are laid down in a slightly overlapping fashion, using less paint or weaker paint for each new stroke, working rapidly so that edges between strokes don't have

Gouache: acrylic

Acrylic gouache lends itself to laying down broad areas of vibrant color.

THE LONG AND WINDING ROAD | Shirley Porter | acrylic gouache on illustration board | 30" × 40" (76cm × 102)

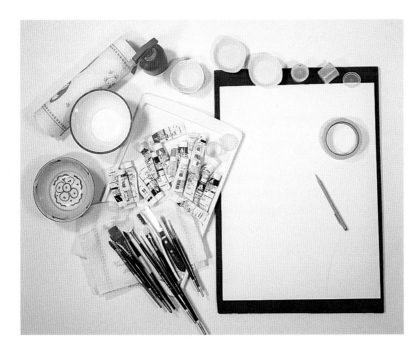

Gouache: acrylic

A typical set of materials for painting in acrylic gouache. Porter prefers small individual dishes and film canisters for her colors, rather than a conventional palette, because acrylic gouache paints spread out on a palette dry fast and become unusable.

Graded wash
To get a smooth transition, I first dampened the paper. I painted the first stroke with a fully loaded brush, the next with slightly diluted paint and so on.

time to dry. It's easier to avoid hard edges if the area to be painted is first dampened with plain water.

graffito
Writing, drawing or scribbling on the faces of buildings, subway cars, trucks and so on. Plural is graffiti. Graffito (from the Italian "to scratch") is not a modern form of expression—such markings have been found on ancient walls in Egypt, Rome and Greece, and have in fact given historians some clues about life in those days.

grain of paper
See paper grain.

granulated wash
A fluid application of paint using pigments such as Ultramarine Blue and the earth colors that tend to settle out in small clusters so that the result is a mottled, textured appearance. *See granulation; flocculation.*

granulation
The tendency of some coarse pigments, such as Raw Umber and other earth colors, to settle into tiny depressions in a support, producing a grainy effect. *See flocculation; granulation medium.*

granulation medium
A colorless fluid that may be added to watercolor paint to cause the paint to dry with a more granular appearance than it would normally have. Colors that ordinarily have no granular appearance at all, such as the Pthalo Blue shown in the example, can be made granular using this medium. It takes a substantial amount of medium to cause any significant granulation—in the sample I used equal volumes of paint and medium. This is one of many mediums available that seem to have limited use.

Granulation medium
Phthalo Blue with and without
Winsor & Newton granulation
medium.

graphic art
Art, including painting, drawing and
printmaking, expressed on flat surfaces.
See arts, the.

graphite
A fine, dense form of carbon used in draw-
ing pencils. Also, because of its slippery
nature, it's used as a lubricant. *See pencil.*

graphite pencil
A drawing pencil having a core of graphite
and clay surrounded by a wood, plastic or
metal sleeve. *See pencil.*

graphite, powdered
Finely granulated graphite used to tone
areas in a drawing, usually by rubbing
with a finger or a stump.

grattage /gra *tazh*/
Scraping the surface of a picture for tex-
tured effects.

grave
To carve out an image by cutting into a
usually flat metal surface with a chisel, as
in engraving.

graver
A cutting or shaving tool, such as an
engraver's burin, used in working metal.
See burin.

grease pencil
A pencil containing pigment and a
greasy binder that adheres well to slick
surfaces such as acetate or china. It's
often helpful to lay a sheet of clear
acetate over a painting or drawing in
progress and test corrections or modifica-
tions using a grease pencil on the
acetate. *See china marker. See illustration on
page 190.*

grid
A series of horizontal and vertical lines
marked off evenly on a photograph or oth-

er picture as an aid to drawing the picture larger (or smaller) on another surface. *See illustration on page 191.*

Grease pencil
A transparent sheet of acetate laid over a drawing or painting allows you to try changes or corrections with a grease pencil without disturbing the picture.

grisaille /gri *zale*/
1| Technique of painting in several shades of a single color, often gray, building up a modeled appearance similar to the look of a relief sculpture. 2| Underpainting in shades of a single color, often gray or umber, to make a detailed monochromatic picture, and then painting colors over the monochrome in many layers of glaze until a full-color effect is achieved. Giotto di Bondone and, later, Andrea Montegna were masters of this type of painting. 3| The name of a gray pigment used in stained glass work. 4| A chiaroscuro enameling technique in which white enamel paste is painted over a dark enamel background; for the lightest areas of the design, thicker, more opaque paste is used, and for areas that are to be shaded, thinner paste is used so that the dark background partly shows through. The effect is an illusion of three-dimensionality. This enameling technique was developed in Limoges, France, during the 1500s.

groin vault
See vault

ground
1| A coating applied over a support before paint is applied. Typically, a ground is white, but there is no reason it cannot be colored in any way the artist chooses. The most common grounds are acrylic gesso,

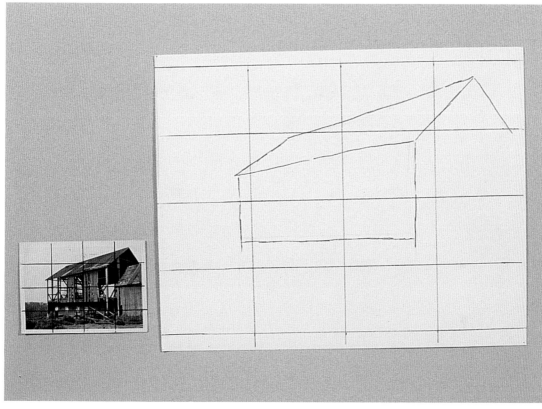

Grid

Divide a sketch or photograph into any convenient number of equal rectangles. Divide a larger paper or canvas into the same number of equal (but larger) rectangles. Use the shapes in the smaller rectangles to help draw similar shapes in corresponding larger rectangles. When enlarging (or reducing) a picture in this manner, be sure the dimensions of the target paper are in proportion to the dimensions of the picture you're working from. For example, if the picture you're working from is 4″ x 5″ (10cm x 13cm), your target picture could be 8″ x 10″ (20cm x 25cm), 40″ x 50″ (102 x 127cm) and so on.

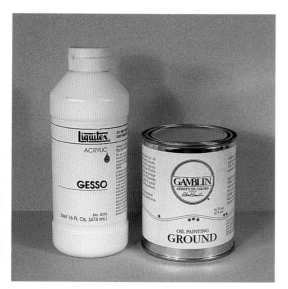

Grounds

Two popular grounds: one for acrylic paintings and the other for oil and alkyd paintings.

a
b
c
d
e
f
G
h
i
j
k
l
m
n
o
p
q
r
s
t
u
v
w
x
y
z

Compatibility

Acrylic gesso is a perfect ground for acrylic paintings and is suitable for pastel, gouache and other mediums as well. Acrylic gesso is also widely used as a ground for oil and alkyd paintings, but conservators have reported incidences of delamination—separation between the oil or alkyd paint and the acrylic ground. Despite its popularity as a ground for oil and alkyd paintings, there is a strong feeling among many conservators and materials manufacturers that "like materials should be on like materials"—that is, oil or alkyd paint on an oil or alkyd ground and acrylic paint on an acrylic gesso ground. There is almost never a problem when that rule is followed. For the artist concerned about the permanence of his or her work, that is sound advice.

If you elect to paint oil or alkyd over an acrylic gesso ground, it's best not to sand the gesso smooth. Oil and alkyd form no chemical bond with the acrylic ground, only a physical bond, and the smoother the gesso, the weaker the physical bond will be.

true gesso and white lead oil paint. *Acrylic gesso* is a suitable ground for many types of painting, including acrylic, pastel and gouache (*see sidebar on page 192*); *true gesso* is a favorite ground among egg tempera painters and oil painters; and *white lead* is a traditional ground for oil and alkyd painting. When white lead (or any oil-based ground) is applied to canvas, the canvas must first be sized to isolate the white lead from the canvas fibers. *See sizing; gesso, acrylic; gesso, true.* 2| An acid-resistant coating on the surface of an etching plate. The artist creates a design on the plate by making marks that penetrate the ground, exposing the plate underneath. Wherever the plate is exposed, the metal is bitten, or etched, when the plate is bathed in acid. The areas of the plate still protected by ground are not affected by the acid. A common ground today is a mixture of beeswax, asphaltum (a tarlike substance) and resin. To coat the plate, the etcher rubs a chunk of ground material over the plate's surface and then spreads it evenly by repeated rolling with a brayer. Other grounds are in liquid form and may be sprayed or brushed onto the plate. The plate is often heated moderately to soften the ground and help spread it evenly. A finished etching ground is typically the thickness of a sheet of writing paper.

gsm
Grams per square meter, a measure of the weight of a paper. Also written g/m^2 and gm/m^2. *See pound for a full explanation.*

gum
A gluey substance exuded by many plants. Gums are soluble in water and are used in adhesives and as binders in paints such as watercolor, gouache and pastel. For example, the binder in watercolor paint is gum arabic; the binder in pastel is gum tragacanth.

gum arabic
A gum obtained from acacia trees, used as a binder in watercolor paints and some inks.

gum tragacanth /tra jeh kanth/
A gum found in certain Asian and European plants, used as a binder in pastels.

gum turpentine

The solvent artists routinely call turpentine or turps, used as a solvent in oil painting. *See turpentine.*

gypsum

A white mineral, calcium sulfate, that is the prime ingredient in true gesso and in many plasters, including wall plaster, plaster board and plaster of paris. One form of gypsum, called alabaster, is fine-grained and is used for carving statues and other ornaments. *See gesso, true.*

hair dryer

An ordinary household electric device for blowing heated air, often used by watercolorists for speeding up the drying of a painting. *See dryer.*

hake /hah kay/

A wide brush with soft hairs, either white or brown, used in oriental painting for applying broad swaths of water or color. *See illustration under brush, painting.*

half-pan watercolor

Watercolor paint sold in small, hard cakes, approximately 0.5″ × 0.6″ × 0.25″ (1cm × 1cm × 0.5cm) and intended for use in boxes or trays with depressions sized to fit the cakes. *See illustration under watercolor paint.*

halftone

1| Loosely, any shade between the darkest and lightest part of an image. 2| An image consisting of dots as a result of photographing an original image through a screen. *See halftone screen; lithograph, offset; chiaroscuro.*

halftone screen

A grid of perpendicular sets of parallel lines through which an image is photographed in the process of offset lithography. The grid breaks the image into fine dots which are then etched onto a printing plate. For full-color reproduction the process is repeated four times to produce four plates, each time photographing with a different light filter. The result is four sets of plates with different sets of dots that will be printed in four different colors: cyan, magenta, yellow and black. *See lithography, offset.*

handmade paper

Paper made one sheet at a time without the use of machinery. *See papermaking.*

hanging rack

An arrangement for hanging wet prints to dry or for storing items such as collage papers. A simple way to set up a rack is to suspend wires or ropes a few inches apart across a space and use clamps or clothespins to hang materials from them. Hanging racks are especially handy for collagists—it may be easier to spot the paper you want on a rack than to rummage through a file drawer to find it. Hanging racks have the added advantage of allowing air circulation among papers to discourage molds and mildew. *See illustration on page 196.*

happy accident

An unplanned effect in painting that produces attractive results. *See accident.*

light

highlight

halftone

shadow

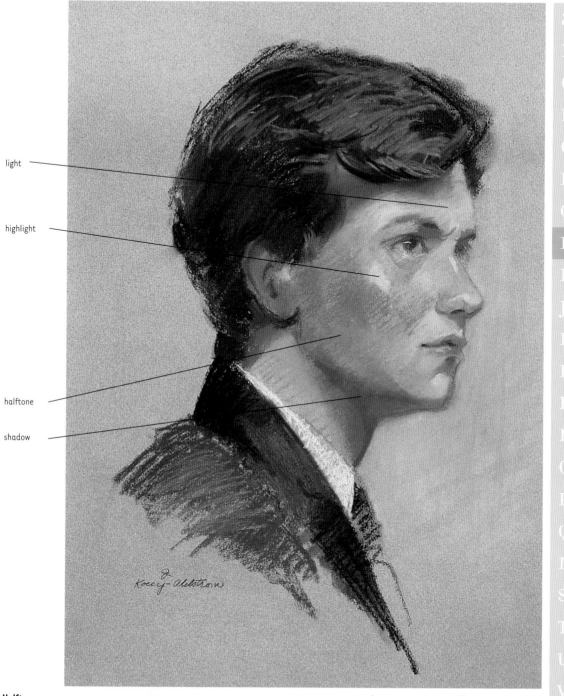

Halftone

HEAD OF A YOUNG MAN | Judith Koesy Ahlstrom | pastel on Canson
Mi-Teintes paper | 16″ × 12″ (41cm × 30cm)

a
b
c
d
e
f
G
H
I
J
K
L
m
n
o
P
Q
r
s
T
U
V
W
X
Y
Z

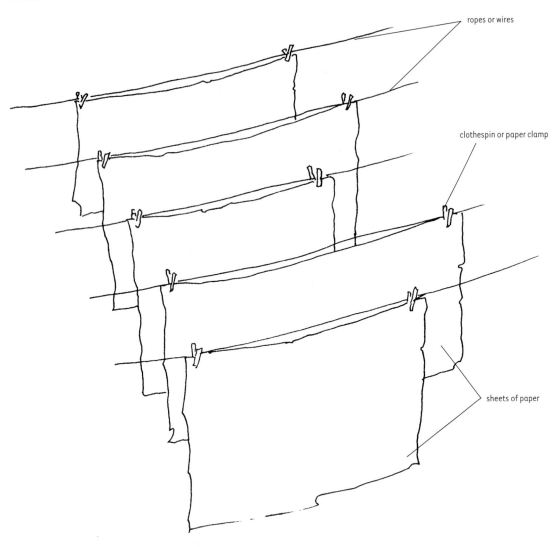

ropes or wires

clothespin or paper clamp

sheets of paper

Hanging rack

hardboard

A stiff building material intended for use in home and furniture construction but also used widely by artists as a painting support and as a drawing board. Hardboard is made by squeezing together shredded wood fibers and other ingredients under intense heat and pressure. The result is a flat surface without grain, very strong and dense. Hardboard has become accepted as an excellent permanent support for paintings provided it's coated (e.g., with acrylic gesso) to isolate its acidic fibers from the painting. It's commonly available in two thicknesses, ¼" (0.6cm) and ⅛" (0.3cm). The hardboard usually used for painting has two smooth surfaces, but another variety has one smooth surface and one textured. While either may be used, many painters prefer the S2S (smooth two sides) type because it tends to warp less. Hardboards are sold in 4' (1.2m) × 8' (24.4m) sheets that may be cut into whatever sizes are required. For smaller paintings, there is no need to reinforce the hardboard, but for

larger ones some bracing may be necessary to prevent warping.

Small amounts of oils are used in the manufacture of modern hardboards, which might cause concern about the adhesion of water-based paints, but the baking process changes the nature of these oils so that the boards are considered safe and reliable for use with all painting mediums. There are two grades of hardboard: untempered (also called Standard) and tempered. Tempered boards are stronger, harder, more compressed and heavier than untempered boards. While both are used as painting supports, untempered is the preferred type because it has a somewhat lower oil content than tempered. Whichever type of hardboard is used, it must be prepared properly before using it as a painting support. The usual preparation involves 1: sanding the surface to provide tooth for the application of gesso (either acrylic gesso or true gesso), 2: sizing with glue or gelatin and 3: coating with several thin layers of gesso, sanding between layers. Apply as many coats as necessary to obtain the whiteness and smoothness you want. Coat the reverse side, also, with one or more layers of gesso to help prevent the hardboard panel from warping.

Masonite

The product called Masonite is one brand of hardboard. It was named for William Mason, who invented it in the 1920s quite by accident. He was pressing a mat of fibers in a steam press that overheated. The resulting heated, compressed mat proved very strong—and Masonite was born!

hard ground

In etching, a ground may be made with varying degrees of hardness. A hard ground is one containing a smaller proportion of waxy or greasy ingredients than would be used in softer grounds. *See etching; soft-ground etching.*

hard pastel

A form of pastel having a higher proportion of binder to pigment than soft pastels. Hard pastels are usually used for sharp details or for initial lay-ins. Pastel pencils are thin rods of hard pastel encased in wood. *See pastel.*

harmony

The close association of either *objects* or *design elements* in a picture. A desk and a chair would be an example of object harmony; similar textures or shapes would be examples of harmony of design elements. A picture containing a square shape, a circle, an ellipse, a rectangle, a triangle and a lozenge would probably lack harmony. *See design.*

hatching

Closely spaced, usually parallel, lines used to suggest texture or shading. Strokes may be fine or broad and the spaces between strokes may be narrow or wide, depending on the effect you want. Hatching can be used in any medium, but it is common in pen-and-ink, pencil and charcoal drawings and in many pastels. Hatching is also often used by egg tempera painters working in the traditional manner, building up a picture from countless tiny strokes. Perhaps more common in egg tempera is the use of *crosshatching*, which consists of strokes at angles to one another. The examples show just a few of the many possible combinations of hatching and crosshatching. There is no reason hatched lines must be straight; they may be curved, zigzagged or

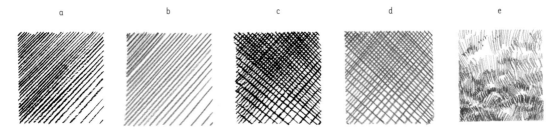

a b c d e

Hatching

(a) Hatching, charcoal pencil

(b) Hatching, colored pencil

(b) Crosshatching, charcoal pencil

(d) Crosshatching, colored pencils

(e) Crosshatching, H, HB and 4B graphite pencils

Hatching

In this drawing I used a variety of pencils ranging from H to 6B and a good deal of hatching and crosshatching to express textures and to suggest shadows. A light lay-in was followed by increasingly stronger, darker strokes.

OLD SPRUCE | pencil on illustration board | 24″ × 30″ (61cm × 76cm)

Health label
Old ACMI seals.

Health label
New ACMI seals.

any shape you wish. Lines may also be laid down in a controlled, regular fashion, as in examples (a) through (d), or in freehand manner, as in (e) and in the accompanying drawing.

health hazards

Many materials used in producing art pose health risks. Materials that give rise to dust, such as pastels, charcoal and sculptors' stones, can coat the linings of lungs and bronchi, causing respiratory problems. Solvents such as turpentine and mineral spirits, if inhaled or ingested or absorbed through the skin, may cause a range of problems including headache, nausea and even death. Similar dangers are posed by acids used by printmakers. Some paints are toxic, including those containing lead (e.g., Flake White, Naples Yellow), cobalt (e.g., Cobalt Blue) and cadmium (e.g., Cadmium Red, Cadmium Orange). To avoid health problems, consider using plastic gloves and a respirator; always work in a well-ventilated space; don't eat or drink while handling art materials; and don't clean your skin with solvents such as turpentine or mineral spirits, which may seep into your pores (use soap and water instead). *See health label; paint rag.*

health label

Many modern materials that pose health risks describe those risks on their labels. A typical turpentine label, for example, states: DANGER! COMBUSTIBLE! HARMFUL OR FATAL IF SWALLOWED. SKIN AND EYE IRRITANT. There are exceptions, of course— a block of marble is not labeled to warn the sculptor about inhaling stone dust— but many risks can be avoided by paying attention to labels.

To bring order to labeling, an organization called the Art & Creative Materials Institute (ACMI) conducts tests and assigns

labels for art and craft materials. Products are currently labeled in three basic ways: AP (Approved Product), CP (Certified Product) and HL (Health Label). There are also several seals that are modifications of these three basic ones. Products with the AP or CP seal are certified to contain no materials in sufficient quantities to be toxic or injurious to humans or to cause acute or chronic health problems. The HL seal is usually used to alert the user to danger, and the danger is spelled out. The HL seal is also sometimes confusingly used along with a statement such as "no health warning required." The reason for that usage is that in some countries the AP and CP seals containing the word "nontoxic" are not allowed, and the HL seal was the only way to get the message across for manufacturers who wanted to sell both in the United States and abroad.

ACMI is now changing its seals, and during a transition period lasting several years you'll find some products with the old seals and some with the new. All the old seals will be replaced by two new ones: AP and CL. The new AP (Approved Product) seal certifies that the product contains no materials in sufficient quantities to be toxic or injurious to humans or to cause acute or chronic health problems. The new CL (Cautionary Labeling) seal certifies that the product has some known health risk and is properly labeled to state that risk and give information on the proper use of the product. *See health hazards.*

Illustrations courtesy of ACMI, 1280 Main Street, PO Box 479, Hanson, MA 02341. Free information is available from ACMI, including a safety booklet, a listing of products ACMI has evaluated and a list of manufacturers and members of ACMI.

Hellenistic period

The period during the fourth to the first centuries BC of Greek cultural dominance following the rule of Alexander the Great. During this time art became less confined and was greatly affected by the influx of ideas from the territories conquered by Alexander, including all the Near East and Egypt. Art, and sculpture in particular, became characterized by realism and a great deal of emotion. Included in the well-known sculpture of this period are the *Laocoön, Old Market Woman, Venus de Milo* and *Nike of Samothrace*—sculptures exhibiting intense emotion and exquisite attention to detail, especially of the human anatomy.

hemp

A plant of the family *Cannabaceae*. Its tough, coarse fibers are used for cord, ropes and burlap, and its leaves and blossoms are used to produce marijuana and hashish. Like the burlap made from jute, hemp burlap is sometimes used by artists as a painting support.

Artist Beware

That's the name of a book by Michael McCann describing the many health risks faced by painters, graphic artists, pastellists, sculptors, printmakers—anyone working in the visual arts. The book is full of details about health risks you may never have considered—just reading the first few pages of *Artist Beware* should be a wake-up call to those of us who handle art materials rather casually. McCann mentions artists like Vincent van Gogh, whose tragic illness may have been directly related to his painting materials, and Goya, who may have had lead poisoning. This is a book worth reading and paying attention to.

hessian

Burlap, a fabric made from jute. Some artists like the rough texture of this material and use it as a painting support, but it's considered a poor choice because it relatively quickly weakens and deteriorates. *See jute.*

hieratic pose /high uh *rat* ik/

A formal and rigid pose, rather than a naturalistic one, in a sculpted work. In such sculpture, especially during the Byzantine era, the subject's individuality became lost as features such as eyes, nose and hair were reduced to set formulas.

hieroglyph /*high* ruh glif/

A character in a system of writing using pictorial symbols, from Greek meaning "sacred carving." Although the term is most often used in describing ancient Egyptian writing, there are other unrelated languages, including those of Mayans and Cretans, that use pictorial symbols. In the case of Egyptian hieroglyphs, their meanings were finally deciphered after discovery of the famous Rosetta stone. Found in 1799 by French troops in an Egyptian town called Rosetta, the stone contained a decree written in three scripts: Greek, hieroglyphic and demotic (a form of Egyptian language used in business and literary circles). By comparing the hieroglyphic and demotic versions to the known Greek script, researchers were able finally to determine the meanings of both the hieroglyphic and demotic symbols. The two men most responsible for the deciphering were French Egyptologist Jean Francois Champollion and English physicist Thomas Young.

high finish

A smooth surface finish on a paper; also called *plate* finish.

high relief

Sculpture in which forms emerge significantly from a surrounding background; compare to bas-relief, in which forms are carved to project only slightly from the background. *See relief.*

high value

Light in tone. On a scale ranging from black through grays to white, white has the highest value and black has the lowest value. *See value.*

highlight

A bright area on an object, usually the highest value on that object.

hog bristle

Hair, typically white and quite stiff, from various types of hogs. Bristles are used in stiff brushes, particularly those intended for oil painting. Bristle brushes are also popular among watercolorists for "scrubbing out" or "lifting" paint. *See brush construction; lifting.*

Homosote

A board made of relatively soft, lightweight material, available at lumber and building-supply yards. It comes in large gray sheets, usually 4′ × 8′ (1.2m × 2.4m) and is suitable for use as a board to which paper may be attached while drawing or painting—for that use it's best to coat the board with acrylic gesso to provide a harder and less absorbent surface. It's a handy material for bulletin boards and as a background surface for photographing artwork because, unlike hardboard, Homosote accepts tacks easily.

horizon

The imaginary line where sky and earth meet. In linear perspective, the horizon is where receding horizontal lines "meet." Synonymous with *eye level*, the level of the

Household brush

eyes when looking straight ahead. *See perspective; linear perspective.*

hot-press paper

Paper with a smooth surface, so named because it usually is pressed between heated rollers during manufacture. *See cold-press paper.*

hot-pressed linseed oil

Linseed oil pressed from flax seeds under great pressure and heat. It's the type of oil most commonly used in manufacturing oil paints. *See also cold-pressed linseed oil.*

household brush

A large flat brush intended for such jobs as painting walls and varnishing furniture. Such brushes are useful to the artist for applying fluid paints, such as watercolors, over broad areas. The most suitable household brushes are usually those that have light, slender handles and brush heads that are not too thick and clumsy; also, the working edge of the brush should not be ragged. Brushes meant for varnishing often satisfy these criteria. *See brush, painting.*

Hudson River School

American painters who worked primarily in New York's Hudson River Valley painting realistic, often large and romantic, landscapes. Early members of this group were Thomas Doughty, Asher Durand and Thomas Cole, all of whom were plein air painters. Others generally associated with this school were Samuel F.B. Morse, John Kensett, George Inness and Frederic Church—some of their work was not literally done in the Hudson Valley, but they all followed the theme of the romantic American countryside.

hue

1| The name of a particular color. Red, orange, yellow, blue, green and gray, for example, are all hues. In casual speech and writing, the words color and hue are used synonymously. 2| The word hue may be added to the name of a paint if the paint is made as a substitute for another paint. For example, one manufacturer sells Gamboge Hue as a lightfast substitute for its nonlightfast Gamboge; Naples Yellow Hue is a nontoxic substitute for toxic Naples Yellow. In each case, the substitute paint closely resembles the paint for which it's a substitute.

hygroscopic

Tending to absorb moisture easily. Many art materials, including papers, canvas, gelatin and dry pigments, are hygroscopic and usually should be shielded from excessive moisture.

icon

A representation in a painting, a mural or a wooden carving of religious figures and themes. During the Middle Ages the making of icons was hotly debated among Christians. Up until the Renaissance, nearly all painting in the West had a religious theme.

illumination

The art of decorating scrolls and manuscripts in ancient times and down through the Middle Ages in places as separate as Greece, Rome, China, Egypt and Central America. Illumination took many forms, but until some modeling was introduced in the fifteenth century, most figures and scenes were represented in a flat style. Much illumination was ornate and brilliantly colored, often including gold backgrounds or lettering.

illusionism

Painting intended to depict a scene with utmost realism; photorealism; trompe l'oeil.

illustration

A picture meant to support or enhance a story. Illustration may be realistic or abstract and may be executed in any style, as long as it helps to illuminate the story. In the eighteenth and early nineteenth centuries, fine illustrators were in great demand. Their work filled newspapers, magazines and books, but as photography grew in importance, the demand for drawings and prints by illustrators declined sharply. Today, one of the more lively fields for illustrators is that of children's books.

illustration board

Drawing paper mounted on stiff cardboard, sometimes on both sides of the cardboard. The permanence of illustration board depends on **1**: the quality of the paper facing and **2**: the quality of the cardboard core. A board that is 100% rag throughout and acid free is best, but these are rare. Many boards have 100% rag, acid-free surfaces with varying qualities of cardboard cores.

impasto

1| A painting technique in which paint is applied thickly. Usually the brush or knife strokes are readily apparent, and often their visibility is a deliberate part of the painting, lending the excitement of bold texture. Impasto techniques are most often seen in oil and acrylic paintings.
2| Decoration in low relief on the surface of a ceramic object, usually made using enamel or slip, a mixture of fine clay and water.

As soon as Sir and James were gone, the woods animals gathered near the wide spot in the stream where the men had been working. They all began chattering and squawking at once.

"Caw! Quiet everybody!" croaked Mister Crow. The animals stopped talking and looked toward Crow, who had hopped up onto a stump.

"That's better!" said Crow. "Now let's speak up one at a time!"

Immediately every animal started yelling again for attention.

The racket made Crow cover his ears and shut his eyes. He took a deep breath and scrawked again as loud as he could: "Caaaawww! Quiet!"

Again they fell silent.

"Now, when I call on you, say your piece," commanded the exasperated Crow. "Fox, what do you think?"

"I heard them say they need water up at the farm . . ." began Fox.

"Yes," squeaked Mister Squirrel, " Sammy the farm dog told me all the farm animals are worried because Sir and James can't give them much water and . . ."

They chattered on excitedly until Mister Crow finally cleared his throat, stood tall on the stump, and said in his most important-sounding voice: "Clearly, the humans have a problem. They don't have all the water they need and they must take some water from our stream and use it at the big barn."

Mister Raccoon snarled: "But why should we give up our water? Why don't they find their own?"

The animals looked sternly at Mister Raccoon. Finally, Crow explained:

"You're new to our woods, Mister Raccoon, so maybe you don't know how lucky you are to live here. The humans take care of all of us. When one of us is hurt or hungry they give us medicine or food. Up at the big barn they take care of farm animals nobody wants."

"Ohhhhh!" said Raccoon softly, "I didn't know."

"Yes," said Crow, "So we should help if we can . . .but how?"

Illustration

Page from a children's book by Phil Metzger called *Friendship Farm*.

impressing

Making shallow grooves (impressions) in a drawing surface so that when any flat drawing tool, such as the side of a graphite or colored pencil or a stick of pastel, is stroked across the area, pigment will not get down into the grooves and the grooves will show up as lighter lines within a darker area. Impressing can also be done using paints such as watercolor provided the paint is not too fluid and is whisked rather quickly across the grooved surface.

Impressionism

A painting style in which artists attempted to capture the effects of light using freer brushstrokes and high-key palettes. Instead of rule-bound, academic painting indoors, these artists painted outdoors for the most part, and attempted to capture light effects at a particular place and during a particular time of day. Most Impressionists used broken strokes of color, often dabs of pure color side by side, so that from a little distance the broken colors merged visually to give an impression of the scene. The time frame for Impressionism is from about the mid-1860s to the mid-1880s in France. The movement was inspired by the work of Édouard Manet; some of its principal members were Claude Monet, Pierre Renoir, Camille Pissarro, Berthe Morisot and Alfred Sisley, later joined for a time by Edgar

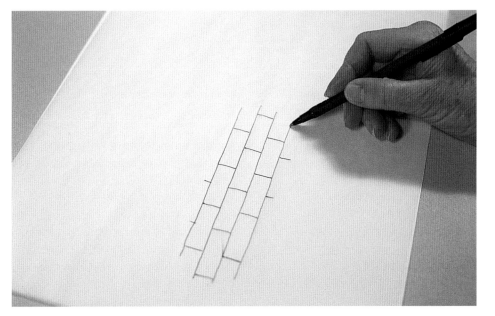

Impressing
A piece of tracing paper is laid over the drawing surface
and a nonsharp instrument, such as this ballpoint pen, is
used to draw a design using firm pressure.

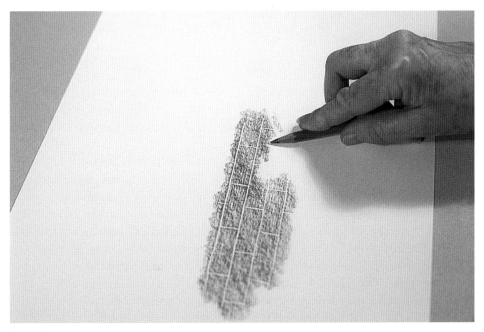

Impressing
The tracing paper is removed and a colored pencil, laid
flat against the drawing surface, deposits color every-
where except in the grooves made by the ballpoint pen.

a
B
C
D
e
F
G
H
I
J
K
L
m
n
o
P
Q
r
s
T
u
V
W
X
Y
Z

Degas and Paul Cézanne. At a Paris show in 1874 a critic derisively called the group "Impressionists," taking his lead from Monet's painting *Impression: Sunrise*. The artists, whose intention was to paint visual impressions, happily adopted the name.

imprimatura /im pree mah *tyour* ah/
A thin preliminary glaze used as an underpainting.

incandescent light
See light, incandescent.

incidence, angle of
The angle at which light strikes a reflecting surface. *See reflection.*

incise
To cut into a surface, as in intaglio printing processes and in intaglio relief sculpture.

India ink
A drawing ink made from carbon black suspended in water, used in China and Egypt more than two thousand years ago and still one of the most reliable of inks. Other substances (for example, soap, glue, gelatin and sugar) are added to help prevent the carbon particles from settling out and to improve the ink in various other ways. *See carbon black.*

India paper
1| A thin, tough, opaque paper used in books such as dictionaries, encyclopedias and Bibles, where toughness is needed to combat wear and tear and where thinness is necessary because of the large number of pages such books require. Also called Bible paper. 2| A thin, tough, absorbent paper used in "proving" inked printing plates—that is, the paper is so thin and sensitive that it will show evidence of even the finest marks on a plate. 3| A type of wallpaper (in this case, called India papers) popular in the late 1600s and early 1700s; this wallpaper was handpainted and of often intricate, nonrepeating design. Also called Chinese papers.

ink
Any of a variety of fluid or semifluid colored materials used in writing, drawing and printing. The earliest inks, going back thousands of years, were chiefly black inks containing lampblack, a finely divided form of carbon derived from the burning of organic materials. Modern inks are made using a great many coloring materials, including carbon, extracts or juices from plants and animals, and specially formulated chemicals. Over time, many different vehicles—the fluids in which colored materials are dispersed—have been used. Depending on the intended use, an ink may contain water, gum, glue, oil and other specialized ingredients. Some inks, such as those used in writing instruments, are very fluid; others, such as those used in woodcut or linoleum cut printing, are relatively thick and pasty. Still others, such as inks used in lithography, are made to be greasy so that they will adhere only to other greasy surfaces and not to watery surfaces. For commercial use, such as printing labels, books and newspapers, there is a wide variety of specialized ink formulas. Almost all inks used by artists contain pigments that are very finely ground. *See sumi-e.*

ink, permanence of
Inks that are carbon-based, such as India inks, are permanent. Most acrylic inks are rated as permanent. Dye-based inks are generally not permanent. Look for permanence ratings on ink containers or in the accompanying literature.

ink, technical pen

There are three types of inks used in technical pens. **1:** Black ink, pigmented by fine carbon particles; it's permanent and works beautifully in any kind of pen. An example of a popular black ink is Koh-I-Noor's 3080-F Universal Drawing Ink. Look for a manufacturer's date on the container—the last four numbers on the container's date stamp tell when it was manufactured. Inks that sit on the shelf for more than two years may settle out and no longer be usable in a technical pen. **2:** Colored dye-based inks; these colors are fugitive and therefore not suitable for permanent artwork. **3:** Colored pigmented inks, relatively recent products that work well in technical pens provided you choose the colors labeled as transparent (there are also opaque versions). Some of these inks are acrylic. Artist Gary Simmons, whose work appears under *technical pen*, points out that crosshatching with colored inks is different from crosshatching with black inks: Where black lines cross, the intersection is still black, but where colored lines cross, the color at the intersection is deeper than the rest of the line.

When you choose an ink for the technical pen, select only transparent permanent inks, as mentioned. In addition, consider the type of surface you're drawing on and choose inks accordingly. Some inks are specifically made for use on paper, some on film and so on. Also, decide whether you need a waterproof ink: If you plan to use washes, you may need nonwaterproof ink. For much more about technical pens and inks, see Gary Simmons' book *The Technical Pen*.

ink, waterproof

Ink that, once dried, is not easily loosened by water. In choosing an ink, this is often an important consideration. If you plan a picture using both linework and ink washes, for example, you may choose nonwaterproof ink to facilitate the washes. But if nonwaterproof ink is used for lines and the lines are laid down before the washes, the lines will be disturbed by the washes. Therefore, some planning is in order. One route is to do the linework after the washes are dry; another is to use waterproof ink for the lines and nonwaterproof ink for the washes.

inlay

An insertion of one material into a shallow opening or depression in another material. In the decorative arts, inlays are common in wood, metal and enamel objects.

inpainting

Replacing missing paint during restoration by matching as closely as possible the surrounding paint but not painting over any existing paint. *See conservation; lining; marouflage; transfer.*

intaglio /in *tahl* yo; in *tah* glee oh/

1| A printing process in which the image is cut into the surface of a metal plate or other hard surface using either sharp cutting tools or corrosive acids or alkalis. The depressions in the plate are filled with ink, and dampened paper is pressed against the plate under pressure so that the paper dips into each depression and picks up ink. 2| A carving in which the subject is sunk below the surface of the stone or other material; concave relief.

interference paint

A type of paint that appears as one dominant color at some viewing angles but as a different color at other angles. *See acrylic paint.*

Intimism

A minor art movement (mostly involving Pierre Bonnard and Édouard Vuillard) in the late nineteenth and early twentieth centuries concentrating on the warmth and intimacy of domestic interior scenes. In a break from Impressionist technique, Intimist painters used exaggerated colors and values to express mood. *See Nabis.*

intonaco /in *tahn* uh koh/

The final layer of fresh lime plaster on which a fresco painting is done.

Ionic order

One of three dominant styles (orders) of Greek architecture. *See illustration under Classical architecture.*

iridescent paint

Paint that imitates the color of a metal, such as gold or silver. *See acrylic paint.*

Iris

Trade name for the inkjet printers first used to produce giclée reproductions at Iris Graphics in Bedford, Massachusetts. *See giclée.*

J

japan color

A form of commercial paint used primarily for signs and decorative work. The name derives from lacquer colors once used in Japan for decorating metal, wood, papier-mâché and other articles. *See lacquer.*

Japanese paper

Any of a wide variety of art papers made in Japan, and sometimes copied elsewhere, made of a number of different types of fibers, but mostly the inner bark of the paper mulberry tree, also called *kozo*. These papers, many of them handmade, are available in numerous textures, thicknesses and colors. Some have visible fibers running through them, and some contain flecks of material, such as dark pieces of bark. Many of these papers are acid free.

japanning

1| In the 1700s, the European art of decorating objects in a manner imitating the fine lacquerwork of Japan. *See lacquer.*
2| In modern use, the coating of metal with baked-on finishes.

judge, art

A person responsible for awarding prizes and honors at an art exhibition. Commonly, a *jury* selects all the work to be included in an exhibition and a *judge* selects from among the juried works those that are to receive an award. Usually there is a single judge, but sometimes two or more. Sometimes the same people serve as both jury and judge.

jury, art

Two or more people responsible for selecting works of art for inclusion in an exhibition. Often a jury makes its selections based on slides or photographs submitted by competing artists, but sometimes the selection is made by reviewing the actual art. Occasionally, a two-step process is used: A first cut is made by viewing slides or photographs of all art submitted and final selection is made by seeing the actual art selected in the first step. Juries are usually made up of artists whose combined backgrounds cover all the types of art submitted for consideration.

jute

Either of two varieties of plants grown primarily in India, Pakistan, China and Brazil. Fiber from the plant is tough and relatively inexpensive. It's used for various kinds of sacks, wrappings, twines, mats, carpet backings and burlap cloth. Burlap (also called hessian) is sometimes used as artists' canvas—however, canvas made from jute is considered decidedly inferior to linen and cotton because jute fibers become brittle and weak in a relatively short time. *See canvas; hessian; hemp.*

kerosene

A petroleum derivative used mainly as a heating fuel and as a cheap solvent for oil paints. It is not recommended for use by artists because of its objectionable odor and its oily residue.

key

1| The dominant tone or value of a picture. High key means light; low key means dark. 2| A wedge-shaped wood or plastic peg used in the slots of stretcher bars to tighten a stretched canvas. *See stretcher bar.*

kinetic art

Art, especially sculpture, that involves actual motion. Sometimes the motion is caused by motors or flowing water, and sometimes it is caused by moving air currents. Some of the earliest kinetic art was made in the early 1900s by Constructivists who built sculptures out of industrial materials. In the 1920s French artist Marcel Duchamp created a number of moving sculptures involving spinning rings and disks; in the 1930s Alexander Calder built the first of a series of sculptures Duchamp called *mobiles*, a name that has stuck. Kinetic art surged again in the 1950s and early 1960s; some artists, notably Jean Tinguely, built sculptures that were intended to destroy themselves. The first of these was Tinguely's *Homage to New York*, which did destroy itself and managed to cause a fire. *See illustration on page 212.*

Key
Keys are made in different sizes for both regular and heavy-duty stretcher bars.

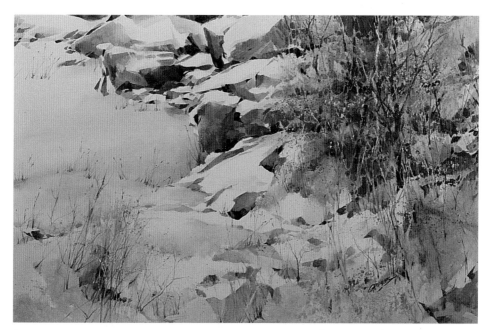

Key
A high-key painting. The overall high key in this painting is punctuated by rich, well-placed darks.

AT McCONNELL'S | Donald Graeb | watercolor on 100% rag Strathmore paper | 21″ × 30″ (53cm × 76cm). Collection of Michael Graeb.

Key
A low-key painting.

WOODS POOL | watercolor and acrylic on illustration board | 30″ × 40″ (76cm × 102cm). Collection of Jeff and Nancy Metzger, Newtown, CT.

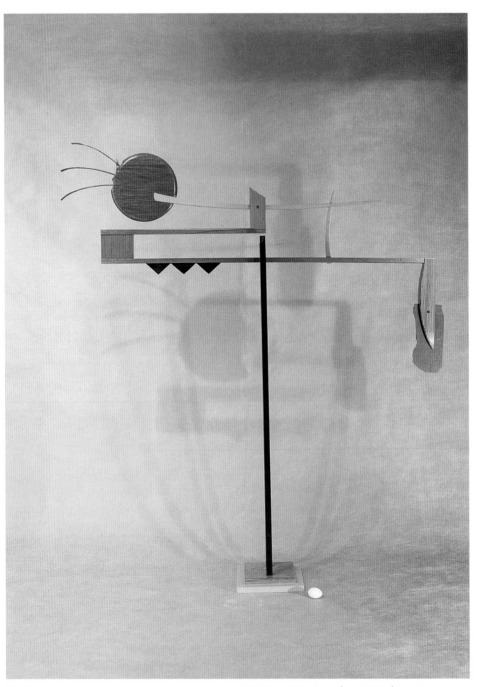

Kinetic art

These delicately balanced pieces are free to swing about the central support.

SHE SWINGS BOTH WAYS | Mark Wallis | mixed woods, painted and natural | 58" (147cm) wide × 60" (152cm) high.

kitsch
Lowbrow, tasteless art; art that is cheap and sentimental; cheap reproductions of existing art, such as poorly made plaster statues.

kneaded eraser
A soft, rubbery material used to erase pencil, charcoal, pastel, etc. It may be squeezed into any shape. A flattened shape will erase broad areas; a sharp-edged shape will erase thin lines. As the eraser becomes clogged with graphite, charcoal, etc., it may be kneaded like taffy to expose a fresh, clean surface. These erasers are usually used with a dabbing, not scrubbing, motion. They are especially useful for erasing from delicate surfaces such as watercolor papers, which might be damaged by other erasers.

Kneaded eraser
Kneaded erasers, new and used.

knife, craft
Any of a variety of knives with blades of differing sizes and shapes, used for fine, detailed work, as in building models or cutting masks. A popular brand is X-Acto.

Craft knife

knife, mat
A knife with an adjustable guide that allows control over the depth of the cut. The blade shown may be adjusted in three ways: **1**: fully retracted for safety when not in use; **2**: extended far enough to cut through a single sheet of standard mat board; or **3**: extended farther to cut through a sheet of double-thick mat board. *See illustrations on page 214.*

knife, painting
A tool, usually steel, with no sharp edge, used for mixing paint and for applying paint to a picture surface. Most painting knives have an offset between the handle and the blade to keep your knuckles clear of the painting surface. The blades come in a number of shapes—including diamond, rectangular and rounded—and in many widths and lengths. *See illustrations on page 215.*

knife, palette
A tool similar to a painting knife but usually longer, used for scraping paint from a palette or other surface. Most palette knives are straight, without the crook or offset found in painting knives. Palette knives are often used as painting knives—whatever tool works, works! *See illustrations on page 216.*

knife, utility
Any of a variety of sharp knives used for cutting paper, mat board, etc. *See illustrations on page 216.*

kolinsky
Any of several Asian minks whose fur is used to make the best quality artists' paint brushes. *See brushmaking.*

Mat knife

A typical mat knife.

Mat knife

The parts of a mat knife.

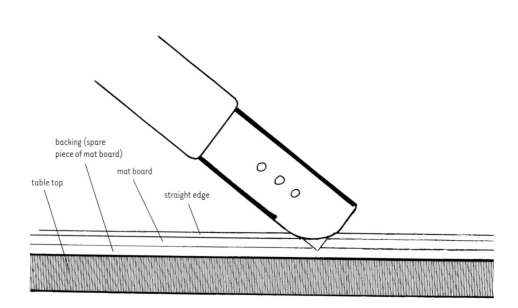

backing (spare
piece of mat board)

mat board

table top

straight edge

Mat knife

The depth of cut is adjusted by lining up the hole in the
blade with one of the holes in the blade holder and then
securing the blade by inserting and tightening the fas-
tening knob. The rounded section of the blade holder
rests on the mat board and allows the blade to cut
through the mat board and penetrate only a short dis-
tance into the backing sheet underneath. To use this type
of knife, draw the lines you want to cut on the back sur-
face of the mat. Place a straightedge along the line to be
cut and insert the knife blade into the mat board with the
side of the blade resting against the straightedge. Draw
the blade toward you while firmly holding the straight-
edge in place.

Painting knife

A painting knife picture in progress. Your needs as a painting-knife artist are few: a support, paints, a couple of knives, a palette and paper towels for wiping blades clean. No solvents or painting mediums are necessary.

Painting knife

Palette knife

Utility knife
Typical utility knives.

L

labels, paint

Hardly anything is more important to the painter than the paints he or she uses. It's not enough to know a tube of paint is "green" or "red"—it's necessary to know which green or red. In addition to hue, such attributes as permanency and toxicity are of great importance. There has always been a lot of confusion in paint labeling for a variety of reasons, many of them having to do with sales competition among manufacturers. There is always the temptation to name a paint something such as "Exotic Green" that sounds sexy but tells you nothing. And there have been many paints given names so similar to old standards that the casual buyer thinks he or she is getting the old standard.

In 1977 the American Society for Testing and Materials began working on new standards for testing and labeling artists' paints. Some paint manufacturers have adopted ASTM's standards; some still have not. There are items you'll find on paint labels that conform to ASTM standards. *See chart on page 218.*

lacquer

A varnish made from the sap of certain trees in China and Japan, usually with color added, that is used as a coating for fine furnishings, jewelry and decorative objects. Lacquer dries extremely hard and can be polished to a high shine. Lacquerwork from China goes back thousands of years; later, the trees that produce the necessary sap were introduced to Japan, and fine work from both countries became prized in Europe. Fine lacquerwork involved many carefully applied layers and often included inlays of gold, silver, jade, porcelain, ivory and other materials.

laid paper

Paper that has a definite texture consisting of vertical lines, or ribs, and less prominent horizontal ribs. The ribs are the result of papermaking molds or machines in which pulp is spread over a screen consisting of prominent vertical wires and finer horizontal wires. When a piece of laid paper is held up to the light, the ribs, especially the vertical ones, should be easy to see. Compare this type of paper to *wove* paper, which is smooth, with no dominant lines, or ribs. *See wove; papermaking.*

lake

A pigment made by dyeing an inert material. There are two broad types of colorants used to make paints—pigments and dyes. Pigments are finely ground materials that are mixed directly with a binder to make paint. Dyes, however, are unsuitable for direct mixing with a binder, so they are

Paint Labels

Item On Label	Examples	Explanation
Common Name	Raw Sienna Cadmium Red Burnt Sienna	The established, accepted name for this paint; often gives a clue to the main pigment ingredient—for example, cadmium in Cadmium Red.
Hue Name	Gamboge Hue	The word "hue" added to the common name tells you this is not genuine Gamboge, but a substitute whose hue approaches that of Gamboge.
Trade Name	Winsor Blue	Winsor & Newton's name for Phthalocyanine Blue. "Phthalocyanine Blue" must appear clearly directly beneath the trade name.
Mixed Pigments	Payne's Gray Phthalocyanine Blue Carbon Black Quinacridone Red	Payne's Gray is a combination of two or more pigments. In this example, the manufacturer has combined three pigments to make its version of Payne's Gray.
Color Index Name	PBr 7	A precise way of defining the colorant used in the paint. The colorant here is a pigment (P) whose hue is brown (Br) and whose assigned number in an internationally accepted list is 7.
	PY97	(P)igment (Y)ellow number 97.
Color Index Number	74160	A five-digit number, not mandatory, that defines precisely the chemical composition of the colorant. The color index number for Phthalocyanine Blue is 74160.
Lightfastness	Lightfastness I Lightfastness II	Category I means excellent lightfastness. Category II means very good lightfastness. Paints conforming to ASTM standards must have lightfastness of either I or II. In the case of a paint made of mixed pigments, the lightfastness stated for the mixture must be that of the ingredient having the *poorest* lightfastness.
ASTM Quality Standard Identifier	D-5067 D-5724 D-4302 D-5098	D-5067 is the standard for labeling watercolors. D-5724 is the standard for labeling gouache. D-4302 is the standard for labeling oils. D-5098 is the standard for labeling acrylics.
ASTM Health Standard Identifier	D-4236	Indicates the paint is nontoxic. If the paint is toxic, there will be a health warning describing any danger. See health label.

Landscape

A traditional landscape that makes excellent use of many perspective techniques to create an illusion of realism and distance. This picture leaves no doubt about what you're seeing, while the accompanying Porter landscape only suggests—and you are left to decide what's going on.

SPRING FIELDS | Ross Merrill | oil on canvas mounted on hardboard | 24″ × 36″ (61cm × 91cm)

first made into pigments by combining them with an inert material such as blanc fixe or alumina hydrate. The resulting pigment (a mass of dyed particles) is called a lake, and it may be combined with a binder to make paint. Not all dyes are sufficiently lightfast to be used to make lakes.

laminating film
Dry-mounting adhesive. *See dry mounting.*

lampblack
A form of carbon black (pure or nearly pure, finely powdered carbon) obtained by burning organic substances, particularly oils. Lampblack is the oldest known black pigment and is used in a variety of drawing and painting materials, especially inks. *See carbon black.*

land art
See sculpture, earth.

landscape
Any drawing, painting or print depicting an outdoor scene. Although usually more-or-less representational, a landscape may also be abstract. A landscape may include a variety of elements, such as sky, water, buildings, roads, fields, hills, trees and mountains. A landscape whose main element is an ocean is usually called a *seascape. See illustrations on pages 219-221.*

latex
1| A milky emulsion found in many varieties of plants, including the rubber tree,

Landscape

This abstract landscape might suggest to some a rocky vista; to others it might suggest a water scene. To the artist who painted it, it's an interesting pattern of interlocking shapes, colors and values.

PATTERNS | Shirley Porter | acrylic gouache on illustration board | 22″ × 30″ (56cm × 76cm)

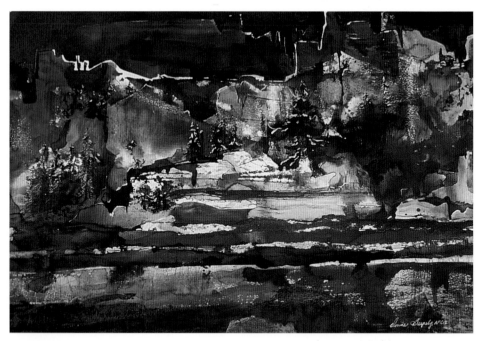

Landscape

Artist Donna Baspaly says of this picture, which is one of a series: "There were some overwhelming walls in my life at the time and I believe the series came as a result." *See more of her work under mixed media.*

MOONLIT CANYON | Donna Baspaly | mixed media on 200-lb. (425gsm) watercolor paper | 22″ × 30″ (56cm × 76cm)

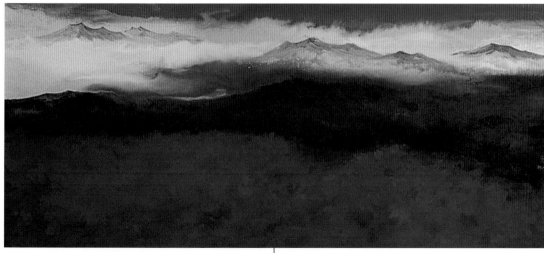

Landscape
A landscape in an oriental style by Diana Kan, whose work has elements of both her worlds, East and West.

Dare to Dream | Diana Kan | watercolor and mineral color on gold leaf | 28″ × 48″ (71cm × 122cm). Collection of the artist.

and used to make such products as rubber and chicle (the base ingredient in chewing gum). Latex from the opium poppy is the source of opium and morphine. 2| A synthetic product that mimics the properties of natural latex and is used in various paints and coatings. *See emulsion.*

layering
Painting one coat of paint over another; if the coat is transparent, it's called a *glaze.*

lay figure
A jointed model of the human body used by artists and dressmakers to study the way clothing and drapery would fall over a human form. Miniature versions, usually called *manikins* or *mannequins*, are used not so much for draping but for envisioning the positioning of the parts of the human figure. *See manikin.*

lay-in
A beginning stage of a painting or drawing in which base colors or values are established as a foundation for the finished work. Sometimes a lay-in consists of only shades of gray (*see grisaille*); more often, color is introduced. The colors may be approximations of the colors in the final picture or colors complementary to the final colors (*see complementary color*). A lay-in may also be a simple thin layer of a single color (*see wash*). In fact any color or colors that help you reach a particular result may be used as a lay-in. *See illustrations on page 222.*

lead
A chemical element that is an ingredient of some paints, such as Flake White, Naples Yellow and White Lead. Lead and the paints containing lead are poisonous and should be avoided or used with great care. Paints containing lead are labeled as toxic. Many ceramic glazes also contain lead because lead assists in achieving satisfactory glazes. In order for such products as food bowls to be labeled as safe, they must be tested and must comply with U.S. Food and Drug Administration guidelines. *See health labels.*

lead paint
Paint containing lead compounds. *See lead.*

Lay-in
A lay-in roughly approximating the colors to be used in the final painting.

Lay-in
Finished painting.

RED MAPLE | acrylic on canvas | 30″ × 24″ (76cm × 61cm)

lead pencil

A writing or drawing instrument with a core consisting mainly of graphite and clay. A lead pencil contains no true lead. The term is a holdover from early times when thin rods of lead, as well as other metals, were used to make gray marks on a white surface. *See pencil, graphite.*

leaf

Metal, especially gold and silver, in very thin sheets, much thinner than foil. A sheet of gold leaf is typically 1/280,000 inches thick. Leaf, especially gold leaf, has been used for thousands of years to decorate picture frames, mummy cases, furniture, illuminated books and so on. It's used today for decorating frames and sometimes as an integral part of paintings or collages. *See composition leaf.*

lean

Containing relatively little oil; a *fat* mixture contains relatively more oil. In layered oil paintings, lean paint layers are painted first; fat, or oily, layers are painted last. *See fat-over-lean rule, oil.*

licensing

Formally and legally giving or selling another individual or organization the right to use your art in specified ways, usually for profit. The drawing up of a license may require the help of a lawyer or at least someone familiar with licensing laws. Licensing could involve such actions as giving (or selling) someone the right to repro-

duce your art on T-shirts and calendars; the agreement would spell out terms, conditions and the amounts and methods of payment to you. To give someone the right to reproduce your work—for example, in a book such as this one—for some sort of one-time remuneration, or none at all, requires only a simple written permission.

lift-ground etching

An aquatint etching technique allowing the artist to directly designate areas to be aquatinted rather than to mask out areas *not* to be aquatinted. For more, *see sugar-lift.*

lifting

Removing paint, charcoal, pastel, graphite or any other drawing or painting material from a picture's surface. The means of removal depends on the medium—charcoal may be lifted with an eraser, tissue or a cloth, watercolor may be lifted with a stiff, damp brush, and so on. Mediums such as acrylic (once dried) may require harsher treatments such as scraping or sanding; such removals are not usually considered lifting. *See fritch scrubber.*

light

The part of the electromagnetic spectrum that enables us to see. Ordinary white light (daylight) is a combination of lights of varying colors, typically described in terms of the so-called "rainbow" colors—red, orange, yellow, green, blue, indigo and violet. In actuality, the number of colors is huge, there being countless shades of color formed by mixing varying amounts of the different wavelengths of light. Although the artist is, of course, vitally concerned with light, the more immediate concern is with the colors of objects and the colors of pigments, which are *different* from the colors of light. For discussion, *see subtractive color mixing and additive color mixing.*

light box

See light table.

light, fluorescent

Light produced by converting invisible energy, such as ultraviolet light, to visible light. In a fluorescent tube, which is filled with inert gases, an electrical discharge along the length of the tube causes the release of ultraviolet light. The ultraviolet light strikes the phosphors that coat the inside of the tube. Phosphors—substances that emit light when stimulated by radiation—convert the short-wavelength ultraviolet light to longer-wavelength visible light. The color of the emitted light may be controlled by using a variety of phosphors.

A related term is phosphorescence, which is the release of visible light after stimulation, but at a slower pace than that occurring in fluorescence. The glow of a watch dial is an example of phosphorescence.

light, incandescent

Light produced by heating a gas or a solid material to high temperatures, usually by passing electricity through the material. Incandescence was first demonstrated in 1801 by Sir Humphrey Davy; the first patent for an incandescent lamp was granted to Frederick de Moleyns in England in 1841. Englishman Sir Joseph Swann in 1878 and American Thomas Edison in 1879 devised the first practical lamps, both consisting of carbon filaments inside an evacuated glass bulb. While earlier filaments had quickly burned up, the evacuated bulb greatly extended filament life. In 1911, long-lived tungsten filaments came into use and soon after it was shown that instead of simply evacuating glass bulbs, it was better to fill them with inert gases, which slowed the disintegration of the filaments. Most common incandescent bulbs pro-

Light table

duce light that is shifted to the warm side of the light spectrum; artists commonly opt for various fluorescent lights that more nearly simulate daylight.

light source

In painting and drawing, the location and nature of the light source, or sources, illuminating the subject are critical. Shadows, which figure importantly in representational art, are wholly dependent on the light source—moving the light changes everything. Likewise, the light falling on the artist's palette and easel is important—painting a scene illuminated by very cool light, for example, while working under very warm light can produce some surprising results. For that reason it's important to try to paint under the same light as that falling on the subject, insofar as that's possible. Furthermore, it's wise to try to paint under the same light as that under which the finished picture will be shown. Accomplishing all this is not always possible, but at least the artist

should be aware of the problems that extreme differences in lighting may cause. *See shadow; Verilux.*

light table

A device that shines light evenly through a translucent surface to allow viewing of slides, transparencies or drawings laid on the surface. Also called *light box.*

lightfastness

The ability of a pigment to resist fading or changing hue over time. Fading means diminishing in intensity or value; changing hue means literally changing from one hue to a different one, such as purple to gray. *See permanence.*

lignin

A major component (along with cellulose) of wood. Lignin is removed from wood pulp in order to increase the brightness of papers made from the pulp. Lignin has a number of commercial uses as an adhesive; it's also used to make artificial vanilla.

limelight

Very bright stage lighting that uses an oxy-hydrogen flame (a flame produced by igniting a mixture of oxygen and hydrogen) to heat a block of lime (calcium oxide). Because of its stage use, the term has come to mean "center of attention."

limn

1| To draw or paint. 2| To outline in sharp detail.

linear perspective

A technique for suggesting depth in a picture by making parallel lines meet. Parallel lines don't actually meet, of course, but they appear to, and in appearing to meet they plant in our minds the idea of distance.

Look down a straight, flat road and its parallel edges seem to meet somewhere off in the distance. Stand at one end of a room and the parallel lines where the walls join the floor and ceiling seem to converge as you look toward the other end of the room. We're surrounded every day by examples of linear perspective. If parallel lines in real life seem to meet, it makes sense to have parallel lines in our pictures meet. To draw convincingly in linear perspective, it's only necessary to understand a few simple definitions and "rules."

1: The point at which parallel horizontal lines seem to meet in the distance is called a *vanishing point*. **2:** Vanishing points for parallel horizontal lines all fall on the *horizon line*, or *eye level*. **3:** You can't always see the horizon because things like buildings and mountains obstruct your view, so instead of using the term horizon we use the term *eye level*. Eye level and horizon, in linear perspective, are synonymous. Think of eye level as a horizontal plane passing through the eye of the observer parallel to the earth. **4:** There can be only *one eye level* in a realistic pic-

ture. That single eye level is the foundation for the picture—everything is made *relative* to that eye level. If you view a scene standing up, you're looking at it from one eye level; if you look at the same scene sitting down you're seeing a slightly different scene—every time you change eye level you change what you're seeing. **5:** Receding lines that are above eye level slant *down* to a vanishing point on the eye level. Receding lines below eye level slant *up* to a vanishing point. **6:** Rectangular objects having one face parallel to the picture plane have a single vanishing point—this is *one-point* linear perspective. Rectangular objects with no face parallel to the picture plane have two vanishing points—this is *two-point* linear perspective. **7:** Each object, such as a building, has its own vanishing point(s) on the eye level. If there are *N* buildings in the picture, there are *N* sets of vanishing points; however,

Dizzy Perspective

If you have a chance to see Roy Lichtenstein's sculpture *House II* (in the mall sculpture garden in Washington, D.C.), prepare yourself for a perspective shock. *House II* is a large painting of a simple house in perspective. As you view it from fifteen or twenty feet away you see a roof and two walls, convex toward you. But as you approach the structure it slowly changes before your eyes until, when you're very close, it becomes concave away from you. As you move toward this object, it actually seems to be changing its form—the illusion is so real it can make you dizzy. And it's all done by cleverly using slanting perspective lines that appear correct at all distances, yet seem to shift as you approach.

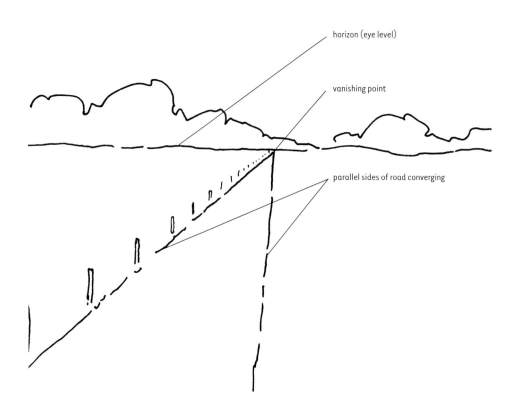

horizon (eye level)

vanishing point

parallel sides of road converging

Linear perspective
This road seems to vanish at the horizon. The point at which it seems to vanish is called the vanishing point.

all of them fall along the *same eye level*.
8: Although two-point perspective is most common in representational pictures, one-point is frequently used. In addition, there may be a third vanishing point (*see three-point perspective*). In fact, there may be numerous vanishing points for special situations.

For a full exploration of linear perspective, *see Perspective Without Pain* and *Perspective Secrets. See illustrations on pages 226-229.*

linen

A cloth made from fibers of the flax plant. Linen canvas is one of the most durable and popular supports for painting, especially in oils but also in acrylics and other mediums. *See canvas.*

liner

1| A part of many wood, and some metal, frames consisting of a rectangle of wood strips, usually covered with cloth and sometimes colored. The liner is a sort of subframe—it fits inside the outer frame, and the picture, in turn, fits inside the liner. *See illustration under frame, wood.*
2| One or more layers of mat board lying beneath the main, outer mat and cut with slightly smaller windows than the outer mat so that the result is a narrow accent surrounding the picture. Often the liner or liners are cut from mat board in a color compatible with the colors in the picture, while the outer mat is white or off-white.

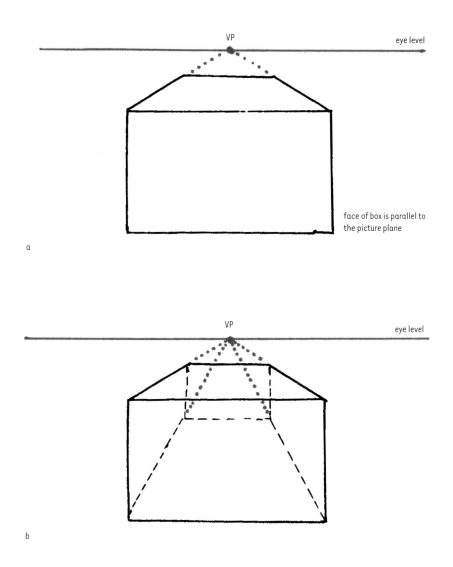

face of box is parallel to
the picture plane

a

b

Linear perspective: one-point
An example of simple one-point linear perspective.
One face of the box is parallel to the picture plane. Its
horizontal parallel lines recede and meet at a single
vanishing point (VP). In (a) you see the outside of the
box; in (b) you see its other (hidden) edges.

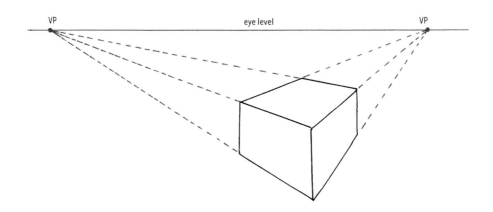

Linear perspective: two-point
This box is twisted so none of its faces are parallel to the
picture plane. It has two vanishing points, both on the
eye level.

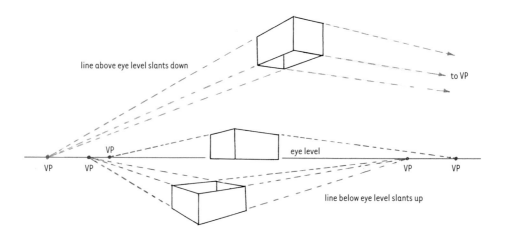

Linear perspective: multiple objects
Here are three boxes in a single scene (they could be
three houses, one at eye level, one on a hill and one in a
valley). A single eye level ties the scene together. All
three boxes have vanishing points on the eye level. In one
case, as often happens, a vanishing point falls far off the
page because of the positioning of the box. Each hori-
zontal receding line that's above eye level slants down;
lines below eye level slant up. Each box in this scene has
its own set of vanishing points. *Sometimes*, depending on
how objects are positioned, one or both vanishing points
for one object will coincide with the vanishing points for
another.

Linear perspective: two-point

This railroad sketch is in two-point perspective. One of the vanishing points (VP2) is far off to the left.

Linear perspective: one-point and two-point

In this sketch, both two-point and one-point perspective are at work. The cab of the truck is broadside to the viewer, not at an angle, so it's in one-point perspective. The rear part of the truck is angled and is in two-point perspective, with one of its vanishing points shown; its second vanishing point is far off to the right.

Linoleum cut
One of a series of prints made on an African theme.

HEN HUNT | Barbara Robertson | linoleum cut | 22″ × 6″ (56cm × 15cm)

3| A paintbrush with a long, slender brush head. *See rigger.*

lining

A conservation technique in which a damaged painting (usually oil) on canvas is mounted on a new, additional support. Typically the entire painting, including its canvas support, is glued to a new fabric support.

lino /lie no/

Linoleum. *See linocut; linoleum cut.*

linocut /lie no cut/

A print made from a design cut into linoleum. *See linoleum cut.*

linoleum cut

A print image made by inking a block of carved linoleum and pressing it to paper or other surfaces. Linoleum, made of a backing of burlap or canvas coated with linoxyn, is easily cut using a variety of sharp tools made for that purpose. Also called linocut.

There are two basic methods used to produce a multicolored image. One way is to cut a separate block of linoleum for each color; the other is to use the "reduction technique," the choice of Barbara Robertson, whose work is shown here. She prints from a single block, cutting away more material for each new color to be printed. The block is "reduced" at each stage and there's no going back—by the time the image is completed, the earlier stages of the block no longer exist. Using the reduction technique means the artist must decide ahead of time how many prints are to be pulled because, again, there's no returning to an earlier printing stage.

Some artists use solid colors with no gradation. Robertson often introduces

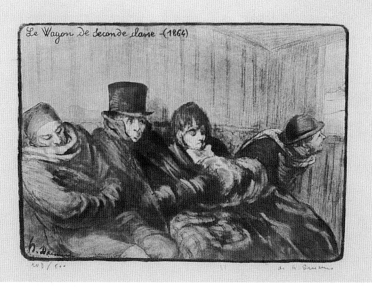

Le Wagon de seconde classe (1864)

Lithograph

Daumier was a prolific artist, both in printmaking and in painting. A display of hundreds of his works in year 2000 at The Phillips Collection in Washington, D.C., demonstrated his skill in capturing the essence of a scene with a deft use of line and value to express human body language, or gesture.

LE WAGON DE SECONDE CLASSE | Honoré Daumier | lithograph | 1864. Collection of Shirley Porter, Rockville, MD.

graded tones by one of two methods: **1:** She inks portions of a block unevenly or **2:** she brushes caustic soda onto parts of the block; the soda "bites" or eats away at the surface, producing a texture that takes ink unevenly rather than solidly. She would use the latter method, for example, to print soft clouds in a picture. *See print; linoxyn.*

linoxyn

An elastic solid made by combining linseed oil, cork and other materials; a main ingredient in linoleum.

linseed oil

Oil obtained from the seed of the flax plant; the name linseed comes from *Linaceae*, the scientific name for the family to which flax plants belong. Its primary uses are as the binder in artists' oil paints, as an ingredient in some varnishes and inks and in the manufacture of linoleum. Linseed (also called flaxseed) was once used as a food by the Greeks and Romans; now the seed remaining after removal of its oil is used to feed livestock.

lintel

A horizontal support spanning the top of an opening such as a doorway or window. In ancient architecture, lintels were sometimes made of wood, but more often, stone. In modern buildings, lintels are made of many materials, including wood, reinforced concrete and steel.

Liquin

A popular brand of fluid medium used in oil or alkyd painting to thin paints, especially for making glazes. A liquid alkyd resin derived from petroleum, its use speeds the drying of oil and alkyd paints. *See glaze; medium; oil paint.*

lithograph

A print made from an image drawn on a flat plate of limestone or metal. The drawing on the plate is made with black, greasy lithographic crayons or tusche, a liquid form of the crayons. After the drawing is complete, the plate is wet with water and then inked with a roller. The lithographic ink is greasy and adheres to the plate only where the image has been

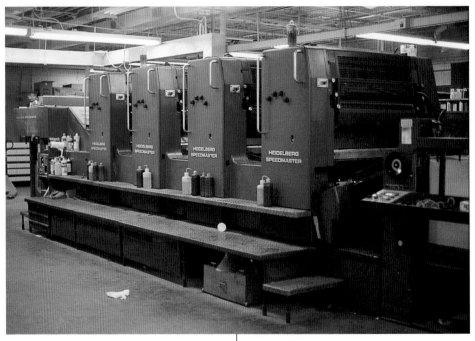

Offset lithograph

This is a Heidelberg Speedmaster offset lithograph press. It's about 30′ (9.1m) long and 8′ (2.4m) high. Each of the four stations contains the apparatus for printing dots in one of the four colors (cyan, magenta, yellow and black) that make up the final image. Each sheet of paper is fed in from the stack at the near end and finally exits onto a stack at the far end. Operators must limit the number of sheets that stack at the output end so that the accumulated weight of the paper does not cause the still-wet inks to transfer from the printed surface of one sheet to the back of the next.

Photo courtesy of Michael Hare, Beach Brothers Printing, Rockville, MD.

drawn, not to the wet, blank areas of the plate. Paper is laid against the plate and run through a press, and a reverse image is printed. The limestone or metal (usually aluminum or zinc) plates used may have a variety of finishes—that is, degrees of coarseness or graininess—depending on the artist's needs. The plates may be cleaned and resurfaced and reused many times once a print edition has been finished. Between the time an image is drawn on the plate and the actual inking of the plate for printing, there are intermediate steps that help ensure that the blank areas do not accept any ink and the drawn areas do accept ink.

lithograph, offset

A reproduction made using the same basic idea that governs lithography, but on a mass-production printing press. The image to be reproduced is on a metal plate in cylindrical form. Instead of inking the metal cylinder and running paper in direct contact with it, another cylinder, this one of rubber, picks up the inked image from the metal cylinder. The paper in turn picks up the inked image from the rubber cylinder. Because the image gets from the metal cylinder to the paper by an indirect (offset) route, the term *offset* is applied to the process. The reason an intermediate (rubber) cylinder is used is to protect the metal master cylinder from damage from great numbers of sheets of paper pressed against its delicate surface.

When producing a full-color offset reproduction, four colors are commonly

used: cyan (green-blue), magenta (red), yellow and black. Four sets of cylinders are prepared, one for each color, and each sheet of paper is run past each of the four cylinders in turn. Each of the four cylinders contains appropriate parts of the original image in the form of tiny dots; one cylinder prints only yellow dots, another prints only magenta dots and so on. The final reproduced image then consists of a mass of dots which combine visually to present the viewer with a good approximation of the original image. Under a magnifying glass you can clearly see the dots that make up the image.

The dots that make up each cylindrical plate are formed by photographing the original art through a series of filters and fine grids called screens, or *halftone screens*. The filters allow one color to get through at a time, and the screens break up that color into dots. *See halftone screen.*

livering

The degradation of oil paint in the tube, forming a rubbery mass. Livered paint is no longer usable and should be discarded.

local color

The actual color of an object unaffected by conditions such as atmospheric haze or unusual lighting. For example, a barn seen up close on a normal day might appear a strong red, and that red would be its local color. Seen at a distance, however, or seen in late evening when the sunlight is weak, that same barn might appear much less vividly red and might even appear grayish. *See aerial perspective.*

London Group

A group of English artists founded in 1913. Early members of the group favored painting the working classes and city scenes using the high-key palettes of the Impressionists. Later members embraced the geometric and color notions of the Cubists. This combination of conservative and radical painters exhibited together, but not without plenty of heated controversy. The group essentially dissolved with the coming of World War I.

loom

A machine on which cloth is woven. A basic loom consists of a frame with a set of parallel threads (warp threads) running in the long direction; other threads (weft threads) are run one at a time in the perpendicular direction, left-right across the warp. Weft threads are woven over and under warp threads to form a dense, interlaced pattern. In a basic weave, weft threads dip under one warp thread and over the top of the next, in regular alternating fashion. By altering this regularity, patterns may be introduced. With colored threads, these patterns become colored designs in the cloth. Manual looms have been used for thousands of years; modern looms are automated to allow high-speed production of the great variety of cloths with which we have become familiar.

loose

Inexact, free, relaxed. Looseness may be achieved in a variety of ways, including the use of edges that are soft and indeterminate, or colors and values that have a free, spontaneous look. On the other hand, a drawing or painting with definite, strong outlines may also be loose if it's done without strict adherence to reality—if shapes, for example are exaggerated.

lost-wax process

In making castings of molten metal, this is one of two processes used for centuries. Although there are variations, the usual procedure is this: A hollow model of plaster or clay is formed around the original sculpture. The model is cut in two and the

inside surface is coated with a thickness of wax. The halves are rejoined and the remaining hollow area is packed with sand. There is now a sandwich of clay or plaster on the outside, sand on the inside and wax in between. This assembly is heated until the wax melts and drains out through carefully placed vents. The space vacated by the wax is then filled through other vents with molten metal such as bronze. When cool, the outer plaster or clay and the inner packed sand are removed, leaving a hollow metal sculpture ready to be polished or fine-tuned by the sculptor. Also called *cire perdue. See sand casting.*

low value
Dark. The lowest value is black. *See value.*

Lucite
Brand name (DuPont) for an acrylic sheet used in framing pictures and in building some sculptures. *See Plexiglas.*

Luminism
An American painting style during the third quarter of the nineteenth century emphasizing the subtleties of light in landscapes and seascapes. Impressionist paintings often depict a rather flat, splashy impression of an object; Luminist paintings faithfully portray the color and value changes that clearly delineate the object. For example, an Impressionist might paint a flat sky in broken color, but a Luminist would paint subtle gradations to give the sky depth.

machine-made paper
Paper made commercially on high-speed machines. *See paper; Fourdrinier machine.*

macrame or macramé |mak reh may|
Ornamental wall hangings, bags and other items made by knotting cords of cotton, linen, jute or other fibers to form geometric, lacelike patterns.

Magna paint
Brand name for a type of paint used by color field artists in the 1960s. It was an acrylic paint based on solvents such as turpentine and mineral spirits rather than water. Once manufactured by Bocour, it is no longer available. Color field artists liked the paint for its intensity of color. A comparable paint called MSA (mineral spirit acrylic) is now available from Golden Paints. *See MSA; color field painting.*

mahlstick
A rod of any material, such as plastic or wood, used by an artist as a rest for his hand. A mahlstick is generally used when working on a detailed area that requires steadiness; it also keeps the artist's hand from touching and possibly smudging the picture. Also spelled maulstick. *See bridge.*

Mahlstick

Manikin

manikin

A jointed model of the human body used to help draw the body in various poses. Also called mannequin.

mannequin

See manikin.

Mannerism

An art style (about 1520-1600) that concentrated on depicting the human form in intricate poses and settings in which features were often exaggerated or figures were shown in unnaturally athletic poses within settings that were not necessarily realistic. This was in contrast to the early Renaissance tendency to treat the figure in a more formal, classical, naturalistic style. The Mannerists concentrated on style and technique, with less regard for the true nature of the subject matter, putting great emphasis on portraying the nude in complex, often artificial, poses. Depth, or perspective, in a painting was often ignored or collapsed into a shallow plane; the arrangement of complex forms on the pic-

ture surface was more important than the degree of realism. Often the arrangement of forms was intricate and contrived, even bizarre, and the colors used were sometimes unnaturally intense. The late works of Renaissance artists Michelangelo and Raphael helped set the stage for the Mannerists. Mannerism began in Florence and Rome, but eventually spread to much of Europe. Once viewed by many in negative terms because it seemed to concentrate on slickness and technical facility at the expense of soul, Mannerism later became admired for its technical excellence and polish. A leading Mannerist painter was Parmigianino, or Girolamo Francesco Maria Mazzola.

maquette /mah *kett*/

A small, three-dimensional model for a sculpture. Sometimes building a maquette is the artist's way of working out a design (similar to thumbnail sketches by painters). Often the purpose of a maquette is to help sell the idea of the full-size sculpture to a patron or an art jury.

marble dust

Pulverized marble sometimes added to paint, gesso or acrylic medium to provide texture, or "tooth." *See tooth.*

marbled paper

Paper that has been painted in a manner to suggest the appearance of marble. Marbled papers are available through art supply stores; many artists, especially collagists, make their own. One way to make marbled paper is this: **1:** Prepare a shallow tub full of a thickish mixture of cellulose wallpaper paste (this is called the *bath*). **2:** Deposit a pattern of oil paints on top of the surface of the bath, using whatever tools are handy, such as eyedroppers. Swirl the paint to form a pleasing pattern, but without mixing the paint with the bath—

the paint must remain lying on the surface of the bath. 3: Lower a piece of paper onto the surface of the bath. 4: After ten seconds or so, gently pull the paper up, starting at one corner, and lay it face up to dry. For more on marbling and other collage techniques, *see Creative Collage Techniques* by Nita Leland and Virginia Lee Williams.

mark

The way an individual artist draws or paints that distinguishes his or her work from others' work; a sort of personal "signature." Examples: the dabbing stroke of a Monet, the slashing stroke of Franz Hals, the rough stroke of a Wyeth watercolor, the delicate line of an Ingres drawing, the bold and aggressive line of a Michelangelo drawing.

marker pen

Pens of various sizes and shapes, usually with soft felt tips, used by artists as fast-sketching instruments. Except for some black markers, many of the colors are not lightfast. Some marker inks bleed through a sheet of paper and others do not—something to consider if you use a marker in your sketchbook and want to be able to use both sides of each sheet of paper. *See illustrations on pages 237-238.*

Marker pen: colored

These Chartpak markers are available in a large variety of colors. The nibs have a unique wedge shape that allows each pen to be used for a thin, medium or broad line. Although the colors are listed as "permanent," they do not carry an ASTM lightfast rating and are probably not appropriate for truly permanent work. However, given the variety of colors available and the versatility of the nibs, these markers are ideal for working up full-color sketches. Like many marker inks, these bleed through many papers, so the reverse sides of sheets may not be usable. In fact, bleeding may go through several layers, depending on the paper used, so protect what's underneath by inserting scrap paper. Photo courtesy of Chartpak, Inc., One River Road, Leeds, MA 01053.

Marker pen

Marker pen

A relatively new and effective marker by Staedtler. Each of these pens has both a broad and a narrow tip. They are sold in several nonbleeding shades between light gray and black. They have a comfortable shape that allows for rapid sketching—the sketch shown was done in just a couple of minutes.

Maroger medium

A once popular oil painting medium containing linseed oil, lead oxide and mastic varnish. From time to time artists take another look at this medium and revive it, but there has always been controversy surrounding its use. Mayer recommends against using it.

marouflage

Attaching a canvas to a wall or other rigid support. Sometimes this is done during restoration of a deteriorating painting on canvas.

marquetry

Decoration on surfaces such as furniture, consisting of intricate patterns made up of thin pieces of gold, silver, wood, shells and other attractive materials. Sometimes the individual pieces are enclosed by metal edgings. André-Charles Boulle (1642-1732), an expert cabinetmaker, was a master at such decoration and is so well known for this work that it's often called *boulle work.*

masking

Hiding a portion of a work temporarily to keep paint, ink, or other materials from that area. *See masking tape; drafting tape; frisket; stencil; template; resist.*

masking fluid

Any fluid used to cover an area of a drawing or painting temporarily to prevent paint or other materials from getting into that area. Any fluid that can be applied without harming the picture surface and can be easily removed may be used. Common masking fluids are Miskit, Maskoid and rubber cement. Painters use cheap brushes for applying these fluids because the fluids are gummy and difficult to clean from a brush. An excellent substitute for a brush is a tool called a Colour Shaper. It has a silicone tip that is easily cleaned. *See Colour Shaper.*

masking tape

Adhesive with a paper backing used to mask areas of a picture not intended to receive paint. Some masking tapes adhere so strongly to a paper surface that when removed, the surface of the paper tears away with the tape. Tape should be removed slowly and carefully to minimize the risk of damage. Tape used to temporarily outline the border of a picture should be removed by pulling in a direction away from the picture so that if any tearing does occur, it will affect only the border and not the picture area. It's safer to use *drafting tape,* which adheres less strongly than masking tape and can be removed with

less danger of tearing the paper underneath. *See drafting tape.*

Masonite

Brand name for a popular type of hardboard. The true name of the product is Masonite Presdwood, but most people use the shorthand term Masonite. *See hardboard.*

mastic varnish

A pale varnish made by dissolving mastic resin (obtained from various trees around the Mediterranean) in solvents such as turpentine or alcohol. Once popular, mastic varnish has gone out of favor because of its tendency to crack and discolor.

mat (mount)

A border used in framing pictures, especially watercolors, prints, reproductions and drawings, both to improve the appearance of the picture and to separate the artwork from the glass covering. The usual material used is mat board.

There are two ways of placing the artwork within the mat. **1:** The art may be hinged to the rear of the mat using archival framer's tape or pasted hinges of torn acid-free paper. **2:** The art may be hinged to the backing (a sheet of acid-free material, such as foamboard). In the latter case, care must be taken to position the art so that it shows properly in the mat window. In either case, two hinges are usually used (*see illustration under framer's tape*) rather than fastening the picture around all its edges—this allows for the expansion and contraction of the art as heat and humidity vary.

Because of the variety of colors and textures available, it's possible to mat a picture to suit all kinds of tastes and decor. Most professionals and art judges prefer that a white or off-white mat be used. There are two reasons for this: **1:** A white

Mat board
Some of the many colors and textures of mat board available.

mat does not call attention to itself and away from the art, and **2:** a white mat is neutral and can hang on any wall in any decor. *See framing.*

mat board

A type of cardboard used to provide a border around a picture. Mat boards come in many colors and textures and in several grades. Most mat board is a wood pulp product treated to eliminate its inherent acidity; other types are made from rag or a combination of rag and wood fibers; still others are made of cardboard covered in fabric. It's essential to choose a mat board that is acid free—otherwise, in time, the mat board will discolor and will likewise discolor the artwork it touches. Even if the art is separated from the mat by a thin sheet of acid-free paper as is sometimes the case, it's possible that in time the acid in the mat board will affect the artwork.

mat cutter

A device with a sharp blade for cutting mat board. There are three basic types of cutter: **1:** A mat knife (*see illustration under knife,*

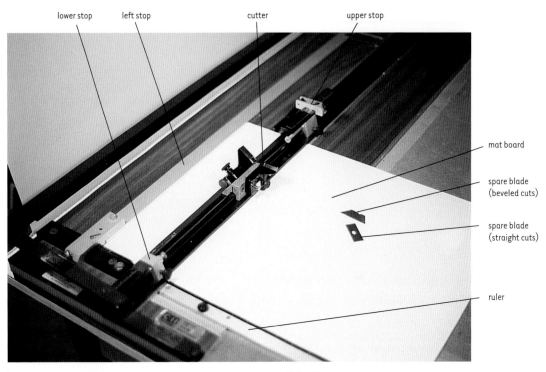

lower stop left stop cutter upper stop

mat board

spare blade
(beveled cuts)

spare blade
(straight cuts)

ruler

Mat cutter

This cutter has two blades. One cuts a straight, vertical edge and is used for cutting the outer dimensions of mats, backings, etc. The other is set at an angle—it's the blade that cuts a beveled mat window. The arrangement has three "stops" that you position depending on the width of the mat you want to cut. As in the case of the handheld model, the mat board is placed face-down; all cutting is done from the back. With this cutter, you pull the blade toward you rather than push it away from you.

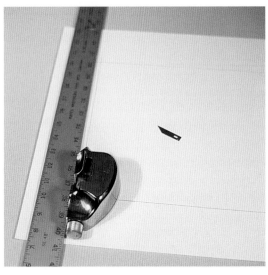

Mat cutter

A typical inexpensive handheld cutter. It has a blade set at an angle so that it cuts a beveled edge. The window is marked and cut from the *back* of the mat board so that the scuffing of the cutter does not damage the face of the mat. The straightedge is an aluminum ruler; on its underside is glued a layer of fine sandpaper, which helps keep the ruler from slipping out of position.

mat); **2**: a small, handheld cutter; and **3**: a more elaborate professional cutter. The handheld cutter, such as the Dexter brand shown here, is inexpensive and suitable for cutting small numbers of mats. For cutting more than an occasional mat, however, this cutter is not very efficient and besides it puts a lot of pressure on the wrists, which can be painful if you have any wrist ailment such as arthritis. Professional cutters range from under a hundred dollars to over a thousand dollars (the Bainbridge C&H model shown is near the high end of the price scale). Naturally, the higher priced cutters have more features to allow you to

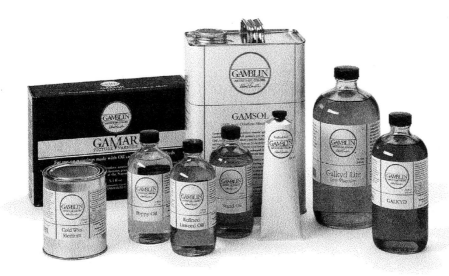

make fancy, accurate cuts; some are convertible for use in cutting glass. Among the options available are cutters for circular or oval mats and cutters that allow you to cut v-shaped grooves in the face of a mat for extra decoration.

mat knife
A knife used for cutting mat board. *See illustration under knife, mat.*

matte finish
A nonglossy, soft, dull appearance on any surface—paint, paper, varnish, etc.

maulstick
Another name for a mahlstick.

MDF
See medium density fiberboard.

medieval
Anything related to the Middle Ages, roughly the period from about 500 AD to 1500 AD.

medium
In art, *medium* has several meanings, depending on context:

Medium
One manufacturer's range of mediums used in oil and alkyd painting. Similar ranges of mediums are available for other types of painting, including acrylic and watercolor. Various combinations of the products shown can be used to increase or decrease the glossiness of paint, make the paint thicker or thinner, or give the paint a matte finish. Courtesy of Robert Gamblin, Gamblin Artists Colors, P.O. Box 625, Portland, OR 97207.

1: A basic *kind* of art. Examples: painting, drawing, etching and sculpting. Plural is media. **2:** The basic *material* used by the artist. Examples: watercolor paint, oil paint, clay, marble, graphite and steel. Plural is either media or mediums. **3:** The *ingredient* in paint that binds the pigment. Examples: gum arabic in watercolor paint, linseed oil in oil paint and egg yolk in egg tempera paint. Plural is either media or mediums. **4:** Material, usually a liquid or a gel, that may be *added* to a paint to alter some of the paint's properties. Examples: Some mediums change paint's viscosity, make the color more transparent, change the degree of surface shine and speed or slow drying. Plural is mediums.

Mezzotint
The linework in this engraving was achieved using a burin—the usual engraver's tool—and the shading and texturing were done with rockers and roulettes.

TOLSTOY | Peter Stoliaroff | mezzotint | 11¾″ × 9″ (30cm × 23cm)

medium density fiberboard (MDF)
A fibrous commercial construction materi-al, usually ¾″ (1.9cm) thick, occasionally used as a painting support. Not acid free, it must be suitably coated for such use.

megilp
A combination of mastic varnish and lin-seed oil popular as an oil painting medi-um during the eighteenth and nineteenth centuries, but no longer used because of its defects, such as a tendency to crack and discolor.

melamine board /mel ah meen/
Formica and similar products made from an organic compound called melamine; sometimes used as a painting support or as a palette.

metal point
Drawing done using a thin rod of various metals, including lead, silver and copper. As the rod is drawn across a sheet of paper, it leaves a mark. Depending on the metal used, it may in a short time oxidize (as in silverpoint) and change color. *See silverpoint.*

metal sculpture
Any sculpture consisting mostly of metal components. *See sculpture, metal.*

methylated spirit
Denatured alcohol. *See alcohol.*

mezzotint /met so tint/
An engraving showing shades of gray or color. The surface of a plate, usually cop-per, is roughened, or pitted, using a variety

of tools such as rockers and roulettes. A rocker is a tool with a curved serrated blade that creates broken lines as it is rocked back an has a wheel with a sharp serrated edge that also creates a broken line as it's rolled across the plate. Other tools such as burnishers and scrapers can be used to modify the plate's roughness and produce any degree of fine or coarse grain. *See print; rocker; roulette; burnisher; scraper.*

Middle Ages

The period from the decline of the Roman Empire to the Renaissance, roughly 500 AD to 1500 AD, during which art, science and social institutions suffered a great deal of stagnation and retrogression.

middle ground

In a representational picture, the area that is neither closest to, nor farthest from, the viewer—the space between the foreground and background.

midtone

A value near the middle of a scale of values that has white at one end and black at the other. *See value.*

mineral color

See oriental mineral color.

mineral spirits

A solvent made from crude petroleum that is used as a thinner and paint remover by oil and alkyd painters. Although it behaves the same as turpentine in most usage, it's much less expensive than turpentine, it's nearly odorless and it keeps well without becoming thick or gummy. Sometimes called *white spirits.*

miniature

A very small work of art, typically a painting but often a sculpture, engraving,

Painting With Spirits

One of the miniature societies that has been around for a long while is the W.P.A., or the Whiskey Painters of America. To enter a picture in a W.P.A. exhibition you must not only conform to size constraints, but must solemnly swear you used whiskey (or some other alcoholic beverage) as your medium! Who says artists don't have a sense of humor?

Mineral spirits

enamel or other art form. Although the word *miniature* is now taken to mean small, it was actually derived from *minium*, the red lead paint used in painting small images in manuscripts during the Middle Ages. Around 1500, miniatures became popular as an art form separate from manuscript illumination. Hans Holbein the Younger took up the art, and his work greatly influenced miniature painting, especially the painting of portraits. Miniatures were often painted in oval shapes on ivory, copper, vellum, paper, wood and many other surfaces, using a variety of painting mediums including gouache, enamel and oil.

Miniature
A miniature painting shown full size.

BLUE ROAD | Shirley Porter | acrylic gouache on illustration board |
3″ × 3″ (8cm × 8cm)

Portraits have given way to still lifes, landscapes, seascapes, animals and other subjects.

Today, there are a number of miniature painting societies, each of which has its own rules for what constitutes a miniature. The oldest society in the United States is The Miniature Painters, Sculptors, & Gravers Society of Washington, D.C., founded in 1931 by Allyn Williams, who had earlier founded the Royal Miniature Society. Paintings accepted for exhibition by this society must be no greater than 25 square inches in area. The Washington Society in 1993 published a book—itself a miniature, measuring 2¾″ × 3″ (7cm x 7.5cm)—called *Art in Miniature*, written by painter Margaret Hicks.

Minimalism

A painting style during the 1960s that attempted to throw off any need for social comment, self-expression, allusions to history, politics, religion—in fact, imagery of any kind—in favor of paintings that stood on their own as objects of interest and beauty. Minimalist paintings were done using flat, simple forms such as squares, circles and rectangles. A 1913 painting by Kasimir Malevich of a black square on a white background is often considered the precursor for Minimalist painting. Critic Clement Greenburg called these works "Post-Painterly Abstractions." Leading Minimalist painters include Ellsworth Kelly, Gene Davis, Frank Stella and Kenneth Noland.

mirror, use of

Most of us draw, paint or sculpt with a built-in visual bias. We tend to place shapes in a certain way or draw lines just so and think the result looks quite right. Another person looking at our image may immediately spot a flaw, or at least a peculiarity, that we don't see at all because he or she is looking at our image with fresh eyes, eyes not biased in the same way as ours. For example, it's common to draw a face with one eye slightly higher than the other and not realize you have done so. Another person may spot the errant eye immediately. You can spot it immediately, too, by simply looking at the image in an ordinary flat mirror. The mirror image is left-right reversed, and that gives the image a wholly different look. That eye that's misplaced or that misdirected line or unsymmetrical shape you thought was perfectly symmetrical will become quite obvious.

It's handy to place a mirror behind you so that as you work you can step aside and glance at your picture in the mirror. If studio space doesn't allow for this, or if you're working outdoors, a small handheld mirror works well. It's easy to pack such a mirror along with your other art tools and take it with you anywhere.

miscible

Capable of being mixed. The term is used in referring to the mixing of gases, liquids and solids, especially metals melted and mixed to form alloys. But in art the word is most often used in the term *water-miscible* to describe a paint that is mixable with water—in particular, water-miscible oil paints that were introduced toward the end of the 1900s. *See water-miscible oil paint.*

mixed media

The use of more than a single kind of material in a work of art. The term is applied to 1: paintings in which two or more types of paint are used—for example, acrylic and pastel; 2: pictures using dissimilar materials such as paint and paper; and 3: assemblages or sculptures built from a variety of materials, such as metal, paint, wire and stone. The term mixed media is broad, and there is no practical limit to the numbers and kinds of materials that may be combined artistically. However, there are limits if the resulting artwork is to be considered archival. For example, newspapers or leaves or grasses used as parts of collages are not permanent (although they may well survive long enough to suit the artist's intent).

Mixed-media art may be as simple as combining pen or pencil lines with paint (*see accompanying example*) or as complex and demanding as the work of Donna Baspaly, whose working methods are shown here. *See illustrations on pages 246-252.*

mobile /*moh* beel/

The kinetic art of Alexander Calder (1898-1976). Mobiles are sculptures consisting of shapes of metal, wood or plastic connected in various ways by wires and rods, with the pieces, and sometimes the whole assemblage, free to move in space. *See kinetic art.*

model

1| A person who poses as a painting, drawing, or sculpting subject for artists.
2| Any three-dimensional representation of a planned sculpture or architectural work, used to work out design problems or to show prospective buyers how a proposed work might look. 3| A rough structure an artist builds to help solve structural or other problems in a drawing or painting. Suppose, for example, you show a building, tree, or other object being reflected in a lake, but you're imagining the scene rather than actually viewing it, so you're not sure just what the

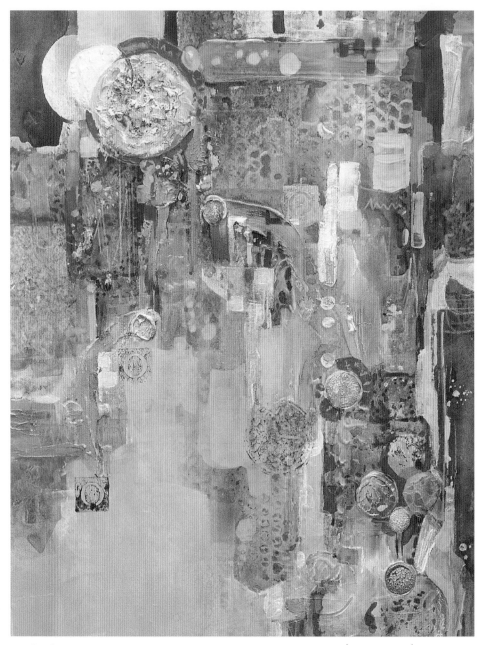

Mixed media

In this painting, Donna Baspaly used modeling paste, colored pencils, soft pastels, oil pastels, chalk, acrylic inks, acrylic paints, acrylic gel medium and photographic images. She uses the photographic images in a unique way: First she photocopies the image she wants to use. Then she places the photocopied image face down on her watercolor paper. She rubs the backside of either the whole image or only a portion of it with a Chartpak blender pen. The solvent in the pen penetrates the photocopy and transfers the image to the paper underneath. The transferred image, of course, is the reverse of the original image.

TIME WAITS FOR NO ONE | Donna Baspaly | mixed media on 200-lb. (425gsm) watercolor paper | 24″ × 16″ (61cm × 41cm)

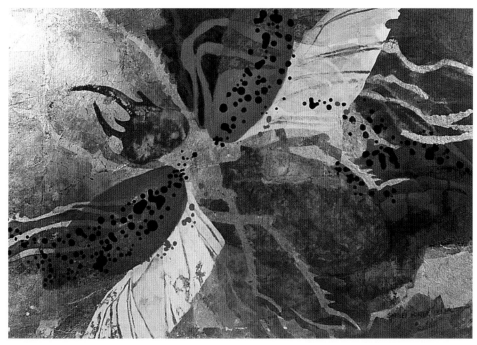

Mixed media

This painting consists of several layers of watercolor and acrylic paints and composition leafs. The acrylic paint not only provides color, but also serves to glue the leaf in place.

Bᴜɢ Fᴀɴᴛᴀsʏ | Shirley Porter | watercolor, acrylic and gold and silver composition leaf on illustration board | 22″ × 32″ (56cm × 81cm)

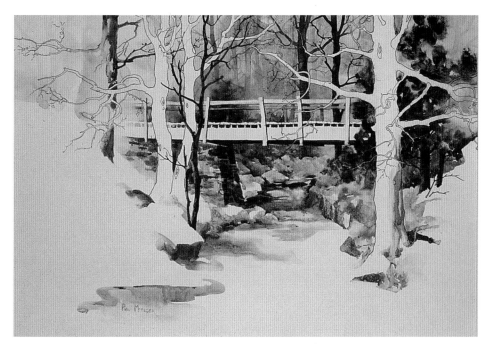

Mixed media

This vignette is a relatively simple mixing of media. The linework is black ink, done with a technical pen, and the paint is watercolor. In the darker areas I mixed a small amount of ink with the watercolor.

Wᴏᴏᴅs Bʀɪᴅɢᴇ | watercolor and ink on illustration board | 22″ × 30″ (56cm × 76cm)

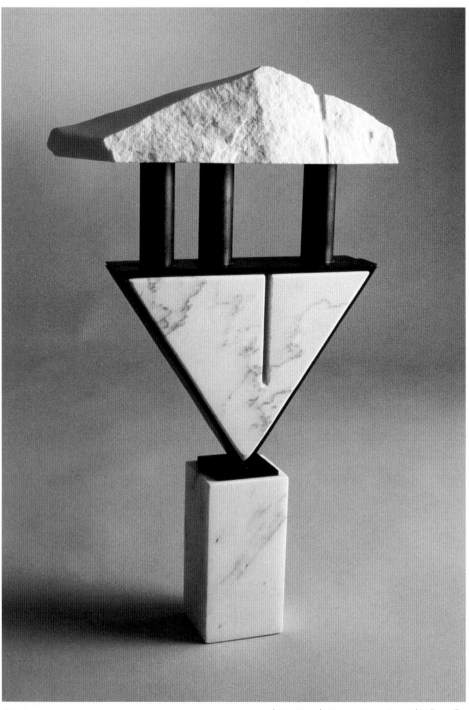

Mixed media

The term mixed media applies to sculpture as well as painting. In this example, Fritz Olsen combines marble and steel in a striking composition. The steel has been treated with gun bluing to get its dark sheen.

ATHENA | Fritz Olsen | white marble and steel | 26″ × 17″ (66cm × 43cm)

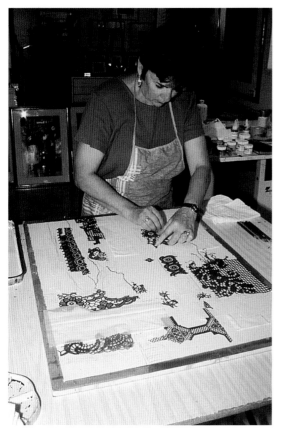

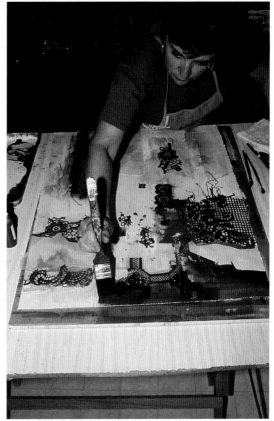

1 | Donna Baspaly began this piece by applying modeling paste to heavy watercolor paper. After the paste was dry, she placed pieces of fabrics, including plastic doilies, facial tissue and lace, in an engaging pattern over the surface. She added marks using yellow oil pastel and then used several colored pencils to draw lines connecting the pieces of the design. Finally, she brushed clear water over the fabrics to help keep them in place; the water seeps under the fabrics and helps pigments to intermix.

2 | She laid in a wash of both acrylic inks and fluid acrylic paints (altogether, three different yellows) over the overall design.

a
B
C
D
e
F
G
H
I
J
K
L
m
n
o
P
Q
r
s
T
U
V
W
X
Y
Z

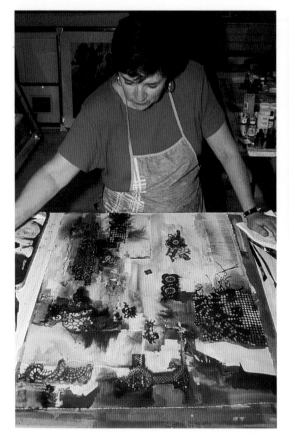 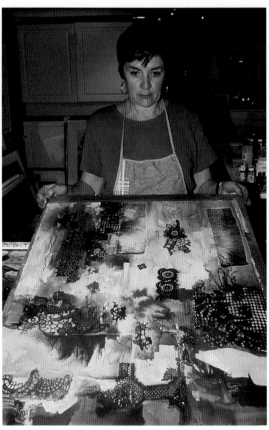

3 | After the yellow underpainting was dry, she painted a pleasing design in fluid reds, yellows and browns, always keeping an eye on both negative and positive shapes.

4 | She tilted the painting and let colors mingle to form intriguing backruns.

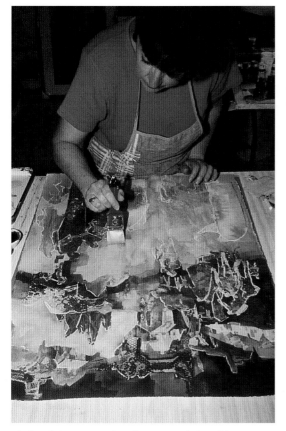 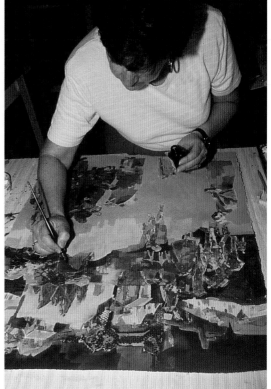

5| Now she's at a stage she calls "coping with chaos." Says Baspaly: "Once my underpainting was finished, I began to ask myself questions about where to go next. I looked for areas that were working and passages that needed to be quieted. I also looked for ideas—some suggested by the painting itself—about what to superimpose on the surface. Using white chalk, I mapped out the figures and shapes I liked, still maintaining some elements of the underlying design structure. Then with light, watered-down gesso, as shown here, I calmed passages of the painting to enhance the design with strong, bold shapes. The underpainting still showed through the veil of gesso as ghostly shadows."

6| She left the painting to dry and the next day, with a fresh eye, used opaque gesso to silence some passages and to enhance others. She painted in some negative shapes with dark inks.

"Now," says Baspaly, "feeling that the cool-gray large shape in the lower half of the picture was pulling the temperature apart, I set about re-unifying the painting by weaving warmer gray tones around the imaginary cool-gray figures as I was creating them. Immediately this pushed the overall painting to a warmer color/temperature dominance. After this process was established I worked simultaneously with darker values of all colors throughout the entire design."

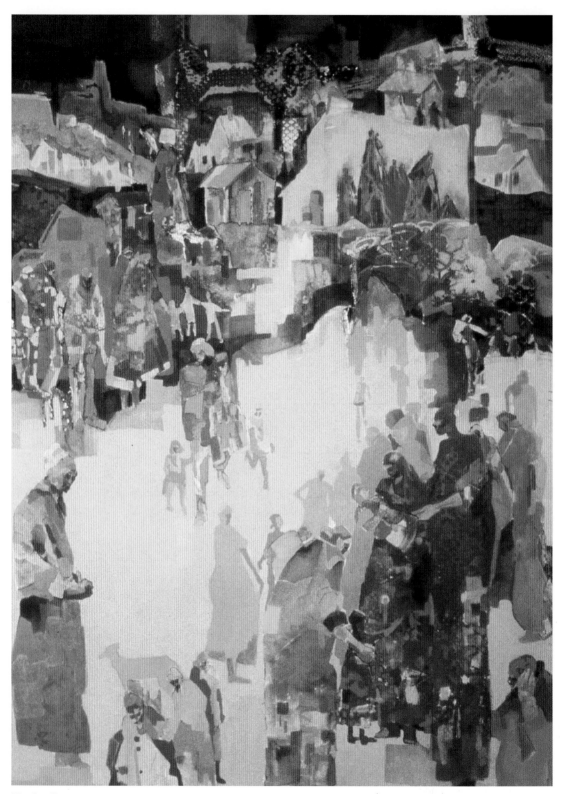

Mixed media

You may see more of Donna Baspaly's work in an article in *International Artist* magazine, December/January 2000.

Souls of the Village | Donna Baspaly | mixed media on 200-lb. (425gsm) watercolor paper | 30″ × 22″ (76cm × 56cm). Collection of Mr. and Mrs. Stuart Poole, Nanaima, British Columbia, Canada.

Model

It's not always obvious how cast shadows will look. Here is a model of a window and some beveled siding, with a flashlight (at upper left, not shown) substituting for the sun. Without observing this you might not realize that those little wedge-shaped shadows would appear. Notice also the shadows cast by the window frame on the recessed glass of the window. This model took five minutes to make out of a scrap of mat board for the siding and a couple of sticks for the window frame. You can move the flashlight around till you get shadows that satisfy your design.

reflections might look like. A simple way to answer such questions is to lay a mirror flat on a table and place near its edge objects similar to those you intend to paint—you can move the objects about and get a clear idea how to paint their reflections. If one of the objects is a hill, cut out a cardboard hill and put it in place. If you're dealing with a house, take ten minutes to make one out of cardboard. Using models in this way can be a real eye-opener—you'll often see details in a reflection that are not observable in the object itself. For an illustration of the use of models and a mirror, *see reflections.*

Another use of models is in helping to figure out how shadows might fall. If you're painting a house, for instance, and are unsure about the shadows its various parts would cast, then build a simple cardboard house, lower the room light and use a flashlight to represent the sun (or moon). Move the flashlight to represent the position of the light source in your picture, and see how shadows fall. In drawing *Country House* (*see pencil*) I decided to change the position of the light source, but that made it difficult to know how the shadow cast by the porch might look. I taped together a rough model of the building with its porch, shined a flashlight on it, and solved my problem.

modeling

1 Giving an object drawn or painted on a two-dimensional surface the appearance of depth or thickness (that is, a third dimension) by showing the effects of value and color change on the object. Whether an object is rounded or rectangular, it can be made to appear three-dimensional by dark-

ening the sides away from the light source. *See chiaroscuro.* 2| The use of a plastic material, such as clay, to make a sculpture.

modeling paste or molding paste
A thick, acrylic-based material that forms a very hard mass when dried. Artists use modeling paste in making sculpture models (maquettes), adding texture to a painting surface and building collages and assemblages—anywhere a tough, paintable surface is required.

modern art
Art from the late 1800s to the present that contrasts with earlier art in its rejection of stiff academic rules and traditions. Modern art does not imply a particular

Modeling
Without modeling, or shading, both the apple and the box look flat. Adding shading helps them to look three-dimensional because our experience tells us to expect shading—that's how *real* objects look.

style or school—instead, the term encompasses many styles and schools. Although some think of "modern art" as necessarily abstract or nonobjective, the broader meaning includes much more than that. Many historians peg the beginning of modern art to the time of the Barbizon School, the Impressionists and others whose work was by no means abstract. Since that time there have been a great many very different directions in art, but most of them have in common a breaking loose from any sort of limits—artists today feel quite at liberty to experiment in any and all direc-

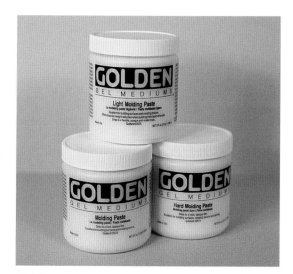

Modeling paste

Manufacturers offer a variety of modeling pastes. Here are three examples: a regular paste, a much denser and heavier paste, and one that dries harder than others. This manufacturer calls its product "molding paste." Courtesy of Golden Artist Colors, Inc., 188 Bell Road, New Berlin, NY 13411-9527.

tions. Included in modern art is not only the freedom to comment on social, political and intellectual conditions, but also to experiment freely with new materials and techniques.

moisture problems

Drawings and paintings on almost any support are subject to problems caused by moisture. **1:** Papers and panels may warp and canvas may sag on its stretchers because most of these materials expand when they absorb moisture. **2:** Fabrics, papers and wood may rot after long exposure to moisture. **3:** Stains may appear on works on paper (*see foxing*). **4:** Under high-moisture conditions, various kinds of molds and mildew may form on almost any surface. **5:** Moisture may cause a haze in or on the surface of varnish (*see bloom*). **6:** Paintings done using water-based media (e.g., watercolor, gouache, egg tempera) may become blotched or streaked by moisture such as that from accidental spills or from droplets condensing on the inside surface of the glass under which they are framed.

All works of art should be protected from exposure to moisture extremes, including high relative humidity. Work stored in damp basements or enclosures with little or no ventilation are extremely vulnerable. Works hung or placed in a normal household environment are reasonably safe from moisture damage.

molding paste

See modeling paste.

monochrome

A painting or drawing done in varying shades of a single color or in several colors that are all very close in hue (such as slightly differing browns or blues). *See example by Borys Buzkij under sgraffito.*

monoprint

A print made by inking an etching, engraving, lithographic, collagraphic, or other plate, in the usual way and then adding ink to the surface of the plate—in effect, painting another image on top of the one already existing on the plate. The result is an image that combines the qualities of both a prepared plate (engraved, etched, etc.) and the added ink. A monoprint is not a print in the usual sense, since more than a single image can be obtained only by the most careful overinking of the already-inked plate multiple times—inking exactly the same image is obviously difficult, if not impossible. A few artists, such as Rembrandt van Rijn, managed to do this quite successfully. There are all kinds of variations artists use in this technique, as in most others. Jasper Johns, for example, made monoprints by inking a plate but then painting the added image with acrylic or oil.

monotype print Plexiglas wet paint on Plexiglas

monotype

An impression made by first painting or inking a sheet of glass, metal or other smooth surface and then pressing paper against the wet paint or ink using either a press, pressure from the hands, a baren or some other tool. Each successive impression is considerably more vague than the last, so usually only a single usable print results. Since that is the case, why not simply paint directly on paper in the first place? The reason is that the image achieved by this method has a different character from a directly painted or drawn image. The squeezing of the paint or ink as paper is pressed against it, the slight shifting of the paper while pulling it from the wet surface and the suction of the paint or ink as the paper is pulled away all combine to produce a unique image. Many artists, including Edgar Degas and William Merritt Chase, produced beautiful monotypes.

Monotype

A simple monotype "print" being pulled. The image was first painted on Plexiglas using watercolor paint. A sheet of hot-press watercolor paper was laid over the wet paint and firm, even pressure was applied using a roller. The nature of the resulting image depends a lot on the amount of pressure you use. If a second image were pulled from this same painted surface, it would be more vague than the first. Very often this procedure is used to establish a general color pattern, and then the picture is finished with conventional brushwork. The masking tape rectangle on the bottom of the Plexiglas helps to place the print properly.

montage

A picture made up of a number of separate pictures or parts of pictures, all related to one another in some manner. The parts of a montage have a common theme. In the illustration, the theme is a particular town, represented by some of its familiar landmarks. The theme of a montage can be anything—family ties, occupations, antiques, automobiles, household pets and so on. Unlike the montage shown here,

Montage

many are done in collage form using such mediums as photographs and newspaper clippings.

mood

A state of mind or emotion, important in most, if not all, works of art. Mood may be suggested in many ways. In a painting *color* is often a dominant factor—bright yellows and reds, for example, may set up a cheerful, upbeat or active mood; dark blues and browns may signal a quiet or somber mood. However, no "rules" can be set for the use of color in expressing mood—a strong red representing a pool of blood may, after all, be anything but cheerful. Most painters choose color schemes that will convey their idea of the mood of a scene, but often this selection is made subconsciously.

Factors other than color can affect mood—*value*, for instance. The darkness of a color may suggest one mood, while a much lighter version of that same color may suggest an opposite mood. This is most apparent when dealing with only black, white and gray. The use of large areas of gray may set a quiet tone, while juxtapositions of bright whites and dense blacks may create a great deal of excitement.

In painting, drawing and sculpture, *shapes* have a powerful influence on mood. Gently curved shapes may suggest quiet; sharp or oblique shapes may imply excite-

Mood

You might read more than one mood into this painting. Some would see a threatening scene with a storm on the way; others might see a storm that has broken and given way to the light breaking through.

SEDONA STORM CLOUDS II | Donald Holden | watercolor on Arches 300-lb. (640gsm) cold press | 7¼" × 10¾" (18cm × 27cm). Photo courtesy of Susan Conway Gallery, Washington, D.C.

Mood

The dark sky says impending storm, but the lighted areas make the mood a bit cheerier, at least until the storm hits.

WINTER MOOD | acrylic on canvas | 24" × 30" (61cm × 76cm). Collection of Pat and Pete Buynak, Woodstock, VA.

Mood

Here's a cheerful scene with bright colors setting the tone, but notice how quiet the scene is. The quiet mood is set by the calm of the water, which in turn is suggested by the long horizontal streaks in the water. Horizontal shapes nearly always suggest a calm, quiet situation; strong verticals or diagonals imply action.

Watermen's Dories | Ross Merrill | oil on canvas | 30″ × 40″ (76cm × 102cm)

ment, action or danger. And finally, *textures* help set a mood. Smoothness usually creates a quiet mood (or sometimes even a mood of danger or foreboding), while roughness may create excitement.

mop

A soft, full brush that holds a large amount of fluid paint; used in watercolor for large areas such as skies. *See brush, painting. See illustration on page 260.*

mordant

1| Acid used in the etching process to "bite" the metal plate. 2| A substance used as an adhesive to secure gold leaf to a surface. 3| A chemical used to bind a dye to a material; some dyes by themselves will not attach to surfaces such as cloth unless assisted by the addition of a mordant—in this sense, a mordant is sometimes called a fixative.

mortar and pestle

A simple device for grinding materials such as pigments. The mortar is either a hard slab with a depression or a vessel

Mop

Mortar and pestle

such as a ceramic dish; the pestle is a hard, rounded object, often glass or ceramic, used to grind material against the mortar. Centuries ago larger versions were used for grinding grains; today, smaller versions are used for grinding or mixing small amounts of pigments.

mosaic
1| An ancient form of decorative art using small pieces of glass, tile or pebbles pressed into a plaster or other ground.
2| In photography, a term for photos pieced together from a number of separate exposures, often used in aerial surveying.

motif
A theme or dominant element in an artwork or series of artworks. Sometimes the motif is a generic one, such as a red barn; in other cases, motif means a particular, usually popular, subject such as a well-known barn, dock, bridge or lighthouse.

mouldmade paper
Originally, paper made by hand in a mould, one sheet at a time, but now paper made by machine in *imitation* of handmade paper. *See cylinder machine; papermaking.*

mounting of prints
Prints and other works on paper are usually fastened (mounted) to the rear of a mat or to the front of a backing. *See framer's tape; mat board; framing.*

mouth diffuser
A bottle-and-tube arrangement that allows one to spray a fine mist of a fluid by blowing through the tube. *See atomizer.*

MSA
Mineral spirit-based acrylic, a paint whose binder is an acrylic resin based on mineral spirits rather than water. Unlike traditional acrylic paint, MSA paints are soluble in

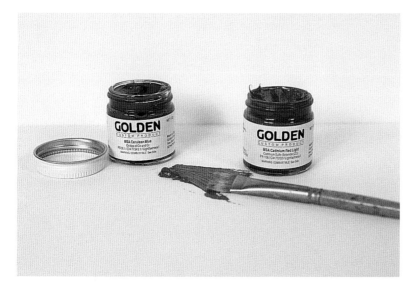

mineral spirits or turpentine. When blended with oil or alkyd paints, they have the "feel" of oil but dry much more quickly. Once dry, they can be removed with mineral spirits.

mucilage
A thick solution of gum in water, used as an adhesive. Gums are sticky substances exuded by many varieties of plants.

muddy color
Color that has lost its vibrancy and become dull. The usual causes are **1**: Overmixing colors; when two colors are combined on the palette, the more they are mixed the more likely the result will be muddy; or **2**: mixing incompatible colors. *See illustration on page 262.*

muller
A hard instrument with a flat end used to grind materials such as pigments against a hard base. Similar to pestle, but a pestle has a rounded end.

Munsell Color System
See color systems.

mural
A painting made as an integral part of a wall or ceiling. Usually a mural is planned to complement the architecture of a place rather than to be simply considered a large painting hung on a wall or ceiling. Following is a mural by Michael Svob; you may see more of his work, including this mural, in the April/May 1999 issue of *International Artist* magazine. *See illustrations on pages 263-265.*

museum board
Mat board that is archival, usually made of acid-free 100% rag fibers. Museum boards in white and off-white are also often used as painting supports for watercolor, acrylic,

gouache, pastel, graphite and other medi-
ums. *See archival; rag; acid free; mat board.*

museum quality

Usually this term refers to art materials
rather than to art, and it signifies materi-
als that are archival—that is, of a reason-
ably permanent nature.

Mylar drafting film

A popular brand of nearly transparent
acetate, available slightly textured on one
or both sides. The textured surface will
accept many mediums, including colored
pencil and watercolor paint. Some artists
use Mylar as their support (*see the work of
Robert Guthrie under colored pencil*). You may
also use it for trying out corrections by lay-
ing a piece of Mylar over a drawing or
painting, textured side up, and making
changes using grease pencil or paint.

Muddy color
Here are two pairs of colors (Cadmium Red + Hooker's
Green and Yellow Ochre + Cobalt Blue) that have been
overmixed, producing a dull result. Keep in mind, howev-
er, that there is no absolute definition of dull or muddy—
what looks like bad color to one painter may look just
right to another for some specific need.

Mural

This is an ink layout, drawn to scale, worked out in Svob's studio. He tried various designs in pencil before arriving at this one, which he then inked over to make it sharp enough to project well using an opaque projector.

Mural

Using a roller, Svob covered the entire wall with acrylic paint. This strong underpainting has a great impact on the final mural. An important secondary reason for an underpainting is to fill in the thousands of tiny cracks and irregularities in the stucco wall. Svob says: "It would take the patience of Job to fill the holes by brush." He used a movable scaffold to work his way along the wall.

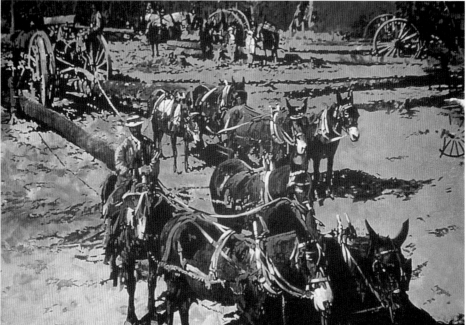

Mural
Detail 1.

Mural

After finishing the underpainting, he used an opaque projector to cast the drawing onto the wall so that he could trace it off. He did this at night so that the image would be easier to see and trace. A side benefit of working at night was that the daytime temperatures were above 100°! During the next few weeks (the project took a total of 28 days) he painted, using the most lightfast acrylic paints, working from top to bottom to minimize dripping paint onto already finished areas. He laid in broad areas of transparent glazes and finished up each area with translucent and opaque passages. One obvious requirement for an artist working on such a scale is stamina. Constantly climbing up and down the scaffolding to "step back" and view the work in progress is no minor concern.

MULES IN THE WIREGRASS | Michael Svob | acrylic paint on a stucco wall, Dothan, Alabama | 30′ × 100′ (9.1m × 30m). Reprinted with permission of The Downtown Group, Dothan, AL.

Mural

Detail 2.

Nabis /nah bee/
A group of painters during the 1890s, led by founder Paul Sérusier, dedicated to the painting and color ideas of Paul Gauguin. The group, which included Maurice Denis, Pierre Bonnard and Edouard Vuillard, treated Gauguin's ideas as profound, almost mystical revelations and accordingly chose their name, Nabis, from the Hebrew *navi*, meaning prophet.

naïve art [also called naïf art]
In most common usage, art produced by someone untrained in art. *See discussion under primitive art.*

naturalism
There is much disagreement among art historians about the meaning of this term and about when and by whom it was practiced in art. It seems a useful term only if used in this broad generic sense: an attempt to render a subject realistically.

needlework
A broad term that includes various ways of making or decorating a fabric. For *making* a fabric, knitting and crocheting are used. Both usually involve a single strand of thread or yarn looped together to make a fabric. In knitting, two needles (metal rods without eyes) are used to connect series of loops; in crocheting a single needle with a hook at the end is used to form a chain of loops and to connect one chain of loops with the previous, parallel chain.

For *decorating* a fabric, many forms of embroidery are used. Embroidery involves yarn or thread run through the eye of a needle and stitched in decorative patterns through a base fabric. Sometimes embroidery is fairly flat, but often it is done in relief so that the resulting pattern is not only colorful but tactile. One of the many forms of embroidery is called cross-stitch, shown here. Cross-stitch is a popular craft in America and elsewhere.

negative painting
Painting negative space. Usually, negative space is darker than the positive space being painted around, but there is no reason negative space may not be *lighter* than the positive space. Painting negative space lighter than positive space is sometimes called *reverse negative painting* and this technique usually implies the use of opaque paint. *See example under reverse negative painting. See illustration on page 268.*

negative space
The space around an object in a picture. *See illustration under positive space.*

Neoclassicism
A period (1750-1830) of revival of the art of

Needlework

The cross-stitch embroidery pattern involves two stitches crossing one another diagonally across the inter-section of a horizontal and a verti-cal thread in the base fabric. Each cross-stitch forms a tiny square and the finished work has a characteris-tic squared-off look.

JANE'S SAMPLER | Lola Akers | cross-stitch on cotton fabric | 19″ × 15″ (48cm × 38cm). Photos of cross-stitch work reproduced with permission from The Prairie Schooler, Inc., PO Box 8381, Prairie Village, KS 66208. Designs by Pam Brunke.

Needlework

A cross-stitch design in progress. The hoop confines the section of cloth being worked on, holding it taut to make for easier stitching. Courtesy of Lola Akers.

ancient Rome and Greece and of the Renaissance, perhaps as a reaction to the sometimes gaudy and ostentatious art of the Baroque. Jacques Louis-David was Neoclassicism's undisputed champion.

Neo-Impressionism
An art movement of the late 1800s that attempted to analyze and systematize the use of color. French painter Georges Seurat, the leader of this movement, painted with small, carefully placed dots of color in contrast with the Impressionists' freer, more spontaneous dabs of color. Also called *Pointillism*.

Neoplasticism
A Dutch movement in painting and sculpture, begun by Piet Mondrian, aimed at painting pure form and color, totally free from realism and free from the artist's temperament.

newsprint
A thin, cheap, acidic paper made from wood pulp and used only for temporary work such as sketches. Newsprint is sold mainly in pads of various sizes, but it's also available in sheets and rolls.

nib
Pen point; or the sharpened point of a quill.

nonobjective art
See nonrepresentational art.

nonphoto blue pencil
See pencil, nonphoto blue.

nonrepresentational art
Art not intended to depict real objects. Nonrepresentational art, whether two- or

Nonrepresentational art

This painting relies on the skillful use of color, value and texture rather than objects for its impact. Cover painting from the catalog for Harold Larsen's 1999–2000 exhibition at the Art Museum of the Americas, Organization of American States, in Washington, D.C.

RED PASSION | Harold Larsen | acrylic on canvas | 68″ × 90″ (173cm × 229cm)

Nonrepresentational art

UNTITLED | acrylic and rice papers on hardboard | 32″ × 38″ (81cm × 96cm)

a
B
C
D
e
F
G
H
I
J
K
L
m
n
o
P
Q
r
s
T
u
V
W
X
Y
Z

North light

Light through a south window shifts rapidly throughout the day; light through a north window stays much more constant.

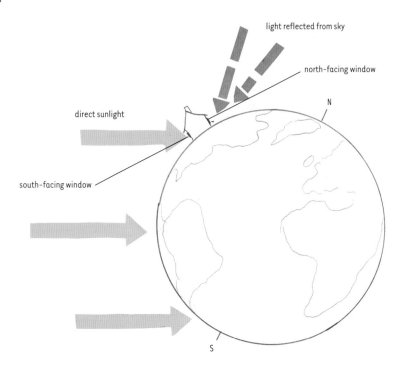

light reflected from sky

north-facing window

direct sunlight

N

south-facing window

S

three-dimensional, relies on qualities such as form, color and texture for its impact. Also called *nonobjective* art. Compare to *abstract* art.

north light

Light that enters a room through a north-facing window. In the northern hemisphere there is a distinct difference between the light you get through north-facing windows and the light you get through south-facing windows. The light through a south window is direct, so as the sun travels the southerly sky the light through a south window shifts markedly. But light through north windows is indirect—that is, it's scattered light reflected from the sky rather than light straight from the sun. That reflected light shows far less shift in color, intensity and direction during the course of a day. This relatively unchanging character is what artists like about north light. In the southern hemisphere, everything is reversed and

south light is desired. Of course, if you set up indoor lighting with a color balance that pleases you, you can have unchanging light all day every day—no matter which hemisphere you live in.

Not-pressed paper [usually capitalized] This term, used mostly in England, describes the surface texture of a paper, especially watercolor paper, and it means whatever various manufacturers want it to mean! Most often it seems to mean "not hot pressed"; often it means "cold pressed"; but at least one source describes it as meaning "hot pressed." After consulting paper manufacturers, art dictionaries and artists' handbooks and having found totally conflicting definitions, I feel the term is one that deserves to be put to rest as not at all useful. Stick with the three terms most consistently used and understood: hot press (smooth), cold press (slightly textured) and rough (heavily textured).

objet trouvé |*ahb* zhay troo *vay*|
French for found object. An object not *intended* as a work of art, but deemed suitable for inclusion in a work of art. *See found object.*

oblique perspective
The way an object is seen when none of its faces are parallel or perpendicular to the picture plane; two-point perspective. Also called *angular perspective*. *See discussion under linear perspective.*

odorless thinner
A solvent such as turpentine or mineral spirits that has been treated to reduce its objectionable odor. Odorless does not imply *nontoxic.*

offset lithograph
See lithograph, offset.

offset reproduction
A reproduction made using the process of offset lithography. *See lithograph, offset; reproduction.*

oiling out
Rubbing the dried surface of an oil painting with linseed or other oil. This was once a fairly common practice, the intent of which was to give the surface of the painting a uniform appearance—that is, to eliminate "dry" spots and impart a soft, all-over glow. Excessive use of this technique leads eventually to yellowing. The better approach is to use picture varnish.

oil medium
1| Any of a number of fluids used by oil painters to modify oil paint. For example, stand oil may be mixed with oil paint to improve its "leveling" quality—that is, its ability to form a smooth film as it dries. Other mediums, such as Liquin, may be used to thin oil paint so that it may be used as a glaze. Still others are added to speed up the drying of oil paint—included here are alkyd resin preparations, such as Liquin, and cobalt driers. 2| Oil paint.

oil paint
Paint containing pigment and a vegetable oil binder. The most common binder is linseed oil, but sometimes poppyseed or other oils are used along with or in place of linseed oil. The proportion of oil to pigment varies considerably from one color to the next—some pigments require more oil to make them brushable and manageable. As a result of the different proportions of oil, there is a significant variation in drying times for the various colors, so some of the slower-drying paints have driers added to speed up the process. In addition to pigment, binder and driers, some paints

include an ingredient to give a "stringy" paint a more buttery consistency. Oil paint "dries" by oxidation of the oil, not by evaporation; the resulting paint film is brittle compared to the more flexible acrylic paints.

Oil painting, in use for over five hundred years, remains one of the most popular of mediums. Oils may be applied in thin veils (glazes) or in thick, vigorous passages (impasto) or anything in between. They may be blended easily because they dry so slowly, and a huge range of lightfast hues is available. Oils, unlike watercolors and gouache, do not change in value as they dry—what you see is what you get.

On the negative side, the slow drying that makes oils so attractive to some painters is frustrating for others. It may not be possible to paint a new layer the next day because the previous layer is still tacky, and you may have to wait months

Oil paint

When he's not painting oils and alkyds outdoors (he rarely paints indoors), Ross Merrill is tending business at the National Gallery of Art in Washington, D.C., where he is Chief of Conservation. As you might expect, that job influences his choices of materials for his own painting—he has seen more problems with paints, supports and so on than most of us will ever experience.

After sizing his stretched linen canvas with PVA (polyvinyl acetate), Merrill applied a white alkyd ground lightly tinted with Raw Sienna oil color. He did a thin underpainting, using oil paint thinned with alkyd medium, and then built up the finished painting using progressively thicker paint and less medium. Alkyd medium causes the paint with which it is mixed to dry more rapidly than straight paint, so you should use more medium for the first stages and less medium for the later layers. In any oil painting, it's important that early layers not be slower-drying than later layers (see *fat-over-lean rule, oil*). Although in this picture Merrill used oil paints throughout, he often does the early stages (the underpainting) using alkyd paints because alkyds dry faster, thus allowing him to get on with the work. Alkyd and oil layers are completely compatible. For this painting, Merrill chose Gamblin products, including an alkyd ground, alkyd medium and oil paints.

SKIFF IN THE COVE | Ross Merrill | oil on canvas | 30″ × 40″ (76cm × 102cm)

Oil paint

Borys Buzkij usually forms his images as he goes, with no preliminary drawing. Painting on hardboard panels with white grounds, he paints boldly and directly, often wiping out areas to reveal layers underneath, and frequently moving paint around with his fingers.

WOMEN IN RED | Borys Buzkij | oil on Masonite panel | 18″ × 24″ (46cm × 61cm)

Oil paint

Teacher Ed Ahlstrom painted this picture as a class demonstration. He was attracted to these trees, with their tall, straight, evenly textured trunks, rather pale in the morning light. "The bright June morning light," he says, "made the trunks quite warm and the shadows delicately violet. I was struck by the pattern of the trunks and shadows and thought it enough for a picture."

SUNNY MORNING | Ed Ahlstrom | oil on hardboard panel | 5″ × 6″ (13cm × 15cm). Courtesy of Gallery K, Washington, D.C.

a
B
C
D
e
F
G
H
I
J
K
L
m
n
o
P
Q
r
s
T
u
V
W
X
Y
Z

Oil Origins

Oil paints had been used long before they became the primary medium for artists—the Roman scholar Pliny the Elder in the first century AD reported the use of oil paint for decorating shields, and many scholars believe it was used as a glaze in some medieval manuscript illumination. But not until the fifteenth century did artists widely adopt oils for use in their easel paintings. Its first use was as a glaze over paintings done in egg tempera. Before oil paint came on the scene, the two most common forms of painting were egg tempera and fresco. It's not known who first used oils for easel painting, but it's generally accepted that the Flemish painter Jan van Eyck (about 1395-1441) perfected their use.

before varnishing and selling the painting. Also, painters must pay attention to the "fat-over-lean" rule to avoid unnecessary future cracking of the paint film (see fat-over-lean rule, oil).

Oil painters are confronted with a bewildering array of special mediums intended to alter the working characteristics of the paint. The best advice to ensure trouble-free painting might be to avoid gimmicks and to use paint straight from the tube, except where a medium is necessary to thin the paint for underpainting or for glazing.

oil paint, cracking of

Cracking of an oil painting has a number of causes, some of which have to do with unsound painting practices, but most of which are the result of environmental conditions. Among the causes of cracking: **1**: Mixing too much drier with the paint, causing the exposed paint to dry faster than the paint underneath. **2**: Artificial drying of an oil painting using heat (a practice that works fine for watercolors, but not for oils). Again, the outer "skin" of the oil dries before the inner paint. **3**: Use of copal varnish mediums during painting. **4**: Varnishing before the paint has had adequate time to dry. **5**: Painting on a flexible support. **6**: Ignoring the "fat-over-lean" rule. **7**: Mixing foreign materials, such as acrylics, with oils. **8**: Hanging or storing the finished painting in an area subject to extremes of temperature and humidity. This last category is most important of all—uncontrolled humidity causes dimensional changes that lead directly to cracking.

oil paint, darkening of
See yellowing, paint.

oil paints, comparing
The chart on page 275 lists some similarities/differences among various types of oil paints. See sidebar.

oil pastel
Color in stick form, similar to pastels but with oil and wax ingredients in place of the gum found in regular pastels. The first oil pastels, called Cray-Pas, were made in the 1920s with children in mind. In 1949 artists Henri Goetz and Pablo Picasso asked French manufacturer Sennelier to make

Yellowing

It's the linseed oil in oil paint that yellows with age, not the pigments. If you add linseed oil mediums to your paints, you increase the chances of yellowing. It's best to use only the amount of oil-containing medium you need to get the effect you want; don't routinely dip your brush into the medium with each stroke.

Comparing Oil Paints

Paint	Relative Drying Times	Clean Up With	Resistance To Damage	Health Risks From Solvents
Alkyd	faster than oil, slower than acrylic; unlike oil, all alkyd colors dry at about the same rate	turpentine, mineral spirits, citrus solvent	less likely to crack than oil film	solvents toxic and flammable
Oil	slow; colors dry at much different rates (e.g., Burnt Umber dries much faster than Titanium White)	turpentine, mineral spirits, citrus solvent	can crack and yellow over time	solvents toxic and flammable
Oil Pastel	does not dry, but remains soft to the touch, similar to children's crayons, but softer	turpentine, mineral spirits, citrus solvent	can be scratched or water damaged	solvents toxic and flammable
Oil Stick	slow, but not as slow as regular oil paint	turpentine, mineral spirits, citrus solvent	can crack and yellow over time	solvents toxic and flammable
Water-Miscible Oil	slow, like regular oil paint	soap and water	can crack and yellow over time	negligible

an artist-quality oil pastel; Sennelier's modern oil pastels are acid free because the oil in them is petroleum-based, rather than a vegetable oil. Oil pastels are available now in a wide variety of colors. Some artists use them along with regular pastels; some use them alone. They have a big health advantage over pastels in that they give rise to no dust at all.

Oil pastels may be applied to almost any surface, including slick surfaces that would not hold regular pastel. They do not dry, but remain soft, much like children's crayons, and may be reworked after any time interval. As is the case with regular pastels, a stroke can dislodge earlier layers, so later layers are often done using sharpened pieces for detail work. Like children's crayons, oil pastels and pictures made

from them should be kept away from heat—don't leave them on a hot radiator, for example. Pictures should be protected by being framed under glass. Oil pastels may be moistened and brushed with turpentine or mineral spirits to make a wash. They may be applied over other paintings—some artists, for example, use them for final surface touches on an oil or acrylic painting—but conservators don't consider such use archivally sound. *See illustration on page 276.*

oil stick
Crayon-like sticks that contain pigment, oil and a paraffinlike wax. Oil sticks behave in much the same way as oil paint, except that they are not fluid. Their marks may be included in a conventional oil or alkyd

Oil pastel

Oil pastel sticks make soft marks that stay soft. Here I've scraped away some of the pastel easily with a razor blade.

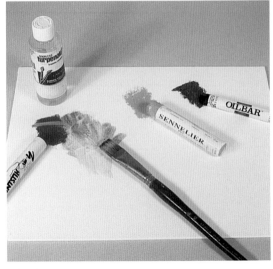

Oil stick

Oil sticks may be mixed with oil or alkyd in a painting or used for final surface touches. Oil sticks may be diluted with turpentine or mineral spirits and brushed the same as oil paint.

painting; they may be thinned with any oil solvent to brushing consistency. The marks from an oil stick dry a bit faster than conventional oil. Oil sticks are used in a number of ways, but especially as a sketching medium or to add surface texture to an oil, alkyd or acrylic painting. Although they may be easily used on paper or canvas surfaces, they are oils (and therefore acidic) and can eventually damage untreated paper or canvas.

old master

Any of the distinguished artists of the sixteenth, seventeenth and early eighteenth centuries.

one-point perspective

Linear perspective in which one face of the object is parallel to the picture plane and all horizontal receding lines meet at a single vanishing point. Also called *parallel perspective. See linear perspective.*

Op Art

Art that relied on optical tricks or illusions to evoke visual responses; also called *optical art.* Op artists—mostly painters, but also some sculptors—used bold colors and geometric designs in ways that made their pictures seem to move or vibrate. Some painted intense complementary colors side by side; others painted stripes, checkerboards, lines or concentric circles. Op Art was active in the late 1950s and the 1960s, mostly in the United States but also in Europe. Among the better known Op artists were Victor Vasarely, Bridget Riley, Richard Anuszkiewicz and Larry Poons.

opaque color

Color applied thickly enough to hide what lies beneath it.

opaque projector

A device for casting an image from paper or other opaque materials onto a screen; also called an *episcope. See projector.*

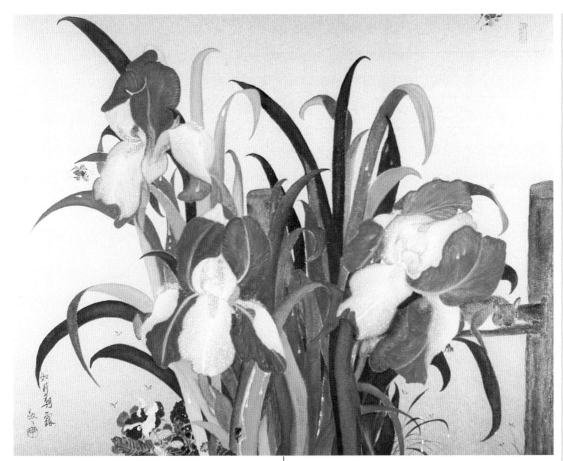

optical art

Op Art.

Oriental art

The painting of Asian countries, especially China and Japan. Traditional Oriental art emphasizes line and the vitality of each brushstroke; it tends to give low priority to elements that Western painters hold dear, such as perspective, shading and individual expression. A characteristic of Oriental art is its continuing emphasis on lifelong learning and practice, a tendency not always present in Western art. Using simple tools—mainly the pointed bamboo brush and either monochrome or colored inks—Oriental artists have always striven to express their subjects through the linear strength of their brushwork. But during the nineteenth and twentieth

Oriental art

The title means "February, Morning Dew." Keiko attributes her painting discipline to the guidance of her father, who began her training in Japan when Keiko was just three years old. She works in the traditional Japanese way, using mineral-based inks, bamboo brushes and silk or rice paper supports. In this painting the support is a sandwich of several materials glued together. The outer layer, that on which she paints, is silk. Next is a thin layer of rice paper, then a layer of gold leaf and finally twenty-four more layers of rice paper. The gold leaf glows through the white silk to give the painting its golden background. In most of her painting, this artist uses combinations of five inks: black (soot made from charred plant seeds or ivory), yellow (from a type of willow tree), red (garnet), white (sea shells) and blue (turquoise). The binder in her inks is an animal glue called "nikawa."

Kisa Ragi A Sa Tsu U | Keiko Hamas | inks on silk | 19" × 23½" (48cm × 60cm). Collection of Fred and Paula Sorrell, Arlington, VA.

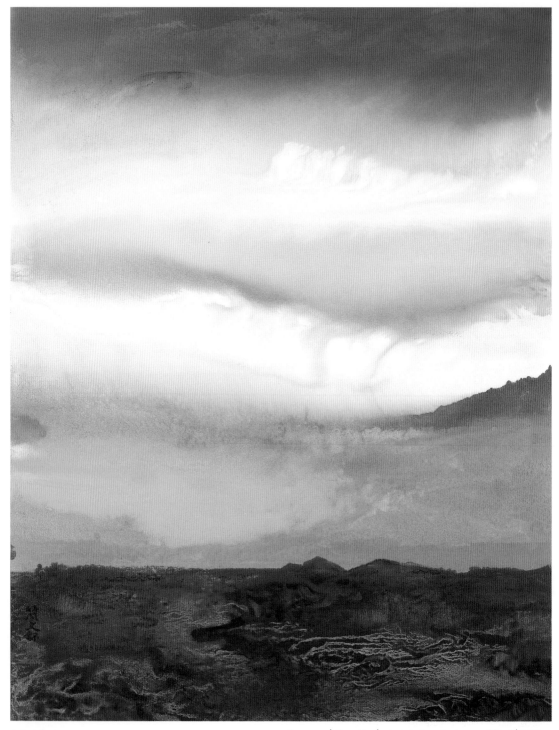

Oriental art

One of the paintings from Diana Kan's exhibit (called Eastern Spirit Western World) at the Taiwan Museum of Art in 1995. As in many of her paintings, the support here is composed of three layers: a stiff paper backing, a layer of fragile gold leaf and a final layer of rice paper so thin that the gold leaf glows through the paper. This is an example of painting in the p'o-mo technique. *See p'o-mo.*

DAYBREAK | Diana Kan | oriental mineral color on gold leaf | 23¼″ × 17¼″ (59cm × 44cm). Collection of the artist.

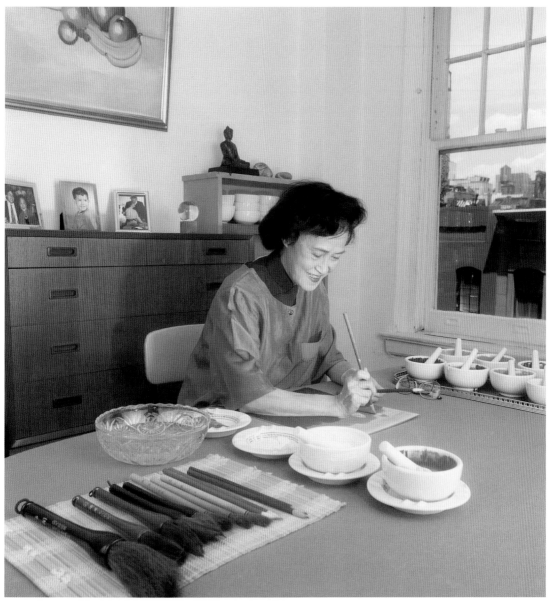

Oriental art

Diana Kan at work in her New York studio. Born in China, Diana has
lived and worked in the United States for more than fifty years. She
is an energetic participant in many art organizations and has trav-
eled and exhibited in many venues, including Hong Kong, Shanghai,
Macao, New York, San Francisco, Washington, D.C., Boston, London
and Paris. Trained at an early age in the techniques of Chinese ink
painting, she now combines watercolor and mineral paints in most
of her work. Over the years, her work has increasingly bridged
Eastern and Western art disciplines. Photographs courtesy of Sing-
Si Schwartz, Diana's son.

centuries there has been so much adoption of Western themes and techniques (and a corresponding flow of Oriental ideas to Western painters) as to make any "definition" of Oriental painting as fruitless as trying to define Western painting in a paragraph or two. It seems reasonable to state that Oriental art still exhibits strong ties to nature, but of course so does much Western painting. One influence of Western painting is the introduction of fluid washes in addition to traditional brush strokes. Such fluid color may be seen here in the work of Diana Kan. *See p'o-mo; sumi-e.*

oriental ink

Traditional Chinese and Japanese black ink, usually made in the form of ink sticks (a combination of carbon and glue). *See sumi-e.*

orientalism

Characteristics of oriental art and culture adopted or mimicked by Western artists.

oriental mineral color

An opaque water-based paint similar to gouache. Available in powder form in small packets, it's mixed with water and a

Oriental ink
Grinding a stick of oriental ink in water.

Oriental mineral color
Oriental mineral color may be purchased either in powder form in small paper packets or premixed in dishes, both shown here. To use the powder, mix it with water and a little glue to form a paste. Lena Liu uses Elmer's glue, adding roughly $\frac{1}{8}$ teaspoon to a packet of powder. Here you can see the glass mortar and pestle she uses for grinding or mixing colors.

Oriental mineral color

A typical oriental-style painting. Liu uses mostly traditional tube watercolors but adds opaque touches with oriental mineral color that she buys from a supplier in China; in this picture she has also used black oriental ink. To work on silk, she stretches the fabric on stretcher strips in the same manner as one would stretch cotton or linen canvas.

FIRESIDE SOLITUDE | Lena Y. Liu | watercolor and oriental mineral color on silk | 20″ × 20″ (51cm × 51cm)

Overlap
Which is closer to you—the box or the ball? Or are they both the same distance away? Overlapping them resolves the question.

little glue to form a paste. Usually kept in small jars or ceramic dishes, it may be rewet for use any number of times in the same manner as traditional watercolor or gouache.

origami
The Japanese art of folding paper into artistic designs. In Japan there is a substantial body of literature describing hundreds of basic traditional folds. Some origami artists, such as Yoshizawa Akira (who has written several books on origami), have developed incredibly complex folds, some of which include moving parts.

original print
A repeatable image produced in limited numbers by, or under the direction of, the artist who designed it. Examples are etchings, engravings and lithographs. *See print; reproduction.*

Ostwald Color System
See color systems.

Ottonian Art
European art from about 950 to 1050 AD, named for three successive German rulers of the Holy Roman Empire, all named Otto, who reigned shortly after the time of Charlemagne. After Charlemagne's death, there was a period of political and social turmoil. The Ottonians restored order and

continued and energized the artistic activity begun under Charlemagne. There was a great deal of activity in ivory carving and in large wood sculpture, such as crucifixes and reliquaries (shrines or containers in which sacred relics were kept), and in the building of churches and monasteries.

overlap

A technique for suggesting depth in a picture. By overlapping two objects, the one in front is clearly made to seem closer to the viewer, while the one in back seems farther away from the viewer. *See illustration on page 282.*

ox gall

An alkaline substance from the liver of an ox, used as a wetting agent. Painters working in watercolor or other water-based media sometimes find that their paint tends to contract into a puddle rather than spread evenly over a surface. This is due either to the surface tension of the water or the resistance to wetting of the surface being painted—or both. A few drops of ox gall or other wetting agent helps the paint to spread satisfactorily.

ox hair

Moderately priced hair from several varieties of cattle, used in artists' brushes. *See brush construction.*

a
B
C
D
e
F
G
H
I
J
K
L
m
n
o
P
Q
r
s
T
u
V
W
X
Y
Z

paint

Any material in fluid, powdered or solid form used to make colored marks on any surface. In common usage, even "dry" materials such as pastels may be called

004 B S1
T St

Paint

Here are the meanings of the symbols for Winsor & Newton Alizarin Crimson from the accompanying chart:

004	Winsor & Newton's own color code
B	moderately durable
S1	series 1, Winsor & Newton's lowest-priced category
T	transparent
St	staining color

paints. All paints have several attributes important to the artist: hue (commonly called color), permanence or lightfastness, opacity and toxicity. Almost all paints contain a pigment and a binder to hold the particles of pigment together and make them adhere to some surface—the exceptions are **1**: certain liquid watercolors that contain dyes rather than pigment particles and **2**: fresco paint, which normally contains only pigment and water. Most paints also contain other materials to make the paint more responsive to the artist's needs.

On pages 286-287 is a chart showing one manufacturer's range of watercolor paint hues. Other manufacturers offer similar sets of paints in various forms—oil, watercolor, acrylic and so on. One manufacturer's hue may not be exactly the same as another manufacturer's, even though they often use the same names. There are other differences, too, including the opacity of paints, their lightfastness and the proportions of binder to pigment used. Artists must determine the best paints for them based on their own trials of competing paints; often artists mix paints from different manufacturers.

paint rag

Any cloth used to clean paint from brushes, palettes and so on. Oil painters should not routinely store paint rags in a confined

Comparing Paints

Medium	Film Strength	Drying Time	Resistance To Physical Damage	Adhesion To Proper Support	Health Risks (other than toxic paints)
Acrylic	tough, flexible at normal room temperatures not below 40 degrees F	fast	high, except when cold	high	low
Acrylic Gouache	tough, some-what flexible	fast	high, but can be stained by water	high	low
Alkyd	tough, less brittle than oil	moderate	high	high	high; solvents
Casein	brittle	fast	low; can be scratched or water damaged	high	low
Colored Pencil	no appreciable film	n/a	moderate; can be smudged	high	low
Egg Tempera	tough, brittle	fast	moderate; can be scratched or water damaged	high	low
Gouache	brittle	fast	low; can be scratched or water damaged	high	low
Oil	tough, brittle	slow	high	high	high; solvents
Oil Pastel	flexible	does not dry	low; can be smeared	high	low
Oil Stick	tough, brittle	slow	high	high	high; solvents
Pastel	fragile	n/a	low; can flake off	low	high; dust
Watercolor	no appreciable film	fast	moderate; can be water damaged	high	low
Water-Miscible Oil	same as oil paint	same as oil paint	same as oil paint	same as oil paint	low; water as solvent

a b c d e f g h i j k l m n o P q r s t u v w x y z

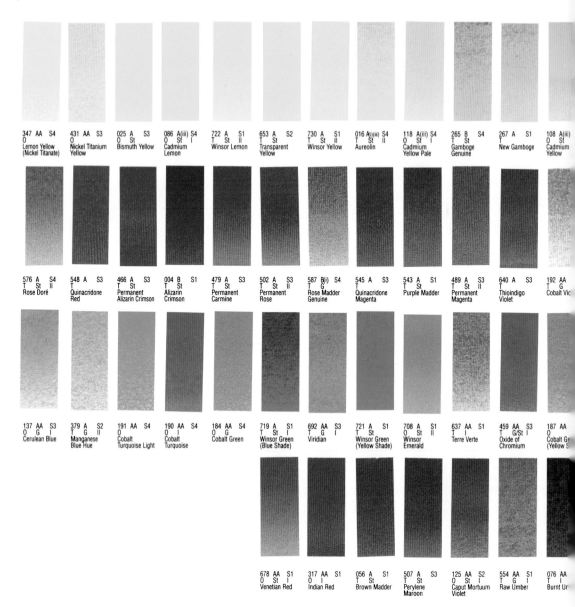

347 AA S4
O
Lemon Yellow
(Nickel Titanate)

431 AA S3
O
Nickel Titanium
Yellow

025 A S3
O St
Bismuth Yellow

086 A(iii) S4
O St I
Cadmium
Lemon

722 A S1
T
Winsor Lemon

653 A S2
T
Transparent
Yellow

730 A S1
T St II
Winsor Yellow

016 A(i)(iii) S4
O St II
Aureolin

118 A(iii) S4
O St
Cadmium
Yellow Pale

265 B S4
T St
Gamboge
Genuine

267 A S1
T
New Gamboge

108 A(iii)
O St
Cadmium
Yellow

576 A S4
T St II
Rose Doré

548 A S3
T
Quinacridone
Red

466 A S3
T St
Permanent
Alizarin Crimson

004 B S1
T St
Alizarin
Crimson

479 A S3
T St
Permanent
Carmine

502 A S3
T St II
Permanent
Rose

587 B(i) S4
T G
Rose Madder
Genuine

545 A S3
T St
Quinacridone
Magenta

543 A S1
T St
Purple Madder

489 A S3
T St II
Permanent
Magenta

640 A S3
T
Thioindigo
Violet

192 AA
T G
Cobalt Vic

137 AA S3
O G I
Cerulean Blue

379 A S2
T G II
Manganese
Blue Hue

191 AA S4
O
Cobalt
Turquoise Light

190 AA S4
O I
Cobalt
Turquoise

184 AA S4
O G
Cobalt Green

719 A S1
T St I
Winsor Green
(Blue Shade)

692 AA S3
T St I
Viridian

721 A S1
T St
Winsor Green
(Yellow Shade)

708 A S1
O St II
Winsor
Emerald

637 AA S1
T
Terre Verte

459 AA S3
T G/St I
Oxide of
Chromium

187 AA
O
Cobalt Gr
(Yellow S

678 AA S1
O St I
Venetian Red

317 AA S1
O I
Indian Red

056 A S1
T St
Brown Madder

507 A S3
T St
Perylene
Maroon

125 AA S2
O St I
Caput Mortuum
Violet

554 AA S1
T G I
Raw Umber

076 AA
T I
Burnt Ur

Paint

A representative set of watercolor paints along with descriptive information from the manufacturer. This set, courtesy of Winsor & Newton, ColArt Americas, Inc., 11 Constitution Avenue, P.O. Box 1396, Piscataway, NJ 08855-1396. Comparable selections are available from dozens of other manufacturers. Here are the meanings of the notations under each color:

AA extremely permanent (Winsor & Newton equivalent of ASTM category LFI)

A permanent (Winsor & Newton equivalent of ASTM category LFII)

B moderately durable (Winsor & Newton equivalent of ASTM category LFIII)

S series number (Winsor & Newton indicator of price category)

T transparent or semi-transparent

O opaque or semi-opaque

A S1	319 A S1	111 A(iii) S4	089 A(iii) S4	724 A S1	042 A S1	106 A(iii) S4	603 A S2	683 A(iii) S3	094 A(iii) S4	097 A(iii) S4	726 A S1
sor Yellow	T	O St	O I	O I	O St	O St	T St	O St	O G/St	O G I	T St
D	Indian Yellow	Cadmium Yellow Deep	Cadmium Orange	Winsor Orange	Bright Red	Cadmium Scarlet	Scarlet Lake	Vermilion Hue	Cadmium Red	Cadmium Red Deep	Winsor Red

A S3	672 A S2	733 A S1	321 A S3	180 AA S4	263 A(ii) S2	667 A(ii) S2	178 A S4	709 A S1	010 A(iv) S1	538 A(iv) S1	707 A S1
G I	T G I	T St	T	T G	T G I	T G I	T G I	T St	T I	T St I	T St II
ve	Ultramarine Violet	Winsor Violet (Dioxazine)	Indanthrene Blue	Cobalt Blue Deep	French Ultramarine	Ultramarine (Green Shade)	Cobalt Blue	Winsor Blue (Red Shade)	Antwerp Blue	Prussian Blue	Winsor Blue (Green Shade)

A S1	503 A S1	447 A S1	294 A S2	422 A S1	425 AA S1	744 AA S1	552 AA S1	285 AA S2	547 A S3	074 AA S1	362 AA S1
er's Green	T St	T St I	O I	O I	O I	O I	T G I	T St I	T I	O I	O I
	Permanent Sap Green	Olive Green	Green Gold	Naples Yellow	Naples Yellow Deep	Yellow Ochre	Raw Sienna	Gold Ochre	Quinacridone Gold	Burnt Sienna	Light Red

AA S1	609 AA S1	322 A S1	465 A S1	430 A S1	034 A S1	331 AA S1	337 AA S1	142 AA S1	217 AA S1	150 AA S1	644 AA S1
St I	O I	O St II	O St II	O St II	O I	O G I	O I	O I	O I	O I	O I
ke Brown	Sepia	Indigo	Payne's Gray	Neutral Tint	Blue Black	Ivory Black	Lamp Black	Charcoal Grey	Davy's Gray	Chinese White	Titanium White (Opaque White)

St	staining color	**I**	ASTM designation, permanent for artists' use
G	granulating color	**II**	ASTM designation, permanent for all artists' uses except outdoor murals

(1) 'A' rated in full strength but may fade in thin washes

(2) bleached by acids or acidic atmospheres

(3) cannot be relied upon to withstand dampness

(4) fluctuating color, fades in light, recovers in dark

space such as a can or box because it's possible for spontaneous combustion to occur—oxidation of the paint and solvents in the rags gives rise to heat and, with no way to dissipate, this heat builds sufficiently to ignite the rags. Many painters prefer to use paper towels rather than rags. Used paper towels are disposable, and it's unlikely they'll be stored long enough to pose a fire threat.

paint roller
A cloth cylinder mounted on a handle used primarily for painting house walls. Sometimes a roller is useful in the fine arts—for example, a mural painter might do initial layers using a roller, or an easel painter might use a roller to apply a ground. *See mural.*

painterly
Having the appearance of a painting rather than that of a drawing or a photograph. An inexact term, painterly usually implies departure from strict realism. Pictures in which brushstrokes are clearly visible, for example, are often called painterly, as are those making lavish use of color, tone or texture.

painting board
Any stiff surface used to hold a painting or drawing in progress. Painting boards such as hardboard, wood or Plexiglas are often used to support watercolor paper or drawing papers.

painting knife
A flexible blade used for applying paint. *See illustration under knife, painting.*

paints compared
The chart on page 285 compares some of the important attributes of the major painting mediums. Lightfastness is not list-ed because that's a characteristic that depends more on the individual color chosen within any of the mediums rather than on the type of medium. *See permanence.* Under "drying time," fast means normally a few minutes; moderate means several hours; slow means many hours or days. These are inexact measures, for much depends on the thickness of the paint film and, in the case of watercolor, the wetness of the paper. Under "health risks" it is assumed nontoxic paints are chosen in all cases.

palette
1| The set of colors a particular artist uses. 2| A flat surface on which an artist spreads and mixes paints. Most palettes may be used for any type of paint except acrylic. Acrylic paint may ruin a plastic palette because, once dried, it's extremely difficult to clean off. Better choices for acrylic are an enameled tray, disposable papers or a glass surface. Another type of palette for use with acrylics is a so-called "wet palette" or "moist palette" that contains a sheet of special, disposable paper lying atop a thin layer of spongelike material. Before setting out paints on the paper, wet the spongy material and its moisture gradually seeps through the paper, keeping the paints from drying out.

Although the examples shown on page 289 are all white or transparent, many artists prefer a dark-colored palette. This is a matter of personal preference: Some feel it's easier to mix and judge colors against a white background; others are comfortable mixing against a darker background.

palette cup
A small container for solvents and mediums designed to be attached to a handheld palette. *See illustration under turpentine.*

palette, disposable

Any surface used by a painter to lay out paints that is thrown away after each painting session. The most common disposable palette is stiff paper treated so that it does not absorb paint spread on it. Disposable papers come in a variety of sizes and shapes, usually bound as pads. *See palette.*

palette knife

A long, flexible blade, usually steel or plastic, used for mixing paint, scraping paint from a palette or picture, or applying paint to a picture. *See illustration under knife, palette.*

palette, slant tile

A china palette that has a row of wells for holding paint opposite a row of wells with slanted bottoms for mixing paints. The deep part of each mixing well can hold

Palette

Shown here are some popular types of palettes, but any smooth, nonporous and easily cleaned surface may be used—many artists use a sheet of glass placed on top of a taboret or table with a sheet of white paper underneath the glass to provide a white mixing surface. At the upper right is a plastic palette popular among watercolor and gouache painters. It has many paint wells, a large mixing area and a lid to keep paints from drying out too fast between painting sessions. The circular palette is popular with watercolorists who like many small wells and don't need a big mixing area. The pad at the bottom contains sheets of waxy papers that may be used with all mediums and may be disposed of after the day's painting is done. The palette next to the pad has a hole for the thumb to allow you to hold the palette in your hand as you paint; these palettes come in many sizes and shapes, including rectangular. At the top left is an enameled butcher's tray. While it has no wells for paints, it's an excellent palette that cleans up easily and may be used for all mediums.

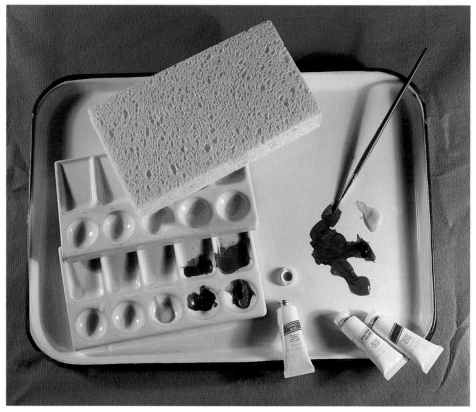

Slant tile palette
Photo courtesy of Daniel K. Tennant, from his book
Realistic Painting.

flat container water paints spongy material absorbent paper

Wet palette

water that you dip into as you mix a color
to the consistency you want on the upper
part of the slant.

palette, wet

A palette for use with acrylics (also called a
moist palette) that contains a sheet of spe-
cial, disposable paper lying atop a thin lay-
er of spongelike material. Before setting
out paints on the paper, you wet the
spongy material; its moisture gradually

seeps through the paper, keeping the
paints from drying out. *See illustration.*

pan watercolor

Watercolor paint in the form of small,
hard blocks arranged in wells in a water-
color palette or box. *See watercolor paints.*

panel

Any rigid support for a painting. Histor-
ically, wood was the most common materi-

Pantograph
A basic pantograph consists of a series of rods forming a parallelogram (a four-sided figure with opposite sides parallel and equal). The rods (a, b, c and d) are hinged so that they may move at all four joints. One joint (A) is fixed to a support, such as a table top, while the rest of the assemblage is free to move. Rod b is longer than the others. A pencil or pen (P) fixed to rod c traces a geometric form; as P traces the outline of the form, another pencil or pen (or an etching or engraving needle) at PP traces a similar outline, either larger or smaller, depending how the apparatus is set up.

al used. Woods such as beech, poplar, oak and walnut were chosen for their smoothness and lack of knots or prominent grains. Planks were joined to make a surface of the appropriate size and then smoothed and coated with a glue size to seal the wood's pores. Then one or more coats of true gesso were applied until the ground was as thick, as white and as smooth as the artist wished. Sometimes canvas was glued to the wood support before applying gesso. Metals such as copper and zinc were also used, especially for smaller panels. These days, plywood and aluminum panels are used, as are a variety of other building construction materials; the most common panel material now is hardboard. *See hardboard.*

panorama

1| A complete view of a scene in all directions. Panoramas were painted during the late 1700s and the 1800s. Generally done in a broad-brush manner without fine detail, panoramas were intended to be shown around the curved inside wall of a cylinder. A viewer in the center could slowly turn (or the cylinder could turn) to show the entire scene. The first known panorama was made in 1788 by a Scottish painter, Robert Barker, who painted a panorama of the city of Edinburgh. An American, John Vanderlyn, painted *The Palace and Gardens of Versailles*, which he exhibited for about ten years in the early 1800s in a round building he built for that purpose in New York City. 2| A picture painted on a long canvas or paper and rolled up on a spool. The picture may be shown, a section at a time, by rolling it past the viewer from one spool to a second spool. A refined example is the traditional Chinese or Japanese picture painted on a scroll made of silk or paper. 3| In today's usage, panorama often means simply a wide view of a scene, not necessarily a 360-degree view. *See diorama.*

pantograph

A device used for copying a shape on either a larger or smaller scale. *See illustration.*

paper

A material made from plant fibers and used for drawing, printing, painting, wrap-

ping, labeling and so on. The name comes from papyrus, an Egyptian plant cut into thin strips and used to make one of the earliest writing surfaces. The basic ingredient in modern paper is the cellulose found in the cell walls of plants. Papers made for long-lasting artistic use are usually made from cotton or linen fibers, which have great strength and permanence. The least expensive and least durable papers are made from trees, grain straw, sugarcane stalks, bamboo and a variety of other plant materials. *See papermaking; rag.*

paper, cockling of

The warping of paper when it is unevenly wet. *See cockling.*

paper grain

1| A discernible texture in some papers showing faint lines in one direction or another. *See wove; laid.* 2| In machine-made paper, the direction in which most of the fibers are aligned. Such papers tear more easily in the direction of the grain than across the grain. *See papermaking; Fourdrinier machine.*

papermaking

Paper is made either by hand or by using mechanical processes. In both cases the basics are the same: **1:** A pulp is made of plant fibers, water, size and sometimes added chemicals; **2:** the pulp is spread over a screen, forming a wet mat of fibers; **3:** the mat is pressed to squeeze out much of the water; **4:** the remaining water is removed by evaporation to provide a dry sheet; and **5:** the sheet may be finished by adding various coatings.

In preparing handmade paper, the raw material is usually clean cotton or linen rags cut into small pieces. The rags are gradually added to water and "beaten"—that is, shredded and smashed until they come apart into individual fibers—to make pulp, a suitably thick "soup" of fibers. Next, a mould and deckle are made ready. The mould is a flat screen, or mesh, the size of the intended sheet of paper; the deckle is a wood frame that fits around the edges of the mould. The purpose of the deckle is to act as a fence to contain the pulp and keep it from running off the edges of the mould. The mould and deckle are grasped firmly and thrust vertically into the tub of pulp. As the mould and deckle begin to fill with pulp, they are brought to a horizontal position to get an even layer of pulp on the mould. The eventual thickness of the paper depends on how much pulp is allowed inside the mould and deckle. The mould and deckle are lifted from the vat and shaken from left to right and from front to back to settle the fibers so that they intertwine randomly. The excess water is allowed to drain through the mesh of the mould back into the vat. What's left is a dense mat of wet fibers lying on the mould. This mat is carefully transferred to an absorbent surface, where it is pressed to remove much more of the water. The mat is dried and the result is a sheet of paper. Later the paper may be sized, unless size has already been added at the pulp stage. Before sizing, a sheet of paper is called a *waterleaf.* For an excellent and entertaining discussion of handmade paper, *see the book Papermaking. See rag; paper; size.*

Commercial papers are made in a similar fashion, with everything, of course, on a larger scale. Two basic kinds of papermaking machines are used: *cylinder* and *Fourdrinier.* In both cases, interconnected devices prepare the pulp, deliver it to a screen, press the wet sheet of fibers, dry the sheets and cut them or roll them onto spools. The irregular deckle edges that occur naturally in the handmade process

A Bit of History

Papermaking can be traced back almost two thousand years to China. After several hundred years the art of making paper reached the Middle East, and by the 1300s there were several paper mills in operation in Europe. The invention of printing in the 1450s was responsible for an immediate demand for better, cheaper and more plentiful supplies of paper.

as pulp is trapped under the edges of the deckle, are simulated by some papermaking machines. At various steps in the papermaking process, chemicals may be added to either bleach or color the paper, alter its pH, coat it, or in other ways prepare it for its eventual use.

Papers made using cylinder machines are called *mouldmade*; those made using the Fourdrinier process are called *machinemade*. Both, of course, are made by machines, but there are pronounced differences. Cylinder machines simulate papers made by hand in moulds (which is why their papers are called mouldmade) by forming dense mats of fiber in a random fashion; Fourdrinier machines form a mat of fibers along a rapidly moving flat belt, and the fibers tend to align themselves in the direction of the belt's movement. Machine-made papers (that is, those made by the Fourdrinier process) have a more predictable, regular texture and are not as strong as mouldmade papers. Less expensive art papers and most commercial papers are made on Fourdrinier or similar machines. *See Fourdrinier machine; cylinder machine.*

paper sculpture
See sculpture, paper.

paper, stretching
See stretching paper.

paper, synthetic
Paperlike products not actually made from cellulose fibers. From time to time, new "papers" are introduced that suit some artists' needs. An example is Yupo watercolor paper, made from a petroleum derivative. Yupo (pronounced yew poh) is available in several thicknesses. It's a smooth-surfaced material that does not absorb water: Paint lies on its surface and may be freely manipulated and easily lifted. Colors do not stain Yupo. It's advertised as acid free.

papier collé /paper ko *lay*; pah *pyay* ko *lay*/
Collage; a picture made from cut and torn papers pasted in place. *See collage.*

papier déchiré /paper deh shur *ay*; pah *pyay* deh shur *ay*/
A collage of torn papers.

papier-mâché /paper mah *shay*; pah *pyay* mah *shay*/ [French: "chewed paper"]
A form of sculpture using paper and paste as the primary materials. There are two basic steps in creating a papier-mâché object: First a rough basic form is made using materials such as chicken wire and crumpled newspaper. That starting form should be reasonably sturdy so that when you begin applying layers of paper and paste the form will not collapse under the weight of wet paper (for larger objects, a heavier wire armature is often necessary). Next, flour paste or wallpaper paste is smeared liberally on the form, and torn or cut strips of newsprint are applied to the wet paste. This is continued until several layers have been built up for strength and the form has been developed fully. Many sculptors, like Dan Page, like to go on to a

third stage, coating the object with a pulp made of shredded paper and paste; some also finish using acrylic modeling paste; and finally, some artists paint the finished sculpture with acrylic paint.

papyrus

Paper made from the papyrus plant from ancient times until the Middle Ages. The use of papyrus originated in Egypt and spread throughout much of Europe. Paper was made by forming a mat of fibers stripped from the stalk of the papyrus plant, dampening it and pressing the mat and allowing it to dry. The sap of the plant fibers acted as an adhesive to hold the mat together as a sheet of paper. Papyrus was widely used for centuries until it was eventually displaced by simpler, cheaper plant fibers.

parallel perspective

Linear perspective in which one face of the object is parallel to the picture plane and all horizontal receding lines meet at a single vanishing point. Also called *one-point perspective. See linear perspective.*

Papier-mâché

Page layers a wire armature with strips of newspaper smeared with wallpaper paste, allowing each layer to dry before the next is applied. After three or four layers the piece is painted to strengthen the form and keep the next stage, the application of wet pulp, from soaking through the first stages and making the shape collapse. He uses a pulp made of shredded newspapers and paste to finish refining the form. Finally, he coats the sculpture with a varnish that provides protection against ultraviolet light. Dan points out that it makes a difference which newspapers he uses, because both the quality of the paper and its inks affect the handling of the material and the look of the final product.

MOTHER AND CHILD | Dan Page | papier-mâché | mother | 19″ (48cm) high × 46″ (117cm) long × 15″ (38cm) wide. Courtesy of Red Door Gallery, Rockport, Maine.

parchment

1| A writing surface made from the hides of goats, sheep and calves. Skins had been used for this purpose for some time, but around the second century BC the methods of preparing them were refined, resulting in a better material, both sides of which could be written on. Once writing on both sides was established, rolled-up scrolls gave

way to bound sets of sheets that we now call books. *Vellum* is a finer grade of parchment, made from kids, lambs and calves. 2| A modern paper of high quality, sometimes with a special finish resembling parchment.

parquetry /*pahr* keh tree/
Geometrically patterned wood designs, used especially in floors.

particle board
A dense sheet of wood shavings and chips glued together. Unlike hardboard, the wood is not first broken down into its fibers—the individual chips are clearly visible in the finished product. It's an environmentally sound product because it provides a use for wood leftovers not usable for other purposes. Sold in sheets, particle board is used mainly in home building and as the foundation for such items as counter tops, shelving and furniture. Some artists use it as a painting support, for which it is suitable provided its surface (which is acidic) is sealed. For such use, the board is usually sized and then coated with gesso.

paste
1| A dense, transparent glass containing lead oxide. Because it refracts light well it's used to simulate the sparkle of natural gems. Paste "gems" can be made either by casting the molten glass or by cutting hardened glass in the same manner as real gemstones. Those that are cut have sharp edges between the facets; those that are cast usually have slightly rounded edges. Unlike gemstones, paste contains tiny air bubbles as a result of the manufacturing process. The term *paste* is used because the ingredients used in manufacture are mixed wet, rather than dry, before the heating process begins. 2| Liquid clay, also called *slip*, sometimes used to decorate

porcelain. The fluid clay is painted onto the porcelain in successive layers, building up a low-relief design—a process called *pâte-sur-pâte* (French for paste on paste). Slip is also sometimes poured into molds. 3| Any of a range of thick adhesives, including schoolchildren's white paste and wallpaper paste. Many such pastes are basically mixtures of flour or starch and water. 4| A resist used in batik to protect areas of cloth from receiving color. *See batik.*

pasteboard
1| Solid cardboard with a paper facing.
2| Cheap, unsubstantial or artificial, as in "pasteboard characters."

pastel
A combination of chalk, pigment and a binder, usually gum tragacanth, a substance derived from various plants. The ingredients are mixed and formed into round or rectangular sticks or blocks and then dried. In pastel, the binder serves to

To Fix or Not to Fix

Pastel artists are divided on the merits of using spray fixative to help keep pastel granules from falling from the picture surface. Those against the use of fixative object because it darkens the colors. Those in favor say that the slight darkening is a reasonable price to pay for protecting the picture; furthermore, the use of fixative to secure early layers of pastel allows for significantly more pastel to be added. If you're new to pastel, try fixative on test sheets to determine whether you like it or not. Artists' fixatives will not damage your pastel, but substituting products such as hairspray is asking for trouble, since such products are not made with art in mind.

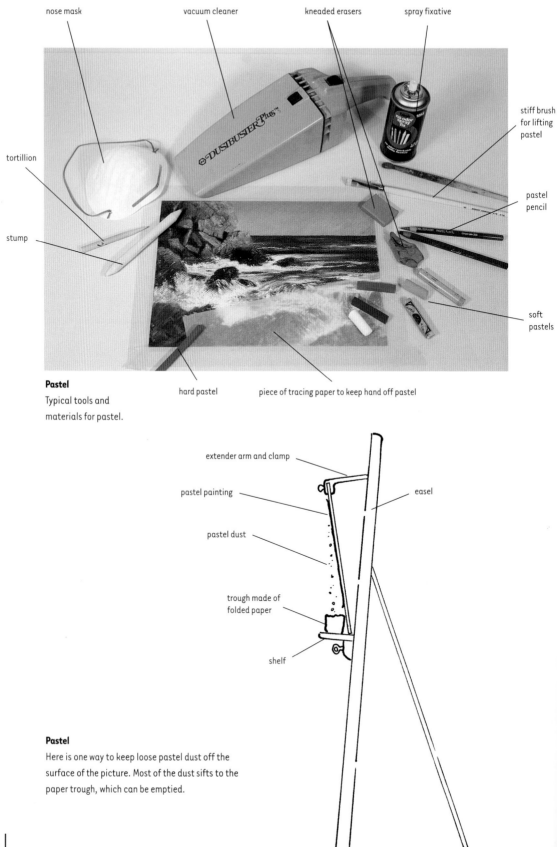

nose mask

vacuum cleaner

kneaded erasers

spray fixative

stiff brush for lifting pastel

tortillion

pastel pencil

stump

soft pastels

Pastel
Typical tools and materials for pastel.

hard pastel

piece of tracing paper to keep hand off pastel

extender arm and clamp

easel

pastel painting

pastel dust

trough made of folded paper

shelf

Pastel
Here is one way to keep loose pastel dust off the surface of the picture. Most of the dust sifts to the paper trough, which can be emptied.

a b C D e F G H I J K L m n o P Q r s T u V W X Y Z

hold the pigment particles together in the stick rather than to help attach the pigment to a support. Some pastels, those with the highest proportions of binder, are hard and brittle; others are soft and more crumbly. Pastel depends on the texture of the support to hold it in place—the rougher the texture, the more pastel can be applied. It's not unusual to find four or five layers of pastel in a picture; many more layers than that pose an increasing risk of flaking off. More layers can be built up by using spray fixatives but fixatives tend to alter, at least slightly, the value of the pastel (usually making it darker), so many artists avoid using it.

Pastel is available in three basic forms: hard pastel, soft pastel and pastel pencils. (*See oil pastel, which is different from regular pastel.*) *Hard pastels* are usually rectangular sticks, while *soft pastels* generally are enclosed in a paper sleeve to help prevent breakage. *Pastel pencils* are thin rods of hard pastel encased in wood. Pastel artists usual-

Soft pastel

In this painting Lachman smeared large areas of pastel with mineral spirits to form a loose underpainting. He followed that with hard pastels, then soft pastels and finally very soft handmade pastels. He builds up fairly thick layers of pastel, allowing earlier layers to show through for a vibrant color effect. Lachman does not generally use fixatives because they dull the color.

SHADOWS | Al Lachman | pastel on sanded paper | 18″ × 24″ (46cm × 61cm)

ly use a mix of hard and soft and also a mix of brands—a favorite red from Brand X and a favorite blue from Brand Y. Manufacturers use their own permanence rating systems, so you must become familiar with their systems to avoid using fugitive or questionable colors.

If you paint in mediums such as oils or watercolors, you have an unlimited range of shades available to you of any color—in oils you can add, for example, white or black paint to a base color to get a range of shades. In pastel, that kind of mixing is not so simple, so manufacturers make a

Pastel

Urania Christy Tarbet is very active in many facets of art, especially in the field of pastels. Among other things, she is Founding President of the International Association of Pastel Societies, an editor for *International Artist* magazine and U.S. editor for *Pastel Artist International* magazine. *Victoria in Spring* is one of a series of pastels done at Bouchart Gardens. She began with a rough under-painting of pastel, which she then smeared using turpentine and a bristle brush to create an abstract color pattern. Once dry, she worked up the painting in a conventional way using a variety of brands of pastel sticks. The accompanying illustration shows her collection of pastels.

VICTORIA IN SPRING | Urania Christy Tarbet | pastel on Ersta sanded paper | 14" × 22" (36cm × 56cm). Collection of Colleen Richeson Maxey.

broad range of *premixed* shades available. One manufacturer lists eight different shades of Ultramarine Blue, for example. Because so many shades of each color are available, the total number of sticks you may buy is enormous—in the case of one brand, over five hundred sticks of soft pastels. Most artists zero in on a much smaller number for their work.

The favorite support for most pastels is some type of paper, including pastel, charcoal, watercolor and printing papers. Some artists also use fabrics and sanded papers. Whatever surface you choose, pay attention to its permanence.

Pastel poses a definite health risk because the fine dust may easily be inhaled and can settle in the lungs. Some precautions you may take to avoid inhaling the dust are: **1**: Don't blow the loose dust from your picture; instead, take it outdoors and tap it lightly from the rear to dislodge the dust; **2**: wear some type of mask to filter dust from the air you

breathe; a paper dust mask provides good protection, but a respirator provides more; and **3**: vacuum loose pastel dust from your easel rather than blowing it away.

Pastel painters use a variety of methods for building up their pictures. Most use some combination of hatching and crosshatching; some do a lay-in using another medium, such as acrylic, watercolor or

Pastel
Urania Tarbet's pastels.

even pastel moistened with water or tur-pentine. Most work from hard pastel to soft (it's easy to stroke soft pastel over hard, but the reverse is difficult). Laying in dark pastel over light pastel results in a pasty, dull look, so it's wise to plan carefully in advance for the darks and to keep light pastel out of those areas.

Many artists combine pastel with water-based paints such as watercolor, acrylic and gouache. Those paints are compatible with pastel and are often used in under-painting; they can also be mixed with the pastel in various ways, either on the sup-port or on a palette. Some painters even spray water on a pastel surface to cause a slight "melting together" of the grains of pastel, and many dip a stick of pastel into water before making a stroke.

Pastels are usually framed under glass to protect their fragile surfaces from dam-age. *See framing for a suggested method of framing a pastel to provide for grains that may loosen and fall to the bottom of the picture.*

pastel board

A stiff surface made specifically for pastel painting. Watercolor or illustration boards may also be used. Some artists make their own sanded boards for pastel work. *See sanded board.*

pastel dust

Fine particles of pastel released as a stick of pastel is rubbed against a support. The dust may become airborne and settle on surrounding surfaces, and it may be inhaled by the artist—a definite health haz-ard that should be guarded against by the use of masks and good ventilation. Pastel artists should avoid the habit of blowing loose dust from the surface of the picture, because that causes the particles to become airborne. A good alternative is to keep a hand-vacuum nearby.

pastel, fat-over-lean
See fat-over-lean rule, pastel.

pastel, hard
A pastel that contains a high proportion of binder to pigment. It requires much firmer pressure than soft pastels to make a mark. Hard pastels are often used for early layers of the picture because they establish color without building up a thick pastel layer that would clog the texture of the paper. Hard pastel may be covered easily with soft pastel, but the reverse is not true: Stroking hard pastel over soft pastel tends to gouge away the soft pastel. Hard pastel is often used for defining sharp details in the final stages of a picture.

pastel paper
A range of white and tinted papers with varying amounts of tooth for holding granules of pastel. Pastels are also painted on charcoal paper, watercolor paper and sanded boards—in fact, on almost any nonslick, nonoily surface. *See illustration under charcoal papers; sanded paper.*

pastel pencil
A thin rod of hard pastel encased in wood. *See pastel.*

pastel shade
An abused term, it means light or pale in color, no doubt going back to the days when most pastels were on the pale side. These days there are many intense hues and strong values among pastels, and certainly many modern pastel paintings contain strong, dark passages, so the term is no longer accurate, at least for artists.

pastel, soft
A pastel stick that has a lower proportion of binder than harder pastels. A stick of soft pastel makes a dense mark with little pressure; it is also fairly fragile and may be easily broken. Soft pastels are the most widely used by pastel artists.

patina /pah *teen* uh; *pat* in uh/
1| A greenish or green-blue coating (copper carbonate) that forms on copper or bronze exposed to the atmosphere. 2| A natural buildup of grime on furniture and decorative objects.

pearlescent color
Color that uses certain metallic ingredients to produce a soft shine, or luster, like that of a pearl.

Pastel

Here is an example of lavish piling-on of pastel color, made possible by the handmade pastels Al Lachman uses, which are extra soft.

UNTITLED | Al Lachman | pastel on sanded board | 30" × 40" (76cm × 102cm)

pedestal

Any support on which an object rests; specifically, the supporting base on which columns rest in Classical architecture. *See illustration under Classical architecture.*

pediment

In Classical Greek architecture, the triangular space between the top of a wall and the peak of the roof; a gable.

pen

A sharp-pointed instrument used to draw images in ink. The earliest pens were quills (the hollow shafts of birds' feathers) and reeds (stiff, hollow grasses of various kinds). The hollow stems serve as small ink reservoirs. Quills and reeds can be sharpened to strong, fine points, and by varying the drawing pressure, they can be used to make expressive lines, both thin and broad. Many artists, including Rembrandt and Vincent van Gogh, were masters of these types of pens. Steel dip pens were developed in the 1830s and eventually supplanted reeds and quills. While many artists still use dip pens, most now prefer technical pens. *See pen, technical; pen, dip.*

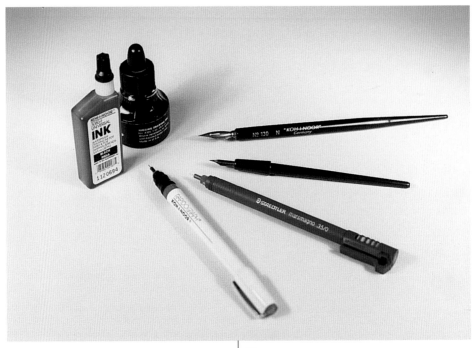

pen, bamboo

A type of dip pen made from a slender stick of bamboo. The bamboo is sharpened to a point and is split. When dipped into ink, a small amount of ink clings to the underside of the point; the ink runs to the tip along the split. *See dip pen.*

pen, cleaning

Every type of pen needs to be cleaned regularly to keep dried ink from stopping ink flow. Soap and warm water suffice to clean most pens, but liquid cleaners sold for the purpose are better. Such cleaners are especially important, of course, for cleaning out waterproof ink. For technical pens, a helpful, inexpensive gadget may be bought that is essentially a syringe that attaches to the pen to force water or cleaning solution through the nib under pressure (*see illustration on page 311*). For anyone doing a lot of ink drawing, an ultrasonic cleaner may be a good investment. Such devices range upwards from around $35.

Dip pen
From top to bottom: a regular dip pen, a crow quill dip pen, a disposable Marsmagno technical pen and a refill-able Koh-I-Noor Rapidograph technical pen. Inks are available in bottles for dip pens and plastic bottles with narrow spouts for refilling cartridges. The cap on the round bottle has a rubber bulb and a glass or plastic tube, similar to an eyedropper. The dropper can be used to fill a cartridge or to deposit a drop of ink on the under-side of a dip pen; it's also sometimes used to draw heavy ink lines.

pen, crow quill

A small dip pen used to draw fine lines. *See illustration under pen, dip.*

pen, dip

A pen with a steel nib that has no built-in reservoir and must be dipped into a container of ink to pick up a new ink supply. When the point is dipped into ink, a small amount of ink clings to the concave undersurface of the point. From this small "reservoir," ink is fed to the tip by capillary action and gravity along a thin cut in the point. A frequent occurrence when

ink travels along cut

Dip pen

using a dip pen is the depositing of an unwanted blob of ink on the paper. One way some artists avoid this problem is by carefully regulating the amount of ink the pen picks up in the first place. They do this by depositing a drop of ink from a dropper or a brush onto the underside of the upturned pen point instead of dipping it into an ink bottle.

Points, or nibs, for dip pens are made in a variety of shapes. Some are shaped for lettering and calligraphy, including versions for right-handed and left-handed users. Other nibs are flexible to allow varying widths of marks. Like any pen, dip pens should be kept clean so that dried ink does not accumulate and prevent proper ink flow.

pen, strokes of

The variety of lines, dots and other marks made with an ink pen. *See illustration on page 304.*

pen, technical

A drawing instrument that has a hollow tip fed by a reservoir of ink. The line width from a given pen depends on the size of the nib, or tip. The illustration on page 310 shows a typical range of line widths available. Unlike a dip pen, a technical pen allows you to stroke in any direction (a dip pen must be pulled toward you or somewhat sideways, but may not be pushed away from you). A

Papers for Ink Drawing

Soft, fibrous papers are unsuitable for use with most pens, especially technical pens, because the fibers may quickly clog the pen point. Choose harder-surfaced papers that will resist damage from the scratching of a point. Papers specifically sold for ink drawing can usually be counted on to have appropriately hard surfaces. Bristol papers and hot-press papers in general, including many illustration boards, are suitable for pen work; some cold-press papers are satisfactory, too, but others will shred too easily. You must try a variety of papers to find those that suit your habits and needs. Of course, whatever paper you choose should be of archival quality if you care about permanence.

technical pen lays down a uniform line width and will seldom leave an unintended blob of ink. There are several types of technical pens: refillable; disposable cartridge and disposable pen. A *refillable* pen (such as the one shown in the illustration on page 310) has a plastic ink cartridge that you fill with your choice of ink. Two popular examples of such pens are the Koh-I-Noor Rapidograph, now distributed by Chartpak, and the Staedtler Marsmatic 700, both of which are available in over a dozen point sizes. A second option is a pen with a *disposable ink cartridge*, such as the Rotring Rapidograph and Marsmagno 2. You buy plastic cartridges already filled with ink and throw them away when empty. The disadvantage of these pens is that they offer fewer point sizes and few ink choices. The third choice is a *disposable pen*—when it runs out of ink, you throw away the entire pen. They're available in a limited number of point sizes.

crosshatching and hatching

dots (Pointillism)

hatching with variable spacing

continuous line

curved strokes

wash (ink dropped into surface wet with water)

Pen strokes

A few of the strokes or marks that may be made with an ink pen.

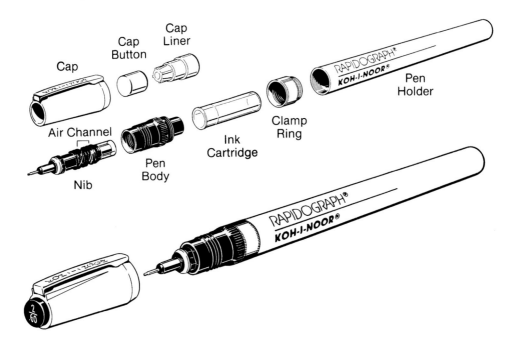

Technical pen

A typical technical pen, the Koh-I-Noor Rapidograph.
Courtesy of Chartpak, Inc., One River Road, Leeds, MA
01053.

6x0	4x0	3x0	00	0	1	2	2½	3	3½	4	6	7
.13	.18	.25	.30	.35	.50	.60	.70	.80	1.00	1.20	1.40	2.00
.005 in.	.007 in.	.010 in.	.012 in.	.014 in.	.020 in.	.024 in.	.028 in.	.031 in.	.039 in.	.047 in.	.055 in.	.079 in.
.13 mm	.18 mm	.25 mm	.30 mm	.35 mm	.50 mm	.60 mm	.70 mm	.80 mm	1.00 mm	1.20 mm	1.40 mm	2.00 mm

Technical pen

These are point sizes available for the Koh-I-Noor
Rapidograph technical pen. Other brands offer similar
selections. Points for some pens are available in steel
(the usual choice) as well as sapphire or tungsten (for
more abrasive drawing surfaces). The top numbers, such
as 6x0 (read as "six-aught" or "six-oh") are an older
form of identification. The next row gives the line width in
millimeters—.13 mm, .18 mm and so on. The chart shows
the actual line widths along with designations in both
millimeters and inches. Courtesy of Chartpak, Inc., One
River Road, Leeds, MA 01053.

Pens come with instructions about their use. Probably the most important aspect of pen usage is cleaning. If a pen is allowed to lie unused without its cap on, it's likely that ink will dry in the point and clog it. The length of time a pen may lie open without clogging is called "open pen time," and that varies with both ink type and point size. As a rule of thumb, the cap should be put on the pen if it's not going to be used within a minute or so. Inside the cap is a cushion that effectively seals the end of the point so that air can't reach the ink in the point and dry it. To do routine cleaning, follow the manufacturer's instructions. Cleaning involves disassembling the business end of the pen and cleaning out the ink using warm water or, better, a pen-cleaning solution made for the job. The more frequently you use a pen, the less often you have to clean it. As a rough guideline, if you use the pen once a week, clean it once a week; if you set the pen aside for a longer time, clean it first.

Pen-and-ink artists use a variety of marks to make their drawings. Probably the most common marks are hatching and crosshatching, but there are many others, including curves, loops, circles, scribbles and dots—and endless combinations of all of these. See Gary Simmons' book *The Technical Pen* for an excellent and exhaustive treatment of the subject. *See ink, technical pen. See illustrations on pages 307-311.*

pencil

Broadly, any stick of marking material encased in a holder, such as wood, metal or plastic. However, unless otherwise qualified, the term pencil means specifically a *graphite* pencil, also called a *drawing* pencil. The core of a pencil is a compressed mixture of graphite (one form of pure carbon) and a clay binder—the higher the propor-

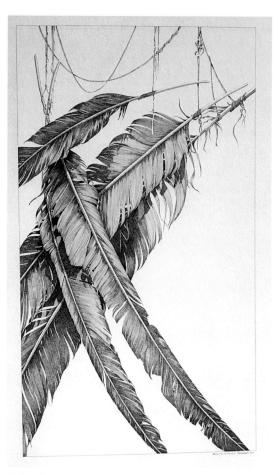

Technical pen

Becky's Trophies | Gary Simmons | technical pen with black ink on Crescent cold-press illustration board | 40″ × 30″ (102cm × 76cm)

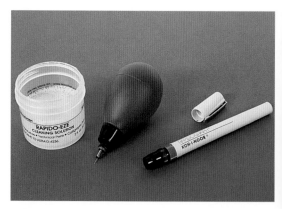

Technical pen

To clean this Rapidograph pen nib, screw the nib assembly into the syringe and squeeze the bulb to force cleaning fluid through the nib. Courtesy of Chartpak, Inc., One River Road, Leeds, MA 01053.

Technical pen

In his book *The Technical Pen*, Gary Simmons illustrates in detail the great variety of strokes he uses to render line, form, texture and value in his ink drawings. Here he uses mostly delicate hatching and cross-hatching to catch all the nuances of light and shadow.

LEVIS | Gary Simmons | technical pen with black ink on Crescent cold-press illustration board | 34″ × 20″ (86cm × 51cm)

1| Here is Gary Simmons' approach to a colored pen-and-ink drawing. In this example, he uses Rotring Artist Colors, which are finely ground acrylic inks made for pen use. Acrylic inks should be cleaned from a pen after finishing a picture—left in too long they can cause clogging. For this drawing he used more than one pen for each color, in sizes ranging from 0 to 4x0. The first image shown here is actually the third in a succession of stages: The first stage was a very light, detailed pencil drawing, and the second was a faint inking over the pencil drawing, concentrating on the flesh colors of the face area. In the stage shown here, he applies a second layer of skin tones and begins work on the hat brim shadow. Note that nowhere in this drawing does he use colored washes—everything is done with individual pen strokes.

2| He deepens the values in the face and begins defining the hair and neckerchief.

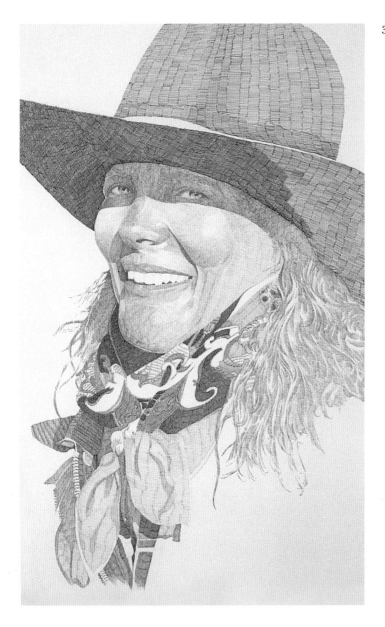

3| He further deepens values in all areas and works on the hat, paying attention to the dark underside of the brim.

a
B
C
D
e
F
G
H
I
J
K
L
m
n
o
P
Q
r
s
T
u
V
W
X
Y
Z

4 | Detail showing individual pen strokes on the face.

5 | Detail showing individual pen strokes in the hair and necker-chief.

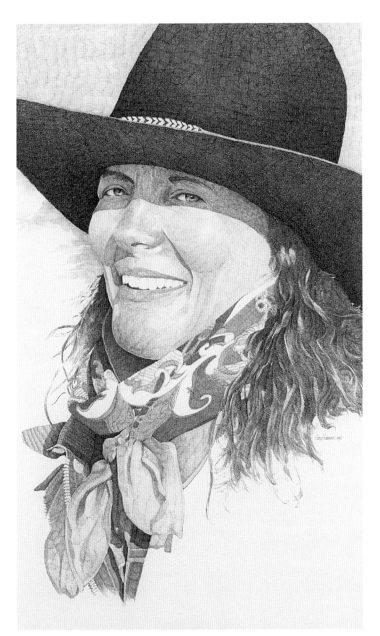

6| Here is the result of a painstaking process of using tiny, individual colored ink strokes to build a complicated picture requiring careful balancing of values and colors and special attention to warm-cool relationships. Where a painter might mix two colors to get a third, Simmons overlays strokes of one color with strokes of another to get a similar result. In this picture he achieved his darks without using black (which he feared might muddy the picture), and he got his highlights by carefully preserving light areas rather than by using white ink. Both white and black inks tend to be more opaque than the other colors, so they pose more clogging problems in the pens.

OKLAHOMA LOUISE | Gary Simmons | technical pens and acrylic ink on Crescent cold-press illustration board | 30″ × 20″ (76cm × 51cm)

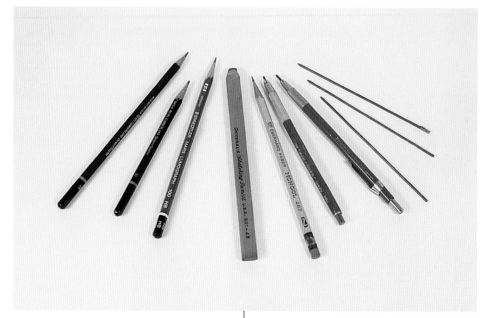

Pencil

At the left are the commonest type of drawing pencils. They have a hexagonal (sometimes cylindrical) wood body with a graphite core. The flat pencil is a carpenter's pencil (also sometimes called a sketching pencil), handy for rough sketching, thick lines or quick shading. Next to it is an ordinary office pencil, perfectly usable for drawing but not available in a wide range of hardness-softness. At the right are mechanical pencils and spare leads for them. There are also pencils (not shown) that have no wood, metal or other sleeve—the entire pencil is graphite (plus other ingredients for strength and smoothness). General Pencil's woodless graphite is an example.

tion of graphite to clay, the softer and blacker the pencil's lead will be. The term *lead* refers to the use centuries ago of a thin rod of lead metal to make darkish gray marks—the term has stuck, even though modern pencils contain no lead. In the mid-1500s a deposit of rich, black carbon was discovered at Borrowdale, England. The carbon was formed into sticks and wrapped in various materials, including wood. Experimentation showed that a range of darknesses could be achieved by combining carbon with other materials such as clay. Pencil drawings, often used as a preliminary step toward developing a painting but sometimes used to create finished works of art, were executed by artists as diverse as Jean-Auguste-Dominique Ingres, Eugène Delacroix and Vincent van Gogh.

As with many other types of art supplies, it's a good idea to experiment but then settle on a brand of pencil that suits you. Although a number of manufacturers offer a good range of pencils, you'll find that the hardness-softness designations aren't always identical. One company's HB may be the same as another company's B.

pencil, colored
See colored pencil.

pencil, nonphoto blue
A pencil with a core of pale blue pigment to which black-and-white film and black-and-white reproduction processes are not sensitive. These blue pencils may be used freely in laying out and marking black-and-white work without fear that the blue marks will show up when the work is photographed or reproduced.

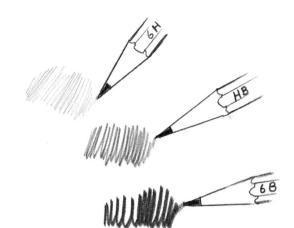

Pencil

Very hard pencils contain a higher proportion of binder, and soft pencils contain a higher proportion of graphite. The range of leads available is constantly being broadened—the range shown here, from 6H (very hard) to HB (medium) to 6B (very soft) will suit most artists' needs, but there are still harder and softer leads available.

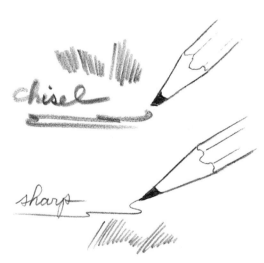

Pencil

Many artists use a combination of sharp points for fine lines and "chisel" points for broader lines. A point may be given a chisel shape simply by rubbing it against a piece of scrap paper or fine sandpaper.

Pencil

Here are just a few examples of pencil strokes: (A) 6H pencil with chisel point; (B) HB with chisel point; (C) 2B with chisel point; (D) HB with the lead held flat against the paper, pressed with more firmness near the top; (E) 2B pointed, used in a stabbing motion; (F) underlying strokes are 2H pointed, next are HB chisel and darkest are 2B pointed.

Pencil: open strokes

This is an example using open strokes rather than smeared or blended strokes. I almost always use the open-stroke method because I like the sparkle of the many little white areas between strokes. One disadvantage of this method is that the strokes "close up" and diminish the effects of the white areas if the drawing is reproduced too small.

I began by lightly drawing in the basic shapes with a 2H pencil. Then I used a chisel-pointed H pencil to lay in all the shadow areas on the buildings, using hatched strokes. Next I used HB and then 2B chisel points to deepen the shadows, using crosshatching. Once the buildings were reasonably solid I rendered the trees, bushes, grasses and rocks using chisel-pointed H, HB and 2B pencils. Finally, I went back over the entire picture with touches of 4B, and occasionally 6B, to deepen shadows and provide stronger value contrasts.

COUNTRY HOUSE | Staedtler Mars Lumograph pencils on Strathmore 500-series illustration board | regular surface | 9″ × 17″ (23cm × 43cm)

Pencil: blended strokes

In contrast to *Country House*, this picture was done using careful blending of strokes for a more real-istic rendering, much like Lund's pastel work (*see illustrations under still life and shadow*).

STILL LIFE | Jane Lund | graphite on paper | 13″ × 16½″ (33cm × 42cm). Private collection.

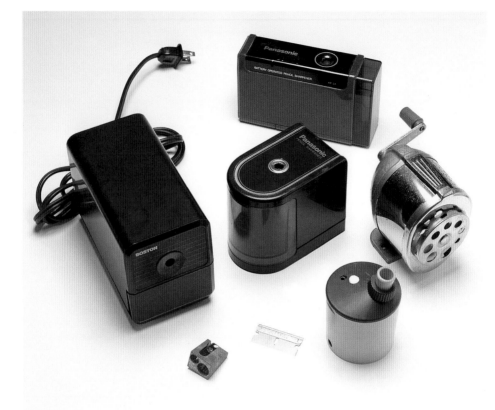

pencil sharpener

Any device for renewing the point on pencils.

pentimento

A ghost image in a painting or print as a result of an insufficiently covered-up change made by the artist. In an oil painting, for example, later layers of paint may become more transparent than they were when the artist first applied them and changes he thought he had covered up eventually show through. A well-known example is a double image of a hat in Rembrandt's painting, *Flora*. Pentimenti also occur in prints when the artist makes a change to a printing plate but does not completely scrape away, or "erase," the original image before making the change. From the Italian *pentire*, to repent.

Pencil sharpeners

Although many prefer the simplicity of a jackknife or razor blade, there are better alternatives if you're interested in saving time. An electric sharpener is certainly a convenience, and if you work in the field, a battery-operated sharpener is easy to carry along. The slim one at the top of the illustration fits easily into a pocket. Most sharpeners are intended for use on wood-clad pencils, but the cylindrical one at the bottom of the illustration sharpens the lead in a mechanical pencil. Whatever type you use, it's a good idea to take along a stiff piece of wire or other pointed object for removing clogs when a point snaps off inside a sharpener.

peristyle

In Roman architecture, a courtyard open to the sky and surrounded by rows of columns called colonnades. Also, the colonnade itself.

permanence

The ability of materials such as paint, paper or canvas to resist deterioration over time.

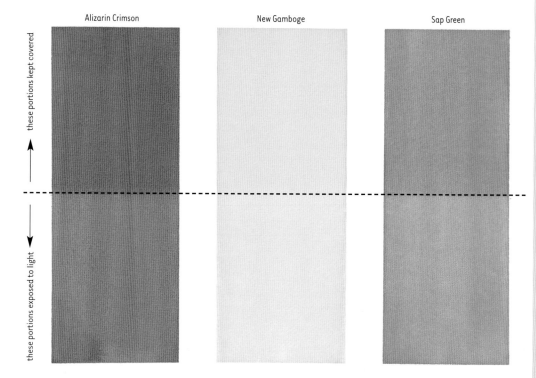

these portions kept covered →

these portions exposed to light →

Alizarin Crimson New Gamboge Sap Green

Paints—An important concern is lightfastness, the ability of paint to resist fading or change in hue under the influence of ultraviolet light, a component of sunlight. The American Society for Testing and Materials (ASTM) has developed standards that many manufacturers have adopted for testing and labeling their paints.

ASTM has defined five categories of permanence for paints, but only the top two are of interest to most artists:

Lightfastness Category I (LFI): excellent lightfastness under all normal lighting conditions.

Lightfastness Category II (LFII): very good lightfastness, satisfactory for all applications except those requiring prolonged exposure to ultraviolet light—for example, outdoor murals.

Paints listed under the other three categories range from moderately durable to fugitive. Some manufacturers have adopted the LFI, LFII . . . scheme. Others have sub-

Permanence

Here are samples of three popular Winsor & Newton watercolor paints subjected to moderate sunlight through a southeast-facing window in Maryland for twelve months. The light intensity was not severe because it was filtered a good deal by trees, yet in only a year's time this much fading occurred. An identical set of test colors placed for the same time under fluorescent lights faded about half as much. The fluorescent lights were two 40-watt tubes placed about 18″ (46cm) from the paint samples and left on all day and night for a year. Results similar to these unscientific tests would be seen using other colors and other manufacturers' paints.

stituted their own symbols, such as AA or **** in place of LFI and A or *** in place of LFII. At least one manufacturer uses a reverse scale in which 5 is tops in permanence, 4 is next and so on. To be sure what manufacturers' designations mean, read their literature. A good rule of thumb for permanent work is to stick with any manufacturer's top two classifications. Sometimes an artist sticks with an old favorite, such as Alizarin Crimson, even though it carries a low permanence rating

Permanence

Some manufacturers show lightfastness ratings on their paint labels; others only list their ratings in separate literature.

Permanence

The yellowed paper is a couple of years older than the whiter one. Newsprint like this will continue to darken and grow brittle.

(LFIV in watercolor), but modern paints offer excellent, more permanent, substitutes and there is little reason not to use a completely safe set of colors. A replacement for Alizarin Crimson watercolor paint, for example, might be Da Vinci's "Alizarin Crimson (quinacridone)." The name signifies that the hue closely approximates that of Alizarin Crimson but its primary ingredient, quinacridone, makes this paint more lightfast (it's rated LFII) than true Alizarin Crimson. *See labels, paint.*

Papers—Papers such as drawing, watercolor and print papers are subject to discoloration and may become brittle over time. Most of the deterioration is caused by the presence of acids in the papers or by exposure to acids in the papers' environment. Papers made from wood pulp are acidic—an ordinary newspaper, made from wood pulp, becomes yellow and brittle after a relatively short time. The remedy is to remove all acids from papermaking materials and then take steps to keep the finished paper away from other acidic materials, such as acidic mat board. To produce acid-free paper, manufacturers add alkaline chemicals to the paper to neutralize the acids. *See rag; framing; buffer; pH.*

Canvas—Most modern artists' canvas is made from cotton, linen or a synthetic fiber such as acrylic or polyester. Synthetic fibers are excellent supports for paintings, not subject to some of the problems of cotton or linen. Synthetics are less subject to shrinking or swelling, for example, because they absorb less moisture from the surroundings. They also are less subject to rot. *See acid free; American Society for Testing and Materials; canvas; framing; lightfastness; rag; ultraviolet light.*

perspective

The art of drawing and painting so that objects appear to have depth and distance. There are many perspective techniques artists use, including the following:

Aerial perspective—In nature, distant objects usually appear paler and bluer than those same objects would appear up close, so if you paint them that way you'll imitate nature and get a feeling of distance in your picture. Also called color perspective and atmospheric perspective. *See aerial perspective.*

Size and space variation—By making objects you know are the same size progressively smaller you create the illusion that the

Perspective center

To locate the center of a rectangle, draw its diagonals. If the rectangle is drawn in perspective, do the same thing to find its "center"—draw its diagonals.

Perspective center

The center of a circle is at the same place as the center of a square drawn around the circle. If we draw the square in perspective, the circle within it becomes an ellipse (that is, a circle in perspective). To find the center, draw the square's diagonals.

objects are marching off into the distance. Similarly, if you steadily diminish the *spaces* between objects, they'll seem to recede. *See size and space variation.*

Overlap—By showing one object in front of another you clearly signal that one object is closer to you and the other is farther away. *See overlap.*

Detail and edge variation—Distant objects usually appear fuzzier and less detailed than similar objects up close, so paint them that way.

Shadows—There are at least two ways to make shadows work for you and suggest depth: **1:** By making cast shadows aim into the distance rather than straight across the picture surface and **2:** by using shad-

ows to model, or give form to, an object. *See shadow; cast shadow; modeling; grisaille.*

Linear perspective—When you draw receding horizontal lines so they converge at the horizon, you draw the eye strongly into the distance. *See linear perspective.*

perspective center
The position of the center of a geometric shape when the shape is shown in perspective.

perspective, linear
See linear perspective.

pewter
An alloy of tin and various other metals, used since Roman times for making utilitarian objects, such as vessels and dinner-

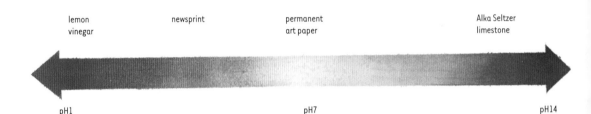

lemon / vinegar newsprint permanent art paper Alka Seltzer / limestone

pH1 pH7 pH14

ware, and sometimes decorative objects, such as jewelry. Early pewter contained a lot of lead, making it (as we now know) dangerous to use in connection with food. Modern pewters usually are lead-free; they contain, in addition to the primary element, tin, small amounts of antimony and copper.

pH

A measure of the acidity or alkalinity of any substance, such as paint or paper. pH is designated by a number from 1 to 14; pH=1 means the material is highly acidic; pH=14 means highly alkaline; pH=7 means the material is neutral, neither acidic nor alkaline. Pure water has a pH=7. The term pH refers to the concentration of hydrogen ions in a solution: The *p* stands for *power* (either German Potenz or French pouvoir) and the H stands for *hydrogen*. *See acid free.*

phosphor

A solid material that, when excited by invisible radiation, emits visible light. There are thousands of different phosphors for specialized uses; some are used in fluorescent tubes to produce a variety of colors of light, and others are used in television and computer screens.

photocopy

See xerography.

pH

A low pH number means a substance is acidic; a high number means it's alkaline, or basic. A pH of 7 means the substance is neutral, neither acidic nor basic. The scale used is logarithmic rather than straight numerical, so that a pH of 5, for instance, is ten times more acidic than a pH of 6, and a pH of 4 is ten times more acidic than a pH of 5. Artists' materials, for long life, should have a pH of 7 (neutral) or a little higher.

photographing art

Making a photographic record of a work of art. Artists who regularly submit their work to juried exhibitions usually need slides or photographic prints of their work—it's relatively rare that actual artworks are submitted for initial jurying. Artists often photograph their work outdoors, but that method relies on acceptable weather. Many set up a photographing system as part of, or in addition to, their work studios.

A simple but effective slide-photographing setup is shown here. The background is a sheet of Homosote or similar material that is firm but that allows easy insertion of tacks or pushpins to hold artwork in place. At the bottom of the board is a shelf on which artwork may rest. An SLR camera is placed on a tripod. SLR means "single-lens reflex"—it's the kind of camera that allows you to look through the viewfinder and see exactly what the camera lens "sees." To avoid jiggling the camera as you shoot, a remote shutter release is a good idea. In the setup shown (many variations

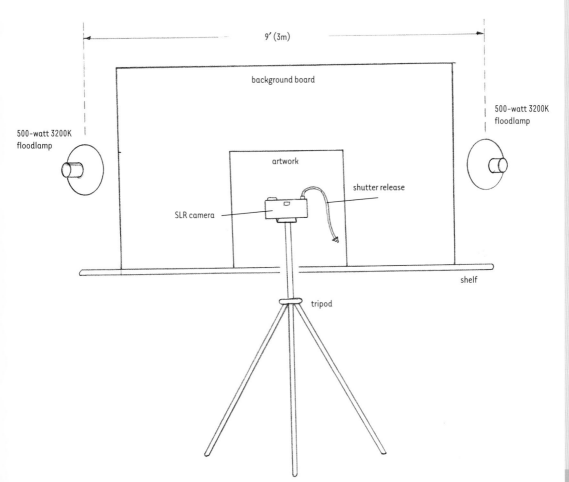

9' (3m)

background board

500-watt 3200K floodlamp

500-watt 3200K floodlamp

artwork

shutter release

SLR camera

shelf

tripod

Photographing art

are possible), two 3200K floodlamps are placed about nine feet apart and about six feet straight back from the wall to which the artwork is fastened. These 500-watt lamps are for use with Kodak Ektachrome 160T slide film. For other films you'll need to investigate to find the proper lamps. The lamps are screwed into broad reflectors to evenly distribute their light. The two lamps are placed about midway between the top and bottom of the background board and aimed toward the center of the board at about 45-degree angles. If this does not fit your space, the lamps may be fastened higher—possibly to the ceiling—and aimed

down toward the artwork. Camera settings for this arrangement are ASA 160; aperture between 4 and 5.6; speed 1/60th of a second. This setup works for most situations, but you may need to experiment with a roll of film and various pieces of art to make adjustments. It's a good idea to "bracket" your aperture settings—that is, shoot at 4, 5.6 and between 4 and 5.6.

photography in art

A great many artists use photographs as an aid in their artwork. Most use photographs to capture a scene or a particular object around which they may later

design a picture or a sculpture. Some use photographs more directly, either projecting and tracing a scene on canvas or paper, or in making prints such as silkscreen prints. There will always be disagreement about the "ethics" of using photographs—detractors would call a photograph a crutch, while proponents (such as I) view photographs as another tool, along with paints, brushes and so on. That's a debate that will go on forever and, in fact, will grow in intensity as computerized art (which may directly involve manipulation of photographic images) becomes more popular. There seems only one aspect of photography that is clearly to be avoided—the copying of someone else's photograph without permission. If a photograph is copyrighted, clearly it must not be copied in any form without explicit written consent from the copyright holder. If a photograph is not copyrighted it's probably legal to copy it, but it certainly seems unethical to do so, except as a not-for-profit learning exercise. An artist may reasonably claim that painting a copy of his or her own photograph is ethical, but painting a copy of someone else's work, even with permission, begs the question: Where is the "art" in this work? The design, the drawing and even the inspiration are already done, and all that's required now is to transcribe the idea into color!

photomicrograph

A photograph of a microscopic image, obtained by combining a camera with a microscope.

photomontage

A picture combining separate photographic images into one. A photomontage may be made by pasting separate photographs together in a suitable arrangement or by using the camera in such a way as to capture more than one image on a single piece of film—as in so-called double- or triple-exposure. Usually the separate images in such a work have a common theme. *See montage.*

Photorealism

Art that portrays objects the way a camera does—with complete realism, down to the finest detail. Viewed up close, there may be some visible brushstrokes or other evidence of the artist's hand, but seen from a comfortable viewing distance the scene looks like a photograph. Photorealism usually implies painting a scene exactly as it exists, but the term is also applied to paintings that are very realistically rendered even though they depart from the actual scene. Edward Gordon's *Solstice*, for example, may be considered an example of Photorealism even though he made radical departures from the scene that inspired the painting. Usually photorealistic painting involves the use of a photograph or slide and either a projector or a grid. *See grid; projector.*

As is so often the case in defining things artistic, there is some disagreement about Photorealism. An authority on Photorealism, Louis K. Meisel (who first coined the term "Photorealism" in1968), defines Photorealism more stringently than I have. In his book *Photorealism* he makes the point that the objective of a photorealistic painting is that it look like a photograph of an actual scene—hence, he would probably not allow for changes such as those shown in *Solstice. See illustrations on pages 323-325.*

phthalocyanine

A family of blue-green synthetic pigments used in artists' paints and valued for their lightfastness and their strong tinting strength.

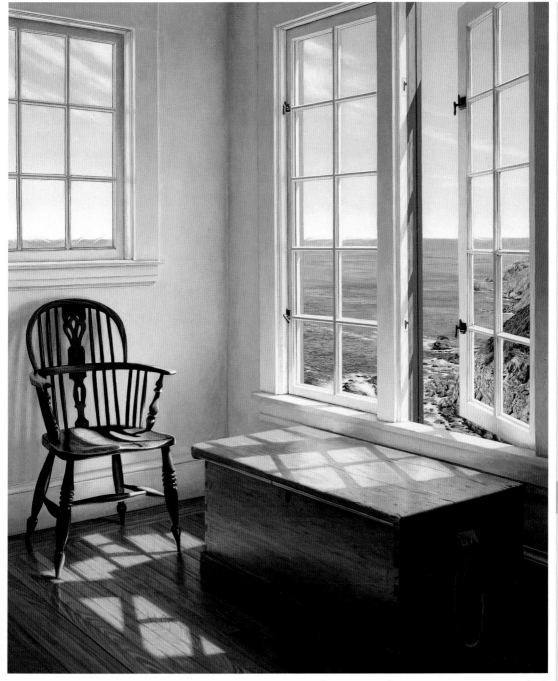

Photorealism

Edward Gordon works in alkyd paint on an eggshell-smooth acrylic gesso surface, carefully brushing on thin coats of paint to build up the luminous finish for which his work is well known.

SOLSTICE | Edward Gordon | alkyd on gessoed hardboard panel | 18″ × 15″ (46cm × 102cm). Private collection.

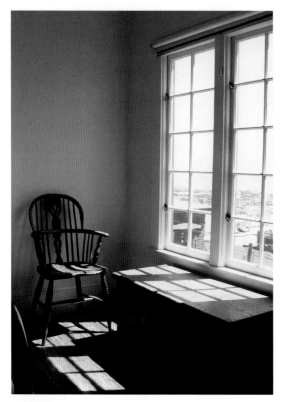

Photorealism

The actual scene from which Edward Gordon conceived *Solstice*. Freely using artistic license, he made two major changes: He substituted an ocean and rocks for what actually lay outside the window, and he added a window above the chair. Painting photorealistically doesn't always mean painting everything that's there—it does mean painting in realistic detail.

Photorealism

Gordon's drawing for *Solstice* before he added the window above the chair.

physionotrace

A device invented in the late 1700s for aiding in reproducing an image, especially a portrait. Basically, the subject (such as a head) is viewed and "traced" through a movable eyepiece. The eyepiece is attached to a pantograph. As the eyepiece moves over the subject's features, an etching or engraving needle (or even a pen or pencil) attached to the pantograph mimics the eyepiece movements, resulting in an image of the subject on either a larger or smaller scale. *See pantograph.*

picture plane

The surface of a picture. When discussing various aspects of design, it's helpful to have a frame of reference, and often that is the picture plane. For example, in talking of linear perspective, one might describe a roadway as receding *from* the picture plane; in discussing a flat, nonobjective painting, one might describe everything that's happening in the picture as being *in* the picture plane.

pigment

A pulverized material that provides the color in most artist's paints and inks. Finely divided particles of pigment are suspended in a vehicle, or medium, such as linseed oil (oil paints) or gum arabic (watercolor paints). Pigments are usually insoluble.

They are derived from a wide variety of natural and artificial materials, both organic and inorganic. *See dye; lake.*

pilaster /pih *las* ter; *pie* las ter/
A vertical rectangular part of a wall, protruding partway from the wall, sometimes acting as a support and sometimes only for decorative purposes, on either indoor or outdoor walls. Pilasters are designed to conform with the surrounding architecture. The forerunners of pilasters were Greek structures called antas, protruding supports that appeared at the ends of walls and always served a structural purpose. Pilasters became a common feature under Roman use—there are, for example, pilasters in the Roman Colosseum—and they play a part in much modern architecture.

Photorealism
Although artist Daniel Tennant eliminates any evidence of his having made this picture, his presence is certainly felt in the skillful arrangement of the composition and, of course, in the fine color sense and technical skills necessary to produce such convincing work.

TREASURED FRIENDS | Daniel K. Tennant | gouache on museum board | 30″ × 40″ (76cm × 102cm). Private collection. Photo courtesy of Bernarducci•Meisel•Gallery, New York City.

pinhole
A tiny hole in a painting. Usually the cause is a porous ground, the result of coating a canvas with acrylic gesso that has been so diluted that the canvas weave is not adequately filled in. Also caused by tiny air bubbles in true gesso as it is applied to a support. *See canvas; gesso, acrylic; gesso, true.*

a b c d e f g h i j k l m n o p q r s t u v w x y z

planographic printing
Printmaking in which the image to be printed is on the flat surface of a stone, plate or other material, neither cut into the surface nor built in relief on the surface; surface printing. Examples: lithography and monotype. *See print.*

plaster
A mix of either gypsum or lime with water and sand, used in coating walls and ceilings on which fresco painting is to be done. *See fresco.*

plaster of paris [Paris sometimes capitalized]
A fine-grained, quick-setting form of plaster made with gypsum and used in some sculpture, in making plaster prints and in forming decorative work on walls and ceilings. It's also the plaster used in setting broken bones and in making impressions of tire tracks at crime scenes. Its name comes from its discovery and use near Paris, but it was used by Greek and Egyptian builders at least four thousand years ago. *See plaster print.*

plaster print
A print using plaster of paris instead of paper. Any intaglio plate, such as an engraved plate, is laid face up and inked in the usual way, with the excess ink then being wiped from the surface. Plaster of paris is poured over the plate (with some sort of surrounding frame in place to contain the plaster) and allowed to harden. When the plaster slab is removed it will bear the imprint of the inked lines. Fine-grained plaster of paris flows into the tiniest grooves and forms a faithful copy of the image on the plate. *See plaster of paris; print.*

plastic art
Three-dimensional art, such as stone sculpture and modeling in clay.

plate
A surface, usually metal, on which an image is formed in printmaking. Also a sheet of material, such as glass, with a coating of light-sensitive emulsion used in photography and some printmaking. *See print.*

plate finish
A smooth surface finish on a paper; also called *high* finish.

plate mark
The slight ridge around the edges of a print, such as an etching or engraving, where the edge of the printing plate is pressed into the paper during printing.

plein air painting /plane *air*/
Open-air painting; painting a subject outdoors on location. One who paints in this manner is called a pleinairist.

Plexiglas
Brand name (Rohm & Haas) for a clear, glasslike, acrylic material (polymethyl methacrylate) used in framing pictures and as a component of many sculptures. The usual generic name for such a product is *acrylic sheet*; another well-known brand of acrylic sheet is called Lucite. Plexiglas is relatively unbreakable (compared with glass) and lighter in weight than glass. It's used in framing pictures that must be shipped or otherwise subjected to the danger of breakage; often it's used to frame large pictures simply because its weight is so much less than that of glass. As a framing material, it has drawbacks: **1**: It develops so much static electricity that it should not be used on pastel or charcoal pictures because the particles of pastel or charcoal are attracted toward the inner surface of the Plexiglas. **2**: It scratches much more easily than glass. Many ordinary glass cleaners will damage its surface,

so Plexiglas must be cleaned either with mild soap and water or with cleaners specifically designed for such use. **3:** On very large pictures, Plexiglas is likely to bow much more than glass.

There are other uses for Plexiglas. Some artists use it as a painting support; they paint on it in acrylics (first rubbing the surface with very fine sandpaper) and then frame the work with the painted surface inward so that the paint is protected from damage. It's also used as a paint palette and a drawing bridge. *See bridge.*

pliers, canvas stretching
See canvas stretching pliers.

plique-à-jour /pleek ah *zhoor*/
An enameling process in which enamel is deposited into cells in the same way as in cloisonné, but with a significant difference—the metal strips forming the cells are not permanently attached to a base. After the enamel has been fired and cured, the enamel and strips are separated from the base. The result is like a miniature stained glass window. *See enamel; cloisonné.*

ply
One of usually several layers, as of paper, cloth or wood. In some cases, as in plywood, the plies are visible. In others, as in two-ply mat board or in bristol board, the plies are not necessarily evident, having been laminated together under great pressure. Most materials made of more than a single ply are stronger than a single sheet

of the same total thickness. In many cases, as in plywood and some papers, if the plies are glued together so that their grains are at right angles, the resulting sheet will be much less likely to warp than either a single thick ply or a sheet in which the several plies are combined with their grains all in the same direction.

plywood
Several thin layers of wood glued together under pressure. The resulting sheet is strong and resists warping. Plywood is sometimes used as a painting support but, like any wood surface, it can develop cracks, even if it is properly sealed and coated with a ground. Some artists glue canvas to the face of plywood, lessening (but not eliminating) the chances for cracks to occur. Plywood is acidic and should be sized and then coated with a ground such as acrylic gesso, oil or alkyd before use as a painting support. *See ground.*

PMA
Pencil Makers Association. This organization's seal certifies that the core (the

PMA
Courtesy of Writing Instrument Manufacturers Association/PMA, 236 Route 38, Suite 100, Moorestown, NJ 08057.

"lead") in a pencil is nontoxic and that the pencil's other parts are nontoxic as well: its wood, plastic or other casing; the lacquer coating on the casing; the eraser; and the ferrule (the metal sleeve that fastens the eraser to the body of the pencil).

pochade box /poh *shodd*/

A sketch box; a small, light, portable box that holds basic artists' supplies and may serve as an easel. In most pochade boxes the lid swings up and locks into position so that it can support a drawing or a painting. A pochade box may be balanced on the knees while you sit and sketch or paint, or it may be fitted with a tripod.

Pointillism

The technique of placing dots of color side by side or overlapping, rather than mixing them on the palette, so that at a distance the colors visually merge and produce the desired effect. As a simple example, dots of blue and yellow, when viewed at a distance, give an overall green effect. Fairly rigid systems for the technique were worked out by French painters Georges Seurat and Paul Signac. Pointillism (also sometimes called Divisionism) came into play at the end of the Impressionist period; *See Post-Impressionism; Neo-Impressionism; stippling.*

pointing

A method of accurately reproducing a sculpture. An arrangement of adjustable arms is set at any point on the sculpture to be copied, and corresponding arms, or pointers, are put in a similar position on the block to be carved. That position is marked; the same process is repeated a great many times as the block is gradually carved away. If the block to be carved is larger or smaller than the original model, arms are rigged so as to be placed in a pro-

portionally correct way. Such a device was used in carving the huge Mount Rushmore presidential heads based on smaller models. The process is similar to hardware store key-duplicating machines that have two stations—one for the key that is to be duplicated and one for the blank key to be cut.

polychrome

A picture or other object made using a number of different colors.

polymer

A chemical compound composed of long, chainlike molecules. Films made of polymers are generally tough, flexible and stable. Polymers are the basis for many plastics and synthetic fibers, and they are what gives acrylic paint its flexibility and strength.

polymer clay

A material made of polyvinyl chloride (PVC) particles suspended in a plasticizer; like earth clay, it is soft and plastic at room temperature, but hardens when heated in a home oven. Polymer clay was originally aimed at children's play activities, but in the hands of artists such as Carol Zilliacus, whose work is shown on pages 330-333, it has become a true art material. Polymer clay is sold in sticks or blocks of varying sizes and in many colors. It carries an AP nontoxic seal.

Polymer clay may be manipulated in many ways (an excellent guide to its use is Barbara A. McGuire's book, *Foundations in Polymer Clay Design*). The differently colored clays may be sandwiched, gouged, cut, squeezed, twisted together, superimposed, inlaid—in short, formed into whatever shapes and color combinations the artist wishes. Working tools are simple enough—fingers, sharp blades, needles and anything else that helps to manipulate the

Pointillism

One set of overlapping color dabs is done in transparent
acrylic and the other in opaque acrylic, in both instances
using Phthalocyanine Blue and Cadmium Yellow Light.
Some painters use dots carefully sized and placed; others
use more ragged dabs, like these.

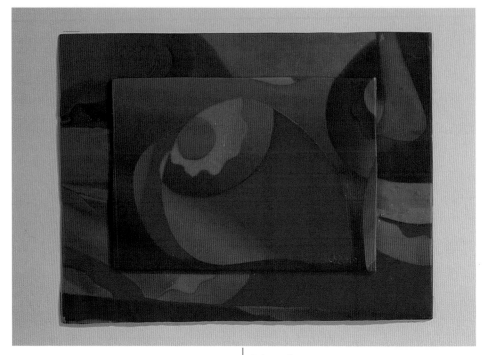

Polymer clay

STILL LIFE | Carol Steinman Zilliacus | polymer clay |
12¼″ × 13¼″ (31cm × 34cm)

clay. A common tool is a simple pasta machine for rolling the clay into thin sheets, pressing colored layers together, and so on. The illustrations show just a sampling of the kinds of objects that may be made with polymer clay. *See illustrations on pages 330-333.*

polyptych */pahl ip tik/*
An arrangement of four or more panels, either painted or carved and sometimes hinged together, all exhibiting a common theme. *See also diptych; triptych.*

polyvinyl acetate (PVA)
A synthetic resin similar to the resin used as the binder in acrylic paints. Polyvinyl acetate, or PVA, may be used to size raw canvas preparatory to oil painting—an example is Gamblin's PVA Size. Polyvinyl acetate is the main ingredient in familiar latex paints; it's also used as a strong adhesive—for example, in pottery repair and in building up a printing plate in collagraphy. *See sizing; collagraphy.*

p'o-mo /poe moe/
1| In Chinese painting, freely applied color not confined within established lines. Ink (or paint) is applied with a broad brush and allowed to run and mingle with adjacent areas of ink or paint; often the artist tilts the picture to encourage the colors to flow as he or she wishes. This is the more common of the two p'o-mo techniques and is often called "splashed ink" or "poured ink" technique. 2| In Chinese painting, the building up of dense, sometimes broad, areas of color within sections that have first been defined by lines.

Pop Art
Art during the 1950s and 1960s using commonplace objects, such as soup cans, comic strips and hamburgers, as subjects. Among the better known Pop artists were Andy Warhol, Roy Lichtenstein, Claes

Polymer clay

Carol Zilliacus begins each design by blending and mixing colored clays, using a variety of techniques she has developed. Then she forms each pendant image by joining color sections using what she calls a "collaging" technique, sometimes also outlining sections of color to mimic an enamelist's cloisonné technique.

PENDANTS | Carol Steinman Zilliacus | polymer clay | each oval 1³⁄₄″ x 1⁵⁄₈″ 44mm × 34mm. Included in *The Many Moods of Polymer Clay* by Dotty McMillan, Sterling Press, 2001.

Oldenburg and David Hockney. They portrayed all aspects of popular culture, especially the images people were seeing increasingly in television advertising.

poppyseed oil [or poppy oil]

Oil from the seeds of the poppy plant, used as a binder in some oil paints. Although considered inferior to linseed oil as a binder, poppyseed oil yellows in time somewhat less than linseed oil; because of this quality, it's sometimes used by paint manufacturers in white oil paints, where yellowing would be most noticeable. The film formed by poppyseed oil is less tough and more likely to crack than that of linseed oil.

porcelain

A type of pottery that is fine-grained, hard, white and translucent. *See pottery.*

portland cement [Portland often capitalized]

A mixture of lime (calcium oxide) and clay (containing silicon and aluminum oxides) along with other minor ingredients. Portland cement is the adhesive used in mortar and in concrete. Basic mortar, used to join bricks and other building blocks, is a mixture of cement, sand and water. Concrete, such as that used in roads and sidewalks, is a mixture of cement, sand, water and gravel. The cement was so named because it resembled a material called portland limestone used in building in Portland, England, in the 1800s. Portland cement is used by some sculptors, and it figures heavily into the work of many architects designing buildings and other structures.

Polymer clay

This piece, which includes some acrylic paint, combines Zilliacus's techniques for suggesting tapestry, embroidery and line drawing.

CEREMONIAL ROBE I | Carol Steinman Zilliacus | polymer clay | 22″ × 19″ (56cm × 48cm). Appeared in The Polymer Clay Juried Calendar 2000 published by To Clay or Not to Clay™ September 2000.

Polymer clay

A sculpted polymer clay mask.

THE LISTENER | Carol Steinman Zilliacus | polymer clay | 4″ × 2½″ (10cm × 6cm). Collection of Shirley Tabler.

Portrait
Urania Tarbet began this painting with a watercolor lay-in and finished with pastels. In many areas of the background and the sombrero the watercolor shows through.

SEÑOR PADILLA | Urania Christy Tarbet | pastel and watercolor on canvas mounted on hardboard | 20″ × 24″ (51cm × 61cm). Collection of the artist.

portrait

A picture or a sculpture representing a real person; also, sometimes, a picture that faithfully represents a particular place or scene. Portraits have always been held in high regard by their subjects; until recent times, only men and women of means had their portraits drawn or painted. Before the advent of photography, portraits were the only record (aside from plaster masks) of what a person looked like. The best portraits, however, capture not only a person's likeness, but his or her personality as well. We all think we have a pretty good idea of both Henry VIII's look and demeanor because of his portrait by Hans Holbein the Younger, and who does not recognize and perhaps even understand something of the character of George Washington thanks to his portraits by Gilbert Stuart. Many artists, such as Rembrandt van Rijn, left marvelous records of their own changing appearance by series of self-portraits. Some of the earliest known portraits are Egyptian mummy portraits dating from about the second century AD—these lifelike paintings in encaustic on wood were fastened over the face of the deceased.

JUDITH KOESY AHLSTROM ©

Portrait

Judith Ahlstrom did a charcoal drawing on paper before beginning to paint this portrait of her friend and business partner, Jeanne Nesbitt. She started with a thin under-painting, using colors close to the final colors that would follow (some artists underpaint in a different manner—e.g., with colors complementary to the eventual colors, or with an overall warm or cool tone).

PORTRAIT OF JEANNE | Judith Koesy Ahlstrom | oil on linen | 20″ × 16″ (51cm × 41cm)

positive space

The subject area in a drawing or painting; the area *around* the subject is called negative space. Often an object is rendered by drawing or painting the space around the object (negative space) rather than the object itself (positive space). In the illustration, the form of the dog was rendered to a great extent by painting the dark (negative) spaces around the light (positive) spaces. Painting positive space may be considered direct painting; forming an object by painting what's around it is indirect painting.

poster

An announcement or advertisement on paper, usually combining words and images. Posters by such masters of the art as Henri de Toulouse-Lautrec in the 1890s caught the flavor of the lives of Parisian notables. Later, during the Art Nouveau period, Alphonse Mucha became widely acclaimed for his intricate, sensuous, flowing poster designs. During World War I the poster had a huge impact on the public through images such as "Uncle Sam." In fact, throughout the first half of the twentieth century, posters were used effectively to advertise everything from shows to shoes. These days, posters are often simply reproductions of an artist's work including some sort of wording—sometimes just the artist's name.

poster paint

Inexpensive, opaque water-based paint with a glue or gum binder, often used by children in schools.

Post-Impressionism

The period from the mid-1880s to the early 1900s during which several Impressionist painters, unsatisfied with the impressionistic aim of capturing fleeting light and color, set out to find more substance in painting, especially in the roles of color, form and solidity. Vincent van Gogh used pure color, as the Impressionists did, to capture a scene, but he also used it to express his *feelings* about the scene; Georges Seurat set out to define an almost *scientific* structure for using color; Paul Cézanne strove to use color to define the *structures* of objects. Cézanne's work in particular helped lead the way to Cubism, a movement in which the structure of things was paramount.

potter

One who makes pottery.

potter's wheel

A horizontal disk holding at its center a lump of wet clay that the potter forms into the desired shape as the disk revolves. As the wheel spins, the potter uses hands and tools to shape the plastic clay into a bowl, pot, vase or other cylindrical form. The potter controls how fast the disk and clay revolve; many potter's wheels have a foot-actuated mechanism, while others are driven by an electric motor.

pottery

Objects made of clay hardened by heating. There are three general classes of pottery: earthenware, stoneware and porcelain. *Earthenware* is hard but porous; *stoneware* is baked at a higher temperature and becomes extremely hard and nonporous; *porcelain*, made of finer clays and crystalline minerals called feldspar, is fired at a still higher temperature and is hard, nonporous, fine-textured and translucent.

Pottery in various forms and degrees of hardness has been made throughout history. The quality of pottery varies with the clays and other materials available in a region. Man discovered early on how to make crude pots and other objects from

Positive space

All the space surrounding the dog may be considered negative space; the dog itself is positive space. Within the dog's form, details are also painted negatively—the ear, for example, is rendered mostly by painting the dark shadows around it (negative space) rather than painting the ear directly. The strong dark at the upper right is negative space that delineates the positive space of the dog's head and shoulder.

Sᴀᴍᴍʏ | Shirley Porter | watercolor on cold-press paper | 14″ × 11″ 36cm × 28cm). Collection of Scott Metzger, Frederick, MD.

a
b
c
D
e
F
G
H
I
J
K
L
m
n
o
P
Q
r
s
T
U
V
W
X
Y
Z

Ostracism

In Greece in the fourth century BC, where beautiful, but functional pottery was commonplace, citizens of the world's first democracy were empowered to vote once each year to banish any single individual they chose. They voted by scratching a name on a pottery fragment (called an ostrakon), and when the votes were counted, out went the person receiving the most votes. They called the voting process ostrakizein, from which we get ostracize.

Pounce wheel

coarse clay. What we now call porcelain was made over a thousand years ago in China; Chinese porcelain was called "china."

Most clays can be easily formed into all kinds of objects, both utilitarian and decorative. Left in the sun to dry, they all become reasonably hard, but not hard enough to hold their shapes when wet. Pottery becomes water-resistant and tough only when baked at high temperatures in ovens, or kilns. To make pottery that is nonporous, coatings called glazes are added, usually after a first firing. The glazed pottery is fired again to make the glaze melt and form a hard, glasslike coating.

pounce wheel
A wheel with a handle, similar to a pizza cutter but with a serrated edge, used to roll over the outlines in a cartoon, a full-scale drawing for a fresco. The pounce wheel uniformly punctures the cartoon's surface so that pigment may then be dusted (pounced) through the punctures onto the painting surface, thus transferring a dotted representation of the cartoon draw-

ing to the painting surface. *See fresco; cartoon.*

pound
A unit designating the weight in pounds of a ream (500 sheets) of a particular paper. If a ream of 22″ × 30″ (56cm × 76cm) paper weighs 300 pounds, we refer to a sheet of that paper as "300-lb." But this is a confusing system because that same thickness of paper made in a larger sheet, say 29½″ × 41″ (75cm × 104cm), would be called "555-lb." because that's how much a ream of the larger paper would weigh. Here are three watercolor papers that have the *same* thickness:
Arches 300-lb. 22″ × 30″ (56cm × 76cm)
Arches 555-lb. 29½″ × 41″ (75cm × 104cm)
Arches 1114-lb. 40″ × 60″ (102cm × 152cm)

An unambiguous way to designate papers of different thicknesses is by stating the weight of the paper in *grams per square meter* (gm/m^2 or gsm). Each of the three papers weighs 640 grams per square meter.

poured ink
See p'o-mo.

poured paint

Paint applied to a surface by being literally poured from a container rather than brushed or sprayed on. This is one of the techniques many nonrepresentational painters use. *See Abstract Expressionism; action painting.*

precipitated chalk

Chalk (calcium carbonate) that is made synthetically. It's used in various paints, such as gouache and pastel, for its whiteness and as a filler. *See chalk.*

Pre-Raphaelites

A group of painters in England who organized in 1848 to introduce into painting what they felt was a purer, more direct depiction of nature than what they saw being painted at the time. Their aim was to emulate the work of Italian artists of the Renaissance before the time of Raphael. The original members of the Pre-Raphaelite Brotherhood, as they called themselves, were three Royal Academy students, Dante Gabriel Rossetti, William Holman and John Everett Millais. The group at first exhibited anonymously, signing their works PRB. When their identities were discovered, some critics, including Charles Dickens, criticized, among other things, their irreverent realism in dealing with religious subjects. But thanks in part to the praise of critic John Ruskin, the group was popular and its work was sought out by patrons. Although the group disbanded by 1854, their work had a significant impact on painting during the 1850s and 1860s.

Presdwood

The name of a popular hardboard made by the Masonite Corporation. Most people refer to the product as Masonite, but the proper name is Masonite Presdwood.

press, dry-mount

See dry mounting.

press, printing

See printing press.

primary color

In painting, the three basic colors red, blue and yellow; in light mixing, the three basic light colors red, blue and green. *See color wheel; additive color mixing; subtractive color mixing.*

priming

Coating, as of gesso, on the surface of a support to serve as a ground for a painting or drawing. *See canvas, priming; ground.*

primitive art

Art produced by someone untrained in art. This is a broad and inexactly defined category—what one person calls primitive art, another might dismiss as junk. What most exemplifies primitive art is a naïvete, or honesty, about the subject that is not masked by sophisticated artistic techniques learned in a school. A primitive artist depicts the essence of what he or she sees without necessarily including the niceties of perspective or balanced design. Painted rural scenes by Grandma Moses (Anna Mary Robertson Moses), done without regard to the "rules" of perspective, are an example of primitive painting. The seemingly innocent work of Henri Rousseau, such as *The Dream*, is another example.

Some art historians use the term *naïve art* as synonymous with *primitive art*, while others make distinctions. *Encyclopedia Britannica*, for example, defines primitive art as "the work of prehistorical and preliterate peoples" and naïve art as "the work of artists in sophisticated societies who lack or reject conventional expertise in the representation or depiction of real

objects." In most current usage, both prim-
itive and naïve art are defined as art pro-
duced by someone untrained in art.

print

A copy of an image produced by, or under
the direction of, the artist who designed it.
The term has been used loosely in recent
years to include images made by purely
mechanical means, such as on a photo-
copier or on an offset press, but such
images should properly be called *reproduc-
tions*. A true print implies the active partici-
pation of the artist in producing each
image. Because the term *print* has been
watered down and made ambiguous, some
prefer the term *original print* to more firm-
ly signal the participation of the artist in
its production.

Prints are made in limited editions—
that is, there are a fixed number of images
made and no more. If, say, two hundred
copies of a particular image are made, the
edition size is 200 (*see sidebar*). Usually the
artist signs and numbers each copy 1/200,
2/200 and so on. Traditionally, the signing
and numbering are done in pencil, which
helps signal that the signing and number-
ing were not done by mechanical means.
Signing and numbering each copy gives
the buyer some assurance that the artist
has personally viewed and approved each
one. (It's become widespread practice to
sign and number reproductions in the
same way—in that case, signing does not
imply that the artist actually had a hand in
producing the copy, but only that he or
she did look at each copy and that the
number of copies to be sold is limited to
the stated edition size.) The term *open edi-
tion* means there is no limit to the number
of copies that will be produced; in this
case numbering the copies would be
almost meaningless.

Prints are made in a number of ways.
Relief prints are made by carving away

When 200 = 230

In addition to the signed and numbered
prints in an edition, there may be a num-
ber of *artist's proofs*, extra prints pulled
ostensibly for the purpose of testing and
adjusting the printing process, but in
many cases pulled for the purpose of
added sales. These "extra" prints may be
signed and marked "A/P." Typically there
might be a number of artist's proofs equal
to about 10% of the regular edition size,
so for an edition of 200 prints there may
be an additional 20 artist's proofs. Also,
some artists add small drawings or other
markings to some of the prints in order to
make those prints different from the rest
of the edition. The added marks are called
remarques, and the altered prints are also
usually called remarques. Remarques are
in addition to the regular print edition and
typically may total five percent of the
original edition.

So a print edition of 200 + 20 artist's
proofs + 10 remarques = 230 salable
prints!

unneeded areas from the surface of a
material such as wood or metal, inking the
remaining areas and pressing paper
against the inked surface. *Intaglio* prints
are made by forming grooves in a surface
such as wood or metal, forcing ink into the
grooves, wiping the rest clean and pressing
paper against the surface so that the paper
picks up ink from the grooves. *Surface*, or
planographic, prints are made by forming
an image on a completely flat surface.
Stencil prints are made by forcing ink or
paint through unprotected areas of a
guide (stencil) onto a sheet of paper, fabric
or other material. The chart shows exam-
ples of each type of print. Printmakers use

Types of Prints

Type of Print	Category	Description (For more, see individual entries)
Aquatint	intaglio	A form of etching, but in addition to the usual lines in an etching, an aquatint has granular etched areas attained by coating those areas with a granular, acid-resisting material.
Cellocut	intaglio or relief	Liquid plastic is poured over a rigid support of hardboard or cardboard and allowed to solidify. The artist works the plastic with various tools, scraping, gouging and texturing it to form an image. The plate may be used for an intaglio process—that is, ink is forced into its grooves and depressions and the rest of the surface is wiped clean—or the plate may be used in relief, in which case ink is deposited only on the raised surfaces.
Chine collé /sheen koh *lay*/	intaglio	A print that includes colored and/or textured papers in addition to the basic print paper. An inked printing plate (e.g., etched or engraved) is placed face-up on the bed of the press. Colored or textured papers (often thin oriental papers torn to suit the artist) are coated with an adhesive on one side; the pieces are placed glue-side-up on the plate. Regular printing paper, usually heavier and stiffer than the colored/textured papers, is placed over the gluey papers and the combination is run through the press. Depending on the shapes and placements of the torn papers, some of the printing paper may show through.
Cliché-verre / klee *shay* vair/	a form of intaglio	The artist coats a piece of glass with an opaque material such as paint and then uses sharp tools to make a drawing by cutting through the coating. The drawing is placed on a sheet of photo-sensitive film and exposed to light. When developed, the film shows a drawing in black where the lines have been cut on the plate, while the rest of the developed film remains white.
Collagraph	intaglio	A three-dimensional surface is built up of various materials. Ink is added to the depressed areas, other areas are wiped dry and the plate is run through an etching press under pressure. Paper is forced into the inked depressions, resulting in an area that is both inked and embossed.
Criblé /kree *blay*/	intaglio or relief	A printmaking technique in which round marks are made in a plate using punches and a hammer. By placing punch marks closer together or farther apart, tones may be created. This technique may be used either in relief or intaglio printing—that is, ink may be confined to the surface of the plate or to the pits in the plate.

Types of Prints

Type of Print	Category	Description (For more, see individual entries)
Drypoint	intaglio	A drawing is scratched directly into the surface of a plate, usually copper, using a sharp tool. The resulting grooves are similar to those produced by etching or engraving, but there are subtle differences. Scratching with a drypoint tool produces along both sides of the groove slightly irregular raised edges that have an effect on the appearance of the printed line.
Engraving	intaglio	A metal plate, usually copper or steel, is cut into cleanly with a tool called a graver, or burin. The tools are made of tempered steel and they come in a variety of widths and shapes. The grooved plate is inked and run through a press with paper that has first been soaked in water and then blotted. The damp paper is forced down into the grooves, where it picks up ink.
Etching	intaglio	A metal plate, usually copper or zinc, is coated with a ground, or resist, often containing beeswax. The design is scratched or pressed through the waxy layer to expose the metal underneath. The plate is then immersed in acid. The acid "bites" into (etches) the exposed metal, forming shallow grooves. The plate is cleaned and inked; ink is cleaned from all areas except the grooves. Printing paper that has been soaked in water and then blotted is forced through a press against the plate; the damp paper is forced down into the grooves, where it picks up ink.
Linoleum Cut or Linocut	relief	An image made by cutting away the excess from a block of linoleum, inking the remaining raised surface and pressing it against a sheet of paper or other material to be printed.
Lithograph	surface	A drawing is made using special greasy pencils or inks on a flat plate made of limestone or metal such as aluminum or zinc. The plate is then wet with water, and when ink is rolled over its surface, the ink adheres to the greasy image areas but not to the wet nonimage areas. Paper pressed against the inked plate in a press picks up a reverse image.
Mezzotint	intaglio	An engraving showing shades of gray or color. The surface of a plate, usually copper, is roughened, or pitted, using tools such as a rocker, a burred tool that is rocked back and forth. Other tools such as burnishers and scrapers can be used to modify the roughness and produce any degree of fine or coarse grain.

Types of Prints

Type of Print	Category	Description (For more, see individual entries)
Monotype	surface	An impression made by first painting or inking a sheet of glass, metal or other smooth surface and then pressing a sheet of paper against the wet paint or ink using either a press or pressure from the hands, a roller, a baren or some other tool. Such an impression is not a true print because precise multiple copies are not possible; usually only a single print results. A monotype is classified as a "print" because that term refers to any image transferred from one support to another, as opposed to direct painting or drawing.
Monoprint	mixed	Similar to a monotype, but instead of applying paint or ink to a smooth, plain surface, it's applied to an already prepared etching, engraving, lithographic, collagraphic, or other plate. Paper is pressed against the plate and the result is an image that combines the qualities of both the prepared plate and the added paint or ink.
Photoengraving	relief	A sheet of metal such as magnesium is coated with a light-sensitive material. A photographic film negative is placed over the coated sheet and then exposed to ultraviolet (UV) light. The UV light passes through the areas of the image that are light and not the areas that are dark. Where the UV light passes through, it hardens the coating on the metal plate. The plate is treated with chemicals to dissolve the nonimage areas, leaving the image in relief.
Plaster Print	intaglio	A print using plaster of paris instead of paper.
Serigraph, Silkscreen Print, or Screen Print	stencil	A fabric is stretched tightly across a frame and certain areas of it are blocked out by various means so that the fabric becomes a stencil. Ink is forced through the weave of the fabric with a squeegee or spatula onto a sheet of paper below; where the fabric is blocked out, no ink gets through. A separate fabric screen is made for each color to be printed.
Woodcut or Wood Engraving	relief	A block of wood is cut away around the image area. The remaining raised image area is inked and pressed to a sheet of paper or other material, producing an image the reverse of that on the block.

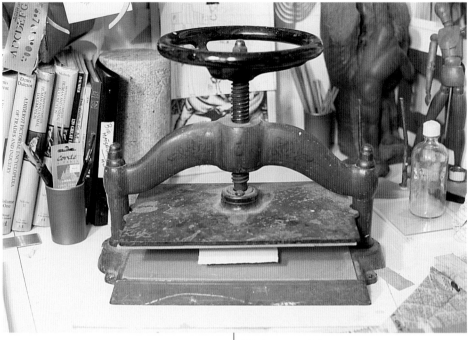

Printing press: relief
A relief press works in essentially the same manner as a rubber stamp. This one is a bookbinding press that may be used for making relief prints, such as woodcuts, wood engravings and linoleum cuts. The inked printing block is placed face-up on the bed of the press and a sheet of paper is placed on top of the block. The upper jaw of the press is lowered, pressing the paper and block together. The upper jaw is raised and the paper is carefully removed from the block without shifting or sliding it against the block, which would cause smearing. Photo courtesy of Peter Stoliaroff.

endless variations to basic printmaking processes and they also often combine processes so that there are kinds of prints not shown in this basic chart. Except in the case of serigraphs, prints are the reverse of the images on the plates, blocks or stones. *See individual entries for more information; for a good description of all printmaking techniques, see* The Complete Printmaker.

printing press
1| A machine that prints images (reproductions) on paper at high speed for commercial products such as newspapers, magazines and books. *See lithograph, offset.*
2| A device used by a fine art printmaker to produce prints one copy at a time. Any printmaker's press works in the same basic way—it applies pressure between a sheet of paper and an inked printing plate, stone or block. But there is a major difference between a press used for intaglio prints, such as etchings and engravings, and one used for relief prints, such as woodcuts and linoleum cuts. Presses used for intaglio printing apply considerable pressure as they force the paper and plate (or block or stone) between a roller and a flat bed, thus squeezing the paper into the inked grooves of the plate. In relief printing, however, ink is transferred to paper by a stamping process rather than a rolling, squeezing action. In addition, presses used for printing lithographs use neither a roller nor a stamping process: A lithographic press moves the stone and paper under a scraper, a wood or plastic bar that scrapes along the top surface of the paper, pressing the paper to the inked stone.

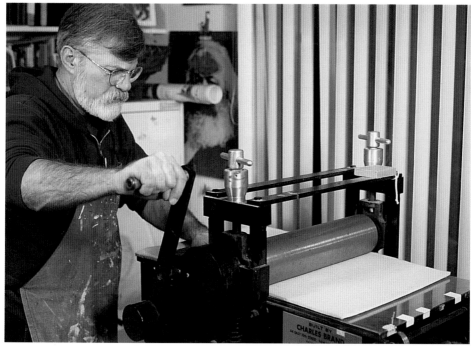

Printing press: etching

This is a Charles Brand etching press. Printmaker Peter Stoliaroff is making an etching, but this same press may be used for engraving, drypoint and embossing as well. To prepare for pulling a print, Stoliaroff first immersed his German etching paper in water (room temperature) for about ten minutes and then placed it between sheets of blotting paper and used a roller to squeeze water out until the paper was uniformly damp. Damp paper is soft enough to be pressed into every tiny groove in the plate—dry paper would resist and would result in an incomplete, unsatisfactory image. While the paper soaked, Stoliaroff inked the surface of his plate. The plate is zinc, approximately $1/16''$ (0.15cm) thick; the ink is a stiff paste. He spread ink over the surface of the plate and forced it into the plate's grooves using a piece of plastic about as stiff as a plastic kitchen spatula. Satisfied that all the grooves were filled, he cleaned the excess ink from the surface of the plate using a wad of fine cheesecloth and rubbing in a circular motion, trying to wipe across the grooves at an angle so as not to let the cloth dip into the grooves and remove ink from them.

He places the inked plate face-up on the flat bed of the press, settles the damp paper over the plate and lowers three layers of felt blankets over the paper (other printmakers use more or fewer layers of blankets). The blankets help to distribute pressure evenly to the paper. Now he turns the crank that moves the flat bed of the press and the plate, paper and blankets under the roller. As the plate and paper move under the roller, pressure from the roller squeezes the damp paper into the plate's grooves and the paper picks up ink from the grooves. The amount of pressure is controlled by screw-type knobs at both ends of the roller. Photo courtesy of Peter Stoliaroff.

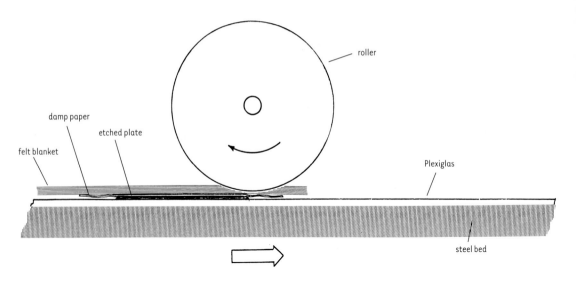

Printing press

The basics of a typical press, such as Stoliaroff's, used for intaglio printing. The sandwich of steel bed, Plexiglas, etched plate, paper and felt blankets moves under the roller as a crank is turned by hand. The heavy roller is free to revolve around its axis but it does not move longitudinally—only the bed moves. Not shown in the diagram is a sheet of paper under the Plexiglas on which the printmaker may draw guide lines to help position the etching plate.

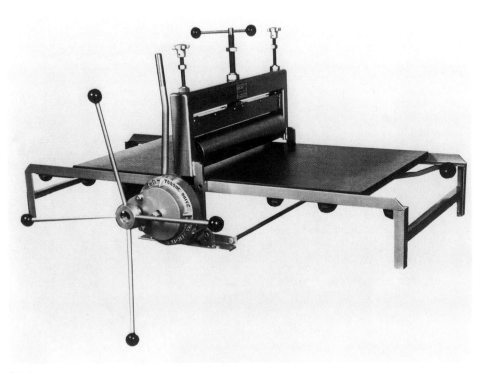

Printing press

A combination press set up for intaglio printing.

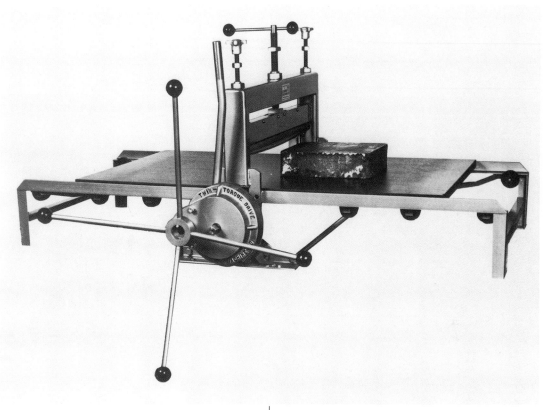

Printing press
The same press as on page 346 fitted with a scraper for printing lithographs. Photos courtesy of Conrad Machine Company, 1525 S. Warner Street, Whitehall, Michigan 49461.

professional grade
Artist-quality; the best grade. *See student-quality.*

projector
Any device used for displaying an image on a wall, screen or other surface. The image to be displayed may be on paper, transparent acetate, slide film or any other material that will fit the projector. The two most common types are slide projectors, which are used for displaying 35mm slides, and opaque projectors for displaying images on paper, photographic prints or other opaque media. Many artists use projectors as painting tools. Some project an image onto a canvas or paper support (or onto the side of a building for a mural), trace off the image (or the parts of the image they want to use) and then proceed to paint using the traced drawing as their guide. Others begin painting immediately, while the projector is on, using the projected image as a rough guide but not necessarily tracing off the drawing at all. Still others project an image on a wall or screen nearby (but not on the painting support) and refer to the image as they paint, much as if they were painting on location with the subject before them. Some critics object to the use of projectors: They feel this is "cheating" and does not represent true art. Had they lived centuries ago, no doubt these same critics would have objected to the use of easels, tube paints and perhaps even brushes—real artists smeared earth and charcoal on cave walls using only their hands! *See mural.*

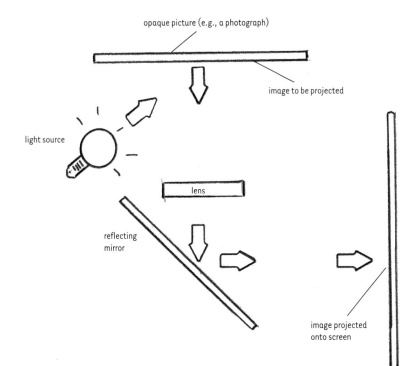

opaque picture (e.g., a photograph)

image to be projected

light source

lens

reflecting mirror

image projected onto screen

Projector: opaque

Greatly simplified schematic of an opaque projector. The image to be projected is illuminated, light from the image passes through magnifying and focusing lenses and strikes a mirror, and the image is reflected onto a viewing screen.

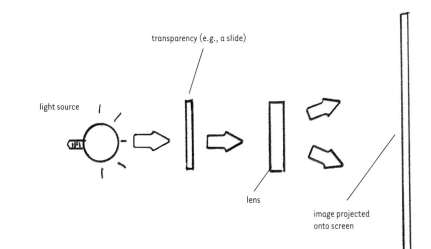

transparency (e.g., a slide)

light source

lens

image projected onto screen

Projector: slide

Simplified schematic of a slide (or transparency) projector. Light passes through the transparency, then through a combination of magnifying and focusing lenses that direct an enlarged image to the screen.

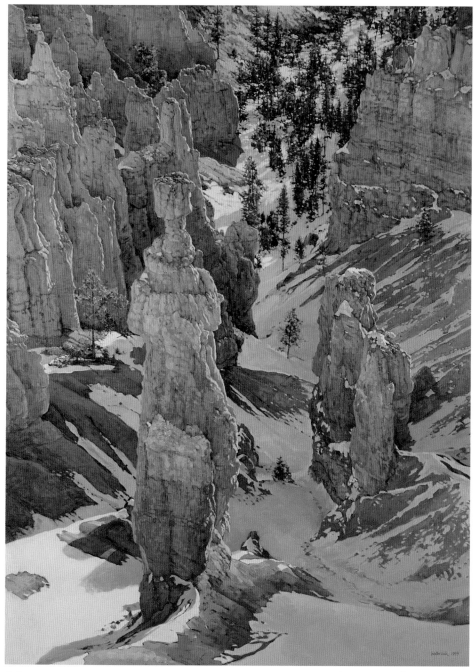

Projector

Peter Holbrook uses a slide projector in the early stages of his beautiful and dramatic landscapes. He does not trace off an image. Instead, with the projector on, he goes directly to painting and does a lay-in that captures the main shapes and values he's after. He then proceeds in the traditional way and develops a picture of a place that, he says, "is only loosely dependent on photography at the start and almost independent of it at the finish."

THOR'S HAMMER-BRYCE | Peter Holbrook | oil and acrylic on canvas | 60″ × 44″ (152cm × 112). Collection of Dane and Melanie Masters.

proof
A test copy of a print. Sometimes the test copies are called artist's proofs and are sold, marked A/P. *See state.*

Proto-Renaissance
The period before the Renaissance, roughly the late 1200s to the early 1300s, that in hindsight can be seen to have set the stage for the Renaissance. It was a time when St. Francis had encouraged people to enjoy the beauties of nature, a time when the great writers Dante Alighieri, Giovanni Boccaccio and Francesco Petrarch lived and wrote in the vernacular that many people could read and understand. It was also a time when Giotto broke from the stiffness of religious themes and introduced nature and real people into painting.

Psalter /*salt* er/
A collection of psalms (or the entire Book of Psalms from the Old Testament). Psalters were often lavishly decorated (illuminated) by fine linework and color. Some of them featured large, multicolored initial letters and fancy decorations in the margins. Printing a Psalter was one of Johannes Gutenberg's achievements.

pulling a print
Making a single copy of any type of print, such as an etching, an engraving or a lithograph.

pulling a proof
Making a test copy, or proof, of any type of print.

pumice
A volcanic rock, consisting mostly of glass, that is hard and light and, in powdered form, is used as an abrasive or as a grit in sanded boards. *See sanded board.*

PVA or PVAc
A synthetic resin, polyvinyl acetate, similar to the resin used as the binder in acrylic paints. PVA may be used to size raw canvas preparatory to oil painting—an example is Gamblin's PVA Size. Polyvinyl acetate is the main ingredient in familiar latex paints, and it's also used as a strong adhesive—for example, in pottery repair and in building up a printing plate in collagraphy. It's also used in Elmer's Glue-All. *See sizing; collagraphy.*

quatrefoil /*kah* ter foil; *kah* tra foil/
A four-lobed leaf design. *See foil.*

quill
The hollow shaft of a bird's feather, long used as a writing and drawing pen.

quinacridone
A family of synthetic pigments ranging in hues from yellowish-red to red to violet.

These pigments are used in artists' paints to replace less lightfast pigments, such as Alizarin and Rose Madder.

quire
Twenty-five sheets of a given paper; one twentieth of a ream. Originally, a quire was defined as twenty-four sheets, but now twenty-five is accepted. *See ream.*

R

rabbitskin glue
A strong glue made from animal parts, including hides and hooves—rarely, if ever, are rabbits used. The origin of the word is unclear. It is used as an ingredient in true gesso and as a size for canvas, hardboard and other supports. *See gesso, true; size.*

rag or rag paper
A rag is a waste piece of cloth. Remnants (rags) from the manufacture of clothing such as T-shirts are used as a raw material for the pulp that becomes fine art and writing papers. A paper designated as "100% rag" has no wood pulp or other content; it's made entirely from rags, which were in turn made from such fibers as cotton or linen. Rag papers, unlike wood pulp papers, are tough and durable and are the papers of choice for serious work.

Some papers are advertised as "100% cotton" rather than "100% rag." Either designation is perfectly acceptable. In some cases (e.g., Fabriano Uno watercolor paper), the reason for the "100% cotton" designation rather than "100% rag" is that the paper is made directly from raw cotton rather than from cotton cloth. *See papermaking.*

rail
See stile.

raku ware [raku sometimes capitalized]
A form of pottery made by the Raku family dating from 16th-century Japan and originally used to make vessels used in the Japanese tea ceremony. Raku pottery is formed by hand rather than on a potter's wheel, so that each piece is unique. Further contributing to its uniqueness is the way glazes are handled. The glazed pot is heated in a kiln until the glazes melt and then is quickly cooled; the suddenness of the cooling causes unpredictable and unique effects, such as crackling. Some raku is fired along with a flammable substance to diminish the oxygen supply around the pot—this adds to the unpredictability of the look of the finished glazes.

razor blade
A blade made for shaving; the type with a single cutting edge is handy for sharpening pencils, scraping away paint and making sgraffito effects. *See sgrafitto.*

Realism
A movement in the mid-1800s toward painting the common, the ordinary and even the ugly rather than stiff, formal pictures of the upper layers of society. Leaders in this movement were Gustave Courbet, Honoré Daumier, Edouard Manet and Jean-François Millet.

Razor blade

To get scrapers of varying widths you can alter blades by snapping off portions with pliers. Be careful to protect your eyes from flying bits of blade with safety glasses or goggles.

ream

Five hundred sheets of a paper of a given size; twenty quires. Originally, a ream was defined as 480 sheets and a quire as 24 sheets. *See pound.*

red sable

Fine animal hairs used in artists' paintbrushes. *See brush construction.*

reduction technique

In making colored linocuts or woodcuts, there are two basic methods: **1**: Using a separate block for each added color and **2**: using a single block and cutting away more material from it for each new color. The latter is called the *reduction technique*—the block is reduced at each stage. At the end it's not possible to go back and print an earlier stage, since the block for that stage no longer exists. *See linoleum cut.*

reed pen

A pen cut from the hollow stems of various plants such as papyrus and bamboo. The shaft is cut to a convenient length and sharpened at one end; the tip is split in a manner similar to modern fountain pen tips. Such pens have been used for centuries and were popular among many well-known artists, such as Rembrandt and van Gogh, who liked the strong, forceful strokes that the pens allowed.

refillable pen

A technical pen that has an ink reservoir that may be refilled by the user; other technical pens have disposable cartridges that are bought already filled with ink. *See technical pen.*

reflection

An image formed by light that has bounced from some surface before reaching your eye.

In sketch *A* (pages 354-355) the observer sees the tree because light travels directly from the tree to his eyes. In *B* he sees a *reflection* of the tree as light from the tree bounces from the pond's surface up to his eyes. Commonly the observer sees both the object and its reflection because light reaches him both directly and indirectly.

Light doesn't bounce randomly. It behaves according to this rule: *The angle of incidence equals the angle of reflection,* as in sketch *C.* Under normal conditions light does not behave as in *D.* Knowing just that much helps you determine whether you would see a reflection in a given scene. The other illustrations show some common reflection situations. *See illustrations on pages 354-358.*

A

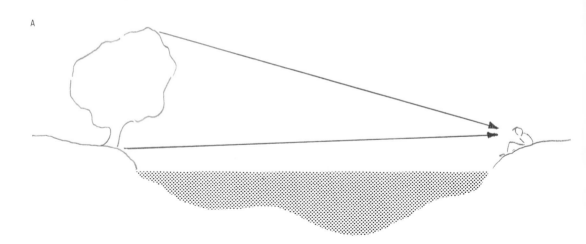

Reflection
We see an object because light travels from the object (tree) to our
eyes.

B

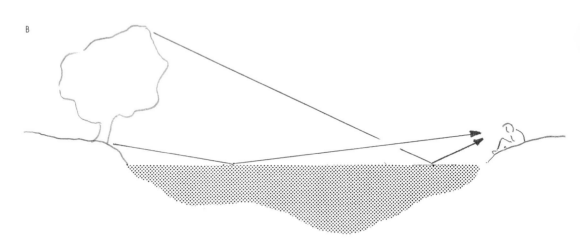

Reflection
We see the *reflection* of an object when light travels from the object
(tree) and then bounces off the water toward our eyes.

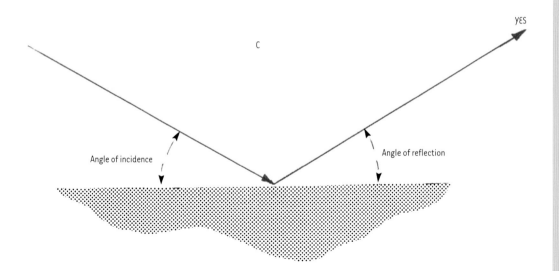

YES

C

Angle of incidence

Angle of reflection

Reflection

When light bounces from a smooth surface, the angle at which it bounces (angle of reflection) always equals the angle at which it meets the surface (angle of incidence).

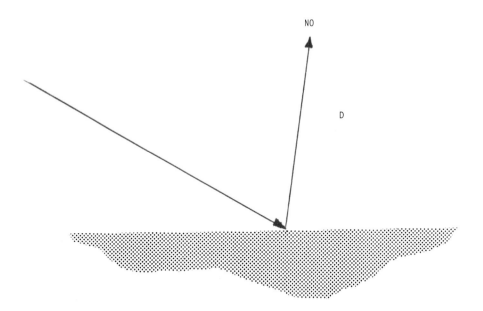

NO

D

Reflection

Light does not bounce randomly from a smooth surface.

Reflection

An effective way to study reflections is to lay a mirror flat on a table and set a variety of objects on it. View the objects from a number of positions. In this illustration you can see that a reflection "leans" in the same direction as the object; that same-size objects show different reflections depending on how far back they are; and that you can see details in a reflection not apparent in the object, such as the underside of the roof overhang.

Reflection

Reflections on a rippled or rough surface are fuzzier or more broken than those on a smooth surface. This is because the many small pieces of the surface (each ripple in this example) act as mirrors and, since each of these "mirrors" is tilted at a different angle, each reflects its bit of incident light in a slightly different direction.

AUTUMN LIGHT REFLECTED, C&O CANAL | Margaret Graham Kranking | watercolor on Arches 260-lb. (556gsm) cold press | 25³⁄₄″ × 40″ (65cm × 102cm). Collection Mr. and Mrs. Thomas A. Gottschalk.

Reflection
Reflections in calm water.

GOOD DAY, BOOTHBAY | Donald Graeb | watercolor on 100% rag Strathmore cold-pressed paper | 29″ × 23″ (74cm × 58cm). Included in 1998 AWS Traveling Show; third-place winner in *The Artist's Magazine* 1997 art competition.

Reflection

Tom Hale, widely known for his exquisite paintings of vintage automobiles, loves to combine the real with the imagined—here a car and a rose. The smooth, shiny surfaces of the automobile produce sharp reflections, compared to the fuzzy reflections in a rippled water surface, but the automobile's curves give the reflections some surprising shapes. Reflections in curved surfaces can be elongated, shrunken and even inverted. Curved surfaces account for the odd reflections in a funhouse mirror. When painting a still life involving curved reflectors, be a keen observer. Painting a still life from your imagination may easily cause you to miss some interesting, hard-to-imagine reflections.

Duesenberg | Tom Hale | acrylic on canvas | 68″ × 44″ (173cm × 112cm)

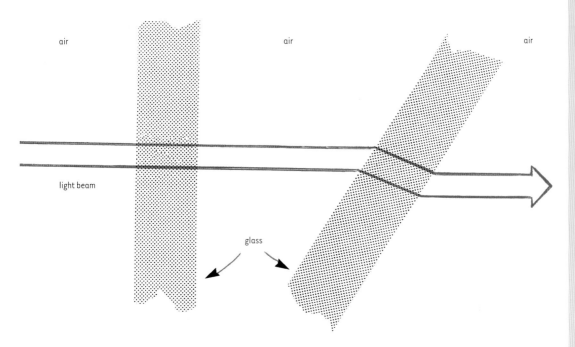

air

air

air

light beam

glass

refraction

The redirection or "bending" of light as it passes at an angle from one substance (such as air) into another of different density (such as glass or water). Light travels more slowly through denser materials than through lighter materials. *See illustrations on pages 359-361.*

Regency Style

In Great Britain, a style of furniture and decoration during the period 1811-1830, the reign of George Augustus. From 1811 until 1820 he had been "acting sovereign," or *regent*, because his father, King George III, had been judged insane. In 1820, when George III died, George Augustus became King George IV. The Regency style was inspired by ancient Greek and Roman fashions, but also drew on Chinese and Egyptian themes. It tended toward rich decoration, including wood veneers and brass marquetry.

Refraction

When the light beam strikes the surface of the first glass perpendicularly, the beam is slowed down but its direction is not changed. However, when the beam strikes the second glass at an angle it does change direction, and where the beam emerges from the glass back into the air it's deflected again. Think of the light beam as a solid rod with a blunt end. The side of the beam that first strikes the slanted glass immediately slows down, but the side that has not yet reached the glass is still traveling fast. The result is a sort of cartwheeling effect as the beam becomes deflected and changes direction. It's as though one front brake in your car grabs and makes the car lurch in that direction.

Regionalism

Any trend in American art whose theme is American life. The term is used especially in dealing with the Depression era—the paintings of Grant Wood, Charles Sheeler and Andrew Wyeth are often considered examples of Regionalism.

registration

Alignment. When a print image is created by applying more than a single impression

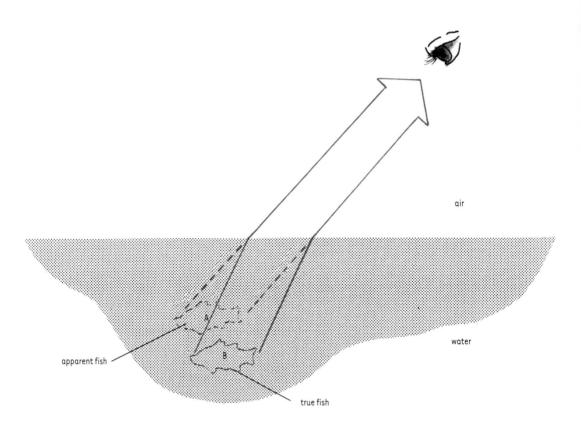

air

water

apparent fish

true fish

Refraction
Your brain processes light as though it has traveled along a straight line, so it seems the fish is at *A*, not *B*. For the same reason, a stick thrust into the water seems to bend where it enters the water.

of ink or paint, it's critical that the printing paper be aligned (registered) in the same position for each impression—otherwise, the result is a blurred image. If a silkscreen print is to be created using, say, ten different screens, each screen must be positioned accurately so that the color squeegeed through it falls on the appropriate areas of the print paper. Proper registration is attained in a variety of ways, often by means of marks along the edges of papers that must be lined up with marks on printing screens or plates. For more on this subject, *see The Complete Printmaker*.

regular finish
A slightly textured finish on some drawing papers.

release paper
See dry-mounting release paper.

relief
Sculpture in which carved forms protrude from a surrounding background. The degree of protrusion may be low (bas-relief), medium or high (haute relief). Relief carvings are often used in architecture for decoration. Occasionally the term *sunken relief* is also used—it refers to carving that lies below the surrounding surface. Other terms for sunken relief are incised

relief and intaglio relief. *See illustration on page 362.*

relief printing

Printing techniques in which ink is deposited on raised surfaces rather than into cut grooves or pits. Woodcuts are an example of relief printing. Even in printing methods such as etching, where ink is normally deposited into grooves in a plate, relief printing may be done. In *relief etching*, stiff ink is applied to the surface of the plate rather than into the grooves. The resulting printed image is of white lines on a black background. *See print; woodcut; wood engraving; etching.*

remarque /ree *mark*/

A small scribble, drawing or other mark along the edge of a printing plate or stone, normally removed before the plate is used for printing. Sometimes the artist pulls a print with the remarque present to help keep track of the development of the plate

Refraction

As you can see in the facets of this bowl, refracted light can take some strange detours. To capture the beauty of objects like these, you must be a keen observer, as Susanna Spann is. It would be difficult to imagine or predict the actual play of refracted light without actually observing the scene. In this picture, there are some reflections as well as refractions.

ROSE BOWL PARADE | Susanna Spann | watercolor on 300-lb. (640gsm) Arches | 30″ × 40″ (76cm × 102cm). Private collection.

as he works on it—such test prints are called remarque proofs. In modern usage, remarque also means a small drawing or other marking added to a print by hand after the print has been pulled. The artist makes each remarque different so that the remarqued prints are unique and thus enhanced in value. *See print.*

Renaissance

The period from about 1400 to 1600 during which in Europe, and especially in Italy, literature and the arts experienced a rebirth

bas-relief high relief

Relief

(*renaissance* in French) of the values and achievements of ancient Greece and Rome that had been lost or neglected during the long Middle Ages. Although it's common to think of the Middle Ages and the Renaissance as consecutive, clearly delineated periods, that is hardly the case. Art, after all, did not suddenly resume in 1400 after a thousand-year layoff. A slow accumulation of social, political and intellectual changes during the Middle Ages led inevitably to a coming-together of all these forces in what looks, in hindsight, like a sudden eruption of all kinds of activity—the period we call the Renaissance.

The Renaissance includes activity and advancement in practically all forms of human endeavor—literature, religion, poli-tics, warfare, government and all the arts. In art, the period from about 1495 to 1520 is called the High Renaissance, a time when some of the most famous artists of the Western world practiced. Leonardo da Vinci (1452-1519) was recognized in his own time as a genius whose mind crossed all artistic and intellectual boundaries. He not only painted and sculpted, but also worked on countless other projects, studying, drawing and writing about subjects as diverse as anatomy, flying machines and war machines. The modern term "Renaissance Man," someone with wide interests and expert in many areas, could well use Leonardo as its model. Michelangelo Buonarroti (1475-1564) is known as much for his frescoes on the

Types of Reproductions

Type of Reproduction	Description
Offset Lithograph	The image to be reproduced is carried on a metal plate in cylindrical form. Instead of inking the metal cylinder and running paper in direct contact with it, another cylinder, this one of rubber, picks up the inked image from the metal cylinder. The paper then picks up the inked image from the rubber cylinder. Because the image gets from the metal cylinder to the paper by an indirect (offset) route, the term *offset* is applied to the process.
Photocopy or Xerograph	A copy made on an ordinary office copying machine. Full-color copying machines can produce reproductions of excellent color quality. The drawbacks are that (1) current copy machines are limited as to the sizes and grades of papers they can handle and (2) the inks used may not be as lightfast as the colorants used in the artwork being copied. As inks become more reliable, this method of making art reproductions will become more accepted, provided more permanent papers are also used.
Giclée	A copy made by storing an image digitally in a computer and then printing it on paper or canvas using a computer inkjet printer. The paper or canvas used can be of highest quality, but the search is still on for more permanent inks.

Sistine Chapel in Rome as he is for his sculpture, although sculpture was his first love. Like Leonardo, he was multidimensional, often taking time out from painting and sculpting to design architecture, write poetry or design war defenses for the reigning pope. Raphael Sanzio, best known for his large, beautiful and serene frescoes, also worked in archeology and served the pope as architect. His quiet early paintings gave way near the end of his life to more animated, violent scenes that ushered in the period called Mannerism.

replica

An exact reproduction of an object, although not necessarily in its original size; a painting copied from an original, down to the finest detail.

repoussé /reh pooh *say*/

Ornamentation in relief on metal, formed by hammering from the back side of the metal and by scratching, punching or pressing with various tools from either side.

reproduction

A copy of an original work of art using commercial production techniques and requiring little or no involvement on the part of the artist. A copy made directly by the artist or under the artist's direct supervision and involving handwork rather than mass production is called a *print*. Although the terms reproduction and print are often used synonymously, this is sloppy and misleading usage. *See print.* A number of methods for making reproductions of paintings or other two-dimension-

al art are summarized on page 363. *See lithograph, offset; photocopy; giclée.*

resin

1| A natural secretion of many plants, especially pines or firs, usually transparent or translucent, yellowish to brown, and semi-hard or brittle after exposure to air. Unlike other plant secretions called gums, resins are insoluble in water. Resins are often ingredients in varnishes, printing inks, shellac and lacquer. One resin called *rosin* is obtained during the distillation of raw turpentine. *See rosin; turpentine.* 2| A synthetic product similar in some ways to natural resins, but chemically different. There are many types of synthetic resins, including one used in acrylic paint and another used in alkyd paint. *See acrylic paint; alkyd paint.*

resin cast

In sculpture, a cast made from a mixture of resin and powdered bronze. Such a casting is much lighter than bronze. Sometimes materials are added to the mix to simulate the look of other metals or stone.

resist

A material used to block a portion of a painting, print or drawing from accepting paint, ink or other marks. Examples of resists include: waxes used in batik work to shield fabric from becoming inked; tapes, liquid frisket or waxy crayons used in watercolor to block paint from an area; and cut stencils used in serigraphy to shield areas of the print from receiving ink.

respirator

Any device used over the nose and mouth to filter potentially harmful materials from the air as it is inhaled. Respirators range from simple, inexpensive paper masks to expensive masks containing filtering materials such as charcoal—the lat-

Respirator
This simple paper mask does a fair job of filtering particles from the air: It's far better than wearing no protection at all.

ter, of course, are much more effective than paper masks. Respirators are especially important to those using sprayed-on materials (including paint, fixative and varnish) and pastel artists. Some artists do their spraying within a well-ventilated enclosure and wear no protection, which is a questionable practice because over time it's inevitable that some of the offensive materials will be inhaled, doing damage to respiratory linings, lungs and other body tissues. Probably the best place to do any significant spraying is outdoors, but that's only reasonable (in good weather) for applications of varnishes and fixatives—airbrush painters could hardly do their work under such conditions. Pastel and charcoal artists often develop bad habits such as blowing loose dust from their pictures or easels. Those minute particles become suspended invisibly in the air for hours and will inevitably be inhaled if no protection is used.

restoration

Bringing a work of art back to its original condition. In the case of paintings, this may mean any or all of the processes of cleaning, retouching areas, remounting on

Respirator
This respirator (called "Survivair" Air Purifying Respirator) uses both filter pads and charcoal. It takes a little time to become used to wearing such a gadget, but the excellent protection it provides against paint, charcoal and pastel particles is certainly worth the effort. Without the respirator, those particles end up in your lungs. This is the respirator airbrush artist Daniel Tennant uses. Photo courtesy of Dan Tennant.

a new support and so on. In sculpture, occasionally broken or missing parts are replaced, sometimes by modern plastic materials. *See lining; inpainting.*

restrike
1| A print made sometime after the original issue, often without the artist's consent or after the artist's death. 2| A coin or medal made from an original die or mold sometime after the original issue.

retarding medium
A fluid mixed with paint to slow its drying. Acrylic retarding mediums are available to slow the usually rapid drying of acrylic paint, but they must be used with care and according to the manufacturers' directions. Adding too much retarding medium can cause shrinkage of the paint

film, poor adhesion or the forming of a skin over the paint layer. Sometimes painters even want to slow down the drying of already-slow oil paint—this can be done by adding a few drops of oil of cloves to the paint.

retouch varnish
A varnish intended to be applied very thinly to dull or "sunken" areas of an oil or alkyd painting. The idea is to refresh the

color so that painting may continue. Retouch varnish may be sprayed or brushed on, but always thinly so as not to build up troublesome varnish layers between layers of paint. Once applied, retouch varnish should be allowed to dry completely before resuming painting. For many oil and alkyd painters, retouch is the only varnish used—just enough to give the painting a uniform, overall finish.

reverse negative painting

Painting negative space lighter than the positive space it surrounds. *See illustrations above and under positive space.*

reverse shadow

A cast shadow caused by reflected light. A reverse shadow looks unusual—it's not where you might normally expect a shadow to be. In the accompanying illustration, the beams cast a shadow upward, even though the sun is high overhead and one would expect all shadows to be cast downward. The reason for the upward shadow is that there is a secondary light source,

Reverse negative painting

In negative painting, it's usual to paint a dark background around a lighter object. This method works in any medium, transparent or opaque. In reverse negative painting, shown here, the light negative space (the background) is painted around the dark positive space (the tree) using opaque paint.

namely, *reflected* light from the shiny roof surface below the beams.

rice paper

A generic term for Oriental papers made from a variety of materials, especially mulberry, but not from rice. Although there are some exceptions, most rice papers are thin, fragile and absorbent. They will not take the scrubbing and abuse that many Western watercolorists inflict on their watercolor papers. When ink or paint is applied to most rice papers, it's there to stay, so artists who paint on these papers tend to be disciplined and sure of their brush strokes.

rigger

A brush with a long, narrow head used to paint long lines and fine details. Similar

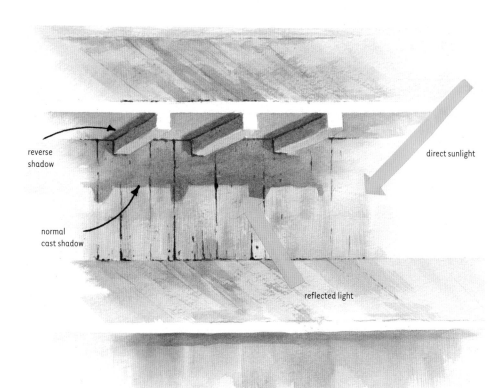

reverse
shadow

direct sunlight

normal
cast shadow

reflected light

Reverse shadow

Rice paper

A beautiful use of mixed media and brisk brushwork on
rice paper.

THE SONG TREE | Kay Stratman | ink, watercolor and
gouache on rice paper | 24″ × 38″ (61cm × 96cm)

brushes are called liners, or script liners. Some have pointed tips and others have blunt tips. *See brush, painting.*

rocker

A tool with a curved, finely serrated edge used in mezzotint printing to roughen the surface of a plate. *See mezzotint.*

Rococo

A style in interior design, painting, architecture and sculpture featuring elegant, elaborate ornamentation making much use of curved, asymmetrical forms. The style began in Paris in the early 1700s; the name alludes to the French *rocaille*, meaning rubble or pebbles. Many wall decorations featured shells, pebbles, scrolls and other forms involving asymmetrical curves. Rococo painting often involves mythological or romantic themes treated in a light, fanciful manner with sensuous color and delicate brushwork. The style is represented by the work of Antoine Watteau, François Boucher and Jean-Honoré Fragonard.

Romanesque

An art style in Western Europe during the period from about 1000 to 1150. In architecture, the Romanesque style revolved around churches and monasteries that featured heavy vaulted ceilings and massive columns and walls necessary to support the weight of the ceilings—this style later gave way to the Gothic, which used external buttresses to support the weight of ceilings, allowing for thinner walls and large window spaces. Romanesque painting and sculpture, decidedly Church-oriented, echoed the classical style of ancient Roman work, but added a great variety of regional differences, depending on the part of Europe in which the work was produced.

Rigger

Romanesque is an inclusise term referring to a combination of Roman, Carolingian, Ottonian, Byzantine and Germanic traditions.

Romanticism

A general movement during the late 1700s to the mid-1800s in literary, philosophical and art circles emphasizing the emotional, the spontaneous and the imaginative as opposed to classical, more rational traditions. Romanticism was a reaction against too much adherence to classical and neoclassical themes, especially religious ones. Romanticism stressed the importance of the senses, the emotions and nature. It began in England and gained prominence there through painters such as William Blake, J.M.W. Turner and John Constable. In France, Romanticism was represented by such work as Théodore Géricault's paintings of human suffering and Eugène Delacroix's lush and colorful paintings of exotic scenes.

rose window

A circular window in Gothic architecture decorated by curved forms often resem-

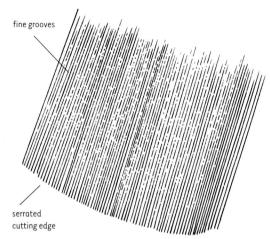

fine grooves

serrated
cutting edge

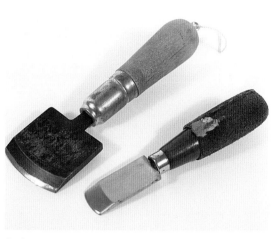

Rocker

Two rockers used by engravers. Photo courtesy of Peter Stoliaroff.

Rocker

The back side of the rocker blade has fine parallel grooves so that no matter how many times the blade is sharpened, the grooves provide a serrated edge.

Rocker

The rocker is held vertically and rocked back and forth so that its tiny teeth bite into the metal plate.

rocker

engraving plate

Roulette
A small engraver's roulette.

Roulette
The toothed wheel of a roulette.

serrated edge

bling the petals of a flower surrounding a central core. The most famous rose windows, such as those in Notre Dame in Paris, include stained glass in intricate patterns called tracery. Early windows used simple petal forms; later ones were more intricately designed, as each basic "petal" was subdivided into smaller sections.

rosin
A hard, brittle resin left as residue after raw turpentine is distilled to obtain the pure turpentine solvent familiar to artists. Rosin is not suitable for use in high-quality artists' supplies, but it is used in making cheaper varnishes, cements, sealing waxes and some soaps. It's also used to size paper, to treat violin bows, to prepare metals for soldering and in some pharmacological preparations. It's the stuff baseball pitchers use, in dust form, to get a better grip on a ball. Also called *colophony*.

rough
1| A surface, such as watercolor or drawing paper, that has significant texture. *See cold press.* 2| A preliminary drawing or sketch.

roulette
A tool with a serrated wheel used by engravers to scratch lines across a plate to create texture or shading in a print.

round
A brush with a round, pointed head. *See brush, painting.*

rubbing
An image made by placing a sheet of paper over a textured object (such as a name carved in a gravestone) and rubbing with the flat of a pencil, a color stick or other pigmented tool. Also called *frottage*.

Round

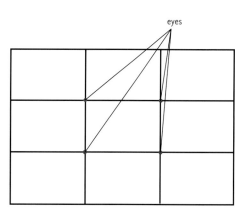

Rule of thirds

rule of thirds

A rule of thumb used by many photographers and painters for placing the center of interest in a picture. The rectangular picture area is divided into thirds both horizontally and vertically so that a grid of nine smaller rectangles is formed. The four points where the grid lines intersect one another are called the "eyes" of the rectangle, and any one of the eyes is considered a suitable location for the picture's center of interest. Like many "rules" in art, this one is reliable but not to be followed blindly. *See grid; center of interest; design.*

ruler

A straightedge with units of measurement marked off. When using the sighting method of estimating the sizes and spacings of distant objects, it's helpful to hold up a ruler rather than, say, a pencil or a brush. *See estimating sizes.*

a
B
C
D
e
F
G
H
I
J
K
L
m
n
o
P
Q
r
s
T
u
V
W
X
Y
Z

sabeline

A good grade of ox hair, dyed to look like sable. *See brush construction.*

sable

Animal hairs used in construction of some of the better paintbrushes. *See brush construction.*

safflower oil

An edible vegetable oil obtained from the seeds of the safflower plant. It is used in the manufacture of some oil paints and in the making of alkyd resins.

salon

1| A fashionable gathering of notables in the arts, often at the home or apartment of one of the notables. 2| A hall where art is exhibited. 3| An exhibition of art. With a capital *S*, the Salon was an official exhibition of French art, begun during the reign of Louis XIV. In this usage, the name Salon was used because the exhibition was held in a salon (hall) at the Louvre Palace.

salt

Ordinary table salt or coarser forms, such as rock salt, used by painters to create textures. In a watercolor painting, if salt is sprinkled onto an area of damp paint, small blotches form as each grain of salt absorbs water and dissolves. The paint should not be too wet or the effect will be lost; likewise, if the paint is too nearly dry, the effect will be minimal or nonexistent.

sand casting

A type of casting used more for industrial than for artistic purposes. A mold is formed by packing a special sand around a model of the object to be cast. The mold is split in two, and the model is removed. The two halves of the mold are rejoined, and molten metal is poured into the cavity left by the removed model.

sanded board

Cardboard (or hardboard) whose surface has been coated with a gritty material to give the surface enough tooth to hold pastel or charcoal. It's difficult to find such boards that are of archival quality, so many artists prepare their own. Start with a museum board or watercolor or illustration board of high quality. Coat its surface with a mixture of grit and either acrylic gel medium or acrylic gesso and let it dry. The grit may be flint, marble dust, Carborundum or pumice—even fine sand. With some experimenting you'll find the proper mix to suit your needs. It will usually be necessary to wet the rear of the board to prevent warping as you apply the wet grit mix to the front of the board.

Scale

HARBOR KING | Ned Mueller | gouache on Crescent cold-press illustration board | 9″ × 12″ (28cm × 30cm)

There are some sanded papers available that have surfaces similar to hardware store sandpaper, but most of them are not acid free.

sand painting
Designs made of various colored sands, powdered minerals or similar dry materials arranged on a flat surface, often done as part of a ritual in Native American, Tibetan, Buddhist and other cultures. Also called dry painting.

sandpaper
Abrasive material glued to a paper surface. The abrasives used include silicon carbide, aluminum oxide and boron carbide. Sandpapers are useful to artists for removing paint from various surfaces, for smoothing gesso grounds and even for scratching texture into a painting. Some pastel artists use sandpaper as supports—a poor choice if permanence is important, because the papers used in sandpaper are not acid free.

satire
Art that pokes fun at human follies, absurdities or weaknesses. Perhaps the best-known satire today is the political cartoon, but many home and office walls are decorated with the skill and wit of artists such as those shown, who find humor in everything from cats to people. *See illustrations on pages 374-375.*

saturation, color
The degree of brilliance, or purity, of a hue. *See color; chroma.*

scale
The relative sizes of objects in a picture. By including an object of known size in a pic-

THE JUDGE

Satire

THE JUDGE | Peter Mulcahy | pen-and-ink and acrylic on paper | 17″ × 11″ (43cm × 28cm)

Satire

Miss Alice and Her Friends | A. Kenneth Koskela | watercolor on Arches 300-lb. (640gsm) cold press | 22″ × 30″ (56cm × 76cm)

Society

Satire

Society | Peter Mulcahy | pen-and-ink and acrylic on paper | 11″ × 17″ (43cm × 28cm)

a
b
c
d
e
f
G
H
I
J
K
L
m
n
o
P
Q
r
s
T
U
V
W
X
Y
Z

Scraper
Photo courtesy of Peter Stoliaroff.

cutting edges

Scraper
This scraper has three cutting edges, as seen in this end view of the blade.

ture you can make clear to the viewer the sizes of other objects. In the illustration on page 373 there is no sure way to know the sizes of the boats, but by including human figures (whose sizes are known) the artist indirectly tells us the sizes of the boats.

scanner
A device that "reads" an image placed upon it and transmits a copy of the image electronically to a computer. Once stored in the computer, the image may be manipulated in hundreds of ways by software. *See giclée printing.*

scraper
1| A three-sided tool used by engravers to remove marks or burrs. In making a mezzotint print, a scraper is used to skim off the tips of the countless tiny burrs formed as a result of using a tool called a rocker. 2| A bar on a lithographic press that applies pressure to force the inked stone and the paper together. The scraper is stationary; the bed of the press, on which lie the stone and paper, passes beneath the scraper. *See illustration under printing press. See mezzotint; rocker.*

scratchboard
A picture created by cutting through a dark, usually black, surface with knives and other sharp tools to expose a white layer underneath. Some artists use commercially prepared boards; some make their own by coating a white surface with black ink or paint. Many supports are made of cardboard, such as illustration board or watercolor board, while others are hardboard coated with either acrylic gesso, true gesso or acrylic paint. Some artists, including Don Townsend, prefer a canvas support. Although originally used primarily to create a picture for reproduction (as in book illustration), the technique is often used today by artists to produce original one-of-a-kind images. Most scratchboard work results in a white image on a black background. However, by exposing much broader areas of white the effect resembles a woodcut—that is, finer black lines on a white background. Think of the two techniques as similar to the zebra question: Are the zebra's stripes white on a black background or black on a white background? *See sgrafitto. See illustrations on pages 377-378.*

screen print

See silkscreen print.

scribbling

Hasty or seemingly careless drawing or writing—but in drawing, often an intentional approach in order to express a particular subject. For example, an ink drawing might use such marks to express a person's curly hair, the swirling of agitated water or tree foliage.

scruffing

1| Blocking in a quick, loose drawing; 2| roughing up a surface in a painting, usually with a brush; or 3| drybrushing color over a rough surface, allowing the color underneath to show through.

sculpture

Hard or plastic materials formed into a three-dimensional work of art, either representational or abstract and either func-

Scratchboard

In this San Francisco scene, Don Townsend expertly uses scratchboard techniques to capture the light and shadow on a building facade. Townsend uses canvas supports coated with white acrylic paint as his working surface. He draws on the white surface and then, section by section, paints over the drawing with black acrylic. He uses single-edge razor blades to cut through the black surface, exposing the white underneath. He can no longer see that part of the drawing, having coated it with black paint, but he works in a carefully controlled fashion, one area at a time, and sees in his mind's eye the covered-up drawing. In many cases, individual areas he works are very small. Work like this is all about values. Townsend uses the spacing between cuts to control the value in a given section, much the way a pencil artist might use hatched lines closely or widely spaced to get a range of values.

Les Mis | Don Townsend | scratchboard on canvas | 36" × 48" (91cm × 122cm)

a
b
c
D
e
F
G
H
I
J
K
L
m
n
o
P
Q
r
s
T
U
V
W
X
Y
Z

tional or nonfunctional. *See individual sculpture entries: stone; paper; clay; metal; earth; wood; polyester resin.*

sculpture, earth

Sculpture using the earth as the sculpting material. This is an open-ended sort of art with no "rules." Lines dug into the earth, fields mowed in a pattern, rocks arranged into shapes and even castles built of sand—all these and much more may be considered earth sculpture. Some of this art is temporary because it's subject to weathering and all the forces that are constantly changing the environment. Also called *land art. See illustration on page 379.*

sculpture, metal

Sculpting using various metals as raw materials. Many metal sculptures are monumental in size, intended for outdoor exhibit; others are intended for indoor use, either freestanding or wall-mounted. Although we tend to think of stone when

Scratchboard
When finished with cutting the thousands of lines that make up a picture like this, Don Townsend paints any solid black areas with acrylic paint and adds his trademark color touches, again using acrylic. Finally, he coats the picture with acrylic picture varnish.

CHICAGO EL | Don Townsend | scratchboard on canvas | 40″ × 66″ (102cm × 168cm)

we discuss sculpture, metals have been used since ancient times. Bronze sculpting has long been practiced, but a great many bronze works have been lost by being melted down in time of war to use the metal for armaments. Many kinds of metals have been used, including bronze, copper, lead, brass, gold and silver, and these days steel and aluminum are very popular. Artists working in metal are freed from some of the problems associated with stone and wood—metals are much more versatile in that they may be cut, bent, drilled, melted and so on while retaining great strength. *See illustrations on pages 380-381.*

Earth sculpture
This beautiful arrangement of stone by talented young artist Ian Brown is transitory, long since destroyed by weather and, no doubt, by human visitors.

HIT AND RUN | Ian Brown | earth sculpture in stone | 14´ (4.3m) diameter. In Two Lights State Park, Maine.

sculpture, paper

Forming three-dimensional objects, either representational or abstract, from paper. Most paper sculptors use their own hand-made paper, and they consider the making of the paper an integral part of the sculpting process. Although methods naturally vary from one artist to another, the approach used by Jeanne Petrosky, is fairly typical (although her results are far from typical). Petrosky makes flat sheets of paper using acid-free cotton fibers. The fibers are blended with water and a variety of lightfast pigments to form colored pulps. The pulp is gathered with a screen that allows the water to drain away, leaving a mat of colored fibers. This mat is transferred to another surface where it is pressed and dried. During the papermaking process the artist controls the proportions of fibers, water and pigments, and thus has a great deal of control over the look and feel of the final sheet of paper. Once a sheet of paper is dried, it's dampened enough to make it pliable and then the actual sculpting begins. *See illustrations on pages 382-383.*

sculpture, polyester resin

Casting a form using a synthetic material called polyester resin, the same tough material used for repairing damage to automobile bodies. Marc Sijan is one of the relatively few practicing this art—his hauntingly lifelike figures have been featured in over twenty-five one-man museum exhibitions.

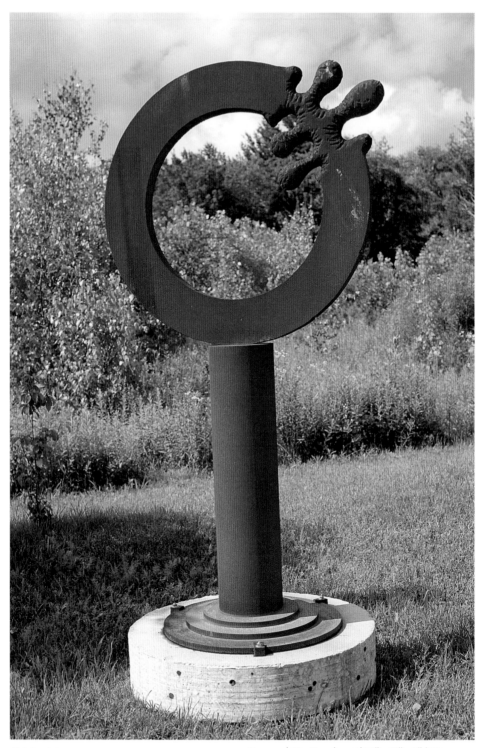

Metal sculpture

The column supporting the "wheel" is made of 8″ (20cm) hollow steel. The wheel, which is free to pivot on the column, is 40″ (102cm) in diameter, cut from a 3″ (8cm)-thick plate using a shipbuilder's carbon arc cutter. The finish is natural rusting.

MARINER | Fritz Olsen | steel | 74″ × 40″ × 3″ (188cm × 102cm × 8cm)

Metal sculpture

Untitled | Fritz Olsen | steel | 24″ × 18″ × 3″ (61cm × 46cm × 8cm)

Paper sculpture

INFORMAL PASSION | Jeanne Petrosky | handmade paper | 24″ × 40″ × 3″ (61cm × 102cm × 3cm)

Each sculpture requires a series of processes that extend over many months. First, after choosing a live model for his work, Sijan makes a mold of the model from head to toe. He makes a mold of the head first, and then the arms, legs and torso, all in separate sections. While his or her face is covered, the model must breathe through tubes. The molds are made from Alginate, the material dentists use for making molds of teeth and gums. This gelatinous material faithfully reproduces the surface over which it's spread so that no detail is missed, not even pores in the skin. Over the Alginate, Sijan packs a layer of clay.

An individual section takes about twenty minutes to dry. Once dry, Sijan splits each mold to remove it from the model. He uses liquid or puttylike polyester resin to fill in the Alginate molds. After the resin has hardened he removes the molds and joins the separate sections of the cast resin to form the complete body in the pose he has planned. Then, using a variety of scraping and forming tools, he refines the castings. Finally, he painstakingly paints the body, using artists' oil paints, until the skin takes on the color nuances of a live figure. Usually he meticulously

preserves the tiniest of marks or blemishes, even the pores in the skin, as you can see here in the close-up of a woman's face. *See illustrations on pages 384-385.*

sculpture, stone
Carving a form from solid stone. The stones used range from relatively light, porous sandstone and limestone to denser and harder marble and even harder granite. The harder, denser stones may be given a smooth, glossy finish, while porous ones usually have a more matte finish. The choice of stones is partly a personal matter—a sculptor may prefer the "feel" of one stone or another just as a painter may prefer the feel of one paint over another—but there are also more practical matters. For example, sandstone, soapstone and limestone are less expensive than marble, and they are lighter and easier to cut and transport. On the other hand, marble allows for a more polished surface, and it often has a beauty unmatched by other stones. Among the harder stones, marble is the most commonly used—it responds well to the cut-

Paper sculpture

For this sculpture the artist first formed an armature out of a light, solid material. Then she wrapped very wet handmade colored paper around the armature, all the while refining the shapes. Once it was dry and rigid, she further modified the surface using iridescent colors.

SOMETIMES IT DOESN'T TAKE MUCH | Jeanne Petrosky | handmade paper | 36″ × 18″ × 12″ (91cm × 46cm × 30cm)

a
b
C
D
e
F
G
H
I
J
K
L
m
n
o
P
Q
r
s
T
u
V
W
X
Y
Z

Polyester resin sculpture

KNEELING | Marc Sijan | sculpture in polyester resin | life size

Polyester resin sculpture
Close-up of one of Sijan's figures showing fine detail. The eyes in his sculptures are made of glass, and the hair is natural hair.

ting tools sculptors use and it's available in many beautiful varieties.

The tools a stone sculptor uses can be as simple as a set of hammers, mallets and chisels or as extensive as a shop full of electric saws, pneumatic chisels, electric grinders, electric buffers and a forklift.

The basic processes for stone sculpture are these: **1**: The sculptor forms a plan for the work either vaguely in his mind or more explicitly on paper. He may build a rough model first out of clay or plaster. **2**: Some sculptors draw rough outlines on one or several faces of the stone block to guide their initial cuts; some work without a drawing. **3**: Carving begins by cutting away major chunks of stone to get a rough approximation of the form. **4**: Progressively smaller, finer tools are used for carefully cutting away smaller pieces of stone to get closer to the eventual form. **5**: Finer chisels, rasps and grinding wheels are used to reveal details. **6**: Various grinding, sanding and buffing tools may be used to refine the surface and create the desired degree of smoothness or polish. Often there is another process involving the sculptor—he may be required to deliver and install the sculpture. For large pieces this may involve a lot of physical work and even the use of trucks and forklifts. *See pointing. See illustrations on pages 386-389. See sidebar on page 389.*

a b c D e F G H I J K L m n o P Q r s T u V w X Y Z

Stone sculpture

Free Form | Gert Olsen | Tennessee Fleuri marble, polished and textured | 38″ (96cm) tall × 26″ (66cm) wide × 6″ (16cm) deep

Stone sculpture

As you might imagine, delivering and installing a work of this size was a major project. Olsen often must make use of forklifts or cranes, not to mention a few hearty helpers.

GETTING TO KNOW YOU | Gert Olsen | Vermont Danby white marble | 9′ (2.7m) tall × 4′ (1.2m) wide × 2′ (0.6m) deep

a
B
C
D
e
F
G
H
I
J
K
L
m
n
o
P
Q
r
s
T
U
V
W
X
Y
Z

Stone sculpture

These chisels are used in an air hammer; the hammering force is supplied by bursts of compressed air. Similar chisels are used with ordinary manual hammers and mallets. Those with straight edges are called flat chisels; the others are called toothed or claw chisels. Photos courtesy of Gert Olsen.

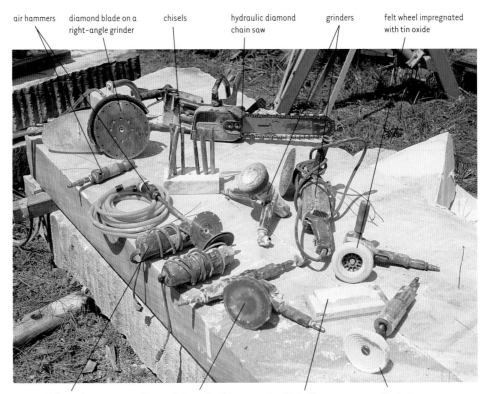

air hammers diamond blade on a right-angle grinder chisels hydraulic diamond chain saw grinders felt wheel impregnated with tin oxide

small diamond saw silicon carbide sanding disk tin oxide buffing rouge cotton buffing wheel

Stone sculpture

Here are some of the tools Gert Olsen uses. At the far end are saws with diamond-tipped cutting wheels used for major cuts; at the near end are sanding and buffing wheels. The bowl-shaped wheel is made of felt and is impregnated with tin oxide, a very fine abrasive.

Stone sculpture
Olsen's marble yard.

sculpture, wood

A decorative or sometimes functional image made of wood. Sculptures range from finely finished assemblies to rough-hewn pieces carved from wood blocks with chain saws, axes, etc. Any wood may be used—often combinations of woods in varying colors and textures are used. *See illustrations on page 390-391.*

scumbling

Rubbing or scrubbing a thin layer of opaque or semiopaque paint over a dry existing area to achieve textural or atmospheric effects or to raise the key of a dark-colored area. For example, landscape painters in oil often rework a dried painting to achieve the effect of atmospheric perspective by thinly rubbing a mixture of white and blue pigment over the distant

Kinds of Stone

Stones for sculpting come from all three basic types of rock: igneous, sedimentary and metamorphic. Igneous rock was formed when molten masses of minerals cooled near the earth's surface (e.g., granite); sedimentary rocks are mineral and organic materials worn from existing rocks and newly deposited, usually by water (e.g., sandstone and limestone); metamorphic rocks are formed when igneous or sedimentary rocks are subjected to intense heat or pressure so that their texture and structure are changed (e.g., marble, which is derived from limestone).

Wood sculpture

For the bench, Mark Wallis used padauk wood (grown in tropical regions of southeast Asia) with both natural and painted finishes. The attached vertical piece at the rear is padauk wood accented with paint, graphite and fabric.

BENCH WITH S-CURVE | Mark Wallis | padauk wood, paint, graphite and fabric | approximately 15″ (39cm) deep, 52″ (132cm) long and 48″ (122cm) high.

Wood sculpture

EAST MEETS WEST | Mark Wallis | mixed woods and slate | approximately 2′ (61cm) high. Collection of Heather and Tobin McGee, Oklahoma City, OK.

Scumbling

Ed Ahlstrom often uses the scumbling technique in his paintings. Here he rendered the white blossoms by scumbling white paint over a darker lay-in; he also muted the distant sky area with a veil of white over darker paint.

A Fine Day | Ed Ahlstrom | oil on canvas | 42" × 36" (107cm × 91cm). Collection of Judith Ahlstrom.

Seascape

BELLE HAVEN MARINA | Ross Merrill | oil and alkyd on canvas | 24″ × 36″ (61cm × 91cm)

planes and details. This scumble provides an effective illusion of haze and distance. Similarly, painters scumble flesh tones over a darker neutral underpainting to produce cool translucent halftones, a practice beautifully employed by the great Venetian painters Titian, Veronese and Tintoretto. *See atmospheric perspective. See illustration on page 392.*

seascape
A picture whose main element is water, as in these examples, rather than land. *See illustrations on pages 393-394.*

secco |sek oh|
1| Painting done on a hard, cured lime-plaster surface, as opposed to fresco, which is painting done on fresh wet plaster. In secco painting, the hard, dry plaster is first dampened with a solution of lime in water, and the painting is done on this moist, but hard, surface. Pigments, instead of being mixed only with water as in fresco, are mixed with binders such as casein, glue or egg yolk. Unlike fresco, in which the paint bonds with the plaster and does not form a separate film, secco paint does form a film. *See fresco.* 2| Loosely, any dry wall painting.

secondary color
On the color wheel, a color halfway between two primary colors. Between the primary colors red and yellow lies the secondary color orange; between primaries red and blue lies the secondary, violet; and between primaries yellow and blue lies the secondary, green. *See color wheel.*

selvage
1| The edge of a piece of woven or knitted fabric finished in such a way as to keep the

a b C D e F G H I J K L m n o P Q r s T u V W X Y Z

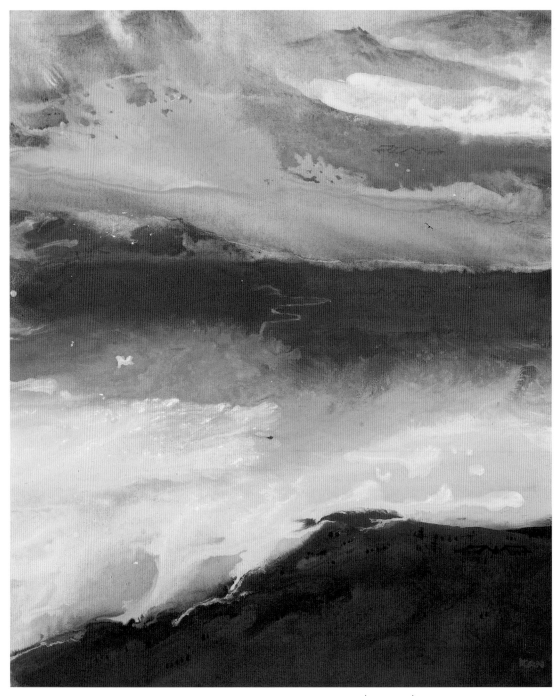

Seascape

God's Compliment | Diana Kan | watercolor and mineral color on silk | 14″ × 11″ (36cm × 28cm). Collection of the artist.

semineutral neutral gray semineutral

fabric from unraveling. 2| A cable made by laying strands of wire parallel to one another (rather than twisted, as in other cables and ropes) and then binding them together with various types of wrapping. Suspension bridge cables are of this type.

Semineutral color

A mixture of two complements, Phthalocyanine Green and Alizarin Crimson. Where the two colors are combined in equal strengths, the result is a grayed, or neutral color; where the green is stronger, the result is a greenish gray (a semineutral) and where the red is stronger, the result is a reddish gray (a semineutral).

semineutral color

1| Color resulting from the mixing of two complementary colors (colors opposite one another on a color wheel) in such proportions that one or the other of the two predominates. When two complements are mixed, a grayed, or neutral, color normally results, but if either of the mixed colors is emphasized, the resulting "grayed" color will lean toward the stronger of the two. 2| Color resulting from the mixing of two colors from any triad on the color wheel, when one of the two mixed colors predominates. *See color wheel; complementary colors; triad.*

sepia

A brown colorant made from the protective secretions of squid and cuttlefish. Long used in inks and watercolors (often in place of *bistre*) , it's being replaced by cheaper and more stable synthetic colors.

series

A group of paintings, drawings or other artwork all by the same artist and having a single narrow theme or subject. There are many examples of series, including those by Monet in which he painted the same subject, such as haystacks or a cathedral, in varying lighting conditions or seasons. A group of pictures by an artist that have a central theme, such as portraits (of many different people) or barns (many different barns), would not ordinarily be considered a series.

serigraph

See silkscreen print.

sfumato

The use of careful transitions in value and color to help define form. The term is nearly equivalent to chiaroscuro, but sfumato always implies fine, delicate shading, while chiaroscuro sometimes describes more aggressive value contrasts. Sfumato also suggests a smoky atmosphere in a picture. From the Italian *sfumare*, to evaporate. *See chiaroscuro; value.*

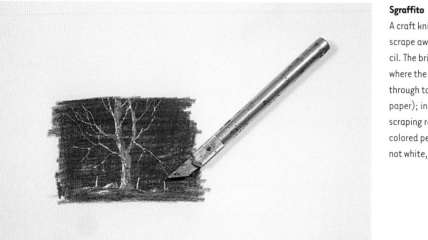

Sgraffito

A craft knife has been used to scrape away a layer of colored pencil. The brightest areas are those where the scraping went all the way through to the ground (white paper); in other areas, gentler scraping removed only some of the colored pencil, leaving a lighter, but not white, effect.

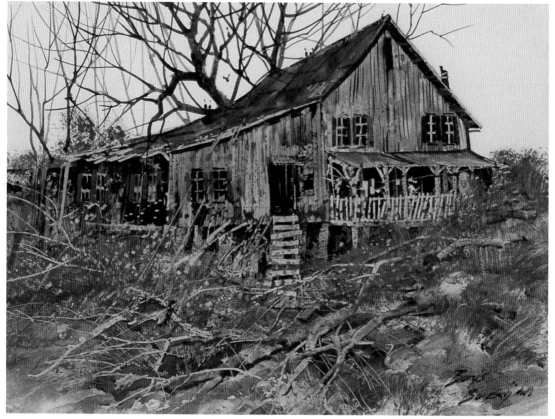

Sgraffito

Although some of the light-dark contrasts here are the result of negative painting, Borys Buzkij relied more on scraping away paint, using the ends of brush handles, the tips of razor blades and similar tools while the paint was still wet.

TEXTURES | Borys Buzkij | oil on foamboard | 9″ × 12″ (23cm × 30cm). Collection of Phil Metzger.

sgraffito

Cutting, scraping or gouging one or more layers of color to expose earlier layers of color or the ground. From Italian *sgraffirre*, to scratch. *See scratchboard. See illustrations on page 396.*

shading

The use of gradual value and/or color change, usually to make an object look three-dimensional; also called modeling. *See shadow.*

shadow

An area darker than surrounding areas because it's receiving less light than those

Shadow

The shadow falls across areas of both different color and different texture. The shadows are sharper where the ground is smoother and broken over the grass; the shadow colors are affected by the colors of the areas they fall on.

areas. We may consider two basic types of shadows: **1**: cast shadows—areas receiving less light because some object is blocking the light source, and **2**: shading—darkening of the sides of objects that are turned away from the light. If you imagine an apple on a white table receiving light from the left, you'll see a shadow to the right of the apple on the table top (a cast shadow) and you'll also notice that the rounded

Shadow

In this woods scene near his home, Michael Wheeler has used shadows to define the entire ground area. Without the shadows the ground would be flat and far less interesting. Long cast shadows faithfully follow the ground contours, and smaller, softer shadows speak of the texture beneath the snow.

In the South Woods | Michael Wheeler | acrylic on canvas | 40″ × 30″ (102cm × 76cm)

What Color Is a Shadow?

That's a question a politician would love because its answer is: It depends. A shadow is only a partial absence of light—it's not a thing with its own local color. The color in a shadow depends on everything else in the scene. The only generalization you can make is that a shadow is never dull—there's a lot of color in there.

side of the apple away from the light is darker than the side facing the light (shading). Shadows are not cut-and-dried: The way they look depends on a number of influences.

Color of the area in shadow. Take a look at the shadow of a tree outdoors on a sunny day—where the shadow falls over green grass it may well have a greenish look, but where that same shadow falls across a dirt path it may look decidedly brown or purple.

Color of the object. The object's color affects the shadow color. A shadow cast by a red apple, for example, may be reddish near the apple and less so farther away from the apple. Likewise, the color of the shading on the apple itself will be strongly affected by the apple's color.

The light source. The size and intensity of the light source, as well as its color, do much to define the shadow. A small but intense light source gives relatively strong, sharp shadows; a broader or weaker source gives fuzzier and less dramatic shadows. Multiple light sources—a common occurrence in room settings—cause multiple shadows. When setting up a still life to paint, it's vital to decide how many light sources there will be and where they are to be placed. You'll notice that even though you have only a single reflector lamp as a source, you may still get multiple, slightly

overlapping shadows. That's because the bulb acts as one source and the reflector around it acts as a second.

Texture of the shadowed area. A shadow on grass or gravel has broken edges and will not be as sharp as a shadow on ice, glass or a smooth floor.

Nearby surfaces. Light bouncing from surrounding surfaces into a shadow can dramatically affect the shadow's value and color.

For the artist, shadows are often an indispensable tool. Used wisely, they can make the difference between a humdrum picture and an exciting one. They can be used to introduce strong value contrasts that enliven a picture; they can add drama or mystery; their shapes can be a key design element; and they can help define the nature, or contours, of the surfaces over which they fall. *See cast shadow; modeling; backlighting; light; light source. See illustrations on pages 397-401.*

shadow accent

On a rounded form, the darkest part of the shadowed side of the form, next to the light area. *See illustration under chiaroscuro.*

shadow box

A type of picture frame in which the artwork is set back far enough from the glass to give an appearance of considerable depth. In most conventional framing, the artwork might be only a quarter-inch (0.6cm) or so from the glass; in a shadow box, the distance is typically an inch (2.5cm) or more. There is usually no reason for such an arrangement other than aesthetics.

shellac

An amber-colored substance derived from lac, a secretion of an insect called *Laccifer lacca*. Shellac is used in many products, such as sealing wax, self-polishing waxes,

Shadow

In this picture, shadows are everything. In a painting with this much dark area, it's vital to show plenty of subtle light within the darks.

INSIDE OUT | alkyd on canvas | 16½″ × 12½″ (42cm × 76cm).
Collection of Jim Halota, Rockville, MD.

Shadow
The fuzzy multiple cast shadows are the result of more than a single light source.

STILL LIFE ON A BLUE TABLE | Jane Lund | pastel on Canson paper | 25³/₄″ × 27⁵/₈″ (65cm × 70cm). Collection of Museum of Fine Art, Springfield, MA.

sealers and hairsprays and, in the early 1900s, in phonograph records. One of its chief uses is in an alcohol solution (also popularly called *shellac*) that is a varnish for furniture, floors and other wood surfaces.

shrink-wrap

A thin, transparent material used to temporarily cover and protect artwork such as prints and reproductions. The artwork is inserted into a sleeve of shrink-wrap and sealed by heat around all the edges. Then a stream of hot air from a device resembling a hair dryer is directed at the sleeve; the heat makes the material shrink so that, when finished, the artwork is neatly enclosed in a taut plastic sheath. *See illustrations on pages 402-403.*

siccative

Drier. *See drier.*

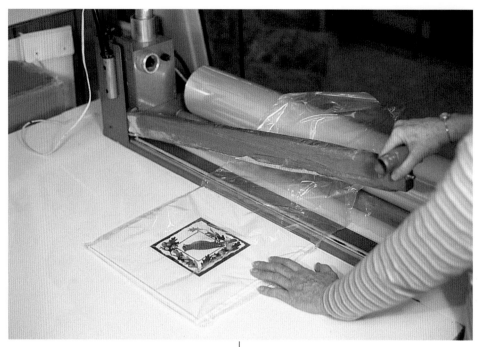

Shrink-wrap
The artwork is enclosed in an envelope of clear shrink-wrap. Here an edge of the envelope is being sealed by a heated wire in the long bar ("wand") of the shrink-wrap equipment. The heating time is short and is controlled by a timer.

silhouette

An outline of a face, figure, or object, usually in profile, either filled in solidly with paint or cut from a dark paper on a light background (or vice versa). The silhouette was a popular art form during the eighteenth and nineteenth centuries, practiced by such artists as Englishman John Miers. The silhouette was named for a French minister, Etienne de Silhouette (1709-1767), whose hobby was cutting paper likenesses.

silkscreen print

A print made by forcing ink through a stencil onto paper or some other surface. The stencil is a sheet of fabric that has had certain areas blocked out to prevent ink from getting through those areas. A separate stencil is made for each color to be printed. Prints made in this way are commonly called silkscreen prints because silk was once the fabric of choice. Satisfactory cheaper fabrics are now also used, including synthetics. Because silk is not necessarily used anymore, the more generic name *screen*

print may be more appropriate. The term *serigraph* is meant to designate a fine art screen print as distinguished from screen prints made industrially (as in T-shirt prints). Serigraph is derived from the Latin *sericum* (silk) and the Greek *graphein* (to write or draw).

There are several ways of making a stencil. **1**: Commercially prepared plastic stencil materials may be cut with a knife and fastened to the screen material (*see accompanying Faust example*). **2**: The design may be painted or drawn on the screen fabric with tusche or lithographic crayon. The entire screen is then coated with glue. After the glue has dried, the screen is washed using a solvent that washes away only the areas where tusche or crayon were used. **3**: A stencil may be made photographically. A photograph is placed on a photosensitive gelatin

Shrink-wrap
A small hole is burned into the rear surface of the shrink-wrap with a heated tool to allow for air to escape as the envelope shrinks.

Shrink-wrap
A stream of hot air causes the material to shrink. The rear surface is shrunk first, and then the front. It's important to move the heat gun uniformly over the surface of the shrink-wrap to avoid burning a hole in it.

Silkscreen print

This is a scene in Old Town Alexandria, Virginia, an area ripe with history. *Springtime* required twenty-four separate screens to provide the many color nuances that typify this artist's work. For most of his work English uses nylon fabric for the screens and Naz-dar 5500 series oil-based inks. The edition size for this print is 100.

SPRINGTIME ON PRINCE STREET | Joseph Craig English | serigraph | 16″ × 22″ (41cm × 56cm)

sheet and exposed to light. The gelatin under the light areas of the photograph becomes hardened, but under the dark areas, where little light penetrates, it remains soft. The soft areas of gelatin are washed away, leaving a stencil corresponding to the photograph. *See illustrations on pages 404-409.*

silverpoint

Drawing done with a thin rod of silver encased in an appropriate holder. Drawing the silver across a sheet of coated paper leaves a grayish mark that soon oxidizes and becomes brownish. Usually the paper is coated with white pigment, such as Chinese White—the coating traps the tiny particles of silver that flake off the silver rod, and the marks show up well against the white background. Silverpoint strokes cannot be erased, so careful work is required. This drawing technique was much used in the 1400s and 1500s by artists such as Albrecht Dürer. *See metal point.*

simultaneous contrast, law of

Complementary colors enhance each other's intensities—for example, placing red and green side by side makes both the red and the green more vivid to the human eye than either alone would appear. This "law" and other aspects of the psychology

HUACHUCA SPRING | Anne Senechal Faust | serigraph | 25″ × 19″ (64cm × 48cm)

Silkscreen print

Anne Faust, a nature-lover and dedicated birdwatcher, draws on material she and her husband collect traveling all over the world. Her silkscreen prints have won her wide recognition, numerous prizes and inclusion in many collections and museums.

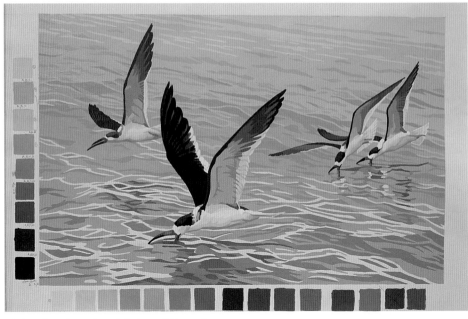

1 | Anne Faust first paints a full-size model in acrylic.
The swatches along the edges are guides to the colors
she will use for the twenty-three separate stages in
this print.

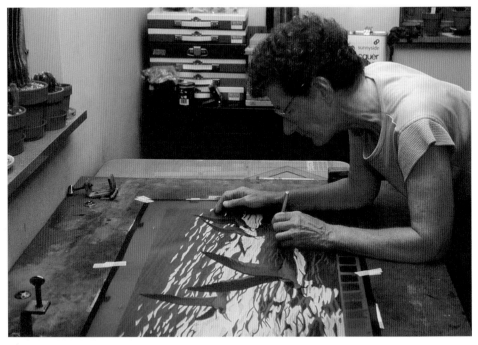

2 | She cuts a stencil from Ulano Sta-Sharp S3S stencil
film, a greenish, semitransparent material, using a
sharp X-Acto knife. She will secure the stencil care-
fully to the underside of her stretched silkscreen
material.

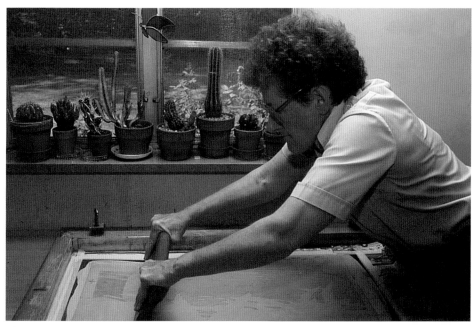

3| With the stencil in place and ink spread over the
screen surface, she pulls the squeegee toward her
with firm downward pressure, forcing ink through the
screen onto the printing paper underneath in all
areas not blocked by the stencil. Typically, Faust
prints editions of around twenty. After all twenty
sheets have been printed using one stencil, she
allows the sheets to dry and cleans the screen in
preparation for the next stencil.

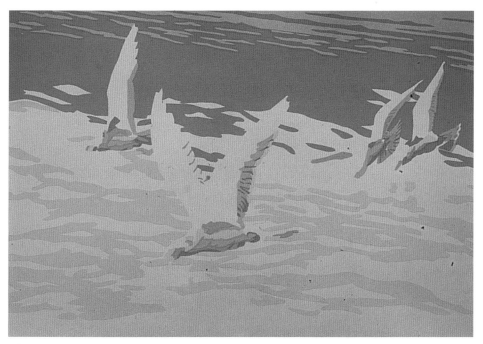

4| An early stage in the print's progress.

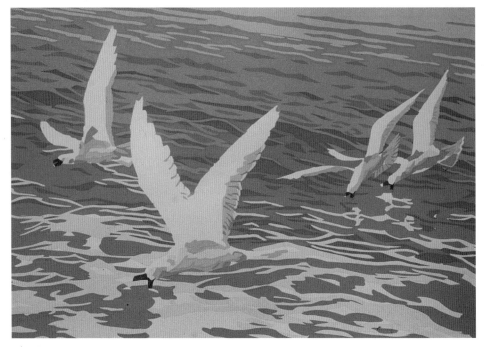

5| A later stage.

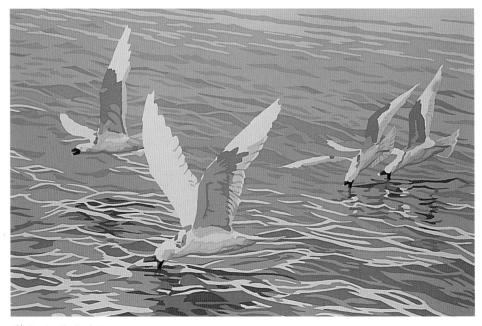

6| Nearing the final stage.

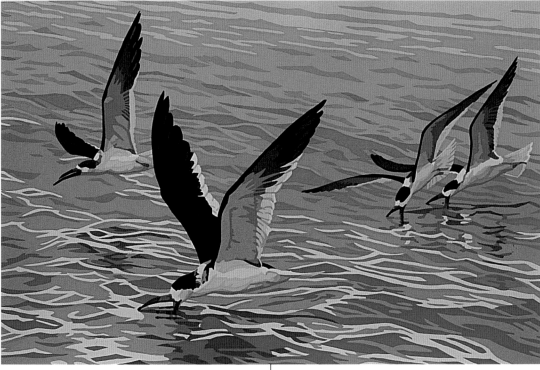

7| **The final print.**
Once all the printing is done, Anne Faust weeds out the sheets that did not print to her satisfaction. For much more about her approach, see "A Life List in Serigraphy," an excellent article written by Ruthe Thompson in *American Artist* magazine, February 2000. I am indebted to Ruthe Thompson for her help and for the information in her article.

SYMPHONY ON A WINTER TIDE | Anne Senechal Faust | serigraph | 16″ × 25″ (41cm × 64cm). Edition of 17.

of color were studied and published in 1839 by French physicist Michel-Eugène Chevreul. His landmark study also defined the *law of successive contrast*, which pointed out that if you look at a color by itself, gradually it becomes surrounded by a halo of its complementary color. That halo of complementary color imposes itself over any other colors that actually surround the central color and modifies their appearance. There are many extensions or corollaries to these two "laws" having to do especially with the "temperature" of colors. Warm colors seem to advance and cool colors seem to recede, for example, and a color may appear warmer or cooler depending on what colors surround it. *See color; complement; successive contrast, law of.*

single-action airbrush
An airbrush whose trigger releases a set mixture of air and paint with no possibility of adjusting the mix. *See airbrush; double-action airbrush.*

size or sizing
1| A material, such as glue, gelatin or a synthetic product, used to isolate one surface from another. In preparing canvas for receiving oil paints, it's necessary to protect the canvas fibers from direct contact with the paint because oil paint is acidic and the acidity will in time destroy the fibers. The raw canvas is impregnated with glue so that the glue forms a barrier between the fibers and the paint. The glue size is not applied thickly—its job is to act as a thin barrier, not a thick film. *See illustration under fat-over-lean rule, oil.* 2| A

material used to make a surface less absorbent. Many papers, especially water-color papers, are treated with size, such as gelatin, so that paints do not become sucked too deeply into the fibers of the paper.

size and space variation
A technique for introducing the illusion of depth in a picture. If you see a series of objects that are all the same size and equally spaced there is no feeling of depth, but if you gradually diminish the sizes of the objects and also the spaces between them, you make them appear to be receding. The result is a strong suggestion of depth, or distance, even though the objects are depicted on a two-dimensional surface. *See perspective.*

sizing
See size.

Size and space variation
The posts all in a row don't give the picture any depth, but rearranging them definitely helps. Notice that the spaces between them, as well as the heights of the posts, diminish.

sketch
Any quick, preliminary drawing or painting not necessarily intended as a final product.

sketchbook
Drawing papers bound together for ease of use and transport. Many artists regard their sketchbooks as their "thinking places" or "idea files" where they can keep track of tidbits, make hasty notes while on the move or work out design problems. It's handy to keep a small, pocket-size sketch-book that you can take anywhere and a larger one for more extensive sketching and note-taking. Books with spiral bind-ings are popular because they open flat and are easy to use. It's a good idea to use

books with acid-free paper (so they won't yellow over the years), but if that choice seems inhibiting (you may not want to use good paper for a sketch) go with cheaper papers. *See illustrations on pages 411-412.*

sketching pencil
A broad pencil, slightly oval in cross section, with a wide flat lead; also called a *carpenter's pencil. See illustration under pencil.*

slant tile palette
See palette, slant tile.

slide projector
A device for casting an image of a slide (a small transparency) onto a screen; also called a diascope. *See projector.*

slip
A mixture of fine clay and water, used for joining pieces of ceramic, for building up

Sketchbook

You can use almost any materials for sketching, but after years of working at your art you'll be happy to have bound books to thumb through and use as sources of both painting ideas and pleasant memories. Carry along pencils, pens or markers—whatever suits you.

designs in low relief on ceramic surfaces and for casting ceramics in a mold.

soaking tray
A shallow container for holding water in which to soak watercolor paper during the stretching process. *See watercolor; stretching paper. See illustration on page 413.*

Social Realists
A catchall label for any group of artists whose art reflects the society about them. Some consider the Ashcan artists Social Realists; similar groups in Great Britain and in Russia have been labeled the same way. *See Ashcan School.*

a
B
C
D
e
F
G
H
I
J
K
L
m
n
o
P
Q
r
s
T
u
v
W
X
Y
Z

Sketchbook

A sketchbook should be used to record what you want—notes to yourself, reminders, etc.—not necessarily finished pictures. Your sketchbooks might be considered your artistic diaries.

drain plug | trim | paper | piece of vinyl swimming pool liner | ¾″ (2cm) or 2″ (5cm) wood strips

soft ground

In etching, a ground made with a high proportion of waxy or greasy ingredients so that it remains relatively soft. *See etching; soft-ground etching. See illustration on page 414.*

soft-ground etching

An etching using a ground soft enough that textured materials pressed into the ground leave their imprint. The textured imprint goes all the way through the ground to the etching plate, effectively exposing the plate in the same way a needle would expose it. *See etching. See illustration on page 414.*

soft pastel

Pastel containing relatively less binder than hard pastels. Soft pastels deposit color more easily than do hard pastels. *See pastel.*

Soaking tray

Although a bathtub will do, it may be more convenient to make a soaking tray to fit the sizes of paper you'll want to soak. This tray consists of four ¾″ x 2″ (2cm × 5cm) wood strips nailed to a base of plywood that is ¾″ (2cm) thick. Line the tray with any waterproofing material, such as a piece of swimming pool liner, glued in place and overlapping the top edges of the sides. Finish the edges with pieces of wood moulding. It's helpful to install a drain—put it in the corner where the paper can't rub against it and become scratched.

solvent

A substance, usually liquid, used to dissolve, thin or remove another substance such as paint. *See chart on page 415.*

soot

The fine powdery residue resulting from the incomplete combustion of wood, oil, coal and other carbon-based fuels. Depending on the burning process and the fuel used, there may be traces of various

Soft-ground etching

Here is a French knight at the battle of Agincourt in 1415
facing an onslaught of arrows from the English army
under Henry V. Two separate plates were made for this
etching, one for black ink and one for red. The red was
printed first; dark colors are usually reserved for last
because they can effectively overlay lighter colors. A soft
ground was used on the black plate and lace fabric was
laid on the ground to provide the design on the horse's
caparison. To enable the lace to penetrate the ground,
Stoliaroff heated the plate and ground.

AGINCOURT | Peter Stoliaroff | etching with aquatint |
$11^7/_8'' \times 8^3/_4''$ (30cm × 22cm)

Comparing Solvents

Solvent	Source	Toxic?	Common Usage
Acetone	derived from isopropyl alcohol	highly toxic	dissolving vinyl and acrylic resins, lacquers, alkyd paints, inks, cosmetics (e.g., nail polish remover) and varnishes
Citrus	peels of citrus fruits	yes	cleaning or thinning oil or alkyd
Mineral Spirits	petroleum	yes	cleaning or thinning oil or alkyd
Turpentine	pine trees	yes	cleaning or thinning oil or alkyd
Water	–	no	cleaning or thinning watercolor, gouache, acrylic and water-miscible oils

elements in the soot, but it's primarily carbon. *See carbon black.*

space plane
A hole or space *within* an object considered an integral part of the object rather than simply empty space—as opposed to the empty space around the object.

spacer
In framing, a strip of material placed between the glass and the artwork **1:** to keep the glass from touching the artwork, **2:** to provide a deeper space for pastel dust to drop to the bottom of the frame rather than onto the glass or **3:** to improve the appearance of the framing by introducing depth. *See illustration under framing.*

spattering
Randomly distributing specks or droplets of paint over a surface. Spattering can be done by riffling the bristles of a paint-filled brush or toothbrush, by tapping a paint-filled brush against the hand or by flinging paint with the hands. In watercol-

or painting, spattering may mean distributing droplets of water, not paint—where the droplets fall onto a damp painted surface, they form small, presumably attractive, blotches. An airbrush may be fitted with a spatter cap to produce beautiful, controlled spattering. *See illustration on page 416.*

spectrum, electromagnetic
The entire range of electromagnetic energy pervading the universe. Electromagnetic theory states that energy is propagated in the form of waves. The measure of the number of waves per second is called the *frequency*; the distance between waves is called the *wavelength*. X-rays and gamma rays at one end of the spectrum have very high frequencies and short wavelengths; microwaves and radio waves at the other end of the spectrum have much lower frequencies and much longer wavelengths. Visible light is in the middle and makes up only a small portion of the entire electromagnetic spectrum. *See illustration on page 417.*

Spattering

spectrum, visible light

The portion of the electromagnetic spectrum that can be perceived by the human eye. *See spectrum, electromagnetic.*

spirits

See mineral spirits; turpentine.

splashed ink

In Chinese painting, the laying down of broad, fluid areas of ink or paint and manipulating the ink or paint by tilting the picture. *See p'o-mo.*

splattering

Spattering.

split complementary

A color scheme in which analogous colors (three colors adjacent on the color wheel) are used to set the overall tone in a painting and the complement of the middle color of the three analogous colors is used as a contrasting accent. For example, if the analogous colors red, red-orange and orange are used, the complement of the middle color (red-orange) is blue-green (directly opposite red-orange on the color wheel). Blue-green would be used as the accent color. For more, *see* Stephen Quiller's book, *Color Choices. See color wheel; analogous colors; complementary colors.*

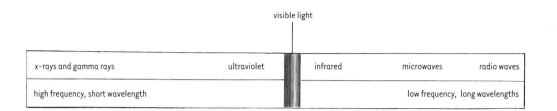

visible light

x-rays and gamma rays	ultraviolet		infrared	microwaves	radio waves
high frequency, short wavelength				low frequency, long wavelengths	

Spectrum, electromagnetic

Near the middle of the electromagnetic spectrum is the portion called the visible light spectrum—the portion of the spectrum humans can see. The visible light spectrum (the familiar "rainbow" colors: red, orange, yellow, green, blue, indigo, violet) extends from red (lower frequency, longer wavelength) to violet (higher frequency, shorter wavelength).

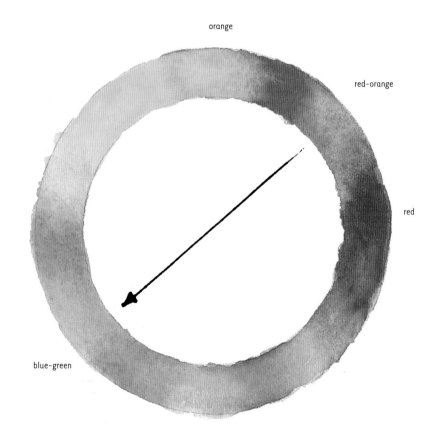

orange

red-orange

red

blue-green

Split complementary

Select any three adjacent colors (analogous colors) on the color wheel. The complementary color opposite the middle analogous color is used as an accent color in a split complementary color scheme.

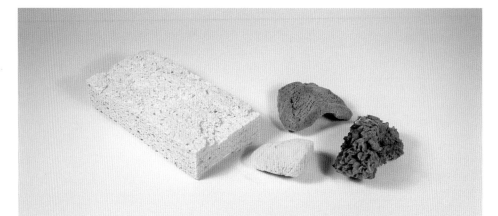

Sponge
An artificial household sponge and natural sponges.

sponge

A multicellular animal with a porous skeleton, found mostly in sea water, but sometimes in fresh water. The skeletons of many sponges are hard, but those with softer, more plastic skeletons are used for bathing and cosmetic purposes. Artists use these sponges for dabbing paint onto a picture to create textured effects. Common household sponges, usually rectangular in shape, are synthetic, made of rubber or cellulose. Natural sponges offer a wide variety of shapes and textures; synthetic sponges are more uniform in texture, but are still sometimes useful for texturing and, of course, for cleaning up.

spotter

A brush with a tiny, pointed tip. *See brush, painting.*

Spotter

sprayer

Any device for producing a fine mist of a liquid such as water. Window-cleaner spray bottles are commonly used to spray water on a watercolor or acrylic palette to keep paints moist. Sprayers are also often used to keep an area of a painting wet. In watercolor, careful squirts from a sprayer can be used to produce tiny blotches in damp paint to simulate texture, snowfall, stars, etc. *See watercolor.*

squaring

Use of a grid of lines to aid in transferring an image from one surface to another, usually larger, surface. *See illustration under grid.*

squeegee

A rubber or plastic blade used to force ink through the mesh in screen printing. *See silkscreen print.*

squirrel hair

Squirrel or other inexpensive animal hair used in some cheaper brushes. *See brush construction.*

stabile /stay beel/

Stationary abstract sculptures, usually of sheet metal in simple forms. The term was first given Alexander Calder's work in the 1930s and has since been used to describe other artists' sculptures. Calder's stabiles tended to be light and airy, suitable for any large space, indoors or out. The term stabile compares to *mobile*, Calder's other works that were not stationary, but that instead contained moving parts. *See mobile; kinetic art.*

stabilizer

An ingredient added to oil paints to keep the oil from separating from the pigment in the tube, thus maintaining the paint's uniformity and consistency.

staging

Building a picture in layers, from back to front, in the manner of stage scenery. *See illustrations on pages 420-421.*

stained glass

Glass that is colored by the addition of a variety of metallic oxides during the glass-making process. Such glasses were used in windows of the twelfth and thirteenth centuries, particularly those of the great European cathedrals. Stained glasses are used today for all manner of articles, including decorative panels, tableware and jewelry.

staining color

The colorants in some paints actually bond or react with a material, while other colorants simply form a film or coating on the material. Those that react or bond are called *staining colors.* They are more diffi-cult to remove, or lift, than nonstaining colors. Phthalocyanine Blue and Phthalocyanine Green are examples of staining colors.

stand oil

A thick oil produced by heating linseed oil. Stand oil is used by oil painters as an ingredient in painting mediums and in some varnishes. When added to oil paint, stand oil is a "leveler"—that is, it helps the paint to form a smooth film as it dries. Stand oil is not as subject to yellowing over time as is straight linseed oil. The name is said to have originated long ago when linseed oil was floated over water in a wooden tank and let stand for considerable periods of time while impurities leached out of the oil.

stapler

A device for inserting U-shaped fasteners called staples. Stapling is an accepted method of attaching canvas to wooden stretcher strips; it can also be used to attach drawing paper or painting paper temporarily to a board. *See illustration under canvas, stretching.*

state, print

Any version of a print that shows the artist's continuing modification of the plate, block or stone used to produce the print. Many artists are known to have reworked their original ideas, sometimes in small ways but often in important ways. Rembrandt van Rijn, for example, created images in drypoint and engraving that he printed in several different states, each state showing drastic changes from earlier ones. He scraped and burnished to remove major areas from the plate and then reworked those areas. There are other ways an artist may introduce changes from one printing to the next, such as by changing inks and papers, but "state" applies only to

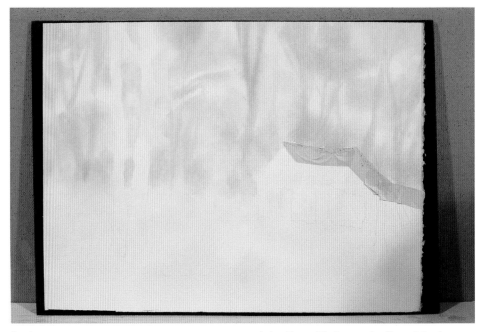

Staging

First the watercolor paper is wet and light color (blue, red, yellow) is splotched randomly over the surface. This breaks up the white of the paper and forms a light under-painting. Then, while the paper is still wet, faint shapes are brushed in loosely to represent the most distant trees in these winter woods. The surface is dried, and drafting tape is applied to protect the white roof area.

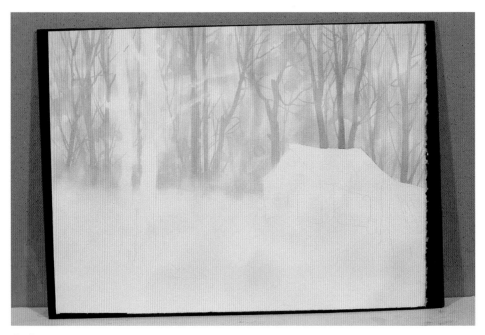

Staging

A second stage of trees is painted. These are painted on dry paper so that they are more solid-looking than the first, fuzzy trees. But these trees are still at some distance, so no detail is added—they are basically flat silhouettes.

Staging
Still on dry paper, a more detailed set of trees is painted
in warmer colors than the more distant ones.

Staging
Finally all the foreground detail is painted. The painting's
progression: cool, indistinct background to slightly
warmer, more distinct middle ground to warmer, more
detailed foreground.

WINTER WOODS | watercolor on Fabriano Uno rough 100%
rag paper | 16″ × 20″ (41cm × 51cm)

changes made by actual alteration of the printing plate, block or stone.

stele or stela /steel ee; steel ah/
A stone slab or pillar in ancient lands such as Mesopotamia and Greece, used to mark graves, to establish land boundaries and to commemorate events. Most were inscribed. One famous stele contained the code of Babylonian King Hammurabi.

stencil
See template.

stencil print
See silkscreen print.

stile
The vertical members of a door; the horizontal pieces are called rails. A modern door, like ancient ones, often consists of stiles and rails surrounding flat or carved panels.

still life
An arrangement of inanimate objects; a picture of such an arrangement. Still life painting began during the Renaissance, at least partly as a response to the desire for secular painting subjects other than portraits. The first still life painting is thought to be one done by an Italian, Jacopo de'Barbari, in 1504. Any object may be made part of a still life and any medium and drawing or painting style may be used. See illustrations on pages 423-424.

stippling
Painting or drawing with small dots of paint, ink, graphite, etc. Graduated tones of any lightness or darkness can be gotten by varying the sizes of the dots, but more commonly by placing dots closer together or farther apart. A particular form of stippling called Pointillism, was explored by some Impressionists; Pointillism is concerned with placing colored dots side by side so that from a distance the colors visually combine to suggest other colors. Stippling has been used in many ways over time. In the 1700s and 1800s artists painted small ivory pieces using tiny pointed brushes and a stippling technique. Farther back, in the eleventh century, a Chinese painter named Fan K'uan painted large, realistic scenes on scrolls using stippled brushwork (sometimes called raindrop strokes). Modern pen-and-ink artists often use fine stippling to suggest texture and shading.

stomp
A tightly rolled cylinder of paper with two blunt points, used to blend or smear charcoal, pastel or pencil marks; also called a stump. See illustration under stump.

stone, lithographic
Limestone, or sometimes marble, on which an image is drawn in lithography. Printmakers select stones carefully, depending on the nature of the images they intend to draw—some stones are too coarse for finely detailed work, for example, and others have unacceptable imperfections. Typical stones for smaller images are about two inches (5cm) thick, while those for larger work may be twice that thick and, of course, very heavy. Stones must be thick enough to withstand the pressure of the press without cracking.

stone sculpture
See sculpture, stone.

stretcher bars or stretcher strips
Wood strips used to form a rectangular support over which canvas is stretched. Most manufacturers offer strips in two widths, standard and heavy-duty. Typical widths are 1⅝″ (4cm) for standard and 2¼″ (5.7cm) for heavy-duty. Which width to use

Still life

Jane Lund is known for her exquisitely rendered still lifes in pastel. She uses combinations of soft and hard pastels and works carefully from top to bottom and left to right, finishing as she goes. She usually begins with a drawing in light Cobalt Blue pastel on gray Canson paper. She works for very long periods on her pictures—often months—and sometimes relies on photographs of perishable items, such as gourds, that wither and change their appearance before she's finished painting. As you can see, she captures every nuance of light and shadow in her work.

WHITE STILL LIFE | Jane Lund | pastel on Canson paper | 30½" × 29¼" (78cm × 74cm). Private collection.

Still life

APPLES | watercolor on Strathmore illustration board | 22″ × 30″ (56cm × 76cm)

depends on the size of the canvas you intend to stretch and on the weight of materials you intend to attach to the canvas (some artists use canvas as a support for heavy assemblages). Generally, standard strips are appropriate for lengths up to 48″ (122cm). Either width can be supplemented by cross-braces, available from most sellers of stretcher strips. *See canvas, stretching. See illustration on page 425.*

stretching paper

Thinner watercolor papers will warp during painting unless they are first stretched. This involves soaking the paper for several minutes in cool water until the paper is saturated. At that point, the paper will have expanded (stretched) in all dimensions, and it can be painted on without warping, or buckling. While painting, keep the underside of the paper constantly wet so that the paper will continue to lie flat. When the painting is finished, or when you're done for the day, capture the paper in its expanded (stretched) state by clamping, taping or stapling it to a board. As the paper dries and tries to shrink back to its normal size, the clamps, tape or staples will prevent it from doing so.

Any time a watercolor paper needs restretching (if, for example, you failed to keep it wet underneath), you can do so by turning the dry painting over and brushing or sponging water on the back surface for a few minutes until the water penetrates the paper and causes it to expand once again. Then turn the paper over and continue painting. While doing this, be careful not to allow water to run around onto the painted surface, where it may harm your painting.

stripping

The removal of varnish from a picture. Conservators prefer the terms *cleaning* or *varnish removal.*

student-quality or student-grade

Adjective describing any art material made to appeal to a low budget. While many student-quality products seem adequate to the novice, they are always inferior to artist-quality materials in some way, such as in permanence or, in the case of paints, color saturation. *See artist-quality.*

studio

Space set aside as an artist's work area, as opposed to temporary space on the kitchen table or in a corner of a bedroom; *atelier.* There are a number of attributes one should consider in organizing a studio, depending, of course, on the type of art to be done. **1**: Good lighting. Many artists prefer studios with north-facing windows, but when that's inconvenient or impossible, perfectly good lighting may be arranged using fluorescent tubes color-balanced especially for artists; good alternatives are regular "daylight" tubes or bulbs or a mix of "warm" and "cool" tubes. **2**: Storage for paints, mediums, pencils, pens, papers, canvases, works-in-progress and all the many items artists accumulate. **3**:

Stretcher bars

Stretcher bars joined to make one corner, with one key inserted. It's best not to insert keys at the outset, but to use them only if necessary later to tighten a sagging canvas. Most bars are beveled on one side—the canvas goes on the beveled side. The bevel prevents the canvas from touching the rest of the strip.

Proper ventilation, especially for those working with volatile or smelly materials, pastels and the like. Some pastel artists keep a hand-vacuum close by for getting rid of loose pastel dust; others keep a vacuum in a separate room (where its noise won't be a disturbance) and run a suction hose from the vacuum to the easel. For spraying fixatives, varnishes and other dangerous materials, either an outdoor arrangement should be made or there should be a closed-off area, preferably a separate room, set aside for such activity. **4**: Work space for mat cutting, shrink-wrapping, collage assembly, frame assembly, light boxes and projectors. **5**: An area for photographing artwork. Many artists keep careful photographic records of their work, especially for use in entering juried exhibitions. Rather than depend on agreeable weather for photographing outdoors, it's most convenient to be able to photograph indoors under controlled conditions. *See photographing art.* **6**: Water and sanitation facilities. Oil painters, in partic-

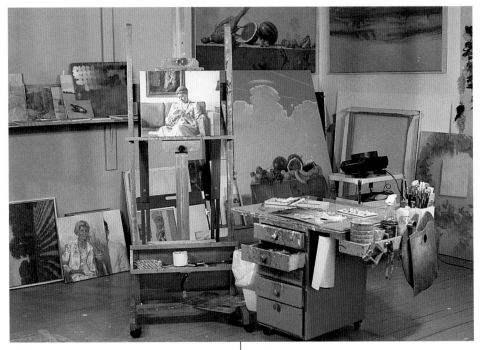

Studio
The studio of painter Ed Ahlstrom in Mt. Airy, Maryland. While there is good light from a window, Ahlstrom relies heavily on fluorescent lights mounted on the high ceiling, along with some incandescent lights on movable stands. Photo courtesy of Ed Ahlstrom.

ular, need to be able to dispose of oily rags that might, if left piled in a waste can, present a fire hazard (spontaneous combustion). Artists whose sewage systems are septic tanks need to arrange for disposal of waste art materials in some way other than flushing them into the septic system; materials such as paints and solvents will destroy the bacterial activity that makes a septic tank work.

Artists such as sculptors may need space for heavy tools and machinery, forklifts, cutting torches, welding equipment and so on. Their needs are quite different from the needs of a painter but, of course, there must still be attention to such needs as lighting, ventilation and safety.

studio easel
A device intended to support a painting in progress in the studio, as opposed to box easels, pochade boxes and other easels intended mainly for outdoor use. *See easel.*

study
A drawing or painting of all or part of a composition intended as a preliminary outline or exploration of a subject, often intended as "homework" before attempting a full treatment of the subject. Frequently a study exhibits a particular charm, beauty or excitement all its own, and it's not uncommon for such a study to be more appealing than the eventual "finished" work.

stump
A tightly rolled cylinder of paper or compressed felt with two blunt points, used to blend or smear charcoal, pastel, pencil or other marks; also called *stomp*. A tortillion is a more tightly rolled cylinder of paper

Stump
The tree at the left was done using individual pencil strokes with no blending. At the right, strokes were blended using a stump. Such use of a stump can change the entire mood of a drawing from active to quiet.

with a sharper point at only one end, used similarly to a stump, but for smaller, finer areas (also spelled tortillon).

style

A particular manner of painting, drawing, designing, sculpting or building. Many artists' works become recognized for a distinctive look, or style, that is unlike that of other artists. While some develop unique styles, some copy the styles of others. Examples of painting styles: the loose color dabs of the Impressionists, the Cubism of Picasso or the high finish of a Wyeth egg tempera. In cathedral architecture, the Romanesque style, with its thick, heavy walls and ceilings, versus the Gothic style, with thinner walls, higher and lighter ceilings and large windows. *See more under art movements.*

styrene plate

Inexpensive plastic plates used for making monotypes. *See monotype.*

Stump
Stumps and tortillions are both tightly wound cylinders of paper (or sometimes other material). A stump has blunt points; a tortillion has a single sharper point.

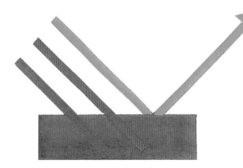 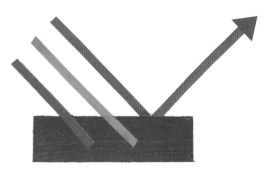

subjective color
Color an artist chooses that may be different from the actual color of the subject. The actual color is usually called local color.

subtractive color mixing
The mixing of colored materials such as paints to produce new colors. In subtractive mixing, the primary colors are usually called red, blue and yellow (*see sidebar*). The reason for the word *subtractive* is this: When you see an object in sunlight and it looks a certain color—for example, red—it looks red because the object absorbs all the other colors in the sunlight except the red and only the red is reflected back to you. The object subtracts from the white sunlight all the colors except the red.

successive contrast, law of
To the human eye, a color seems surrounded by a halo of its complement. If you look hard at a sample of green on white paper, for example, after a minute or two you'll notice a slight halo of light red around it and vice versa. *See simultaneous contrast, law of; color; complement.*

suede effect
The tendency of some paints, especially oils, to look different when brushed in one direction from the way they look brushed

Subtractive color mixing
Here are two simplified examples of subtractive color mixing. When white light (made up of red, green and blue) strikes a paint we know as "green," all the components of the white light except the green are absorbed by the paint and lost to our vision. Only the green survives to reach our eye. Similarly, in the second example, red paint absorbs all colors from the white light except red, which is reflected to our eyes.

Color Confusion

Most artists consider red, yellow and blue primary colors. When they have offset reproductions made of their paintings, the color dots that make up the reproductions look like red, yellow and blue (along with some black), but they are actually magenta, yellow and cyan. Magenta is a slightly purplish red and cyan is a greenish blue. It was found long ago that these three colors—magenta, yellow and cyan—are best suited to produce the widest variety of color mixes.

Successive contrast
Stare at this green square and soon you'll notice a light reddish border around the green.

in a different direction—named for the way a piece of suede leather looks when its fuzzy surface is brushed in different directions.

sugar lift

An aquatint etching technique (also called *lift-ground etching*) in which the areas of a plate to be aquatinted are first painted with a sugary fluid. When the sugar-painted areas have dried, the entire plate is covered with a ground or a layer of stop-out varnish. When this is dry, the plate is immersed in lukewarm water. The water softens and swells the sugar-painted areas, and those areas lift off the plate along with the ground or stop-out that had covered those areas. Now the exposed areas may be aquatinted in the usual way (*see aquatint*).

The advantage in aquatinting in this manner is that the artist deals with positive image areas instead of negative ones. In regular aquatinting, the artist saves areas *not* to be aquatinted by coating those areas with a masking fluid, but in that case he is coating negative spaces. For most artists it's easier to deal with positive rather than negative spaces. *See etching; aquatint.*

suiboku or suiboku-ga /swee bo koo; swee boh koo zhah/
Synonymous with sumi-e: Oriental painting in black ink on rice papers. However, sumi-e generally means painting traditional oriental subjects, while suiboku often implies painting a broader range of subjects, including Western themes. *Sui* means water, *boku* means ink and *ga* means picture.

sumi
A stick or cake of black ink used by Japanese sumi-e painters. Sumi is made of carbon (the soot of burned plants) and glue.

sumi-e /sue mee eh/
Japanese painting using black inks, originally practiced by the Chinese. The traditional ink used is a sumi ink stick made of carbon and glue. Some ink sticks produce a cool, slightly bluish ink; others make a darker, blacker ink. The artist makes ink by rubbing the end of the stick in a little water in a shallow dish or grinding stone. The dish has a slanted bottom, and as ink is formed it runs into the low end. The artist grinds ink until satisfied with the darkness of the ink in the well. Sumi-e painting is done on a variety of papers including many Japanese rice papers.

In sumi-e, brush strokes are always evident; in other forms of oriental painting, this is not necessarily the case. In *p'o-mo*, for example, paint is poured and manipulated and allowed to run freely. Under Western influence, sumi-e has been gradually expanded to include color in addition to the traditional black-ink painting. For color, artists use a variey of inks or paints, including oriental mineral colors and trational watercolors. Typical brushes used are those shown under brush, painting. *See also suiboku; p'o-mo. See illustrations on pages 430-431.*

Sumi-e

A traditional sumi-e using black ink.

PINE AND CRANE | Kay Stratman | sumi-e on rice paper | 21″ × 13″ (53cm × 33cm)

Sumi-e

Peony Branch | Kay Stratman | sumi-e and watercolor on rice paper

a
B
C
D
e
F
G
H
I
J
K
L
m
n
o
P
Q
r
s
T
U
V
W
X
Y
Z

sun-thickened linseed oil

Linseed oil that has been exposed to sunlight under controlled conditions to increase its viscosity, decrease its drying time and make its color somewhat paler. It is used as a medium by some artists; some artists prepare their own paints by grinding their pigments into sun-thickened oil. Although known and used for centuries, it is not much used today.

sunken relief

Carving that lies below the level of a surrounding surface; intaglio relief. *See relief.*

superimposed order

Architecture in which different orders (such as Doric and Ionic) are mixed, usually with one order on one level and another on the next level. *See Classical architecture.*

support

The material on which a drawing, painting, print, collage or assemblage is made. The major supports are paper (for watercolor, prints, gouache, acrylic, casein, charcoal, pencil, pastel, etc.); canvas (for oil, alkyd, acrylic) and hardboard (for almost all mediums). Other supports less commonly used are metals, Plexiglas, plaster and wood. *See paper; hardboard; canvas; ground.*

Suprematism

An art style that eliminated all natural forms in favor of flat geometric patterns, seeking to represent feeling rather than objects. The style began with Kasimir Malevich, a Russian, in 1913. Malevich helped write a "Suprematist Manifesto" that called for the "supremacy of pure feeling or perception." His most famous work was *White on White*, an oil painting showing a tilted white square on a white background, the two squares slightly differing in tone. Suprematism ended with Malevich's 1919 exhibition of his work.

surface printing

Printmaking in which the image to be printed is on the flat surface of a plate, stone or other material; planographic printing. The prime example of surface printing is lithography, in which the image is neither cut into the plate or stone nor raised in relief on the plate or stone. Another type of surface printing is the monotype. *See print; lithograph; monotype.*

surface tension

The attraction among like molecules on the surface of a liquid and between surface molecules and those underneath. The result of these attractions is to cause the liquid to try to form a spherical shape—it's what causes a water drop to form. The effect is as though there were a thin skin surrounding the liquid. In gardening, surface tension causes insect sprays to bead up rather than coat a plant's leaves; in painting, surface tension sometimes tends to make paint gather into a bead or ball rather than spread over the painting surface. To combat this effect, small amounts of so-called "wetting agents" are sometimes added to help break down the surface tension, allowing the fluid to spread. *See wetting agent; ox gall.*

Surrealism

In literature and in art, a move to join the real and the unreal, the conscious and the unconscious. Surrealistic paintings often have a dreamlike quality, showing objects in incongruous settings. Poet and critic André Breton, the foremost spokesman for the movement, drew heavily from the theories of Sigmund Freud and wrote of uniting dreamlike and conscious experiences to form a "surreality." Surrealism was

a
B
C
D
e
F
G
H
I
J
K
L
m
n
o
P
Q
r
s
T
u
v
W
X
Y
Z

Surrealism

This recent painting by artist Ken Koskela has the dreamlike quality of earlier surrealist paintings. It invites the viewer to decide for himself what's going on, and any interpretation is fair game. Notice that in paintings such as this, it's not only the figures and surroundings that set the mood, but the color scheme as well.

THE RETURN OF THE FIFTH SISTER | A. Kenneth Koskela | watercolor on Arches 300-lb. (640gsm) cold press | 11½″ × 8½″ (29cm × 22cm)

sweet spots

active between the two World Wars and was, at least in part, a reaction against the destructive policies that had produced the havoc of World War I. Among the leading Surrealist painters were Salvador Dali, widely recognized for *The Persistence of Memory*, a painting featuring distorted watches in an eerie landscape, and Max Ernst, Yves Tanguy and Jean Arp.

suzuri /soo zoor ee/
The stone on which a sumi ink stick is ground.

sweet spot
A term used by artists to refer to areas in the four quadrants of a rectangle considered the safest areas to locate the center of interest of the picture.

Symbolism
A movement in painting during the 1880s and 1890s aimed at more use of fantasy and imagination and less use of straight-

Sweet spot
A sweet spot (a "safe" place for a center of interest) is located within any of the four quadrants of a rectangle rather than in the center of the rectangle or along any edge or along any of the lines that divide the rectangle into quadrants.

forward depiction of objects. Symbolists looked for metaphors, or symbols, to suggest a subject, often making use of mystical or occult themes. Gustave Moreau, for example, painted figurative scenes based on legendary or ancient stories; Odilon Redon used mythical and dreamlike figures in settings often fantastic or even macabre.

symmetry
A pictorial arrangement in which the left side is a mirror image of the right side. Although it's unusual to design an entire drawing or painting with symmetry, there are often individual objects in the picture that require it. When symmetry eludes

a

b

TRACING
PAPER

c

ƎNIƆAᴚT
ᴚƎꟼAꟼ

d

you, a simple way to "fix" an object is as shown here.

synthetic brush

A paintbrush made with synthetic fila-ments, or "hairs," rather than animal hairs. *See brush construction.*

Synthetism

A style of painting emphasizing two-dimensional flat patterns, often with areas of pure color separated by strong

Symmetry

Suppose you've drawn this bottle (a) and you'd like to make it more nearly symmetrical. One way to fix the drawing is to (b) erase one half, (c) copy the other half on tracing paper and (d) flip the paper to complete the bottle. Now all you have to do is trace the new half.

lines. A leading exponent of this style was Paul Gauguin, who began as an Impressionist but later looked for some-thing he considered more substantial than the fleeting snapshots of Impressionism. *See cloisonnism.*

taboret or tabouret /tab uh *ret*;
tab uh *ray*/
A small, portable cabinet. Taborets take
many forms; most have a flat working sur-
face on top and a set of drawers or shelves.

tacking iron
A small electrically heated instrument
used by some collage artists to fasten small
pieces of a collage in place; it resembles a
soldering iron but the heated tip is usually
flat and trowel-shaped. The tacking iron
works the same way as a dry-mount press,
but on a very small scale. *See dry mounting.*

taklon
The generic industry name for a dyed syn-
thetic filament (polyester nylon) used in
paintbrushes.

tape
A paper or fabric strip with an adhesive on
one or both surfaces. Masking and drafting
tapes are useful for masking (hiding) areas
of a drawing or painting temporarily; two-
sided tapes are handy for temporarily
attaching photos or other papers to a back-
ing; packaging tapes may be used to fasten
a watercolor sheet or drawing paper to a
board; and framer's tape may be used to
attach a picture to a mat or to a backing.
None of these tapes are advertised as

Taboret
This plastic taboret is a handy size, especially for a small studio. It
has wheels to help move it when necessary. For working in more
than one medium, it's helpful to have more than one taboret, each
containing the paints and tools for a particular medium.

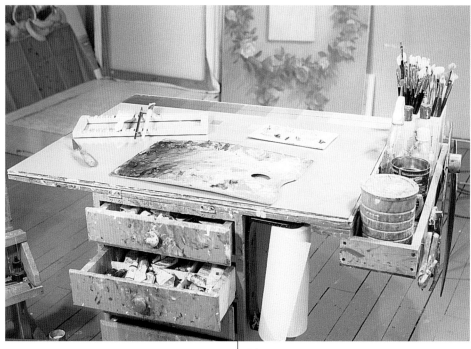

Taboret
This taboret has a large glass top. Paints may be mixed directly on the glass surface rather than on a handheld palette—a matter of personal preference. Many artists insert a sheet of white or colored paper under the glass to provide whatever background suits them for paint mixing. Photo courtesy of Ed Ahlstrom.

archival except for a few framer's tapes. Tapes such as masking tape should never be used for any permanent attaching—the tape will eventually crumble. For permanent hinging of works on paper to mats or backings, conservators prefer using tough, acid-free paper, such as Japanese rice paper, with wheat paste or a pH-neutral glue. *See drafting tape; masking tape; framer's tape.*

tapestry
A woven fabric, often depicting a scene, intended usually as a wall hanging but sometimes used for furniture upholstery, rugs and other decorations. Tapestry work has flourished during many periods from the Middle Ages to modern times. Often a tapestry is a collaboration between a designer and a weaver—the designer prepares a cartoon as a map for the finished work, and an expert weaver converts the idea to an array of woven colored threads. Wool has been a favored material for tapestries, but many others are used as well, including silk, cotton and gold and silver threads.

Some tapestries are made as single pieces, but many are designed as sets of several panels. Unlike most weaving, the crossing threads (weft) in a tapestry often do not extend across the entire width—each colored thread is introduced only in lengths and positions that fulfill the intent of the design. Finishes range from coarse to fine, depending on the fineness and spacing of the threads. Designs for tapestries have been made by some famous artists, including Raphael and Peter Paul Rubens. *See warp; weft; weaving.*

tarlatan /*tar* luh tn/
A stiff, open-weave cotton cloth, such as cheesecloth, used in wiping ink from an intaglio printing plate. *See etching.*

technical pen
See pen, technical.

temper
To render something usable. In painting, tempering is the addition of a material such as a medium to make a powder or other substance manageable and usable as a paint—for example, the addition of egg yolk to pigment.

tempera
Traditionally, tempera was any paint consisting of a pigment combined with a binder. While that may sound as though it includes any paint at all, it does serve to separate fresco paint from others, since fresco paint requires no binder, only pigment and water. In modern usage, tempera has taken on differing shades of meaning.

Some define tempera as a paint having an emulsion as its binder—but acrylic paint has an emulsion binder, and yet we never refer to acrylic paint as "tempera." The most accurate and meaningful way to use the word is to qualify it—for example, egg tempera is an unambiguous usage, a paint using egg as its binder. Egg tempera, in fact, is one of the two most common tempera terms used today, along with tempera paint, which refers to cheap starch- or glue-based paint meant mostly for children's use.

tempera paint
In current usage, a cheap starch- or glue-based paint meant for children's use.

temperature, color
The warmness or coolness of a color. For example, Phthalocyanine Blue is considered a cool blue (it has an icy look), while Ultramarine Blue is a warm blue (it has a slight reddish cast). *See color.*

tempered hardboard
A building material made of compressed wood fibers, used as a painting support and as a painting board. *See hardboard; Masonite.*

template
A pattern or model. In the decorative arts, and occasionally in painting, a shape cut from cardboard or plastic film is sometimes used to help paint a repetitive pattern. In silkscreening, a template, or stencil, is used to define areas to receive ink. *See silkscreen print.*

Tenebrism /*ten* ah brizm/
The use of strong light-dark contrasts to give dramatic emphasis to a scene; often the background for the scene is very dark and shadowy and the foreground subject is lit as though suddenly illuminated by a spotlight. Michelangelo de Merisi, usually known as Caravaggio, introduced this style. It has since been used by many painters, especially portrait painters.

terra-cotta
Fired clay, usually relatively coarse, with a reddish-brown color. From the Italian meaning "baked earth." Some terra-cotta is left unfinished, but often it is glazed or painted. Terra-cotta is used today commercially in the form of roof tiles, flowerpots, building blocks and many kinds of ornaments. In art, terra-cotta objects—both in sculpture and architecture—have been around for millennia in the Middle East, the Mediterranean countries, China and

Template
Dabbing paint through a template, or stencil, to paint the letter *A*.

Template
The result.

Central America. During the Renaissance it was widely used by sculptors for both models and finished works. The Della Robbia family are known for their finely enameled terra-cotta reliefs. It remains a popular material today for architectural purposes, both functional (walls, roofs, etc.) and decorative.

terrazzo /tehr *ah* zoh; ter *aht* so/
A material consisting of stone (usually marble) chips mixed into a cement binder and, when hardened, polished to a high sheen. Terrazzo is most commonly used for floors.

tertiary color
A color produced by mixing a primary color with a secondary color next to it on the color wheel. Examples: mixing red (primary) with orange (secondary), we get red-orange (tertiary); mixing red (primary) with violet (secondary), we get red-violet (tertiary). *See color wheel.*

a
B
c
D
e
F
G
H
I
J
K
L
m
n
o
P
Q
r
s
T
u
v
W
X
Y
Z

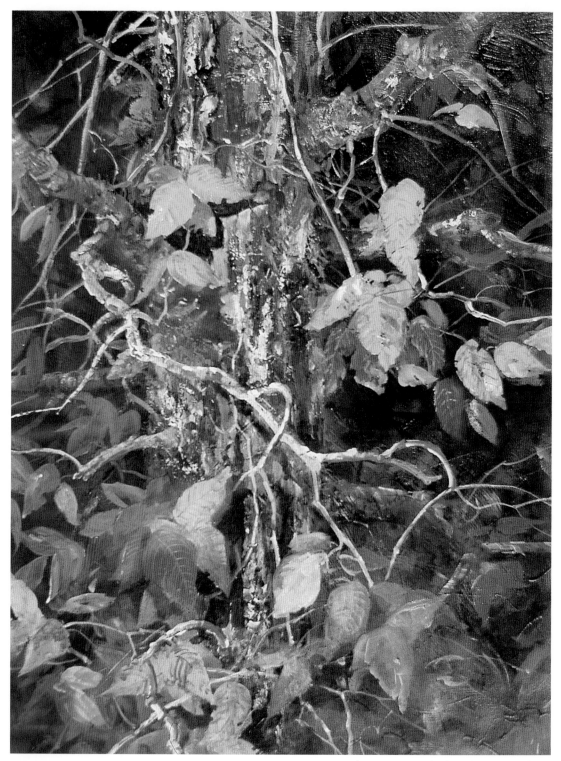

Texturing

In this painting the tree bark was textured by a combination of bro-
ken color (in shades of browns and blues) and glazing over white
paint.

WOODS TEXTURES | acrylic on canvas | 20″ × 16″ (51cm × 41cm)

texture medium

A fluid that may be added to paint, such as watercolor, to give the paint a grainy appearance. Such mediums contain some form of fine grit, which becomes dispersed throughout the paint with which it is mixed. Many artists simply add grit to their paints without using a prepared medium.

texturing

The use of various techniques to increase either the actual or the apparent texture of a surface. In sculpture, chisels and other tools can be used to score and pit a surface; in drawing, techniques such as hatching or crosshatching may be used; in printmaking, acid or caustic materials are sometimes used to "bite" a plate; and in painting, techniques such as drybrush may be used. Paint may also be textured by adding to it coarse ingredients such as marble dust or Carborundum.

Texturing

Douglas Wiltraut worked up this seemingly simple scene in many thin layers of translucent egg tempera. With great patience and a fine eye for design and color, he catches every nuance of texture. Notice the transparency within the shadow areas—those areas are by no means dull or opaque, but very much alive.

WHISKEY | Douglas Wiltraut | egg tempera on gessoed hardboard panel | 17″ × 24″ (43cm × 61cm). Collection of Mr. and Mrs. Michael Kasprenski.

The Eight

See Ashcan School.

The Ten

A group of ten American painters who exhibited together in New York City for twenty years, beginning in 1898, in order

Three-color drop
An example of three-color drop. *See more under aquatint.*

Kᴇᴡ Gᴀʀᴅᴇɴs | Shirley Tabler | aquatint | 9″ × 12″ (23cm × 30cm)

to try to get public attention for their work, attention they were unable to get through the large exhibitions such as those of the National Academy of Design. The members of the group were Childe Hassam, John Henry Twachtman, J. Alden Weir, Thomas Dewing, Joseph De Camp, Frank Benson, Willard Leroy Metcalf, Edmund Charles Tarbell, Robert Reid and E.E. Simmons. In 1902, Twachtman died and was replaced by William Merritt Chase.

thinner

Any fluid used to decrease the viscosity of another. In oil painting, turpentine and mineral spirits are common thinners; in watercolor, water is a thinner; in acrylics, water and acrylic mediums are thinners.

three-color drop

In aquatint printing, the use of a single plate, inked three separate times for three runs through the press. For each run, ink is applied only to the portions of the plate that are intended to be printed in that color. A contrasting method is to use separate plates, inking each one entirely with the appropriate color. *See aquatint.*

three-point perspective

Linear perspective in which, in addition to vanishing points on the eye level (horizon),

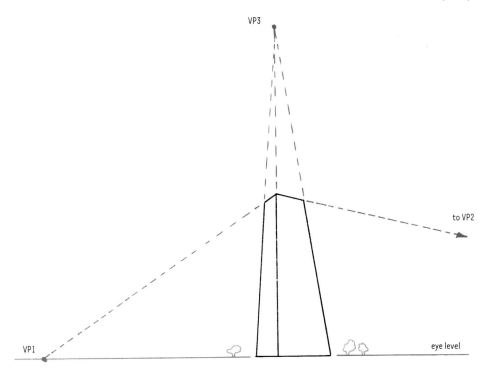

Three-point perspective

In most linear perspective drawing, short vertical lines are left vertical—they are not made to converge anywhere. But in the case of a very tall object, it may be necessary to take the verticals into account. If you were standing at the base of a skyscraper, for example, and looking up, you would notice that the vertical sides of the building seem to converge at a point high in the sky. Where they converge is called a vanishing point. There are two "normal" vanishing points at eye level, and this added one, not at eye level, is a third.

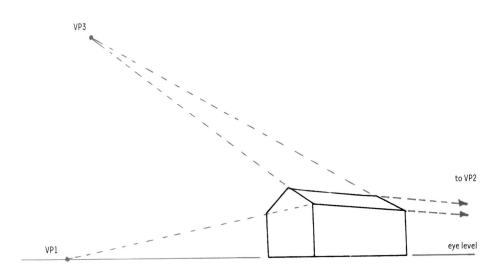

Three-point perspective

Any set of parallel lines slanted away from you will eventually "meet" somewhere at a vanishing point. The edges of a slanting roof, for example, should not be drawn as perfectly parallel (even though in fact they are); instead they should be angled slightly toward each other.

there is a third vanishing point above or below the eye level. *See linear perspective; bird's-eye view.*

thumb hole
A hole for the thumb in a handheld palette to allow a firm grip on the palette.

thumbnail sketch
A small, rough design for a picture, useful in solving problems such as placement of shapes, relative sizes of objects, color schemes and values. Thumbnails usually save time in the long run by giving the artist a "roadmap" to show him where he's headed.

tint
A lighter shade of a color. By either diluting a color with some medium or by mixing white paint with the color, an infinite number of tints of any color (except white) may be produced.

tinting strength
The ability of a color to affect other colors to which it is added. Colors such as Phthalocyanine Blue and Phthalocyanine Green, for example, have high tinting strengths—a small amount of either of them may dominate colors with which they are mixed. A measure of relative tinting strengths may be determined by mixing set amounts of various paints with a set amount of white paint and observing the influence each has on the white.

tissue, dry mounting
See dry-mounting tissue.

toile /twahl/ **or toile de Jouy** /twahl deh zhwee/
Eighteenth-century fabrics printed with a design. The fabrics were usually cotton or linen, sometimes silk, and the designs were originally printed using woodblocks

A Cuticle Story

By some accounts, the term thumbnail is attributed to painter William Hogarth, who once wanted to record a tavern scene. He had no paper, so he sketched the scene on his thumbnail!

but later using other methods. Typical designs included flowers, birds, peasants, historical figures, operatic characters, naval battles and balloons. Today, toile is made using the original two-hundred-year-old designs as well as new ones. The printed fabric is used for all sorts of interior decoration, including pillows, wall-hangings and coverings for tables, footstools and chairs. While most original toile was printed monochromatically, some used several colors. The name *toile de Jouy* comes from the name of a French town near Versailles where toile was originally made.

toile peinte /twahl *pahn*/ [French: fabric or cloth+paint]
A fabric on which a full-sized cartoon of a planned tapestry has been painted. Unlike paper cartoons, a toile peinte is a finished study that is intended also to be hung. This art form dates from sixteenth-century France. *See cartoon.*

tole
Metal, such as tinplate and pewter, decorated, often lavishly, with colored lacquers. Objects decorated include teapots, cups and jewelry boxes. *See japanning; lacquer.*

tone
1| A relative measure of a color's lightness or darkness; often called value. Because it's impossible for any set of pigments to fully represent the range of tones found in nature, from darkest to brightest, artists

a

b

c

d

e

f

a B C D e F G H I J K L m n o P Q r s **T** u v W X Y Z

Thumbnail sketch

Suppose you've found a farm scene you'd like to paint. There are many objects you could include but you decide on a barn, a fence and some trees. How do you arrange them effectively? You might start with a quick sketch (a) showing how things are actually arranged. The sketch has all the elements you want—barn, trees, sky and fence—but the barn is too big and the rest of the arrangement is not particularly exciting, so you try making the barn smaller and getting rid of a tree (b). The posts are lined up too neatly along the front of the picture, so relocate them (c). The tree and the barn seem too isolated and plain, so add a tree to connect the first tree and the barn and turn the barn to get a better shape (d). Now look at values. With the sunlight coming from the right the two barn sides are equally lit (e). Move the sun to the left (f). Now the end of the barn is in shadow, providing better value contrast. Also, the fencepost shadows now point into the picture instead of out of it.

resort to "tricks" to fool the eye—for example, placing very dark areas next to light areas to make the light areas seem even lighter or placing colors that enhance each other's visual impact next to one another. **2|** A tint or shade of color. *See value; color; simultaneous contrast.*

toned ground

A ground, or painting surface, that has been colored rather than left white, in preparation for painting on it. The color may be added by simply applying a thin coat of paint to the ground, or color may be mixed with the ground material (e.g., gesso) before it's spread on the support. *See lay-in; underpainting.*

toned paper

Paper that is colored other than white, including many pastel, charcoal and drawing papers.

tooth

The degree of roughness of a surface. A ground for most paintings needs some roughness to help hold the paint to the surface. Powdery mediums such as charcoal and pastel need relatively more tooth than fluid mediums. *See ground; Carborundum.*

torn paper

Paper ripped by hand, usually for one of two reasons. **1:** The torn, ragged edges are considered attractive by the artist, especially for use in collages. **2:** When hinging a work of art on paper to the back of a mat, torn paper, such as rice paper, is sometimes used as the hinge. Tearing the paper results in a thin, beveled, ragged edge that has less chance of making a discernible line or ridge that might be visible on the front surface of the artwork.

tortillon or tortillion /tore tee *ahn*/

A tightly wound cylinder of paper with a fairly sharp point at one end, used for rubbing, blending or smearing pastel, charcoal and other mediums, or for lifting fine lines from those mediums. *See illustration under stump.*

toxic

Poisonous. Some art materials are poisonous and should be either avoided entirely or used with great care. Paints containing cadmium or lead, for example, must never be ingested or otherwise absorbed into the body; turpentine, mineral spirits, glues and varnishes should not be inhaled or absorbed through the skin or ingested. Other materials, while not literally poisonous, are nonetheless potentially harmful—dusty materials such as pastels and charcoal, for example, can give rise to severe respiratory ailments if inhaled. *See health hazards.*

tracing paper

A thin, translucent paper used to copy or to test changes to a design over which it's placed. To be effective, tracing paper should be translucent or transparent and strong enough that a drawing instrument won't easily penetrate it and damage the design lying beneath it.

transfer

1| To copy a drawing from one support to another—for example, from a newsprint sketch to a sheet of watercolor paper or to a canvas. **2|** In restoration, to remove a paint film, sometimes including the ground, from one support and fasten it to another (a radical, rarely used form of restoration).

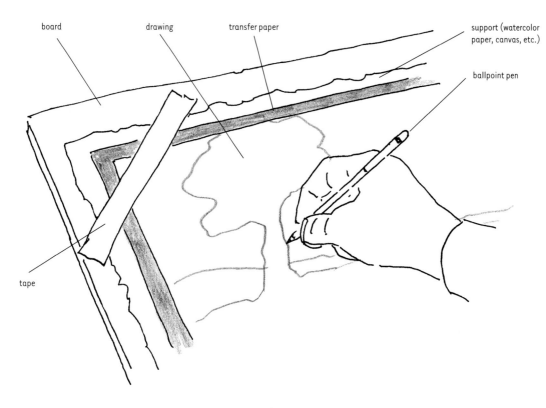

board drawing transfer paper support (watercolor paper, canvas, etc.)

ballpoint pen

tape

translucent

Clear enough to see through, but not perfectly clear, not transparent. Tracing papers and matte mediums are generally translucent.

transparent color

Color through which the underlying ground or other color layers may be seen—as opposed to body color, the color of opaque paint. In watercolor, for example, the white of the paper shows through the transparent paint and greatly affects the look of the painting.

trefoil

A three-lobed leaf pattern. *See foil.*

triad

A set of three colors equally spaced around a color wheel. Examples of triads: primary colors red, yellow and blue; secondary colors, orange, violet and green; tertiary colors red-orange, blue-violet and yellow-green; and tertiary colors yellow-orange, red-violet and blue-green. Many painters choose triads as their basic set of colors for a painting, letting two be dominant and the third be an accent. For a full treatment of triads, see Stephen Quiller's book, *Color Choices. See color wheel. See illustration on page 448.*

Transfer

To transfer a drawing to a canvas or paper support, insert transfer paper between the drawing and the support and trace with moderate pressure to get just a dark enough impression. A ballpoint pen is good for tracing because it lacks a sharp point that might cut through to the support; also, the ink from the pen serves to show where you have traced so far. For transfer paper, don't use ordinary office carbon paper—it's too dark and it produces a greasy image that may not be easy to hide if you're painting with thin paint, such as watercolor. Instead buy graphite transfer paper or prepare your own sheet by smearing one side of a sheet of paper with medium-soft graphite pencil.

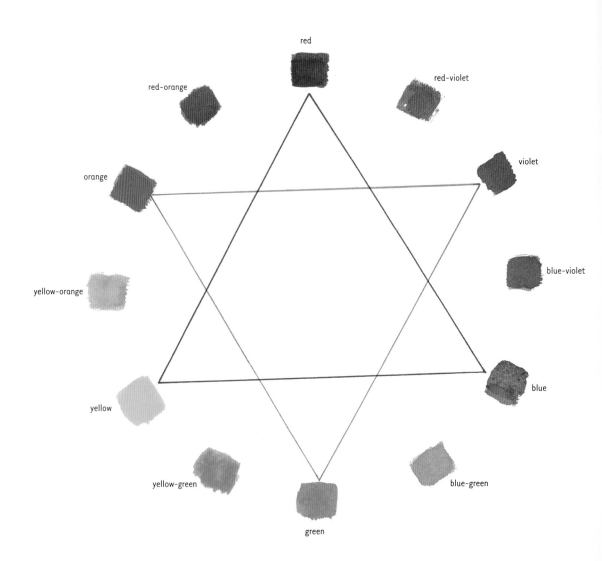

red

red-violet

red-orange

violet

orange

blue-violet

yellow-orange

blue

yellow

blue-green

yellow-green

green

Triad

A color wheel showing two triads, one involving the primary colors and the other, the secondary colors. Two more triads could be shown, linking two sets of tertiary colors. In a color wheel showing further color gradations, even more triads could be formed—for example, red-red-orange, yellow-yellow-green and blue-blue-violet. There is no limit to the number of triads, but as a practical matter only four are usually considered.

Triptych

Although many triptychs have had religious themes and are found in places of worship, this bold and beautiful painting is a thoroughly modern piece that can cheerfully hang anywhere! While some triptychs are divided in such a manner that the three sections may be placed a considerable distance apart, this one needs close placement because objects from one section continue into the next.

Strawberry Quartet | Tanya Davis | watercolor on Arches 555-lb. (640gsm) cold press | 54″ × 107″ (137cm × 272cm). Collection of Sarah Robertson, Cleveland, OH.

triptych /trip tik/

A work of art, usually a painting or carving, in three separate sections arranged side by side. Usually the three parts are made to fit together to suggest a single scene, but sometimes the three sections are separate scenes only related by a common theme.

trois crayons technique

The use of the three basic chalk colors—black, white and red—together. This use was popular in the eighteenth century and practiced by many artists, including Jean-Antoine Watteau.

trompe l'oeil technique /trahmp loeh/

A French term for a painting technique that "deceives the eye" by rendering objects with photographic realism; also called *Illusionism*. William Harnett (1848-1892) was one of its greatest early practitioners. Although this technique generally requires the same technical expertise as Photorealism, the two are not the same. In both cases, realism is a goal, but trompe l'oeil goes further, trying to fool the viewer

into thinking he is seeing something that's not really there. In the accompanying illustration, the viewer is led to believe he is seeing a still life in front of a painting, while, of course, the still life and "painting" are *both* parts of a single painting. *See illustration on page 450.*

true gesso

See gesso, true.

ts'un /(t)sun/

A Chinese painting technique of dabbed brush strokes, giving an illusion of texture to an object. There are many different

Trompe l'oeil

Ed Ahlstrom has painted a series of pictures like this one, in which we have the illusion of a real still life with a painting hanging behind it. Says Ahlstrom: "I love both still life and landscape painting and find in this series not only a means to paint them both at once, but also that combining them this way creates a mood neither would have alone. *Vacation* relates to the painting's mood of stillness and restfulness. But I was also thinking absence. A quite wonderful moment is passing and no one is there to see it."

VACATION | Ed Ahlstrom | oil on canvas | 60″ × 48″ (152cm × 122cm)

turning knob

jaws turn to
squeeze out paint

Tube wringer

Turpentine

Turpentine, along with metal cups often used to hold turpentine
and painting mediums. The cups clip onto a handheld palette.

accepted, fairly formalized strokes,
depending on the object being represent-
ed; a tree might demand one type of stroke
and a mountain another.

tube wringer
A small device used to squeeze the last bits
of paint from a tube.

Turpenoid
Brand name for an odorless solvent (miner-
al spirits) derived from petroleum, used as
a substitute for turpentine. *See mineral spir-
its; turpentine.*

turpentine
Familiar name for a popular solvent for oil
paints. More accurately, turpentine is a
thickish yellow-to-brown fluid obtained
from the sap of various plants, especially
certain pines in the southeastern United
States. When this raw turpentine is dis-

tilled, it separates into two products, oil of
turpentine (the liquid we generally call
turpentine; also sometimes called spirits
of turpentine or gum turpentine) and a
hard, dark resin called rosin. *See rosin; resin.*

turps
Turpentine.

tusche /toosh/
A liquid form of the greasy crayons used to
draw images on a lithographic plate.
Tusche is also used by some artists in serig-
raphy as a resist. *See print; lithograph;
silkscreen print.*

two-point perspective
Linear perspective in which objects are sit-
uated so that horizontal lines recede to
two different vanishing points. *See discus-
sion under linear perspective.*

U

ultraviolet light
Ultraviolet (UV) light is an invisible part of sunlight that causes deterioration of some materials, such as papers, and fading of some pigments. Paintings, prints, drawings and collages must be protected by keeping them out of direct sunlight or by using some method of screening the UV light from the artwork. Special UV glass and UV-inhibiting varnishes are effective (but not perfect) means of protecting art from UV damage. *See varnish; glass, framer's.*

underpainting
Any preliminary coat of paint that sets the stage for later coats. *See lay-in.*

unity
A design principle that says a work of art is psychologically satisfying only if there is a wholeness, a certain consistency, about it. A picture that is fractured into many unrelated colors, shapes, or other elements may lack unity. A common example of lack of unity is a landscape with no overall color dominance, or one in which the picture is divided among unrelated colors. One way to help achieve unity is to underpaint in a color that is allowed to show through subtly all over the finished picture. Another approach is to subtly repeat colors—add some of the sky's color to the foreground, for example, or repeat some of the foreground color in the sky. Other methods are to choose a family of colors that are compatible and to limit the number of colors used.

Unity involves more than color. Shape, size, texture, line, direction and value—the other design elements—must also be unified. Textural unity, for example, may be lost if textured areas of a picture are too divorced from untextured areas; shape unity may be missing if there is too much diversity in shapes without any one shape being dominant. Repetition of any design element aids unity. *See design.*

untempered hardboard
Hardboard is a stiff building material made by squeezing wood fibers together under heat and pressure. The untempered type is less dense, less hard and slightly less oily than the tempered variety. *See hardboard.*

UV
Ultraviolet. *See ultraviolet light.*

𝒱

value

The relative lightness or darkness of a color; tone; shade. Darker colors are said to have low value; lighter colors have high value. Strongly contrasting values, such as black and white, placed next to one another in a painting or drawing tend to arouse greater visual excitement than two values that are similar. *See color; tone. See illustrations on pages 453-455.*

vanishing point

A point at which receding lines meet in linear perspective. *See linear perspective.*

varnish

A fluid used to coat a work of art to enhance its fresh appearance and to protect it from dirt and damage. When using any varnish, it's vital to read its literature to make sure it's suitable for the work you

Value

When it comes to judging values, everything is relative. What you place next to an object can change the way the object appears. Here the little squares are all the same value, but they seem markedly different. The square at one end appears light because of the contrast with its dark surroundings, while the square at the other end seems dark because of the contrast with its light surroundings.

Value

Buzkij often uses women in surreal settings as a theme. This painting is a skillful arrangement of dark and light values that give the painting its punch.

IMPRESSION 77 | Borys Buzkij | oil on Masonite panel | 24″ × 36″ (61cm × 91cm)

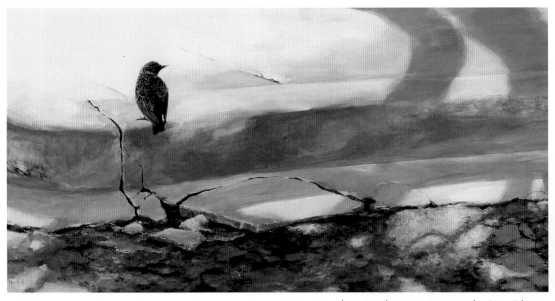

Value

Mae Rash skillfully arranges light and dark shapes throughout this painting for interest and impact. She makes the starling clearly the center of interest by using a number of devices, not the least of which is the placement of the starling's dark shape against a light background.

CURB SEATING | Mae Rash | acrylic on hardboard | 28″ × 60″ (71cm × 152cm)

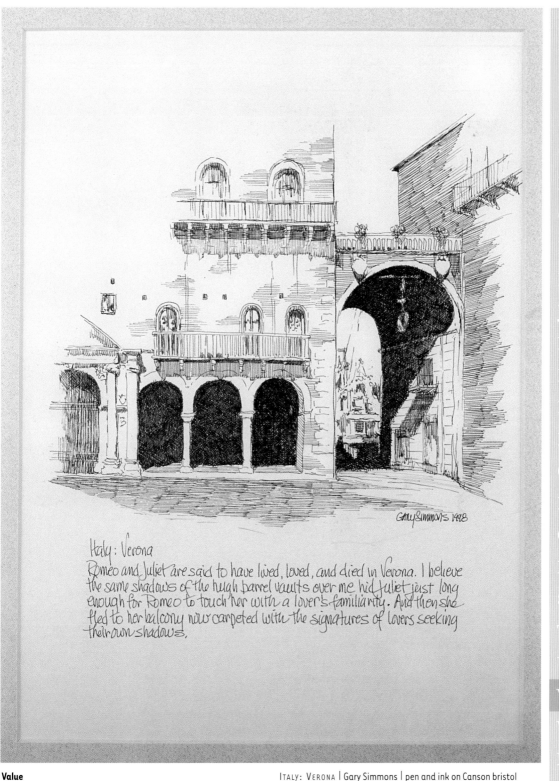

Italy: Verona

Romeo and Juliet are said to have lived, loved, and died in Verona. I believe the same shadows of the hugh barrel vaults over me hid Juliet just long enough for Romeo to touch her with a lover's familiarity. And then she fled to her balcony now carpeted with the signatures of lovers seeking their own shadows.

Value

In this drawing the contrast between the sunlit structures and the darkened arches enlivens the entire scene. For the darkened areas Simmons used solid blacks rather than his usual crosshatching.

ITALY: VERONA | Gary Simmons | pen and ink on Canson bristol board | 14″ × 12″ (36cm × 30cm)

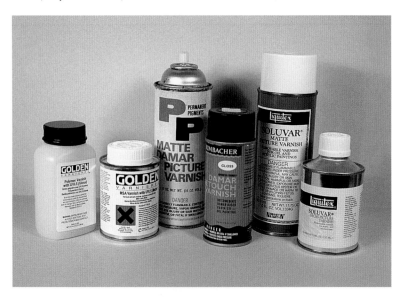

Varnish

There are dozens of varnishes available for various uses, both in spray and brush-on types. Before varnishing any picture, be sure to read labels and literature to be sure you use the appropriate product.

Varnish

Gamvar (pronounced Gammer) is a product of Gamblin Artists Colors. It was formulated based on research being done at The National Gallery of Art in Washington, D.C. and is suitable for oil, alkyd and acrylic paintings. This product is packaged along with helpful printed information about varnishes and varnishing.

wish to varnish. There are two main qualities to look for in a varnish. **1:** It should be removable without harming the underlying art. Varnish may need removing and replacing if over time dirt builds up on its surface, if it becomes scratched or otherwise damaged or if the painting needs some restoration. An excellent removable varnish is Gamvar (pronounced Gammer), sold by Gamblin Artists Colors. **2:** It should not yellow, crack or otherwise change its appearance over time.

Some varnishes contain materials designed to limit the effects of UV light on a painting, but they are of limited usefulness. *See ultraviolet light; acrylic varnish; retouch varnish.*

varnish, acrylic
See acrylic varnish.

varnish, final
See final varnish.

User Beware!

There is no perfect varnish, and there is no simple means of removing varnish—in fact, the removal depends entirely on the particular varnish in question. There are three pieces of advice to heed: (1) Always test a varnish or a varnish remover on samples that are very similar to the painting rather than on the painting itself. It's easily possible to ruin a fine painting because of inexperience with varnishing. (2) Read varnish labels carefully, but look beyond the labels: Find whatever literature is available and study it. For example, Liquitex (1-800-272-9652) offers a publication called *The Acrylic Book* which, among other things, describes its varnishes in much more detail than you'll find on the varnish containers. According to a technical expert at Liquitex, the vast majority of calls for help concern the use and removal of varnish. (3) If you're really in doubt and afraid of ruining a painting, consult a professional conservator.

Varsol

Brand name for a somewhat deodorized kerosene. Used as a cheap oil brush cleaner, it should be followed up with soap-and-water cleaning.

vault

An arched ceiling. Vaults were built in pre-Roman times, but the Romans greatly advanced design and construction methods. Two early basic designs were the *barrel* vault and the *cross-barrel* vault (*see illustration on page 458*). The barrel vault is essentially a semi-cylindrical structure (like a barrel sliced in two) resting on two parallel walls. Built of masonry, the barrel vaults are so heavy that they impose great loads on the walls on which they rest—not only downward forces, but outward forces as well, which means that the supporting walls must be very thick and strong. A partial solution is the cross-barrel vault, essentially two barrel vaults at right angles to one another. This type of vault exerts less force against the supporting walls and concentrates the force instead at the corners where the barrels join, so instead of super-thick walls larger piers are used at the corners. The cross-barrel vault is also commonly called the groin vault.

These two types of vaults were used from Roman times through the Romanesque period until Gothic architecture made at least two significant changes. First, the uniformly thick stone vaults were replaced by a framework of stone *ribs* on which thinner stones were laid, so that the total weight of the vault was decreased. Second, the usual thick, solid walls were replaced by thinner walls supported by exterior braces called *flying buttresses*. With the introduction of buttresses, walls could be thinner and no longer needed to be solid—they could accommodate windows to allow a great deal more light to enter the buildings. In churches and cathedrals many of these windows were done in stained glass. *See stained glass; Romanesque; Gothic. See illustration on page 458.*

vegetable oil

Oil derived from any plant matter. Common kitchen oils are canola oil (derived from rapeseed), olive oil, corn oil and peanut oil; the best known artistic oils are linseed (from flax seeds) and poppy, or poppyseed, oil (from the seeds of the poppy). Linseed oil and poppy oil are among those oils called *drying oils*—oils that "dry" to a tough film, which is what makes them useful as binders in oil paints. When these

cross-barrel, or groin, vault

barrel vault

oils dry, they don't do so through evaporation, like the water in watercolor paint, but by oxidation. *See oil paint; linseed oil; poppyseed oil.*

vehicle

Binder; a usually fluid material used to bind pigment particles together in a paint. *See binder.*

vellum

Originally, the fine-grained skin of a calf, kid or lamb used for writing or in bookbinding; now, drawing paper with a slight tooth. *See parchment.*

velvet

A densely woven fabric, such as silk, rayon or wool, having a short, soft, thick pile. Sometimes used as a painting support but subject to ridicule because so many paint-

Vault

Two common types of vaults. The barrel vault is essentially a semicircular arch in three dimensions and it can be made as long as necessary. It requires strong supporting walls. The cross-barrel, or groin, vault requires somewhat less wall support, but it needs strong support at the four intersections where the two barrels join. In the cross-barrel vault, sometimes the two crossing barrels are not the same height; some authorities reserve the use of the name *groin* vault for only those cross-barrel vaults in which both vaults are the same height.

ings on velvet have been overly sweet or sentimental.

veneer

1| A thin layer of wood glued to another surface. Ordinarily, the veneer wood is an attractive and expensive variety, while the base to which it is applied is a less expensive wood or other material. Some veneers

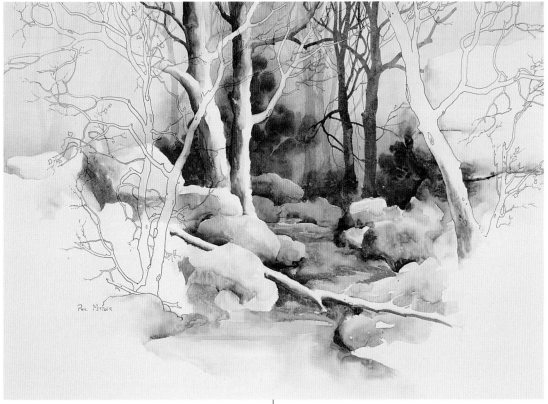

PHIL METZGER

See illustration under framing a scene.

are as thin as a sheet of paper; they are sliced from rotating logs in a continuous sheet. Small pieces of veneer glued to form a pattern are a form of marquetry. *See marquetry.* 2| An outer coating over a surface, such as brick veneer on the face of a wooden house.

Verilux
A brand of lighting that includes fluorescent lights color-balanced to closely approximate natural outdoor lighting.

viewfinder
1| The opening in a camera through which a scene is observed. 2| Any device, such as a piece of cardboard with a hole, through which you can look to select a scene to draw or paint. The viewfinder acts as a sort of frame to help you look at one

Vignette
This vignette is oriented around the center of the page; many others are less symmetrical.

WOODS STREAM | watercolor and ink line on Arches 140-lb. (300gsm) hot-press paper | 22″ × 30″ (56cm × 76cm)

area at a time and decide where to focus your attention. A 35mm slide mount makes a handy viewfinder. *See illustration under framing a scene.*

vignette /vin *yet*/
A picture that bleeds off gradually toward the edges. Some vignettes are designed symmetrically as circles, ovals or squares, fading evenly toward all edges. Others are designed asymmetrically, fading unevenly and touching edges of the page or support at different locations.

vine charcoal

Charcoal made by heating certain woody vines in the absence of air. *See charcoal.*

Vorticism

An English art movement about 1912-1915 that has been called the English version of Cubism. It was founded by Percy Wyndham Lewis, a writer and an experimenter in abstract art forms. Vorticists painted themes involving modern machinery and industry.

vp

See vanishing point.

warm color

Color at the long-wavelength end of the spectrum (e.g., red and yellow). *See illustration under spectrum, electromagnetic.*

warp threads

Threads or yarns extending the length of a cloth made on a weaving loom; the crossing perpendicular threads are called the

Warm color

An excellent example of a painting done in overall warm tones, relieved by the contrasting patches of cool color in the plums, on the highlighted leaf and in the sky area at the upper right in the picture-within-a-picture.

PASSING THOUGHT | Ed Ahlstrom | oil on canvas 10″ × 12″ (25cm × 30cm). Collection of Michael and Victoria Findlay.

Comparing Water-Based Paints

Paint	Waterproof When Dry?	Transparent/Translucent/ Opaque In Normal Usage	Paint Film
Acrylic	yes	transparent or opaque	either thin or thick; tough, flexible
Acrylic Gouache	yes	opaque	either thin or thick; moderately flexible
Casein	no	opaque	brittle, cannot be built up too thick
Egg Tempera	no	translucent	somewhat brittle, cannot be built up too thick
Gouache	no	opaque	brittle, cannot be built up too thick
Watercolor	no	transparent	no appreciable thickness

weft. By varying the relationships between warp and weft threads, fabrics of differing textures can be made—for example, taffeta or poplin cloths are made using weft threads of different thickness from the warp threads. Artists' canvases are usually woven straightforwardly, with equal numbers and weights of warp and weft threads. *See weaving; loom.*

warping
Twisting or unevenness in a surface that is normally flat. When using water-based paints on stiff surfaces such as hardboards, illustration boards and watercolor boards, it's common for the board to bow convexly (upward) toward the wet side. That's because the fibers on the wet side expand while the fibers on the dry side do not. The remedy is usually to wet both sides more or less equally to begin with. If a board still has a bulge after drying, turn it over and wet the concave side evenly until the bulge gradually disappears. If the painting is on the concave side, you can still wet it, but take sensible precautions not to disturb the painting—for a watercolor, for instance, use a sprayer rather than a brush or sponge. Bear in mind, though, that spraying, even with plain water, can leave faint spottiness on the picture. *See cockling; cradling.*

wash
A thin, fluid, relatively transparent coat of paint or ink over any size area, but usually over broad areas.

waste mold
A mold used in the making of a casting that is destroyed during the process.

water-based paints compared
Above are some similarities and differences among various types of water-based paints (all are fast-drying and all have negligible health risks, provided nontoxic colors are chosen).

watercolor

1| Paint consisting of pigment and a binder of gum arabic, along with other materials: glycerin to improve moistness and brushability and to prevent excessive caking; sugars and wetting agents to improve the paint's smoothness; a preservative; and water. Watercolor these days is usually applied in thin, transparent layers on white paper—when used in this fashion, it's sometimes called by the French term "aquarelle." Earlier watercolors (by Sargent, Turner and Homer) included plenty of opaque passages. Watercolor paint dries by evaporation of the water rather than by chemical change. Once dry, the paint can be made fluid again by reintroducing water. The binder (gum arabic) serves more to attach particles of pigment to the painting surface than to form a continuous paint film—there really is no appreciable film. Because of the thinness of a watercolor paint layer, the painting surface, usually paper, shows through. *See also stretching paper; cockling; soaking tray.*

2| The term is sometimes loosely (and confusingly) used to mean any paint in which water is an ingredient or that uses water for thinning or cleaning up. Better terms for this usage are *water-based* or *watermedia*. *See illustrations on pages 463-464.*

Watercolor

This watercolor was painted on a dry surface, wetting only a section at a time as the painting progressed. This is the usual approach when the desired result is a combination of hard edges along with some soft passages.

FRONT END PARKING | Margaret Graham Kranking | watercolor on Arches 140-lb. (300gsm) cold press | 22″ × 30″ (56cm × 76cm). Collection of Dr. and Mrs. Henry Metzger.

Watercolor

An example of a wet-in-wet painting. The painting was begun with the paper surface uniformly wet. Porter quickly laid in large areas of fluid color and allowed them to run together, tilting the board to influence the running. Near the end of the painting session she added details on relatively dry paper.

Deep Blue | Shirley Porter | watercolor on Strathmore illustration board | 22″ × 30″ (56cm × 72cm)

watercolor block

A stack of watercolor papers firmly glued together around all four edges, except for a small area that is left unglued so that a blade may be inserted for the purpose of separating a sheet from the rest of the block. Blocks come in a variety of sizes, including 7″ × 10″ (18cm × 25cm), 14″ × 20″ (35cm × 51cm) and 18″ × 24″ (46cm × 61cm) and in cold-press, hot-press and rough surfaces. All the sheets in a given block have the same surface. Blocks are handy for painting or sketching in the field, since they are compact and require no painting board, clamps, tape, etc. They are best for painting relatively dry; if made too wet, the paper, because it's fastened around the edges, has no way to expand laterally, so it expands vertically instead, forming hills and valleys. *See cockling. See illustration on page 465.*

watercolor board

Watercolor paper glued to a stiff backing of cardboard. When looking for an appropriate watercolor board for your work consider these qualities: **1:** The surface texture—usually available in rough, cold press and hot press; **2:** the rag content and acidity rating of the paper surface; **3:** the rag content and acidity of the backing, or core; **4:** the overall thickness of the board; and **5:** the absorbency of the paper surface. A typical board may have a cold-

Watercolor block
Separating the top sheet from a block of watercolor papers.

press, acid-free surface paper mounted on a core that is not acid free. By paying more you can get boards that have acid-free cores and will last indefinitely. To put things in perspective, a board with an acid-free surface but nonacid-free core will probably last at least a generation before acid from the core causes much deterioration of the surface.

watercolor paint

Watercolor is packaged in three forms: tubes (pastelike), bottles (liquid) and pans or cakes (solid).

Tubes—Tube paint is moist and spreadable and is the most popular form sold. Manufacturers offer several tube sizes, commonly 5 ml (0.17 fluid ounces) and 14 ml (0.47 fluid ounces), and sometimes jumbo 37 ml (1.25 fluid ounces). Paint bought in the larger tubes is more economical than in the small tubes.

Pans or cakes—Paints come either already poured and hardened in little wells ("pans") or in individually wrapped cakes that you may insert into pans. Although many artists prefer tube paints—no scrub-

bing around to loosen the paint you need—pans and cakes have a real advantage if you want to do small paintings as you travel. They're compact and lightweight and the boxes that hold them usually have a lid that serves as a mixing palette. Some pans and cakes are more densely pigmented than tube colors—that is, there's more color in one of them than there is in an equal volume of tube paint—so a small pan or cake will go a long way.

Ready-poured pans come in sets containing as few as six and as many as two dozen colors. Individual cakes are commonly sold in "half-pan" size, about 0.5″ × 0.6″ × 0.25″ thick (1.3cm × 1.5cm × 0.6cm). Watercolor boxes to hold the cakes have wells for either half-pans or full-pans or both. If you normally use tube colors, you can make your own lightweight box of "pan" colors for travel. Simply buy an empty watercolor box, squeeze tube color into the wells and let it harden. Or do the same with your regular watercolor palette if it's small enough to pack.

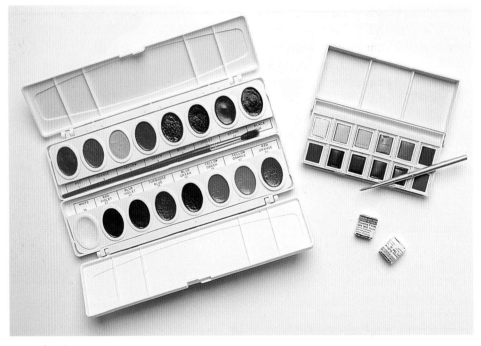

Watercolor paint
Pans and cakes are hard, so you must moisten them and
scrub loose some paint.

Watercolor paint
Liquid watercolors are appropriate when you want totally
fluid, brilliant, transparent paint.

Watercolor paint
Tube paints have a buttery consistency and are ready to use.

Bottles—Some brands of watercolor, such as Dr. Ph. Martin's Hydrus, are sold in liquid form. If you're dealing with straight liquid washes (or are using an airbrush or pen), liquid paints are a good choice. If you want to include some thickish, grainy passages, you'll have to add some white or other tube color to the liquid paint—adding white, however, will change the shade of your color. Use liquid watercolors when you want totally fluid, brilliant, transparent paint.

watercolor paper

Paper made specifically with watercolor painting in mind. Paper thicknesses are expressed in "pounds" or in grams per square meter. The best papers are 100% rag and acid free.

Watercolorists have an assortment of papers from which to choose. The attributes an artist may consider include: **1:** Surface texture—rough (significant texture), cold press (moderate texture) and hot press (smooth). Textures differ among brands; one company's rough, for example, may be similar to another company's cold press. **2:** Whiteness—some papers are snowy white, while others have an ivory tone. **3:** Rag content—the best papers are 100% rag; others are partially rag or have no rag content at all. **4:** Thickness or weight—heavier papers take more abuse and lie flatter than others. **5:** Absorbency—some papers have a hard surface, so that paint tends to puddle on the surface; others are more blotterlike and absorb paint quickly. **6:** Surface toughness—some papers, such as Arches and Fabriano Uno, take lots of "abuse" (such as erasing and scraping), while others, such as Lanaquarelle, are more delicate. *See pound; gm/m², papermaking; acid free; rag.*

watercolor pencil

A colored pencil whose marks are soluble in water. Strokes may be softened with a brush and water so that in a given picture there may be a combination of sharp and fuzzy marks as well as washes. Unless you find a watercolor pencil with a suitable lightfastness rating (such as ASTM LFI or LFII), do not assume it is suitable for permanent work. *See illustration on page 468.*

watermedia

Paints that have water as an ingredient and that may be thinned and cleaned up with water. Watercolor, gouache, casein, acrylic and egg tempera are watermedia. It may be argued that water-miscible oil paints, which can indeed be thinned and cleaned up with water, should be included, but those paints are oil-based and are not made with water as an ingredient, so they are not considered watermedia.

water-miscible oil paint

Oil paint specially formulated (chemically altered) to accept plain water as a solvent. Since the late 1900s these paints have become available in a growing range of col-

Other Painting Surfaces

Watercolor (as well as other mediums) may be painted on surfaces other than true paper. Some watercolors are painted on canvas or on clay-coated hardboard. There is a synthetic paper called Yupo that is acid free, lightweight, nonabsorbent and tough. Although not intended for artists' use, some watercolorists like the fact that this "paper" does not absorb paint; the paint sits on the surface where it may be easily manipulated. It's like a slick hot-press surface, but colors don't stain this material and all colors may be easily lifted. The product is made by the Yupo Corporation in Chesapeake, Virginia.

Watercolor pencil

ors. Brands include MAX (Grumbacher), Duo AquaOil Color, H$_2$Oil (Van Gogh) and Artisan (Winsor & Newton). Although traditional solvents—turpentine, mineral spirits or citrus—work fine with these paints, there is no need for them. These paints enjoy the advantage that soap and water can be used to clean brushes; thinning may be done using traditional oil mediums or water; however, very thin mixtures, such as glazes, should be made using traditional mediums, not water. Water-miscible paints have roughly the drying times of regular oils. These paints are too new to know for sure whether their films are as satisfactory as those of oils, but manufacturers' test results have been positive. Water-miscible paints can be mixed with regular oil paints in as high a ratio as two parts water-miscible to one part oil and still be cleaned up with water. Beyond that ratio the mix becomes less water-friendly.

wax

Any of a range of hard, but pliable, substances derived from animal, plant or mineral sources, used in many commercial and artistic processes. Waxes in some ways resemble fats, but they are denser and are made up of heavier molecules. Commercially, some waxes are obtained from the leaves of various plants, including carnauba wax from a Brazilian palm tree and sugarcane wax. Others, such as paraffin, are derived from petroleum. Probably the most important wax for artists' use is beeswax, used in etching grounds, encaustic painting, batik and some varnishes. *See batik; etching; ground; encaustic paint.*

wax bloom

A whitish haze that sometimes forms on a colored pencil picture. The term may be a misnomer, since it's not clear to conservators that it's actually wax that causes the haze. If you use the colored pencil with light pressure, there may be little or no haze—it's most noticeable when dark colors are applied heavily. Wax bloom may not occur right away, perhaps not until the next day. To get rid of the bloom, gently polish the area with a *soft* cotton cloth or tissue. When finished with the picture, a light spray coating of fixative will prevent the bloom from returning.

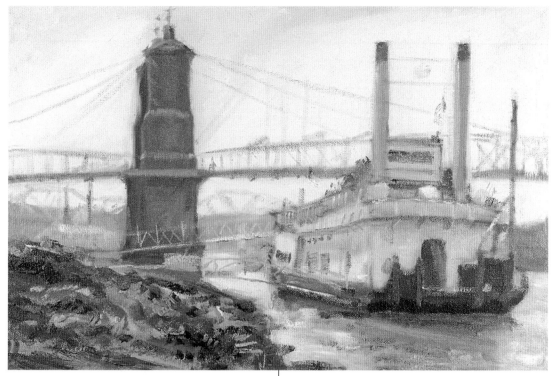

wax emulsion

In tempera painting, the use of melted wax as an ingredient in the painting medium; not commonly used in modern practice.

wax pastel

A pastel having a firm, waxy texture, similar in feel to children's crayons but soluble in water. Wax pastel strokes may be thinned and mixed by brushing with water. Those available so far (e.g., Caran d'Ache "Neoart Aquarelles") are advertised as having "excellent lightfastness" but, because they carry no ASTM lightfastness ratings, it would be inadvisable to use them for permanent artwork.

wax resist

In batik, and sometimes in serigraphy, the use of a wax coating to block out areas not to receive ink or paint. In watercolor, the use of wax as a mask to prevent paint from getting onto an area. Most paints, particularly water-based paints, do not adhere to wax.

Water-miscible oil paint

This is one of Greg Albert's favorite scenes, the Roebling 1856 suspension bridge over the Ohio River near Cincinnati, a bridge William Least Heat-Moon, in *River Horse*, calls "the noblest on the Ohio." Albert likes the convenience of working on site and taking along a jug of water that he can dump when he's finished without harming the environment. No way to do that with turpentine!

DOWN BY THE RIVER | Greg Albert | water-miscible oil paint on canvas | 12″ × 18″ (30cm × 46cm)

weaving

Producing cloth by interlacing strands of thread or yarn. The apparatus on which the threads are woven is called a *loom*. In basic weaving, one set of parallel threads (called the warp threads) runs in one direction on the loom and the second set (called the weft or filling threads) runs in a perpendicular direction. The warp threads

Comparing White Pigments

	Titanium Dioxide	Basic Lead Carbonate	Zinc Oxide
Toxicity	None	High	None
Opacity	Very High	High	Low
Film	More brittle than lead carbonate	Tough, flexible	More brittle than lead carbonate
Drying	Slow	Fast	Slow

form the base; the weft threads pass over and under the warp. By varying the thicknesses of the threads, their colors, spacing, and so on, cloths of many different characters may be produced. In some cloths, the numbers of warp and weft threads are the same; in others, there are more warp threads than weft, or vice versa. In most artists' canvases, the numbers of warp and weft threads are equal and the threads used in both directions are identical. *See loom; canvas.*

weft threads
The threads running across the width of a woven cloth. *See warp threads; weaving; loom.*

wet-in-wet
A painting technique in which paint is applied to an already wet surface. Although usually applied to watercolor painting, the term is also used in other media. Painting oils over freshly painted (not yet dried) oils is often described as wet-in-wet painting, even though the "wet" in this case has nothing to do with water. *See watercolor.*

wetting agent
A substance used to make a surface more receptive to a liquid. In watercolor, for example, ox gall may be added to the paint to help it spread on the paper rather than forming droplets, or beads. The wetting agent breaks down the paint's viscosity and surface tension enough to allow the paint to "crawl" along the painting surface rather than gathering into pools.

white charcoal
See charcoal, white.

white lead
Basic lead carbonate, the pigment used in Flake White and White Lead oil paints. Very toxic. *See white pigments; health hazards.*

white-line print
A print in which the image consists of white lines on a black background. In relief printing, such as linoleum cuts, woodcuts and wood engravings, the usual method of preparing the printing block is to cut away the broad areas that are to be the background of the print—those cut-away areas receive no ink, so they show as white in the print. But if the carving is reversed—that is, if the background areas are left in relief and the image areas are cut away—then the background areas become inked and the background prints as black while the image lines remain white.

white pigments
There are three primary white pigments used in artists' paints. Zinc oxide is the white in Chinese White and Permanent

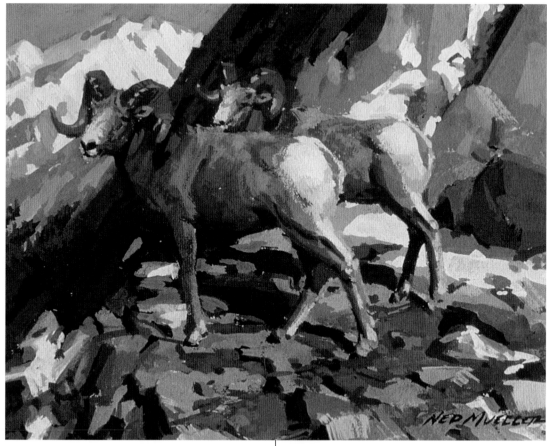

Wildlife art

BIG HORNS | Ned Mueller | gouache on Crescent cold-press illustration board | 7″ × 9½″ (18cm × 24cm)

White; basic lead carbonate is the white in Flake White or White Lead; and titanium dioxide is used in Titanium White. Above left is how they compare when used in oil paints.

whiting

Finely ground, relatively pure natural calcium carbonate (chalk) used as a substitute for gypsum in making a variant of true gesso. It's also an ingredient in many commercial products, including some ceramics, cosmetics, plastics and paints. When mixed with oil, it's the common plastic substance called *window putty*.

wildlife art

Any picture or sculpture representing non-domesticated animals. As a painting genre, wildlife—especially in the United States—has become a popular subject with both artists and the public. Because they appear in such a great variety of colors, shapes and textures and in such diverse surroundings, animals present the artist with an intriguing array of possibilities for expression. *See illustrations on pages 471-474.*

willow charcoal

Charcoal made by heating willow twigs in the absence of air. *See charcoal.*

window tracing

Drawing a scene viewed through a window or other transparent surface. By drawing

a b c D e F G H I J K L m n o P Q r s T u V W X Y Z

2/50 BEASTLY TAXI MBROWN

Wildlife art

BEASTLY TAXI | Michael David Brown | pen-and-ink and watercolor on paper | 6½″ × 9½″ (16cm × 24cm). Edition of 50 hand-colored reproductions.

Wildlife art

SACK LUNCH | Mae Rash | acrylic | 32″ × 32″ (81cm × 81cm)

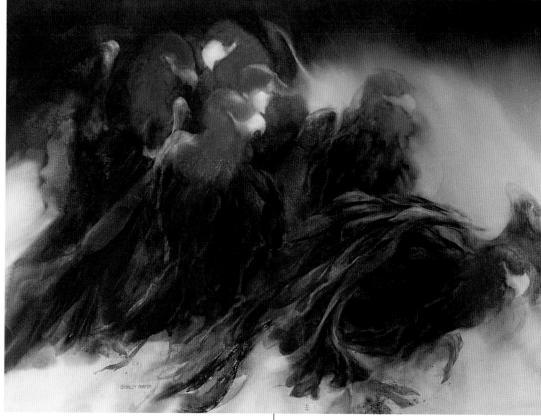

Wildlife art

MIDNIGHT CHOIR | Shirley Porter | watercolor on illustration board | 30″ × 40″ (76cm × 102cm). Collection of James Patrick, Atlanta, GA.

with grease pencil or other removable material on a sheet of glass (or Plexiglas or acetate), it's easy to make an accurate drawing of what you see beyond the glass. Similar to copying a picture using an overlay of tracing paper, this is a useful method of learning to draw. Leonardo da Vinci (who apparently thought of everything before anyone else) wrote: "Perspective is nothing else than the seeing of an object through a sheet of glass, on the surface of which may be marked all the things that are behind the glass."

wood engraving

A form of woodcut using the end grain—that is, a cross-section—of a slab of hardwood, such as cherry. Use of the dense end grain allows the cutting of very fine lines with engravers' tools. By cutting fine lines close together it's possible to produce prints that simulate smooth gradations in tone. Wood engravings were once used extensively for magazine and book illustrations. Prints are pulled in the same manner as woodcuts, but a stiffer ink is used so that it will not flow into the fine cuts. *See woodcut; white-line print. See illustrations on page 475.*

wood panel

Any slab of wood used as a painting support. *See panel.*

Wildlife art

MORNING MEADOW | Shirley Porter | acrylic on illustration board | 24″ × 30″ (61cm × 76cm)

wood pulp

A soupy mix of cellulose fibers, water and various chemicals. The pulp is run through a variety of machines where it is formed into thin sheets for use as paper, cardboard, etc.—it's also the raw material for making rayon fabric. Unless further treated, wood pulp is acidic and unsuitable for use in permanent artistic work. *See paper; papermaking; acid free.*

wood sculpture

See sculpture, wood.

woodcut

A print made by carving away the wood around the image area on a block of wood. The remaining raised image area is inked and pressed to a sheet of paper or other material, producing an image the reverse of that on the block. Fine-grained boards of woods such as pine and cherry are commonly used in preference to harder woods. The artist draws or paints an image on the wood's surface and then cuts away the excess wood, leaving only the image in relief. Sometimes the wood's smooth surface is first coated with shellac to help facilitate the cutting of sharp, clean lines. Some artists use softer woods with prominent grain patterns so that the imprint of the grain becomes part of the print— Edvard Munch liked this method. In modern usage, all sorts of chisels and gouges

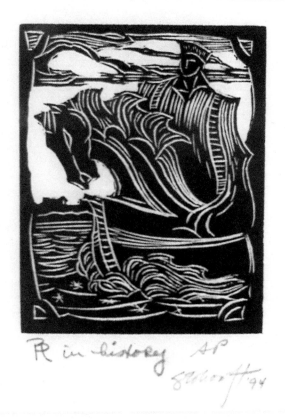

Wood engraving

THE BLUE RIDER IN HISTORY | Peter Stoliaroff | wood engraving | 3¹/₄″ × 2³/₄″ (8cm × 7cm)

Wood engraving

This is the block from which Stoliaroff's print was made. The wood is cherry, chosen for its fine, dense grain.

Woodcut

Self-Portrait | Shirley
Porter | woodcut | 24″ ×
8″ (61cm × 30cm)

are used to cut the wood's surface in whatever ways the artist deems suitable. A roller is used to distribute ink evenly over the raised surface of the block, and then an image is formed by pressing paper over the block with even pressure, either using a press or hand-rubbing with almost any tool, such as the bowl of a spoon, that distributes pressure evenly. Relatively thick ink is used to prevent its flowing into the recesses of the block. Japanese rice papers work well for printing because they accept ink without heavy pressure.

The earliest known woodcuts date from the fifth century AD in China. The technique, which is widely believed to have been brought to the West by Marco Polo, was used by artists as diverse as Albrecht Dürer, Paul Gauguin and Rockwell Kent in the West and Hokusai and Hiroshige in Japan. One of the best known examples of Japanese woodcuts is Hokusai's color print called *The Breaking Wave Off Kanagawa*. That print is an example of the Japanese art genre called ukiyo-e, a style that drew on themes from everyday life, in contrast to the more rigid, formal art that preceded it. *See wood engraving.See illustration on page 476.*

worm's-eye view

A view of a scene with a very low horizon, or eye level. *See perspective.*

wove paper

Paper that has no prominent texture. Wove paper is made by spreading pulp over a screen that has a uniform makeup, similar to the screens in a home's windows but much finer. When held up to the light, wove paper looks either smooth, with no texture at all, or very finely, uniformly textured. Compare to *laid* paper, which has prominent texture. *See laid paper; papermaking.*

X

X-Acto knife
A brand of craft knife that has many interchangeable blades of varying shapes and sizes; useful for cutting masks and for fine carving in wood.

xerography
Reproducing an image on an ordinary office copying machine. Full-color copying machines can produce reproductions of excellent color quality. The drawbacks are: 1: Current copy machines are limited as to the sizes and grades of papers they can handle and 2: the inks used may not be as lightfast as the colorants used in the artwork being copied. As inks become more reliable, this method of making art reproductions will become more accepted, provided more permanent papers are also used. Also called *photocopying*.

yellowing, paint

Gradual darkening of oil paint, often with a yellow cast, for a variety of reasons: **1**: Too much oil, or inferior grades of oil, in the paint; **2**: use of too much oil-containing painting medium; **3**: gradual accumulation of dirt on the painting's surface; and **4**: use of copal resin in mediums. In addition, an oil painting allowed to dry in a dark place or in a very humid atmosphere may darken—it should receive a normal amount of indirect light in a nonhumid atmosphere while drying. According to conservators, any oil paint, no matter how well it is made, will yellow slightly with age.

yellowing, paper

Gradual darkening of paper with a turn toward a yellowish or brownish color due to acidic content, exposure to acidic environments or long exposure to light. Yellowing is especially noticeable in papers made from wood pulp, which are normally acidic. Acid-free art papers that are kept away from acidic environments are virtually free of the danger of yellowing. *See pH; acid free.*

Z

zinc plate
A flat sheet of zinc used in making many types of prints, such as etchings and engravings.

Zinc White
White paint whose pigment is zinc oxide. This pigment appears in many mediums, including oils, alkyds, acrylics and water-colors—it's the white in Chinese White and Permanent White. As a substitute for Flake White (basic lead carbonate) in oil paints, Zinc White is nontoxic but considerably less opaque and cooler than Flake White.

Resources

Books by Individual Authors

Bays, Jill. *Drawing Workbook*. David & Charles, 1998.

Brown, Michael and Phil Metzger. *Realistic Collage*. North Light Books, Cincinnati, OH, 1998.

Calle, Paul. *The Pencil*. Watson-Guptill Publications, New York, 1974.

Clemson, Katie and Rosemary Simmons. *The Complete Manual of Relief Printing*. Alfred Knopf, New York, 1988.

Elsworth, Anne. *Watercolour Workbook*. David & Charles, 1997

Feldman, Edmund Burke. *Varieties of Visual Experience*. Prentice-Hall, Inc., Englewood Cliffs, N.J., [no date given].

Gardner, Helen. *Art Through the Ages*. (Revised by Horst de la Croix and Richard G. Tansey). Harcourt, Brace & World, Inc., New York, 1970.

Graves, Maitland. *The Art of Color and Design*. McGraw-Hill Book Company, New York, 1951.

Heller, Jules. *Papermaking*. Watson-Guptill Publications, NY, 1978.

Hope, Augustine and M. Walsh. van Nostrand, NY 1992.

Hults, Linda C. *The Print in the Western World: An Introductory History*. The University of Wisconsin Press, Madison, WI, 1996.

McCann, Michael. *Artist Beware*. Lyons & Burford Publishers, NY, 1992.

McGuire, Barbara A. *Foundations in Polymer Clay Design*. Krause Publications, Iola, WI, 1999.

McMillan, Dotty. *The Many Moods of Polymer Clay*. Sterling Press, 2001 [no city given].

Metzger, Phil. *Enliven Your Paintings with Light*. North Light Books, Cincinnati, OH, 1993.

Metzger, Phil. *The North Light Artist's Guide to Materials & Techniques*. North Light Books, Cincinnati, OH, 1996.

Metzger, Phil. *Perspective Without Pain*. North Light Books, Cincinnati, OH, 1988.

Metzger, Phil. *Perspective Secrets*. North Light Books, Cincinnati, OH, 1999.

Porter, Shirley. *Drawing and Painting Birds*. North Light Books, Cincinnati, OH, 2000.

Quiller, Stephen. *Color Choices*. Watson-Guptill Publications, New York, 1989.

Rodwell, Jenny. *Acrylic Workbook*. David & Charles, 1998.

Ross, John, Clare Romano and Tim Ross. *The Complete Printmaker*. Macmillan, Inc., New York, 1990.

Simmonds, Jackie. *Pastel Workbook*. David & Charles, 1999.

Simmons, Gary. *The Technical Pen*. Watson-Guptill Publications, NY, 1992.

Sloan, John. *Gist of Art: Principles and Practise Expounded in the Classroom and Studio*. Dover Publications, New York, 1977.

Smith, Stan. *Oil Painting Workbook*. David & Charles, 1999.

Spann, Susanna. *Painting Crystal and Flowers in Watercolor*. North Light Books, Cincinnati, OH, 2001.

Steiner, Raymond J. *The Art Students League of New York: A History*. CSS Publications, Mt. Marion, NY, 1999.

Tennant, Daniel K. *Photorealistic Painting* (to be re-released as *Realistic Painting*). Walter

Foster Publishing, Inc., Laguna Hills, CA, 1996.

Vickrey, Robert. *New Techniques in Egg Tempera.* Watson-Guptill Publications, New York, 1973.

Whitney, Edgar. *Complete Guide to Watercolor Painting.* Watson-Guptill Publications, New York, 1969.

Wilcox, Michael. *The Wilcox Guide to the Best Watercolor Paints.* Colour School Publications, London, England, 1995.

Williams, Virginia and Nita Leland. *Creative Collage Techniques.* North Light Books, Cincinnati, OH, 1992.

Publications

In the USA:

Art Times, published monthly, includes editorials, reviews, artist profiles and art criticism: PO Box 730, Mt. Marion, NY 12456-0730.

American Artist magazine, published monthly, includes technical information and articles on the visual arts: BPI Communications, Inc., 1515 Broadway, New York, NY 10036.

International Artist magazine, published bimonthly, includes technical information and articles on the visual arts: U.S. office is Publisher's Creative Systems, 2060 Wineridge Place, Escondido, CA 92029. UK office is PO Box 4316, Braintree, Essex, CM7 4QZ.

The Artist's Magazine, published monthly, includes technical information and articles on the visual arts: F&W Publications, 1507 Dana Avenue, Cincinnati, OH, 45207.

In the UK:

The Artist, published monthly, includes practical art tuition, reviews, artist profiles and art criticism: Caxton House, 63-65 High Street, Tenterden, TN30 6BD.

Leisure Painter, published monthly, includes practical instruction in all media from professional artists as well as reviews and artist profiles: Caxton House, 63-65 High Street, Tenterden, TN30 6BD.

Artists and Illustrators, published monthly, includes editorials, reviews, artist profiles and art criticism: Fitzpatrick Building, 188-194 York Way, London N7 9QR.

General Reference Books

Time-Life Library of Art. Time, Inc., New York, 1970.

The Random House Encyclopedia. Random House, New York, 1977.

The New York Public Library Desk Reference. Simon & Schuster, Inc., New York, 1989.

Encyclopaedia Britannica. 1999.

Oxford English Dictionary. Oxford University Press [no edition date given].

The New Columbia Encyclopedia. Columbia University Press, New York, 1975.

The Praeger Picture Encyclopedia of Art. Frederick A. Praeger, New York, 1965.

Random House Unabridged Dictionary. Second edition. Random House, Inc., New York, 1993.

The Encyclopedia Americana. Grolier, Danbury, CT, 1999.

The American Heritage Dictionary of the English Language. Fourth edition. Houghton Mifflin Company, Boston and New York, 2000.

Merriam-Webster's Collegiate Dictionary. Tenth edition. Merriam-Webster, Inc., Springfield, MA, 1993.

Index to Contributors